PENGUIN BOOKS

UTOPIAS

Catriona Kelly grew up in London and studied at Oxford and at the University of Voronezh, southern Russia. She has held various posts at Christ Church, Oxford, was Lecturer in Russian at the School of Slavonic and East European Studies, University of London, for the period 1993–6, and is now Reader in Russian at New College, Oxford. Her books include a study of the Russian Punch and Judy show *Petrushka*, and an anthology and a pioneering history of women's writing in Russia.

UTOPIAS

Russian Modernist Texts 1905–1940

Edited by
CATRIONA KELLY

PENGUIN BOOKS

PENGUIN BOOKS

Published by the Penguin Group
Penguin Books Ltd, 27 Wrights Lane, London W8 5TZ, England
Penguin Putnam Inc., 375 Hudson Street, New York, New York 10014, USA
Penguin Books Australia Ltd, Ringwood, Victoria, Australia
Penguin Books Canada Ltd, 10 Alcorn Avenue, Toronto, Ontario, Canada M4V 3B2
Penguin Books (NZ) Ltd, Private Bag 102902, NSMC, Auckland, New Zealand

Penguin Books Ltd, Registered Offices: Harmondsworth, Middlesex, England

First published in Penguin Books 1999
10 9 8 7 6 5 4 3 2 1

Set in 9.5/12.5pt PostScript Adobe New Caledonia
Typeset by Rowland Phototypesetting Ltd, Bury St Edmunds, Suffolk
Printed in England by Clays Ltd, St Ives plc

Contents

5 Origins

List of Illustrations

Acknowledgements

My work on this anthology could not have been carried out without access to the outstanding holdings of Russian modernist literature which I was able to consult in various libraries, most particularly the Taylor Institution Library and the Bodleian Library, University of Oxford, the British Library, the Library of the School of Slavonic and East European Studies, University of London, and the Slavonic Library, University of Helsinki. Slavonic librarians are uniformly an enthusiastic, knowledgeable and helpful group of people who make working in their institutions a pleasure. I likewise record a more than personal debt to the editors and publishers of recent years who have rescued modernist writers and their work from oblivion, a task that, in pre-1991 Russia, often meant risking one's livelihood or even one's life.

Among the many friends and contacts who have made suggestions for texts to be included, or commented on the translations, I would particularly like to thank Robin Aizlewood, Philip Bullock, Julian Graffy, Barbara Heldt, Alan Myers, Andrew Reynolds, G. S. Smith and Ian Thompson. They have also supplied information which has been useful in annotating the passages, as have Catherine Atherton at New College, Oxford, Ian Carter at the Science Museum Library, Jonathan Mallinson at Trinity College, Oxford, Richard Rutherford and Lindsay Judson at Christ Church, Oxford, and Galin Tihanov at Merton College, Oxford.

At Penguin, I would like to thank Anna South and Paul Keegan, and my copyeditor, Donna Poppy.

A Note on Conventions

In annotating the texts, I have limited myself to allusions that would not be traceable in standard one-volume English-language works of reference. This means above all information relating to the Russian cultural background that a non-specialist reader might find elusive or puzzling. To take two examples: a reference to Baudelaire would not be annotated, whereas one to Lermontov would be. The headnotes to the texts are intended for general scene-setting and, in the cases of works cited in extract, for skeletal plot synopses; they aim to avoid foisting a specific interpretation of a poem or passage upon the reader. The endnotes provide commentary on specific linguistic difficulties, supply biographical outlines of persons mentioned, and pinpoint passages where the translation departs from the original for stylistic reasons (or where the meaning of the original is obscure).

The publication details given before a passage generally refer to a first publication; in the very few cases where a text was published more or less simultaneously in a small-circulation journal or newspaper and in book form, I have cited the latter (on the grounds that it is likely to be more accessible to readers who wish to search out the Russian original). Readers needing fuller information about editions in English and Russian of a particular author should consult the encyclopedias and bibliographies given in the 'Further Reading' section under 'Reference Sources'.

Transliteration is according to the British Standard system, except that the hard and soft signs are not transcribed, and that very well-known names customarily spelt idiosyncratically (e.g., Tchaikovsky, Diaghilev) are given in the usual form. British spelling is used throughout (extracts from translations by Americans have been edited for the sake of consistency). Editorial elisions in the original text are indicated with ellipses enclosed in square brackets or, in the case of longer elisions, with centred asterisks. Titles supplied by me are also in square brackets.

Introduction

During his time at Cornell in the late 1940s and 1950s, one of the writers in this collection, Vladimir Nabokov, taught a course under the title 'The Modernist Movement in Russian Literature'. The authors who figured on it were the symbolist poet Aleksandr Blok (the sole representative of the twentieth century, though even he had died in 1921), Leo Tolstoy (with *The Death of Ivan Ilich*), Chekhov ('The Lady with the Little Dog') and the nineteenth-century poets Afanasy Fet and Fyodor Tyutchev.[1]

Nabokov's decision to extend the term 'modernism' to Tyutchev (a contemporary of Pushkin, whose survival into the late nineteenth century was attributable to his avoidance of duels, if not of *grandes passions*), but not, say, to Mayakovsky, Pasternak or Tsvetaeva, appears at first sight contrary, to say the least. A comparable list from the Anglophone world might consist of Dickens, Thomas Hardy, Shelley, Keats, Stevenson, Rupert Brooke and early Yeats, rather than Joyce, Virginia Woolf, T. S. Eliot and Ezra Pound. However, Nabokov's choices seem still odder in the Russian context than their hypothetical equivalents would do in the context of the term 'modern literature' in English, given the far larger role played by avant-garde and experimental forms in twentieth-century Russian culture. For in the decade after the Bolshevik Revolution in October 1917, the radical artistic tendency that was usually referred to as 'contemporary art' (*sovremennoe iskusstvo*) dominated culture in Russia to an extent unmatched anywhere else in the world. Its influence touched not only elite forms such as poetry, theatre design and easel-painting, but popular or populist forms such as movies, best-selling novels, the 'mass festivals' held to mark the new Soviet holidays, posters and pamphlets. After 1921, when a group of avant-garde painters and sculptors formed the Constructivist movement, art began reaching out into everyday life as well: architecture, furnishings, fabrics, clothes and tableware all reflected the determination of young and idealistic left-wingers to construct a utopian new society, a 'scientific', rationalistic,

collectivist community in which citizens would work contentedly and efficiently in modern offices and factories before returning home to streamlined apartments with shared cooking, eating and child-care facilities.

To be sure, many of the new projects remained no more than projects, while those that were realized sometimes proved less attractive than their inventors had anticipated (as the poet Olga Berggolts recalled in *Daylight Stars*, daily life in the concrete communes of 1930s Leningrad was subject to much the same stresses as it was in their distant successors, the high-rise blocks of the 1960s).[2] What is more, the most powerful figures in the Soviet government, including the Commissar of Enlightenment (and overseer of cultural institutions) Anatoly Lunacharsky, Leon Trotsky and of course Lenin himself, remained at best lukewarm towards the most adventurous manifestations of 'contemporary art', even before the rise of Stalin and the 'cultural revolution' of 1927–8 began to curb the ambitions of modernist artists to dominate Soviet culture. But Soviet leaders, Stalin among them, recognized the value of avant-garde design in promoting the Soviet Union's image as a uniquely vital and youthful society, an alternative to the conservative and establishment-ridden societies of other European countries on the one hand, and to the undeniably modern and dynamic, but socially unjust, 'American way of life' on the other. Though the appropriate mode for Soviet arts after 1932 was officially held to be socialist realism, which, while never realist in the ordinary sense, was definitely anti-modernist, the virulence of attacks on *formalizm* (i.e., modernist art forms and theory) indicated the continuing importance of these in Soviet culture. It was not until the late 1940s – when Soviet art assiduously revived the bombastic buildings, sentimental paintings and chauvinist values that had characterized tsarist official art at its most inward-looking and least creative period, the 1890s – that modernism was entirely suppressed. Between 1921 and 1939 'contemporary art' and 'Soviet culture' seemed not only compatible; they seemed inseparable.

The perception that artistic change was an essential part of cultural revolution, and that the arts had a vital role in creating the new anti-bourgeois utopia, inevitably led to the politicization of artists themselves: no work of art was now seen as politically neutral. Even if writers and painters did not choose to be involved in the Soviet artistic establishment (and complete detachment from this was nearly impossible, given that publishing institutions, exhibition facilities and film studios were subject

to state control from the earliest days of Bolshevik power), they were forced to react in some way to the association between 'modern' and 'Soviet'. And some voiced their approval of the association very vehemently. The towering figure of the 1920s was Vladimir Mayakovsky, poet and visual artist, whose participation in the Left Front of Arts (Lef) put him at the forefront of the utopian avant-garde. In his poetry Mayakovsky lambasted vestiges of pre-Revolutionary culture; nothing was so trivial as to escape scrutiny and excoriation. The possession of top hats, double beds, spats, frock coats, china ornaments, film-star posters and canaries – rather than the folding single beds, stacking racks for newspapers, and rational workwear championed by Lef – was accounted a betrayal of the Revolution. Conviction that the Soviet Union had the potential for an ideal society was so strong that it led Mayakovsky to overlook or even celebrate the more sinister aspects of the new culture: in poems of 1927 he asserted that literary censorship was a guarantor of true democratic freedom, and praised the Cheka as 'the clenched fist of [proletarian] dictatorship'.[3]

It is scarcely surprising that many with doubts about Soviet society's egalitarian pretensions, and a more mature awareness than Mayakovsky's of the regime's potential to suppress intellectual dissent, should have begun to doubt the probity of that society's preferred symbolism. With a few significant exceptions such as Ilya Zdanevich, a Russian futurist who spent most of his later life in France, and who remained a practitioner of avant-garde *zaum* (transrational language) there, those coolly inclined to Soviet power tended to eschew experimentalism as well. In Paris and in Berlin taste was dominated by 'Petersburg modernism' – elegant, ironical and inclined to the defence of 'art for art's sake' – rather than 'Moscow avant-garde' – raw, politically interventionist and energized by contact with street culture. (This was one reason for the unhappiness in emigration of Marina Tsvetaeva, a Moscow writer who was sympathetic to the Soviet avant-garde.) The distaste for experimental work evident in Nabokov's Cornell syllabus was not merely personal, then (though the writer's dislike of avant-garde art is well attested in his writings and table-talk).[4] It also expressed an ideologically and aesthetically motivated determination to rewrite the history of modernism without the Soviet contribution, a determination that would have been approved by many other émigré writers.

Yet the existence of non-Soviet, anti-experimental modernists producing genuinely innovative work (the poets Anna Akhmatova and Vladislav

Khodasevich, the painters Léon Bakst and Boris Grigoriev, for example, as well as Nabokov himself) invalidates a definition of modernism along the lines of Lenin's famous 'electrification' slogan: 'Modernism equals Soviet power plus experimentalism in the entire artistic world.'[5] Even 'futurism', the umbrella term for the most avant-garde sections of the Russian modernist movement, and including Cubo-Futurists, Ego-Futurists, Centrifuga and others, sheltered not only writers and painters who shared the Italian futurists' affection for the modern city, but also writers and painters (such as Velimir Khlebnikov or Olga Rozanova) whose attachment to folk tradition, medieval history and indigenous myth made them far closer in spirit to German romantics such as Novalis or Eichendorff than those poets' Russian contemporaries had been.

The contradictory character of Russian modernism – as much anti-modern as modern – means that there is more logic than there might at first seem in Nabokov's apparently wilful decision to begin the history of modernism with Tyutchev, a mystical romantic. Indeed, there is a sense in which it would be perfectly legitimate to apply the term 'modernism' to the whole of Russian literature from the reign of Peter the Great, which saw the first systematic attempts to introduce Western cultural models, and witnessed the beginning of a tradition that associated the West with novelty and Russia with backwardness, and (as a result) the beginning of a tradition according to which the voicing of opposition to 'newfangled Western ways' became an important way of laying claim to a 'true Russian' identity. The Western culture/native culture polarization, enhanced in the 'Westerner' versus 'Slavophile' debates of the 1840s to the 1880s, became still sharper during the reigns of Alexander III and Nicholas II, when nationalist mythology dominated every area of Russian life, from the symbolism employed by these tsars to legitimate their rule, right down to fairground shows and to commercial art forms such as advertising. At the same time the rapid industrialization and urbanization that ensued after the Emancipation of the Serfs in 1861, furthered by state policy, turned Moscow and St Petersburg from cities comparable in size with London in the early eighteenth century to metropolises on the scale of contemporary Paris or Berlin; and urban popular culture had an increasing impact on the Russian villages supplying migrant labour to the capitals. If some of the regime's opponents saw tradition as necessarily inimical to progress, others celebrated the supposedly age-old culture of rural outposts as a defence against encroaching commercialization. Earlier generations of

Slavophile-inclined thinkers had been political conservatives. Now, those who espoused artistic directions rooted in the past, such as neo-primitivism and neo-barbarism, were as likely to be radicals as reactionaries. And consciousness of international trends was as important among nationalist modernists as among their self-consciously Westernizing colleagues. The paradox was that writers and painters who turned to Russian folklore often did so as a result of interest in these subjects on the part of Western observers.[6] And, conversely, the urbane internationalists of St Petersburg never allowed their admiration of the West to become slavish; visits by Matisse and Marinetti, for example, were treated with a striking degree of hauteur by many Russian observers, such as Aleksandr Blok.[7]

Deciding what *was* 'modern' in artistic terms was also difficult because news of a new artistic style often arrived simultaneously with news of that style's fall from grace in the West. 'Symbolism' and 'decadence' (evident in France from the 1850s) established themselves in Russia only in the 1890s, and were soon being vigorously challenged by post-symbolist movements such as Acmeism and Cubo-Futurism, which opposed both the mystical directions in Russian symbolism, and the ethereal vocabulary that had become ubiquitous for its followers. What in Western literature had been discrete phases of the modernist movement overlapped to a high degree, and a number of major figures moved between artistic modes that their Western colleagues would have considered incompatible. Important instances are Aleksandr Blok, whose writings include the harsh polyphony of *The Twelve* as well as musical evocations of 'The Beautiful Lady', or Anna Akhmatova and Boris Pasternak, both of whom began as post-symbolists, but whose last writings have more in common with the pre-1910 poems of Aleksandr Blok than with their own early poems.

The curious status of 'modernism' in Russia is traceable not only to aesthetic or political factors, but also to the idiosyncratic, late and rapid, character of the modernizing process there. It was not uncommon for Russian factories to contain the latest machinery, but for this to be operated by workers fresh from the village in foot-rags and bast shoes who used crosses to sign their names and could barely puzzle out street signs. Modern improvements were apparent in the superbly appointed department stores with plate-glass windows and art nouveau apartment blocks of city centres, but not in worker barracks, where an entire family shared a partitioned niche without sanitary facilities, and where the

latest baby hung in a sling over the parental bed, pacified in the traditional manner with a lump of chewed bread or a filthy rag. And although Russian biological science had produced a Nobel Prize winner (in Ivan Pavlov) by as early as 1904, the provision of primary health care, and indeed of primary education, remained grossly inadequate. In the circumstances, colonizing Mars by spacecraft could seem as likely a possibility as lowering infant mortality, providing rural areas with sanitation or paving the streets of provincial towns.[8]

The social dislocation brought by modernization meant that not only members of the landowning (or ex-landowning) classes, such as Tolstoy, looked with nostalgia to the rural past. The early twentieth century saw an increasingly fierce defence of peasant values on the part of writers such as Nikolai Klyuev or Aleksandr Chayanov, who themselves came from the peasantry. In these circumstances the traditional legend of the 'drowned city of Kitezh', a peasant utopia lying in the past, could seem as attractive as any 'visionary dream' of the future (as a matter of fact, folk etymology fancifully derived *utopiya* from the verb *utopit*, 'to drown'). The myth of 'the drowned city of Kitezh' became all the more powerful after the state-sponsored utopianism of the Soviet period used celebration of the 'bright future' to divert attention from the reality of deprivation and exploitation in the present. And the post-Revolution years also saw the birth of a new genre, the 'dystopian' narrative, a cold-eyed parody of the rational, harmonious collectives that communes and state centralization promised to create.

Attitudes to the future, and to the city as harbinger of the future, lay bare some of the most characteristic aspects of Russian modernism. The term *fin de siècle* has no equivalent in English, but neither does the Russian term *nachalo veka*, which signifies not only 'the beginning of the century', but also 'the dawn of a new era'. This is why I have chosen to begin the collection with a selection of writings on the theme of 'visions of the new world'. Later sections pick up further developments in early-twentieth-century culture that, while not unique to Russia, were strongly evident and influential there. The section 'Men and Women' represents the debates on equal rights for women and sexual liberation that erupted in the late nineteenth century, the latter subject proving particularly controversial in a culture that had been governed since medieval times by a public ethos of sexual asceticism and reticence.[9] 'Origins' deals with the discovery of childhood as the foundation of the creative personality, and with the artistic creations of children and

'primitives' of other kinds, as the material for appropriation by adult artists. 'The Last Circle' and 'Exile' show Russian writers and painters responding to the harrowing experiences of their times: war, political repression and enforced residence beyond the boundaries of their home country. And 'Visions of Art' and 'Altercations and Provocations' give a sense of the lively intellectual debates about the nature and purpose of art that resonated in the early twentieth century.

Such debates are fundamental to an understanding of early-twentieth-century Russian culture, since Russia was much more like France than like the Anglophone world in terms of the role played by theory and by philosophical or pseudo-philosophical discussion (*filosofstvovanie*). The Bloomsbury group was a loose association of friends, lovers and family connections ungoverned by any express philosophy, and in Britain an intellectually ambitious theorist such as Wyndham Lewis was very much a rarity. In Russia, on the other hand, the Acmeists, a group sociologically not dissimilar to the Bloomsbury group, could not have attained artistic credibility without programmes and manifestos.

But while it would be impossible to understand the Russian modernist movement without a knowledge of the firm commitment to explicit aesthetic statements that was felt by many writers and painters, and the strong drive to analysis that is evident in the work of creative artists who saw theory and practice as mutually enriching spheres of activity, it is also important to understand that practice sometimes pre-determined theory. The important writings of Mikhail Bakhtin on 'carnival culture' and 'polyphony' have their roots in the intellectual history of Bakhtin's time (Bergson, Dostoevsky, Vyacheslav Ivanov), as well as in the work of artists such as Mandelstam or Khlebnikov. Therefore, theoretical statements are to be found not only in 'Visions of Art', but also elsewhere in the book; conversely, 'Visions of Art' includes not only analytical texts, but also literary essays and imaginative evocations of the creative process.

The significant role played by abstract discussion did nothing to combat the elasticity of the term 'modernism' in the Russian context, the diversity with which the term 'contemporary art' was interpreted. There is no unified and well-defined 'modernist aesthetic' that might be used as a criterion for including some texts and excluding others; hence, while I have selected some examples of writing and painting employing techniques such as fragmentation, montage composition, word-play and linguistic innovation, I have also included material that might strike Western readers as neo-romantic and even anti-modernist

in spirit (for example, the poetry of Klyuev and Pasternak, the essays of Vyacheslav Ivanov, the paintings and drawings of artists like Bilibin and Somov). The boundaries of the anthology are defined chronologically rather than aesthetically: it could be described as a sampler of what is sometimes known (however misleadingly[10]) as 'the Silver Age' of Russian culture. Its starting point is the beginning of the so-called 'crisis of Russian symbolism' (1905–13), the stage at which Russian symbolism became the single most dominant tendency in Russian literature, but at the price of the movement's atomization, followed by a split into numerous post-symbolist movements (Acmeism, Cubo-Futurism, Ego-Futurism, and so on). The anthology draws to a close in the late 1930s, when (as is clear from the biographical index) large numbers of modernist writers and artists living in the Soviet Union became victims of Stalinist political terror, and when the start of the Second World War devastated the émigré communities that had formerly offered refuge to modernist artists living outside Russia.

I have stretched my own chronological constraints in one or two cases in order to find a place for important pieces by authors who had established themselves before 1940 (as with Akhmatova's 'To the Defenders of Stalin' (1962) or Prismanova's 'Triangles' (1946). However, I have not allowed room to the modernist revival of the 1960s, 1970s and 1980s, when writers such as Joseph Brodsky, Evgeny Popov, Nina Sadur, Elena Shvarts and Olga Sedakova continued the interrupted tradition of the early twentieth century. This is mainly because the first four decades of this century already offer such an embarrassment of riches: it would have been easy to compile a volume of material stretching to two or three thousand pages.[11]

It is fair to say that the thematic structure of the book would have been unlikely to appeal to some of the artists included.[12] That said, the very idea of appearing in a collection with their rivals would also have caused outrage among many writers and painters (the acerbity of faction-fighting is extremely clear from the reviews appearing in 'Altercations and Provocations'). Fidelity to the wishes of individuals would hardly allow the composition of an anthology at all. And organization by theme in the broadest sense (obviously, few of the texts here address a theme in the direct manner that a prize poem or school assignment might be expected to) appeals because it allows the inclusion, in addition to texts that were famous among contemporaries or that are now considered canonical among literary scholars, of those that offer

unexpected insights into Russian life. For example, it is impossible to imagine that Kuzma Petrov-Vodkin's recollections of domestic violence in provincial Russia, or Yury Olesha's macabre recollections of Mayakovsky, or Rozanov's marginal note on homosexuality, or Khlebnikov's utopian 'Proposals', would find space in a systematic historical anthology of the Russian modernist movement; yet these texts have as much to tell us about the atmosphere in which Russian writers, artists and composers worked as do classics of the early twentieth century such as Akhmatova's much anthologized *Requiem*. Lesser figures of the modernist movement appear alongside major names; less familiar texts by well-known writers have been preferred to those customarily anthologized. The main criteria for inclusion were that texts should be striking or vivid in English as well as in Russian. This has meant the under-representation of some work (the poetry of Vyacheslav Ivanov and other representatives of the mystical–religious tradition, or the folkloric narratives of Aleksei Remizov, for instance) that survives surgery on the part of translators only in mutilated form. On the other hand, I was also determined not to exclude material because of its difficulty at first sight; to do so would be to travesty an era in which immediate accessibility was seen as a virtue only by a minority of intellectuals (albeit a vociferous and, eventually, politically triumphant minority). As Mandelstam put it in 'Literary Moscow', 'to address a reader who hasn't the smallest preparatory knowledge of poetry in your work is a painful task; you might as well impale yourself backside-down on a sharp stick'.[13] In order to give Mandelstam and the many artists who thought as he did their due, therefore, work that is demanding or strange appears alongside texts that speak more directly; the introductions to each section, the headnotes to the individual extracts and the endnotes supply information that will help readers who are not familiar with the material to work their way through the selections.

In a marginal jotting from one of her commonplace books, the Russian critic Lidiya Ginzburg argued that disillusion, the loss of enthusiasm, was a necessary part of entry into professional life. Compiling this anthology has made it clear to me that this does not have to be the case: it was one of the most enjoyable experiences I have had in the best part of twenty years' work as a Russian specialist. The ideals of some of the contributors, their beliefs in the perfectibility of the human race, may now seem naïve, but the power of their creations has not faded. I hope that this anthology will not only give readers a sense of that power, but

will also inspire them to explore the field of early-twentieth-century Russian culture more deeply (a list of Further Reading appears at the end of the book). And I hope that it will encourage translators and publishers to add some lesser-known writers, such as Daniil Kharms, Sofiya Parnok, Nadezhda Teffi and Konstantin Vaginov, to the established repertoire of Russian authors widely available in English translation, such as Bulgakov, Akhmatova, Pasternak, Mandelstam and Tsvetaeva.

Notes

1. See Brian Boyd, *Vladimir Nabokov: The American Years* (London, Vintage, 1993), p. 171.
2. Berggolts's account of life in a Leningrad commune appears in 'New Worlds', below.
3. The poems concerned were 'Ivan Ivanovich Gonorarchikov' and 'The Soldiers of Dzerzhinsky'. On the avant-garde's relationship to totalitarian politics, see Boris Groys, *The Total Art of Stalinism: Avant-garde, Aesthetic Dictatorship and Beyond* (Princeton, New Jersey, Princeton University Press, 1992); on utopian ideas in the 1920s, John Bowlt and Olga Matich (eds.), *Laboratory of Dreams: The Russian Avant-garde and Cultural Experiment* (Stanford, California, Stanford University Press, 1996). See also Stephen Hutchings, *Russian Modernism: The Transfiguration of the Everyday* (Cambridge, Cambridge University Press, 1997); Richard Stites, *Revolutionary Dreams: Utopian Vision and Experimental Life in the Russian Revolution* (Oxford, Oxford University Press, 1989).
4. According to Boyd, a recording exists on which Nabokov can be heard expostulating 'That's ghastly' (*Eto uzhasno*) after hearing a reading of a poem by perhaps the most talented Russian futurist poet, Velimir Khlebnikov (see *Vladimir Nabokov: The American Years*, p. 215). Cf. the author's satirical comments on 'bric à Braque' in *Pnin* and *Lolita*.
5. The original slogan by Lenin parodied here is 'Communism equals Soviet power plus the electrification of the whole country' (*Kommunizm est sovetskaya vlast plyus elektrifikatsiya vsei strany*).
6. On the rediscovery of Russian culture through the prism of Western theory, see, for example, Rachel Polonsky, *English Literature and the Russian Aesthetic Renaissance* (Cambridge, Cambridge University Press, 1998). Even such a folksy painter as Boris Kustodiev was profoundly influenced by travelling in Paris, and by the collections of modern art held by Russian entrepreneurs such as Shchukin. See Mark Etkind, *Boris Kustodiev: Paintings, Graphic Works, Book Illustrations, Theatrical Designs* (Leningrad, Aurora Art Publishers, 1983; New York, Harry N.

Abrams, Inc., 1983). And Degas's paintings of Russian dancers were predecessors both of Malyavin's studies of peasant women and of the Ballets russes productions.

7. Blok wrote in his diary on 29 November 1911: 'In Moscow, Matisse, "surrounded by the symbolists", commends Russian art with careless smugness. Quite the "little Frenchman from Bordeaux"': *Collected Works* (8 vols.), vol. 7 (Moscow and Leningrad, Khudozhestvennaya literatura, 1963), p. 78. (The term 'a little Frenchman from Bordeaux' comes from Griboedov's 1824 comedy *Woe from Wit*, in which the hero, Chatsky, explodes with fury over a provincial Frenchman who has dared to patronize Moscow society because it is so like what he is used to in France.)

8. The architectural historian William C. Brumfield points to the gap between aspiration and practical realization of utopian ideals: 'Frequent reports in the Russian architectural press [of the early twentieth century] did not [. . .] lead to the practical assimilation of American building methods such as the skeletal steel frame. The Russian economy and its industrial base could not produce the materials or the demand to justify a technologically intensive system of construction.' See *Reshaping Russian Architecture: Western Technology, Utopian Dreams* (Cambridge, Cambridge University Press, 1990), p. 3.

9. On the history of Orthodox attitudes to sexual activity, see E. Levin, *Sex and Society among the Orthodox Slavs 1100–1700* (Ithaca, New York, Cornell University Press, 1989); on the modernist era, Laura Engelstein, *The Keys to Happiness: Sex and the Search for Modernity in Fin de Siècle Russia* (Ithaca, New York, Cornell University Press, 1992).

10. The term 'Silver Age' originates from a regretful comparison of the early twentieth century with the 'Golden Age' of early-nineteenth-century culture. This mythology has recently been assailed by Omry Ronen; see *The Fallacy of the Silver Age in Twentieth-century Russian Literature* (Harwood Academic, Amsterdam, 1997). One way in which the term 'Silver Age' is inappropriate is that the early twentieth century was far richer so far as music, theatre and painting were concerned than the early nineteenth century, a 'literary era'.

11. An anthology including both early and late Russian modernists would be immensely valuable, allowing the reintegration of post-1960 Russian writers and painters into the tradition broken by socialist realism.

12. A German critic of modernist sympathies described the thematic exhibitions popular in Germany during the Third Reich as 'reminiscent of a weekly outdoor market where fish, flowers, meat, poultry and other items are offered for sale at different stalls'. (B. Hinz, quoted in Igor Golomstock, *Totalitarian Art* (London, Harvill, 1990), p. 217. It is probable that many Russian modernists would have reacted likewise.

13. Most of Mandelstam's 'Literary Moscow' appears in 'Altercations and Provocations', below. The particular target of Mandelstam's remark was Mayakovsky, but the latter was by no means as committed to accessibility as Mandelstam

suggested. In ' "Workers and Peasants Don't Understand You" ' (1928) he argued that 'the better a book, the more it runs ahead of circumstances [. . .] Pushkin was only understood by his own class.' See Vladimir Mayakovsky, *Complete Works*, vol. 12 (Moscow, Khudozhestvennaya literatura, 1959).

1
New Worlds

In medieval Russia, a land of wooden buildings, churches and monasteries were among the few structures made to last. Constructed in white stone, they rose above the steppe or on steep river banks like tangible visions of the city of heaven. Some sites – like that of Solovki Monastery in northern Russia – emphasized the triumph of faith over the most daunting conditions of landscape, the power of creation amidst a barren waste land (the word pustyn, *or 'desert', was sometimes used as a title for monastic settlements: so, for example, Optyna Pustyn, the real-life model for the monastery in* Brothers Karamazov).*

Inside their defensive walls, though, the monasteries were as loosely organized as the kremlins of secular cities, huddles of buildings of different periods and styles without cloisters to provide spatial unification. The coenobitic tradition of communal worship and shared domestic facilities (refectories, dormitories) was always subject to challenge from the idiorrhythmic tradition of separate cells and private contemplation. The great regulatory mechanisms of Roman Christianity – orders, and rules such as that of St Benedict – had no parallels in the Eastern Church, in which laypeople were also supposed to live according to very strict standards of sexual restraint, frequent fasting and denial of the flesh. Ideal communities, the monasteries were at the same time very much part of ordinary life, centres for alms-giving and pilgrimages, and indeed so remain to the present day.

Russian religious culture, then, did not provide a foundation for utopian visions of rational and well-ordered societies, which did not arise as easily from monastic culture as they had from the culture of the early modern West. Religious utopianism came late in the day, as a response to the increasingly assertive character of secular culture in the eighteenth and nineteenth centuries, and it was based on the desire to order worldly life on the ecclesiastical pattern of collectivism, sobornost.

The mainstream tradition of utopianism in Russia looked to the West for inspiration, was resolutely urban in its preferences, and emerged at a late stage: it was constructed by and for laypeople. Its foremost creation was the new city of St Petersburg, built by Peter I at a huge cost in human lives, upon a site as inhospitable in its way as that of Solovki. Especially after its remodelling by Catherine II, whose architects encased the unruly Neva in granite and built streets of regular and proportionate dwellings surrounded by squares and gardens on the former bogland, Petersburg was a city quite apart from other Russian settlements: the labyrinthine streets of Moscow, or the sprouting domes and bell-towers of Novgorod and Pskov. Its dominants horizontal rather than vertical, it was ideally represented in a favourite genre of eighteenth-century urban art, the panorama. And, as the new capital rose, Russians became increasingly familiar with Western dream visions of alternative societies – tales of well-ordered kingdoms set on desert islands or on the fringes of the known world. 'Potyomkin villages' represented aspirations as well as enacting deceptions, according with the Empress's own description of a perfect peasant cottage in her fable 'The Tale of Prince Khloros' (1781):

Not far away they saw a peasant house, with round it a few desyatins *of very well-tilled soil, sown with all kinds of crops: rye, oats, barley, buckwheat, and so on. Some were already ripening, others just pushing through the soil. Further off, they saw meadows where sheep and cows and horses were feeding. They found the master of the house with his watering-can in hand, sprinkling the cucumbers and cabbage his wife had planted; the children meanwhile were occupied elsewhere, weeding the vegetable patch.*

Catherine, with her plantations of sober Germans on the Volga and endorsement of industry in all its senses, behaved as Europe's most powerful improving landlord; some of the better-educated and wealthier aristocrats and gentry took their tone from her, turning their estates into experiments in modern civilization.

At the same time, oppression was woven into the fabric of dream communities from the beginning, and not only because they depended upon serf labour. Just as Russian monasteries had had a traditional function as prisons for the discarded wives and obstreperous opponents of rulers, so imprisonment was placed at the centre of St Petersburg, whose Peter and Paul Fortress was used for the incarceration (in solitary confinement) of the prisoners considered most dangerous to the state. And

an indicative type of state-sponsored utopia was the military settlement introduced under Alexander I in imitation of the estate village constructed by the Tsar's Minister of War, Aleksandr Arakcheev. Soldiers were housed, with their families, in well-constructed, tidy houses: social order was presented as inseparable from military discipline. (The experiment was not a success: rather than turning all of Russia into a well-regulated society, as Alexander had hoped, the settlements created serious disciplinary problems within the army itself.)

As the last example suggests, impracticality and failure to engage with real social conditions also bedevilled utopian projects. Model villages such as Arakcheev's were rare; much commoner was the type of landowner caricatured by Gogol in his Old-World Landowners, whose contribution to estate management was the importation – at vast expense – of six English steel scythes; commoner yet was the gentleman (less often lady) who bankrupted his or her estate and family through a passion for cards, travel and luxury goods. As reform via the establishment came to seem less likely, the search for an ideal society turned away from what was realizable under present conditions to what might be realizable in the future. French utopian socialism fell on fertile soil in Russia. Its most famous product, Nikolai Chernyshevsky's novel What is to be Done? (1863), despite its clumsy construction and turgid style, inspired generations of youthful idealists to anticipate a world of egalitarianism and joyful labour.

Those who were not inspired by Chernyshevsky included Dostoevsky, the protagonist of whose Notes from Underground ridiculed the novel via selective citation, making Chernyshevsky's images of the Crystal Palace and the anthill, metaphors of the harmonious collective, vehicles for an argument in favour of capricious self-assertion. An implicit argument was that if the 'Underground Man', product of St Petersburg, 'the most abstract and premeditated city in the entire world', was such a tortured creature, it was scarcely likely that the inhabitants of futurist cities would be as unproblematically happy as Chernyshevsky's naïve vision had suggested. However, if Dostoevsky's bilious story made him the founder of Russian dystopian narrative, the socialist vision of ideal urban society retained its hold; indeed, it was strengthened by the promise of late-nineteenth-century technological advance. Rather than on far-off islands, Russian writers now placed their utopias on distant planets. Science fiction (a hugely popular genre between the 1880s and the late 1920s) promised that machinery would overcome the gulf of

space and time, bringing to the industrial culture of Russia the technical insights of advanced societies in other worlds. Learning from Martians was a more palatable alternative, in terms of national pride, than dependence upon Western expertise, which in the real Russia was painfully evident even as late as the 1930s (many hundreds of the new enterprises built during the first two Five-Year Plans were designed by foreign specialists, above all from Germany and the USA).

The vast divisions between tradition and modernity in early-twentieth-century Russia, between the country's colossal wealth in terms of natural resources and its underdevelopment in terms of industry and modern agriculture, meant that, to a higher degree than in any other European country, reality was interpreted in terms of potentiality. The nearest analogy for their society that many Russians could find was America, whose hugeness, newness and dynamism made it at once the antipode of 'backward' Russia, and an image of what Russia might, given appropriate political and social change, soon become.

The acceleration of cultural progress was an insight common to most Russian writers in the early twentieth century, but the promise that the future might arrive almost instantly inspired very different reactions. Some, such as the radical populist and science fiction writer Aleksandr Bogdanov, were certain mechanization would bring freedom from the slavery of manual labour and housework, and make possible a new life given over to rational pursuits and intellectual leisure. Others, most famously Evgeny Zamyatin, whose visit to the Tyneside shipyards in England between 1916 and 1917, like Dostoevsky's stay in London five decades earlier, had seemed a crucial encounter with the modern world at its worst, offered nightmare visions of mechanization as inevitably bringing about the standardization of human existence and an erosion of individual freedoms. Others again, such as the peasant poet Nikolai Klyuev, lamented the traditional patterns of life that were being destroyed by the pull of rural populations to the cities, and by the pollutant presence of 'satanic mills' in country areas. A sense of the new century as the 'dawn of a new age' competed with fears that not only a century but an age had come to an end. Even some of those who admired the city, such as Valery Bryusov or Vladimir Mayakovsky, celebrated the potential of city life as anti-civilization, its capacity to unleash the forces of destruction; the streets of Russian towns came to be haunted by monsters, some in human shape.

It befitted the paradoxical character of Russian modernism, in which

celebrations of aeroplanes and of the barbarian past sat incongruously alongside each other, that Moscow, the city frequently seen by Western visitors and Russian commentators alike as 'Asiatic' and 'backward', was an even more fertile breeding ground for urban fantasies than St Petersburg. Moscow was also the home of many of the most enthusiastic supporters of the machine aesthetic, such as Mayakovsky and Aleksei Kruchonykh during the 1910s, and the Constructivist artists and theorists (including Aleksandr Rodchenko and Osip Brik) in the 1920s. The transformation of the medieval capital during the early Soviet period, during which churches were torn down, boulevards laid out, and futurist structures of iron and glass put up, was in a sense the culmination of the avant-garde's determination to create the future by machine-assisted Caesarean section. At the same time St Petersburg, one of Europe's most modern cities, fostered a tradition of what Osip Mandelstam described as 'nostalgia for world culture'. The painters of the World of Art group looked back to the eighteenth-century elegance of Versailles or Tsarskoe Selo, accompanying celebrations of St Petersburg's first hundred and twenty years with grim delineations of its later history (as, for example, in Mstislav Dobuzhinsky's bleak illustrations to the fiction of Dostoevsky, or in the same painter's vision of looming tower blocks and horrifically assertive bridges). And Acmeist poets, such as Anna Akhmatova, Mandelstam and Nikolai Gumilyov, not only commemorated the granite embankments of the city, but suggested the dislocations of history that were also the capital's heritage.

If the need to respond to the potential and the reality of city life was a constant of Russian modernism, the responses offered were extremely diverse. And the selection of texts that follows explores that diversity, from visions of urban utopias reachable by rocket, such as Bogdanov's Red Star, *to neo-romantic laments for mutilated nature, such as Klyuev's* 'In the Factory Yards'; *from Andrei Bely's 'symphonies' of Moscow life to 'The Beginning of a Wonderful Summer's Day', Daniil Kharms's parodistic 'symphony' set on a Leningrad street.*

Aleksandr Bogdanov's novel Red Star, *depicting the experiences of a Russian visitor to Mars, was a pioneering example of a science fiction narrative in which space travel is the means to the discovery of utopia: Mars turns out to be a rational society where equality, fraternity and joyful labour are the principles of existence.*

ALEKSANDR BOGDANOV
[A Martian Factory]

From *Red Star* (St Petersburg, 1907)

We covered approximately 500 kilometres in two hours. That is the speed of a plummeting falcon, and so far not even our electric trains have been able to match it. Unfamiliar landscapes unfurled below us in rapid succession. At times we were overtaken by strange birds flying even faster than we. The blue roofs of houses and the giant yellow domes of buildings I did not recognize glittered in the sunlight. The rivers and canals flashed like ribbons of steel. My eyes lingered on them, for they were the same as on Earth. In the distance appeared a huge city spread out around a small lake and transversed by a canal. The gondola slowed down and landed gently near a small and pretty house that proved to be Netti's. Netti was at home and glad to see us. He got into our gondola and we set off for the factory, which was located a few kilometres away on the other side of the lake.

It consisted of five huge buildings arranged in the form of a cross. They were all identically designed, each of them having a transparent glass vault supported by several dozen dark columns in a slightly elongated ellipse. The walls between the columns were made of alternating sheets of transparent and frosted glass. We stopped by the central building, also the largest, whose gates were about 10 metres wide and 12 metres high, filling the entire space between two columns. The ceiling of the lower floor transected the gates at the middle. Several pairs of rails ran through the gates and disappeared into the interior of the building.

We ascended in the gondola to the upper half of the gates and, amid the deafening roar of the machines, flew directly into the upper storey. Actually, the floors of the factory were not storeys as we understand

them. At each level there were gigantic machines of a construction unfamiliar to me, surrounded by a network of suspended glass-parquet footbridges girded by beams of gridded steel. Interconnected by a multitude of stairways and lifts, these networks ascended towards the top of the factory in five progressively smaller tiers.

The factory was completely free from smoke, soot, odours and fine dust. The machines, flooded in a light that illuminated everything yet was by no means harsh, operated steadily and methodically in the clean fresh air, cutting, sawing, planing and drilling huge pieces of iron, aluminium, nickel and copper. Levers rose and fell smoothly and evenly like giant steel hands. Huge platforms moved back and forth with automatic precision. The wheels and transmission belts seemed immobile. The soul of this formidable mechanism was not the crude force of fire and steam, but the fine yet even mightier power of electricity. When the ear had become somewhat accustomed to it, the noise of the machines began to seem almost melodious, except, that is, when the several-thousand-ton hammer would fall and everything would shudder from the thunderous blow.

Hundreds of workers moved confidently among the machines, their footsteps and voices drowned in a sea of sound. There was not a trace of tense anxiety on their faces, whose only expression was one of quiet concentration. They seemed to be inquisitive, learned observers who had no real part in all that was going on around them. It was as if they simply found it interesting to watch how the enormous chunks of metal glided out beneath the transparent dome on moving platforms and fell into the steely embrace of dark monsters, where after a cruel game in which they were cracked open by powerful jaws, mauled by hard, heavy paws, and planed and drilled by sharp, flashing claws, small electric railway cars bore them off from the other side of the building in the form of elegant and finely fashioned machine parts whose purpose was a mystery to me. It seemed altogether natural that the steel monsters should not harm the small, big-eyed spectators strolling confidently among them: the giants simply scorned the frail humans as a quarry unworthy of their awesome might. To an outsider the threads connecting the delicate brains of the men with the indestructible organs of the machines were subtle and invisible.

When we finally emerged from the building, the engineer acting as our guide asked us whether we would rather go on immediately to the other buildings and auxiliary shops or take a rest. I voted for a break.

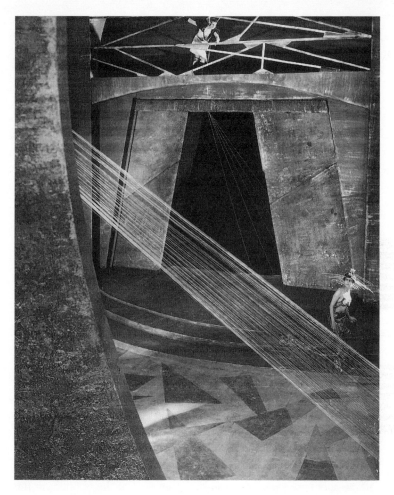

1. Martian princess: Yakov Protazanov's film *Aelita* (1924), with designs by Aleksandra Ekster, transformed a run-of-the-mill science fiction novel about an ideal society on Mars into a film of spectacular beauty, wit and imaginative power.

'Now I have seen the machines and the workers,' I said, 'but I have no idea whatever of how production is organized, and I wonder whether you could tell me something about that.'

Instead of answering, the engineer took us to a small cubical building between the central factory and one of the corner edifices. There were three more such structures, all of them arranged in the same way. Their black walls were covered with rows of shiny white signs showing tables of production statistics. I knew the Martian language well enough to be able to decipher them. On the first of them, which was marked with the number one, was the following:

'The machine-building industry has a surplus of 968,757 man-hours daily, of which 11,325 hours are of skilled labour. The surplus at this factory is 753 hours, of which 29 hours are of skilled labour.

'There is no labour shortage in the following industries: agriculture, chemicals, excavations, mining,' and so on, in a long alphabetical list of various branches of industry.

Table number two read:

'The clothing industry has a shortage of 392,685 man-hours daily, of which 21,380 hours require experienced repairmen for special machines and 7,852 hours require organization experts.'

'The footwear industry lacks 79,360 man-hours, of which . . .' and so on.

'The Institute of Statistics – 3,078 man-hours' . . . and so on.

There were similar figures on the third and fourth tables, which covered occupations such as pre-school education, primary and secondary education, medicine in rural areas and medicine in urban areas.

'Why is it that a surplus of labour is indicated with precision only for the machine-building industry, whereas it is the shortages everywhere else that are noted in such detail?' I asked.

'It is quite logical,' replied Menni. 'The tables are meant to effect the distribution of labour. If they are to do that, everyone must be able to see where there is a labour shortage and just how big it is. Assuming that an individual has the same or an approximately equal aptitude for two vocations, he can then choose the one with the greater shortage. As to labour surpluses, exact data on them need be indicated only where such a surplus actually exists, so that each worker in that branch can take into consideration both the size of the surplus and his own inclination to change vocations.'

As we were talking I suddenly noticed that certain figures on the

table had disappeared and been replaced by others. I asked what that meant.

'The figures change every hour,' Menni explained. 'In the course of an hour several thousand workers announce that they want to change jobs. The central statistical apparatus takes constant note of this, transmitting the data hourly to all branches of industry.'

'But how does the central apparatus arrive at its figures on surpluses and shortages?'

'The Institute of Statistics has agencies everywhere that keep track of the flow of goods into and out of the stockpiles and monitor the productivity of all enterprises and the changes in their work forces. In that way it can be calculated what and how much must be produced for any given period and the number of man-hours required for the task. The Institute then computes the difference between the existing and the desired situation for each vocational area and communicates the result to all places of employment. Equilibrium is soon established by a stream of volunteers.'

'But are there no restrictions on the consumption of goods?'

'None whatsoever. Everyone takes whatever he needs in whatever quantities he wants.'

'Do you mean that you can do all this without money, documents certifying that a certain amount of labour has been performed, pledges to perform labour, or anything at all of that sort?'

'Nothing at all. There is never any shortage of voluntary labour – work is a natural need for the mature member of our society, and all overt or disguised compulsion is quite superfluous.'

Translated by Charles Rugle

Andrei Bely's Symphonies *was the writer's first book. Described as 'lyrical prose', and equally classifiable as 'prose poems', the 'symphonies' represent the urban milieu favoured by Russian naturalist writers, but dispense with conventional fiction's requirements of 'plot' and 'character' in favour of a 'musical' structure of repeated motifs and shifting emotional dynamics.*

ANDREI BELY
[Moscow Symphony]

From 'The Dramatic Symphony' in *Symphonies* (St Petersburg, 1902)

1. A season of sweltering grind. The roadway gleamed blindingly.
2. Cab-drivers cracked their whips, exposing their worn, blue backs to the hot sun.
3. Yard-sweepers raised columns of dust, their grime-browned faces loudly exulting, untroubled by grimaces from passers-by.
4. Along the pavements scurried heat-exhausted intellectuals and suspicious-looking citizens.
5. All were pale and over everyone hung the light-blue vault of the sky, now deep-blue, now grey, now black, full of musical tedium, eternal tedium, with the sun's eye in its midst.
6. Streams of white-hot metal poured down from the same spot.
7. None knew where they ran to or why, fearing to look truth in the eye.

1. A poet, writing a poem about love, was having difficulty with the choice of rhymes. And dropped an ink-blot, and, turning his eyes towards the window, took fright at the tedium of the sky.
2. The grey-blue vault smiled at him with the sun's eye in its midst.

1. Two men were arguing over a cup of tea about people great and small. Their cracked voices had grown hoarse with debate.
2. One sat with his elbows on the table. He raised his eyes to the window. He *saw*. He broke all threads of the conversation. He had caught the smile of eternal tedium.
3. The other was leaning his short-sighted, pock-marked face towards

his antagonist, spattering him with spittle, as he finished bawling out his objection.

4. But the other did not bother even to wipe his face with a handkerchief; he had withdrawn into the depths, plunged into the fathomless.

5. And the victor threw himself back in his chair, his good-natured, stupid eyes peering out at the silent one through golden spectacles.

6. He knew nothing of the removal of the final veils.[1]

7. And in the sweltering streets, in the blinding whiteness, men in dark-blue jackets drove by on water-carts.

8. They sat on barrels that gushed out water underneath.

1. High buildings towered like a spread of bristles, puffed up like fattened pigs.

2. One moment they would wink their countless windows at the timid pedestrian, the next they would flash him a blind wall as a sign of contempt, then they would sneer at his hidden thoughts with belching columns of smoke.

3. On these days and at these hours documents and memoranda were being composed in offices, and a cockerel led hens around the paved courtyard.

4. Two grey guinea-fowl were in the courtyard too.

5. A talented artist had painted a 'miracle' on a large canvas,[2] and twenty skinned carcases hung in the butcher's shop.

6. And everybody knew this, and everybody concealed it, fearing to turn their eyes towards the tedium.

7. And yet there it was, shadowing everyone, a misty, invisible outline.

8. Although the water-cart men were consoling each and everyone by spreading mud everywhere, and children bowled hoops along the boulevard.

9. Although the light-blue vault laughed into everyone's eyes, the terrible, grey-blue vault of the sky with the sun's eye in its midst.

10. Which was where they came from, the austere and cheerless songs of sovereign Eternity. Eternity supreme.

11. And these songs sounded like scales. Scales played from the world invisible. Always the same and the same. Just as they finished so they began again.

12. Just as they soothed, so they began again to disquiet.

13. Always the same and the same, without beginning or end.

1. In a fashionable shop a lift was operating. The operator of this mechanical diversion spent his time frenziedly flying up and down between the four floors.
2. Everywhere crowds of men and women tried to burst their way into the little box, crushing and cursing each other.
3. Although staircases had been set in the same place.
4. And over this crush an expressionless voice of majesty and mystery proclaimed from time to time: 'The account.'

Translated by Roger and Angela Keys

Velimir Khlebnikov, part genius, part holy fool, part sage, was a characteristic figure of the Russian modernist movement. The utopian schemes that he sets out here combine fortuitous predictions of the future with whimsical, other-worldly fancies, straddling the boundaries between sense and nonsense.

VELIMIR KHLEBNIKOV
'Proposals'

From *Took – The Futurists' Drum* (Moscow, 1915)

[°]**G**row edible microscopic organisms in lakes. Every lake will become a kettle of ready-made soup that only needs to be heated. Contented people will lie about on the shores, swimming and having dinner. The food of the future.

°Effect the exchange of labour and services by means of an exchange of heartbeats. Estimate every task in terms of heartbeats – the monetary unit of the future, in which all individuals are equally wealthy. Take 365 times 317 as the median number of heartbeats in any twenty-four-hour period.

°Use this same unit of exchange to compute international trade.

°End the World War with the first flight to the moon.

°Establish a single written language for all Indo-Europeans, based on scientific principles.

°Effect an innovation in land ownership, recognizing that the amount of land every single individual requires cannot be less than the total surface of Planet Earth.

°Let air travel and wireless communication be the two legs humanity stands on. And let's see what the consequences will be.

°Devise the art of waking easily from dreams.

°Regard capital cities as accumulations of dust at the nodes of standing waves, according to the theory of resonant plates (Kundt's dust figures).[1]

°Adopt apes into the family of man and grant them selected rights of citizenship.

°Assign numbers the names of the five vowels: *a*, *u*, *o*, *e*, *i*, thus *a* = 1, *u* = 2, *o* = 3, *e* = 4, *i* = 5, *ia* = 0. A system of notation based on five.

°All the ideas of Planet Earth (there aren't that many), like the houses

on a street, should be designated by individual numbers, and this visual code used to communicate and to exchange ideas. Designate the speeches of Cicero, Cato, Othello, Demosthenes by numbers, and in the courts and other institutions, instead of imitation speeches that nobody needs, simply hang up a card marked with the number of an appropriate speech. This will become the first international language. This principle has already been partially introduced in legal codes. Languages will thus be left to the arts and freed from humiliating burdens. Our ears have become exhausted.

°Take 1915 as the first year of a new era: indicate years by means of the numerical expression for a plane $a + b\sqrt{-1}$, in the form $317d + e\sqrt{-1}$, where e is less than 317.

°Instead of clothes wear medieval armour, all white, made out of the same material that is now used for those silly starched collars and stiff-front shirts.

°Set aside a special uninhabited island, such as Iceland, for a never-ending war between anybody from any country who wants to fight now. (For people who want to die like heroes.)

°For ordinary wars, use sleep guns (with sleep bullets).

°Introduce into the business of birth the same order and organization that is now reserved for the business of killing; birth battalions, a fixed number of them.

°Redesign chemical and biological warfare so that it merely puts people to sleep. Then governments will earn our admiration and deserve our praise.

°Usher in everywhere, instead of the concept of space, the concept of time. For instance, wars on Planet Earth between generations, wars in the trenches of time.

°Train wrecks would be unavoidable if the movement of trains was organized only in terms of space (the railway network). It's precisely the same with governments; we need a timetable for their movements (as for different trains over the same network of tracks).

°We must divide up humanity into inventor/explorers and all the rest. A class of far-seeing visionaries.

°Serious research in the art of combining human races and the breeding of new ones for the needs of Planet Earth.

°Reform of the housing laws and regulations, the right to have a room of your own in any city whatsoever and the right to move whenever you want (the right to a domicile without restrictions in space). Humanity

in the age of air travel cannot place limits on the right of its members to a private, personal space.

°Build apartment houses in the form of steel frameworks, into which could be inserted transportable glass dwelling units.

°Demand that armed organizations provide individuals with weapons to dispute the opinion of the Futurians, that the whole of Planet Earth belongs to them.

°Establish recognized classes of geogogues and superstates.

°Let factory chimneys awake and sing morning hymns to the rising sun, above the Seine as well as over Tokyo, over the Nile, and over Delhi.

°Organize a worldwide authority to decorate Planet Earth with monuments, turning them out like a lathe operator. Decorate Mont Blanc with the head of Hiawatha, the grey peaks of Nicaragua with the head of Kruchonykh, the Andes with the head of David Burlyuk. The fundamental rule for these monuments to be as follows: the individual's birthplace and his monument must be located at opposite poles of the Earth. The white cliffs of Dover can provide a maritime monument (a head rising out of the sea) for Huriet el-Ayn, a Persian woman burned at the stake. Let seagulls perch upon it, beside ships full of Englishmen.

On the great mall of Washington, DC we must have a monument to the first martyrs of science – the Chinese Hsi and Ho, state astronomers who were put to death for daydreaming.

Erect portable moving monuments on the platforms of trains.

°Create a new occupation – penmen – recognizing that the graphic quiver of handwriting itself has a powerful effect on the reader. The unheard voice of handwriting. Also create a recognized class of artists who work with numbers.

°Utilize the boring eyes of trains as projectors for flashing out schedules of what's happening tomorrow in the arts, like an arrow in swift pursuit.

<div align="right">Translated by Paul Schmidt</div>

It is not always appreciated in the West that socialist realism was a utopian genre, but that is made very clear by Gladkov's Cement, *a pioneering 'production novel' named at the 1934 Congress of Soviet Writers as a model for authors to emulate. The starting point of* Cement *– which, like Nikolai Ostrovsky's* How the Steel was Tempered, *enjoyed genuine popularity with readers – is plausible enough: Gleb Chumalov returns from the Civil War to find the factory where he worked at a standstill. However, the ease with which the muscular and manly workers overcome obstacles to get the factory going again, and the lush (and unintentionally hilarious) romanticism of the descriptions of the factory premises (to be toned down, but not altered unrecognizably, by Gladkov in later editions), soon indicate that the novel's aim is myth rather than verisimilitude.*

FYODOR GLADKOV
[The Temple of the Machines]

From *Cement, Krasnaya nov*, 1–2, 5–6 (1925)

Gleb walked down the long night-dark tunnels into the machine section. A dense light from the heavens illuminated this temple of machinery. The floor was laid with coloured tiles in a chessboard design. With black marmoreal sides outlined in silver and gold, the diesels rose like pagan idols. They stood firm and upright in their long rows, ready for work – a single touch and they would burst into life, metal flashing like mirrors. The flywheels were spinning, and Gleb seemed to sense air filled with soot and oil pulsing on his cheek. The diesels rose like altars demanding their sacrifice of human blood. And the flywheels now paused, now flew. The machines stood solidly under the hand, steady on the earth: they were like great crystals ready to explode into life.

Here, as before, everything was tidy, clean; every component of the machines breathed with tender loving human care. As before, the floor shone under its film of wax, and there was no speck of dust on the windows; the panes (there were so many panes!) held trembling shafts of blue and amber light. Human life was stubbornly persisting here; its presence kept the machines alive and tense for action.

And now that human life approached, in blue overalls, in a cloth cap,

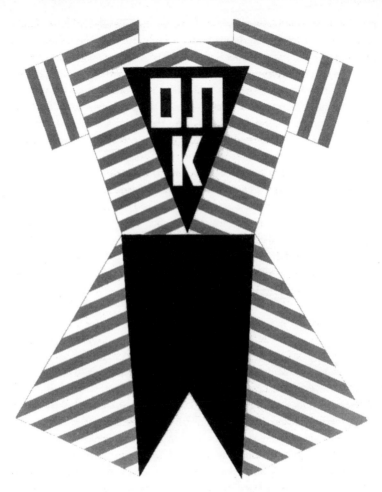

2. Futurist leotard: *Fizkul'tura*, or 'physical culture', was an obsession of the early Soviet era. Varvara Stepanova's 1925 sketch for a sports uniform shows that the practical need for freedom of movement could be compatible with streamlined elegance.

running from one of the passages between the diesels, rubbing hands on a clump of tow, flashing eyeballs and white teeth. The peak of his cap hung like a leaf over his nose, and his ginger moustache bristled over his mouth: every inch of him was alert, focused, ready for action.

'There you are, mate! Can it really be you, though? A division commander, no less! And you said we'd pick things up where we left off when you got back! Long time no see: delighted you're here, mate! Come here and let me rub you down with juice from the machines!'[1]

It was him! It was Brynza[2] the mechanic, Gleb's old mate.

He had been born here (his father was a mechanic, like him), he'd grown up among the machines; the machine section was the whole world to him. Brynza and Gleb had spent their youth together, they'd started work as apprentices on the same day.

'Eh, soldier boy! Let's be looking at you, then . . . You may have shoved a soldier hat on, but you're just the same . . . only your nose's a big bigger, and that star there.'

Gleb snorted with delight and spread his arms to embrace his old friend.

'Brynza, mate! So you're still here? Damn you, eh! Why aren't you idling like everyone else? Or have you started a sideline in making cigarette lighters?[3] Just look: got the machines working, so I see?'

Brynza grabbed Gleb's hand and dragged him deep into the narrow passage between the machines.

'Look at them, the devils, eh . . . Sweet and clean as virgins, every one. But all you have to do is to tell me to get going, and every one of them will turn over and strike up the joyful steel march . . . Machines need just as much discipline as you soldiers do, you know. [. . .]

When the diesels fell silent and people left the factory in their masses to fight for the Revolution in the Civil War, to endure hunger and suffering, Brynza had remained alone in the silence of the still machine room. He had shared the life of the machines, the solitude of the stern shining diesels. [He had remained faithful to them till the bitter end.][4]

Translated by Catriona Kelly

Andrei Platonov, who began life as a 'proletarian poet', is one of the many cases that show the difficulty of drawing a line between 'Soviet' and 'anti-Soviet' sensibilities. His novel The Foundation Pit, *banned from publication until the glasnost era, is often interpreted as a brilliant parody of the 'production novel', and as an illustration of the futility of socialist construction. But at the same time the text portrays ordinary Soviet citizens' efforts to build utopia in the present day with remarkable sympathy and insight. In the following scene, which occurs early in the novel, Prushevsky, the project supervisor, suffers anxieties about the task of building 'The Palace of the Future' as he contemplates the foundation pit where the structure is to rise.*

ANDREI PLATONOV
[The Building-site of the Future]

From *The Foundation Pit*, written 1930, first complete edition *Novyi mir*, 6 (1987)

It was pitch black when the work supervisor for the All-Proletarian Home emerged from his drawing office. The hollow of the foundation pit was now deserted; the work-team were all asleep, packed closely together inside the barrack, and all that could be seen through the slits in the boards was the glow of a night lamp, shining dimly in case there were some mishap or somebody suddenly felt thirsty. Prushevsky walked up to the barrack and peered in through a hole where there had once been a knot in the wood: Chiklin was sleeping right up against the wall, his hand bulging with strength as it lay on his belly and his entire body rumbling away in the nourishing work of sleep; Kozlov had bare feet and was sleeping with his mouth open; his throat was gurgling as though each breath he took had to work its way through dark, heavy blood, and occasional tears were trickling down from his pale, half-open eyes – because of a dream or some yearning of his.

Prushevsky took his head away from the wooden boards and thought for a while. Far off in the night a construction site for a factory was shimmering with electric light, but Prushevsky knew there was nothing there except lifeless building material and exhausted, mindless people. It was he who had thought up this common home for the proletariat,

this single building that was to replace the old town where to this very day people lived fenced off from one another on their private plots; in a year's time the entire local proletariat would leave the old town and its petty properties and take possession of the monumental new home. And, in another decade or two, some other engineer would construct a tower, in the very centre of the world, where the toiling masses of the whole earth would happily take up residence for the rest of time. From the point of view of both aesthetics and static mechanics, Prushevsky could already see what kind of structure would be required in the centre of the earth, but he was unable to get a sense of the psychic structure of the inhabitants of his common home in the middle of the plain, let alone imagine that of the people who one day would live in the tower at the centre of the earth. What kind of bodies would young people have then? What new force would stir them and set their hearts beating and their minds thinking?

Prushevsky wanted to know all this now, so the walls of his construction would not be built in vain; the building would have to be occupied by people, and people were filled by that surplus vital warmth that had once been termed the soul. He was fearful of erecting empty buildings, ones that people only used so they could shelter from the elements.

Feeling the night cold, Prushevsky went down into the foundation pit that the navvies had started to dig. It was quiet down in the hollow and he sat there for some time. There was stone beneath him and the walls of the excavation rose up on either side; he could see how the topsoil rested on a layer of clay and yet had nothing to do with it. Would a super-structure necessarily develop from any base whatsoever? Was the soul of man an inevitable by-product of the manufacture of living material? And if waste could be eliminated from the manufacture of this material, would it give rise to unexpected by-products?

Ever since he was twenty-five, engineer Prushevsky had had a sense that something was cramping his consciousness and stopping him from understanding anything further about life; it was as though there were a dark wall in front of his groping mind. And he had been in torment ever since, fidgeting about beside this wall of his and trying to comfort himself with the thought that he had, essentially, already grasped the true, innermost structure of the matter whose various permutations constituted mankind and the rest of the world; the fundamentals of science all lay on this side of the wall of his consciousness, while whatever

lay beyond the wall was so boring there was no real point in even bothering with it. All the same, he couldn't help but wonder if anyone else had managed to climb over the wall and get any further.

Once again Prushevsky walked up to the wall of the barrack, bent down and peered through the wall at the nearest of the sleeping bodies, hoping to discover something about life he didn't know; but there was little to be seen, since the night lamp was running out of kerosene, and all he could hear was the sound of slow, flagging breathing. Prushevsky left the barrack and went off to the night-shift barber's for a shave; when he felt low, he liked to have someone touch him with their hands.

After midnight Prushevsky went back to his room – an outhouse in an orchard – opened a window into the darkness and sat down for a while. From time to time a faint breeze rustled the leaves outside but, after a while, silence would set in once again. Beyond the orchard someone was walking along and singing to himself – it was probably the accountant on his way home after working into the night, or just someone who didn't feel like sleeping.

Far away, suspended beyond any hope of salvation, shone a dim star that was now as close as it would ever be. Prushevsky looked at it through the murky air, time passed by, and he wondered: 'Or should I kill myself?'

Prushevsky couldn't think of anyone who really needed him so much that it was essential he should keep on living, come what may, until the day death finally caught up with him. In place of hope all he had left now was endurance, and somewhere beyond the long succession of nights, beyond the orchards that faded, blossomed and died again, beyond all the people he had come across and who had then gone their own way, there would come a day when he would have to take to his deathbed, turn his face to the wall and pass away without ever having been able to cry. Only his sister would then be left in the world, but she would have another of her babies and the pity she felt for it would be stronger than her grief over a brother whom death had destroyed.

'I'd be better off dead,' thought Prushevsky. 'I may be useful to people, but I don't make anyone happy. I'll write a last letter to my sister tomorrow – I must remember to buy a stamp in the morning.'

And, having decided to put an end to it all, he lay down on his bed and fell asleep, happy not to have to bother with life any longer. But he needed more time to savour this happiness to the full, and so

he woke up at three in the morning, lit a lamp and sat there in the light and silence, surrounded by apple trees, until dawn; he then opened a window so he could hear the birds and the footsteps of the passers-by.

Translated by Robert Chandler

The story by Aleksandr Chayanov, from which the extract below is taken, is unusual in associating the 'bright future' with rural rather than with urban tradition. Transported to Moscow in 1984, the committed communist Aleksei Kremnyov finds himself in a city of historic buildings surrounded by parks and gardens, where time-honoured customs are observed. The following extract comprises Chapter 10 of the narrative (subtitled, with eighteenth-century expansivity, 'In which the Fair at White Kolp is Described and the Author's Complete Agreement with Anatole France's Dictum that a Story without Love is like Fat without Mustard is Explained'), and is an especially effective depiction of a world in which 'the passing of centuries had changed nothing in rustic delights'.

'IVAN KREMNYOV' (ALEKSANDR CHAYANOV)
'The Fair at White Kolp'

From *Journey of My Brother Aleksei to the Land of Peasant Utopia*
(Moscow, 1920)

We know, from the surviving 'Book of Expenditure of the Patriarch's Office', that at the beginning of the eighteenth century the Most Holy Patriarch Adrian was daily supplied at table with 'porridge, fresh pike in brine, white sturgeon soup, a dish of stellate sturgeon, cabbage soup and underbelly of fish, fish joints and horseradish, a choice cut of white sturgeon, a pasty with meat' and at least a further twenty dishes in breathtaking quantities and of excellent quality. Comparing this feast of ancient times with the utopian table in the hospitable house of the Minins, we have to admit that the Patriarch's fare was a little more sumptuous. But only a little ... Paraskeva had arrived from Moscow and at her bidding such quantities of open pasties and pies, stuffed carp and carp in sour cream and other delicacies appeared on the table that its legs would surely have bent had they been but a little less sturdy; while the socialist politician Kremnyov fully expected all the participants in the meal to be dead by the evening from over-indulgence. However, the national dishes prepared for the American's edification vanished rapidly and without trace to the accompaniment of a rising chorus of praise for Paraskeva, who modestly readdressed it to 'The Russian Cuisine' compiled by Mr Levshin in 1818.[1]

After a nap in the hay-loft in the traditional Orthodox manner, the young people carried Kremnyov off to the fair in White Kolp.

As Kremnyov and his companions walked by the banks of the Lama, the shadows of clouds drifted over the mown meadows, flowering tansy made yellow patches along the road, and in the dense autumn air spiders' webs floated about.

Katerina walked along with head held high; a gust of wind outlined clearly the contours of her body against the blue depths of sky beyond the river. Meg and Natasha were picking flowers. There was a smell of autumn wormwood in the air.

'There's the main road!'

They turned on to the highway lined with weeping birches and in the distance they could see the domes of White Kolp Church.

Carts, bright-painted like trays and packed full of lads and lasses cracking nuts, overtook the travellers. The strains of a popular song rang out over the road.

> Little pigeon on the roof-top
> Soon you will be pigeon pie;
> Come and help me, O my darlings,
> Choose the one with whom I'll lie.

Kremnyov was surprised by the almost complete absence of any difference between his companions and those who met or overtook them. The same dress and the same Moscow manner of speech and expression. Gaily, and with evident enjoyment, Paraskeva jokingly rebuffed the pleasantries of the passing lads, while Katerina simply hopped into one of the carts, kissed all the girls sitting in it, and took away a bagful of nuts from a surprised youth as she popped a chunk of banana into his mouth.

The fair was in full swing.

Mountains of Tula gingerbreads were piled on a stall, both the crisp variety and that with candied fruit; there were Tver mints in the shape of fishes and of generals and there were the juicy, multicoloured Kolomna fruit-drops.

The passing of centuries had changed nothing in rustic delights, and only a careful observer would have noticed the considerable quantities of preserved pineapple, the bunches of bananas and the extraordinary abundance of good chocolate.

As in the good old days, little boys whistled on gilded clay cockerels, just as they had done in the days of Tsar Ivan Vasilievich[2] and in Novgorod the Great. A double accordion played a fast polka.

In a word, everything was fine.

Katerina, entrusted with the education of Mister Charlie, led him into a large white tent, and without comment pronounced: 'There!'

The walls of the tent were hung with paintings of both old and modern schools. Kremnyov joyfully recognized some old friends: Venetsianov, Konchalovsky, Rybnikov's 'Saint Hieronymus', the Novgorod 'Elijah' from the Ostroukhov collection, as well as hundreds of new, unfamiliar paintings and sculptures which vividly put him in mind of yesterday's conversation with Paraskeva.[3]

He stopped before 'The Christ child' of Giampetrino which had held him spellbound in the Rumyantsev Museum and, at the risk of destroying his incognito, exclaimed: 'But however did these get to White Kolp Fair?'

Paraskeva hastened to explain that the booth was a touring exhibition from Volokolamsk Museum to which some Moscow paintings had been temporarily loaned.

The densely crowded visitors, looking attentively at the exhibits and exchanging comments, showed Kremnyov that the representational arts had become firmly established in everyday peasant life and met with an informed understanding. Of the latter he was further convinced by the rapid rate of sale at the door of the 132nd edition of P. Muratov's *A History of Painting in a Hundred Pages* and the booklet *From Rokotov to Ladonov*,[4] the dust-jacket of which told him that Paraskeva not only could talk about painting, but also wrote books.

In the next tent, peasant women clustered round samples of ancient Russian embroidery, and two lads were sizing up a Boulle cabinet.

Soon the exhibition began to empty; the sound of voices and the ringing of a bell heralded the start of the eurhythmics. This was followed by a knuckle-bone match, a hurdle race and other Yaropol *volost* championships. Huge blue posters promised *Hamlet* by Mr Shakespeare at seven o'clock, to be performed by a company from the local co-operative union.

But it was time to hurry home and call in at the bee-garden for some honey on the way. So, abandoning the celebrations, the company only found time to visit the panopticon exhibited by the cultural and educational department of the Guberniya Peasant Union.

Along the walls stood wax busts, portraying historical personages; a panoramic display acquainted the spectators with the major events of national and world history and with the wonders of tropical lands.

Animated exhibits showed Julius Caesar at the Rubicon, Napoleon on the walls of the Kremlin, the abdication and death of Nicholas II, Lenin speaking at the Congress of the Soviets, Sedov routing the typists' rebellion, the basso cantante Chaliapin and the bass Gaganov.

'Look, but this is your portrait!' Katerina exclaimed.

Kremnyov was rooted to the spot. A bust, reminiscent of photographic postcards, stood before him on canvas under a glass. Underneath, the inscription read: 'Aleksei Vasilievich Kremnyov, member of the college of the World Economic Council, the suppressor of Russia's peasant movement. According to medical opinion, most probably suffered from persecution mania; degeneration is clearly evidenced by the asymmetry of the face and the structure of the skull.'

Aleksei blushed deeply and did not dare look at his companions.

'It's marvellous! An amazing likeness; even the jacket is like yours, Mr Charlie,' cried Nikifor Minin.

Everybody became oddly embarrassed and they left the panopticon tent in silence.

They were in a hurry to get home, but Katerina dragged Kremnyov off to the bee-garden for honey. The path cut across some cabbage patches. The intense splashes of their firm, almost blue, heads accentuated the blackness of the earth. Two women, strongly built and wearing white dresses with pink polka-dots, were cutting the ripe ones and throwing them into a two-wheeled cart.

For the first time in his utopian journey, Aleksei, shaken by the confrontation with his waxen double, fully realized the seriousness and hopelessness of his position.

The original sin of his pretended birth bound him hand and foot, while his real name evidently branded him as an outlaw in the land of peasant utopia.

But this surrounding world of cabbage patches, blue distances and the red rowan clusters was no longer alien to him.

He felt a new and precious bond with it, an affinity even closer than to the socialist world he had left; and the cause of this closeness, Katerina, flushed from the rapid walk, was at his side, spellbound, clinging to him imperceptibly.

They slackened their pace as they descended the steep slope of an

old stream. Aleksei touched her hand and their fingers intertwined.

The crowns of apple-trees, their boughs bent as in an old Japanese print and laden with fruit, rose in neat rows above the utterly black, freshly tilled earth. Large, red, fragrant apples and the trunks white with lime filled the air with the smell of fertility; the scent seemed to him to soak its way through the pores of his companion's bare hands and neck.

So began his utopian love.

<div align="right">Translated by R. E. F. Smith</div>

*Nikolai Klyuev, who shared Chayanov's country background, was no
less steadfastly opposed to the industrialization of Russia than the latter.
However, his response, as with William Blake (a poet of a similar
sensibility), was to lambast the ugliness of modern factory culture, while
at the same time celebrating the beauty of the traditional culture that
was now under threat, not only in Russia but all over the world (some
of Klyuev's poems link the fate of the oppressed peasants of Russia with
their counterparts in Scotland, with the Indian tribes of America or, as
here, the citizens of Byzantium).*

NIKOLAI KLYUEV
From *Lenin*

(Moscow, 1924)

In the factory yards, with their slag and their poisons
Like a star or a tear glows a dandelion:
Machines cannot rule the invisible Byzance
Where the lark and her double the pipit[1] give tongue.

Slogans may rumble: 'Fall on your knees
Before the coal's dust, the greed of the furnace':
My soul shall soar much higher than steam:
To the hinter-stove heights, to the top of Mount Tabor,[2]

Where the heads of our fathers are grey-petalled flowers,
And loaves look like brains, and embroidered cloths
Are girl's slender fingers, sorrow's seismographs
That can't be unravelled; where magic birds sob.

And where the birch's iron brother rebukes her
That she, like the song, abhors the axe:
Oh, see the whale splash in a foaming bucket,
The moon dive like a dolphin in drops of sweat.

The orioles trill in their old wives' bonnets
(Fifes sing in brocade, and waves splash in a pearl);
This is Russia's lament for the singer, her son,
For the bison and wigwams on Vyatka fields.

Words are the noses of Solovki[3] barges,
The wisdom of deeps and the triumph of sails:
I shall coast into time on the back of a walrus,
With my undertow suite, my poems, for whales.

Translated by Catriona Kelly

In Mikhail Bulgakov's 1925 story, The Heart of a Dog, *Professor Preo-brazhensky, a specialist in rejuvenation techniques (which were a fashionable subject of scientific investigation at the time the story was written), implants the pituitary gland and testicles of a human being into the body of a stray dog, Sharik. As the dog recovers from the operation, it becomes clear to the observers of the experiment that something very strange has happened.*

MIKHAIL BULGAKOV
[An Experiment Goes Wrong]

From *The Heart of a Dog, Grani*, 69 (1968)

January 6th (entries made partly in pencil, partly in violet ink):
Today, after the dog's tail had fallen out, he quite clearly pronounced the word 'liquor'.

Recording apparatus switched on. God knows what's happening.

(Total confusion.)

Professor has ceased to see patients. From 5 p.m. this evening sounds of vulgar abuse issuing from the consulting-room, where the creature is still confined. Heard to ask for 'another one, and make it a double'.

January 7th Creature can now pronounce several words: 'taxi', 'full up', 'evening paper', 'take one home for the kiddies' and every known Russian swear-word. His appearance is strange. He now only has hair on his head, chin and chest. Elsewhere he is bald, with flabby skin. His genital region now has the appearance of an immature human male. His skull has enlarged considerably. Brow low and receding.

My God, I must be going mad . . .

Filipp Filippovich still feels unwell. Most of the observations (pictures and recordings) are being carried out by myself.

Rumours are spreading round the town . . .

Consequences may be incalculable. All day today the whole street was full of loafing rubbernecks and old women . . . Dogs still crowding round beneath the windows. Amazing report in the morning papers: *The rumours of a Martian in Obukhov Street are totally unfounded. They have been spread by black-market traders and their repetition will be severely punished.*

What Martian, for God's sake? This is turning into a nightmare.

Reports in today's evening paper even worse – they say that a child has been born who could play the violin from birth. Beside it is a photograph of myself with the caption: 'Prof. Preobrazhensky performing a Caesarean operation on the mother.' The situation is getting out of hand . . . He can say a new word – 'policeman' . . .

Apparently Darya Petrovna was in love with me and pinched the snapshot of me out of Filipp Filippovich's photograph album. After I had kicked out all the reporters one of them sneaked back into the kitchen, and so . . .

Consulting hours are now impossible. Eighty-two telephone calls today. The telephone has been cut off. We are besieged by childless women . . .

House committee[1] appeared in full strength, headed by Shvonder – they could not explain why they had come.

January 8th Late this evening diagnosis finally agreed. With the impartiality of a true scholar, Filipp Filippovich has acknowledged his error: transplantation of the pituitary induces not rejuvenation but *total humanization* (underlined three times). This does not, however, lessen the value of his stupendous discovery.

The creature walked round the flat today for the first time. Laughed in the corridor after looking at the electric light. Then, accompanied by Filipp Filippovich and myself, he went into the study. Stands firmly on his hind (deleted) . . . his legs and gives the impression of a short, ill-knit human male.

Laughed in the study. His smile is disagreeable and somehow artificial. Then he scratched the back of his head, looked round and registered a further, clearly pronounced word: 'bourgeois'. Swore. His swearing is methodical, uninterrupted and apparently totally meaningless. There is something mechanical about it – it

is as if this creature had heard all this bad language at an earlier phase, automatically recorded it in his subconscious and now regurgitates it wholesale. However, I am no psychiatrist.

The swearing somehow has a very depressing effect on Filipp Filippovich. There are moments when he abandons his cool, unemotional observation of new phenomena and appears to lose patience. Once when the creature was swearing, for instance, he suddenly burst out impulsively: 'Shut up!'

This had no effect.

After his visit to the study Sharik was shut up in the consulting-room by our joint efforts. Filipp Filippovich and I then held a conference. I confess that this was the first time I had seen this self-assured and highly intelligent man at a loss. He hummed a little, as he is in the habit of doing, then asked: 'What are we going to do now?' He answered himself literally as follows: 'Moscow State Clothing Stores, yes . . . 'from Granada to Seville' . . . MSCS, my dear doctor . . .' I could not understand him, then he explained: 'Ivan Arnoldovich, please go and buy him some underwear, shirt, jacket and trousers.'

January 9th The creature's vocabulary is being enriched by a new word every five minutes (on average) and, since this morning, by sentences. It is as if they had been lying frozen in his mind, are melting and emerging. Once out, the word remains in use. Since yesterday evening the machine has recorded the following: 'Stop pushing', 'You swine', 'Get off the bus – full up', 'I'll show you', 'American recognition', 'kerosene stove'.

January 10th The creature was dressed. He took to a vest quite readily, even laughing cheerfully. He refused underpants, though, protesting with hoarse shrieks: 'Stop queue-barging, you bastards!' Finally we dressed him. The sizes of his clothes were too big for him.

(Here the notebook contains a number of schematized drawings, apparently depicting the transformation of a canine leg into a human one.) The rear half of the skeleton of the foot is lengthening. Elongation of the toes. Nails. (With appropriate sketches.)

Repeated systematic toilet training. The servants are angry and depressed.

However, the creature is undoubtedly intelligent. The experiment is proceeding satisfactorily.

January 11th Quite reconciled to wearing clothes, although was heard to say, 'Christ, I've got ants in my pants.'

Fur on head now thin and silky; almost indistinguishable from hair, though scars still visible in parietal region. Today last traces of fur dropped from his ears. Colossal appetite. Enjoys salted herring. At 5 p.m. occurred a significant event: for the first time the words spoken by the creature were not disconnected from surrounding phenomena but were a reaction to them. Thus when the professor said to him, 'Don't throw food-scraps on the floor,' he unexpectedly replied: 'Get stuffed.' Filipp Filippovich was appalled, but recovered and said: 'If you swear at me or the doctor again, you're in trouble.' I photographed Sharik at that moment and I swear that he understood what the professor said. His face clouded over and he gave a sullen look, but said nothing. Hurrah – he understands!

Translated by Michael Glenny

When depicting London in his story The Fisher of Men, *Zamyatin did not strive for verisimilitude or topographic accuracy. The real Hammersmith Station of the First World War era had no lifts and served a surface line. Instead, concrete details from the city's real existence – its pioneering experience of bombing raids, the ubiquity of advertising (from which Zamyatin took one of his leitmotifs, the 'Automatic Sun', the name of an insurance company) – were used to construct a picture of a dystopian hell peopled by subhuman inhabitants. Here we see Zamyatin's anti-hero, Mr Craggs, the embodiment of a vile suburban smugness that early-twentieth-century Russians considered particularly English, make his way through an air-raid to his wife, Laurie, and her collection of crested souvenir teaspoons, while at the same time terrorizing a young woman from whose lover he has earlier extorted fifty guineas when he finds the two canoodling in a public park.*

EVGENY ZAMYATIN
[Hammersmith Station]

From *The Fisher of Men, Dom iskusstv*, 2 (1921)

Darkness. The door into the neighbouring room is not tight shut. Through the crack – a bar of light across the ceiling: people with lamps, moving about. Something's happened. The bar moves ever more rapidly, and the dark walls recede further and further, into infinity, and this room is – London and thousands of doors, lamps running riot, bars of light racing across ceilings. And perhaps it is all a fever dream . . .

Something had happened. The dark sky above London had shattered into fragments: white triangles, rectangles, lines, a silent geometric frenzy of searchlights. Blinded elephant-buses rushed off headlong, their lights extinguished. On the asphalt, the distinct clatter of belated couples – a feverish pulse – died away. Everywhere doors were slamming, lights going out. Swept bare by an instantaneous pestilence, a deserted, echoing, geometrical city: silent domes, pyramids, circles, arches, towers, battlements.

The silence swelled for an instant, expanding like a soap-bubble, and then – burst. The iron footsteps of bombs began stamping and droning in the distance. Growing ever taller, up to the very heavens, a fantastical truncated creature – all legs and belly – was trampling its bombs

down on the cubic anthills and the ants below with sightless stupidity.
Zeppelins . . .

The lifts could not swallow them all: the ants scattered down the
emergency staircases. They hung on to the footboards, and sped thunder-
ously off through the tunnels – indifferent as to where they were going
or where they got off. They huddled together in a weird subterranean
world with its lowering concrete sky, mazy caves, stairways, kiosks,
vending machines.

'Zeppelins over London! Extra! Extra!' Mechanical, clockwork urchins
scurried about.

Mr Craggs was standing up in a speeding carriage, holding on to a
strap, his eyes glued to the extra edition. Toppers and hats accumulated,
pushing him forwards off his plinth, in the direction of someone's knees.
The knees were trembling. Mr Craggs shot a glance; the Lady-Apple.

'Well, so . . . You're here too? Very nice too . . . very . . . I do beg
your pardon: such a crush . . .' Mr Craggs doffed his top hat, smiling.

The Lady-Apple was by herself. The Lady-Apple responded with a
smile, dully submissive.

In Mr Craggs' left inside pocket lay the cheque for fifty guineas, warming
the heart of Mr Craggs. Mr Craggs joked politely: 'We are like the early
Christians, forced to seek refuge in the catacombs. Very amusing, don't
you think, miss?'

Miss was supposed to laugh – but couldn't. She strove mightily and
eventually did start to laugh: what came out was ludicrous and indecently
loud, filling the whole carriage. Everybody turned round. Mr Craggs
raised his top hat and hastily made his way forward . . .

'Hammersmith! Train terminates here!' The guard clattered the door
and they surged out.

Up above, through the lift shafts and staircases, could be heard a
muffled iron booming. The toppers and the huge hats, worn at a rakish
angle, stayed on the platform, clinging to the dazzling white walls,
merging with the raspberry and green posters of immobile individuals
hurtling along in a Rolls-Royce, with the Automatic Sun. In the white-
tiled catacombs a throng of strange poster-Christians was taking refuge.

The Lady-Apple gazed about her forlornly, and her eyes sought out
the only figure she knew – with claws folded across his stomach, flippers
slapping – and automatically, as if in a dream, entered the lift with
Craggs. The lift bore them aloft to the street.

There the black sky flickered with lines and white triangles. Trees and silent tortoise-houses sped along with a trampling rumble. The Lady-Apple overtook Craggs.

'Please . . . Excuse me . . . Could you take me somewhere for goodness sake? I should have got off at Leicester Square, I don't know what's going on . . .'

The little monument[1] halted and stared at her for an instant, eons. From beneath lowered lids in the dark – razor eyes: 'Really, I do sympathize. But I'm in a hurry to get home. And besides . . .' Mr Craggs laughed silently. It was simply ridiculous, just imagine, him and . . . and some . . .

Directly overhead, in the attenuating silence, droned an enormous hornet. Mr Craggs hurried on. Laurie was on her own. He swiftly slapped his flippers down on the asphalt. He imagined that the cheque had ceased rustling in his pocket; Mr Craggs paused to feel for it – and heard tremulous little staccato footsteps behind him: from far off a shadow was running towards him, like a ownerless lost dog, timid and cowed.

It was obvious now: this . . . this woman would follow him right up to the door, and stand there all night, or sit on the steps – something nonsensical anyway, the way things happen in dreams.

Mr Craggs mopped his brow with his handkerchief, glancing back over his shoulder, then ducked into the first dark alley: he would get into the house from the back. Mr Craggs located his gate by feeling along to the projecting bricks at the post, then knocked. A face glimmered faintly white in the dark bedroom window. It was manifestly Laurie's face. Laurie swung her arm and tossed something out of the window. What could all this mean?

Mr Craggs knocked for a long time, louder and louder, for the whole of Abbot Street to hear, but the gate did not open. Mr Craggs considered the situation and his mind was striving to make some kind of sense of it, when suddenly the iron feet stamped right next to him; shards of glass tinkled, Mr Craggs's top hat fell off, and, as he tried to catch it, the little monument tumbled to the asphalt.

Translated by Alan Myers

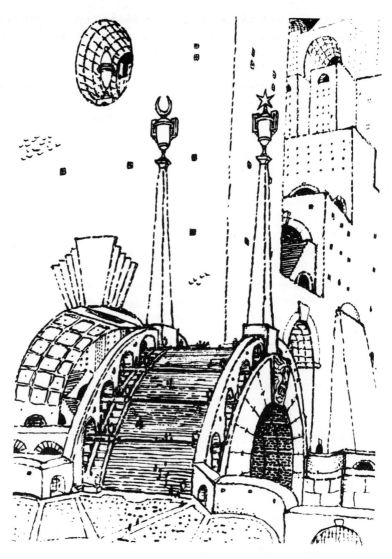

3. Totalitarianism prophesied: Mstislav Dobuzhinsky's *Bridge in a Fantastic City* (1913), from a series of drawings depicting futuristic cities, well illustrates the ambivalence with which many Russian artists reacted to modernization. Dwarfing the mite-like human beings who can barely be seen mounting the bridge, the structures imagined here have affinities to the nightmare visions of Piranesi.

Soviet communism, like most progressivist ideologies, drew a direct link between biological evolution and cultural development. In his portrait of Lamarck, the early-nineteenth-century evolutionary theorist, Mandelstam accepts the link, but fantasizes about reversing the evolutionary process and descending the hierarchical ladder to become one of the most primitive organisms in the chain of being (and, by implication, evade the non-being that terminates human existence).

OSIP MANDELSTAM
'Lamarck'

Novyi mir, 6 (1932)

Who is this old man, tongue-tied as a youth,
This fiery, halting patriarch,
Who fenced for nature's honour, though uncouth?
Why, naturally, the answer is Lamarck.

If all that lives is only a scribbled error,
Lasting a short, intestate day,
Then as I ride the Lamarckian escalator
The last step is the one I'll occupy.

I shall descend to ciliapedes, annelids,
Rustle past lizards and infernal serpents, tear
Down springy gang-planks and through watersheds,
Decline, decrease; like Proteus, disappear.

And I'll put on a thick and warty mantle,
I shall renounce my warm and scarlet blood,
Grow suckers on my hands and plunge my tentacles
Into the ocean's foaming flood.

We've now passed by the classes of insects waiting
With juicy eyes like goblets full of wine.
For as he says, 'Nature's disintegrating:
Sight will not be: you see for the last time.'

He said, 'You've had your fill of the sonorities,
Your love for Mozart was in vain, of course,
For now arachnid deafness creeps upon us,
This gap cannot be bridged by your weak forces' force.'

And nature withdrew from us, as if asserting
She had no need, she turned her back for good,
She took a long thin brain, which she inserted
Into a backbone scabbard, like a sword.

And she was late in lowering the drawbridge:
She left it up, forgetting those behind,
Those destined to have grass green round their gravestones,
Whose breath is scarlet, and their laughter lithe.

Translated by Andrew Reynolds

When he published the collection of essays from which the extract below is taken, in 1915, Vadim Shershenevich was associated with the Ego-Futurist movement; three years later, however, he was to become a founder of the Imaginist group, whose other members included Sergei Esenin and Nikolai Erdman. Though Green Street *looks forward to Shershenevich's break with futurism through its emphasis on the centrality of the poetic image to verse composition, and its advocacy of a method according to which images should be heaped on images without any attempt to establish logical continuity between them, the collection is still recognizably futurist in its celebration of machine-age culture.*

VADIM SHERSHENEVICH
[The Rhythm of the Future]

From *Green Street* (Moscow, 1915)

Every epoch differs from every other not in terms of individual episodes, anecdotes or facts, but in terms of its special rhythm.

We have lived through the age of foot transport, the age of horse transport and the age of the motor car (the twentieth century); soon we will have the age of the aeroplane.

If the rhythm of motion in the eighteenth century might be represented as a, then that of the nineteenth century might be represented as $a + x$, and that of the twentieth as $a + x + y$.

Accordingly, the rhythm of the art of those centuries will be equal to a, $a + x$ and $a + x + y$ respectively.

The task of the contemporary poet is to express the dynamics of the contemporary city. That dynamics cannot be conveyed with the aid of content. That is: we cannot convey the city merely by talking about it. The rhythm of reality is a question of form and for that reason the appropriate formal method must be found.

Let us consider how earlier poets wrote. They usually selected some image as the basis of the piece, an image as leitmotif, so to speak, and the whole poem developed and illuminated that image quite logically. All the other images were subordinated to, and dependent upon, that one leading image.

This strategy, which was a legitimate and essentially correct one when

the old, slow and strictly orderly tempo of life was being communicated, is utterly useless today.

The chaos of streets, the movements of towns, the roars of stations and harbours, the whole fill, the quick[1] of contemporary life, cannot be communicated other than by the internal motion of the verse.

This motion is brought into being by the multi-thematic or polythematic character of a poem. It is achieved because the images are no longer subordinated to a leading image. Every line is pregnant with a new image, sometimes one that directly contradicts the one in the line before. Images are heaped upon each other as messily as possible; they compete with each other for attention, and this increases the sense of tension and the notice taken of each individual image. If one image happens to be weaker and more anaemic than the others, then the others will gang up and rub it out, trample it to death, leaving an empty space that defaces the whole line and indeed the whole poem. The images should not lie down next to each other tidily, like convent schoolgirls retiring to bed in the dormitory of the reader's mind. What is tidy and sequential is incapable of capturing a synthesis of the city; its motion is that of a horse being made to canter in circles on a lunging-rein. It does not matter if one image crowds out the one before because it contradicts this; that will mean that the reader is forced to be on his guard, forced to hunt down the crude and dominating lyricism of the images as a borzoi hunts down a wolf.

On the city street, hundreds of motor cars, electric trams and bicycles flash before my eyes every moment, yet I retain all of these in my mind at once; why, then, is the view commonly held that such disorder and speed in poetry makes it meaningless for the reader?

Translated by Catriona Kelly

Olga Berggolts can be said to have grown up with the Russian Revolution, and shared the enthusiasm of many young Soviet people in the 1920s and 1930s for the Soviet cause. However, fifty years later she humorously recollected that the utopian architecture of Leningrad and Moscow had presented its human residents with rather similar problems to those endured by the denizens of tower blocks in the 1960s and 1970s.

OLGA BERGGOLTS
[Living in Utopia]

From *Daylight Stars* (Leningrad, 1971)

Our house was the most absurd house in all of Leningrad. Its official title was the Writers' and Engineers' Communal Apartment Block. Later, though, a facetious nickname for it seized the Leningrad popular imagination: the Teardrop of Socialism. As for us, the young people who had set up the commune and who lived in it, we were known as 'the cry-babies'. We were a group of young (very young!) engineers and writers who'd built the house on a co-operative system right at the beginning of the 1930s. It was part of an all-out fight against 'the old domestic order' (i.e., cooking, nappies, and so on). So not one single flat had anywhere to prepare food, let alone a kitchen. There weren't even lobbies where you could hang clothes – the cloakroom was communal too, and on the same floor, by the entrance, was a communal nursery and a communal playroom; we'd decided at the very first planning meetings that we wanted to spend our free time as a collective. There was to be no individualism.

We settled into the new house with enthusiasm, excitedly handing over our ration cards and 'obsolete' cooking pots to the communal kitchen – enough of the slavery of individual cooking! – and immediately setting up a huge number of committees and 'troikas' of all kinds. Even the 'imitation Le Corbusier' exterior of the house, with its dozens of tall thin balconies, whose steel surrounds made them look like cages, didn't faze us. On the contrary: we relished the grim mediocrity of the architecture, convinced that its sternness suited the new life we proposed to lead . . .

But a couple of years later at most, when ration cards were abolished,

and we had grown a little older, we suddenly realized that we'd been too hasty: our life was so communal that we hadn't a single corner to retreat to in case of direst need . . . Well, or only the windowsills. And it was on the windowsills that the first backsliders began cooking up a little bit of what they fancied, when it turned out the communal canteen couldn't satisfy the varied tastes of the inhabitants. As for the nappies (and for some reason the numbers of these grew ever larger), they were a real nightmare: wherever were you to dry them? We had a wonderful solarium, but the attic was useless for drying things. What was more, the acoustics in the house were so superb that if Misha Chumandrin on the second floor happened to be playing tiddlywinks or having a poetry reading with some friends, you could hear absolutely everything in my flat on the fifth floor, duff rhymes included. The over-intimate contact with other people that was forced on you proved to be very wearing. 'There's many a slip 'twixt cup and lip', someone joked,[1] and, to be perfectly frank, we often felt very fed up both with the 'teardrop' itself, and with our hasty decisions about how to run our lives in it.

Translated by Catriona Kelly

*The subtitle of this tiny story, or prose anti-poem, by Daniil Kharms
marks it as a bitter parody of the 'musical' manner of Andrei Bely in
his 'Dramatic Symphony' (see above).*

DANIIL KHARMS
'The Start of a Really Nice Summer's Day: A Symphony'

From *Incidents*, in *Flight to the Heavens* (Leningrad, 1988)

The instant the cock had got through crowing, Timofei leapt out
of the window on to the roof and scared everybody walking along the
street. The peasant Khariton halted, picked up a stone and let fly at
Timofei. Timofei disappeared somewhere. 'Artful beggar!' shouted the
human herd, and a certain Zubov took a run and rammed his head
against a wall with all his might. 'Oh!' shrieked an old wife with a
gumboil. But Komarov gave this wife a real tickle-tackle and the wife
ran away howling into her gateway. Fetelyushin chuckled as he walked
past. Komarov went up to him and said, 'Hey you, bag of lard!' and
punched Fetelyushin in the belly. Fetelyushin leaned up against the
wall, hiccuping. Romashkin starting spitting out of his window up aloft,
trying to land on Fetelyushin. Near by, a big-nosed wife was hitting her
child with a wash-tub. A plump young mother was grinding a pretty
little girl's face against a brick wall. A tiny dog, its fragile little leg broken,
lolled on the footpath. A small boy was eating something foul out of a
spittoon. There was a lengthy queue for sugar outside the grocer's. The
old wives were swearing loudly and shoving at one another with their
purses. The peasant Khariton, drunk on methylated spirits, stood in
front of the women with his flies undone, uttering nasty words.

It was the beginning of a nice summer's day.

Translated by Alan Myers

*Zoshchenko is one of Russia's most popular writers. His clever, appar-
ently simple but in fact highly self-conscious stories, ostensibly written
from the viewpoint of the Soviet 'little man', depict the frustrations of
everyday life in Soviet cities where grandiose building projects and
plans to reform human nature were accompanied by a contempt for
details such as the availability of consumer goods and public services,
and where bureaucrats dealt with the public on the basis of* proizvol
(arrogant whim).

MIKHAIL ZOSHCHENKO
'The Bath-house'

Begemot, 10 (1925)

They say, citizens, that in America the bath-houses are very
amazing.

For instance, a citizen gets there, throws his underthings into a special
box and heads off to get washed. He doesn't have to bother with any
'watch out, there's a thief about' sort of thing; he doesn't even have a
ticket to look after.

Well, maybe the odd American might say to the attendant, if he's a
worrier: 'Gut bai,' he says, 'keep an eye on these, eh?'

And that's it.

This American has his wash, comes back, and they give him clean
underwear – washed and ironed. Footcloths whiter than snow, no doubt.
Drawers patched and mended. That's the life!

Of course, our baths aren't bad either. But not quite so good. Although
you can wash yourself well enough.

It's just the ticket business that's the trouble. Last Saturday I went
to the baths (well, I'm hardly going to go to America, am I?), and they
handed me two tickets. One for the underthings, one for my coat and
cap.

But where can a naked man put his tickets? I'll tell you straight –
nowhere. No pockets. Just belly and legs. No peace for the wicked with
those tickets. You can hardly tie them on to your beard, can you?

Well, I tied one on each leg, so as not to lose them both at once.
Then off I went, into the bath-house.

The tickets was flapping round my legs by now. Walking was a nuisance, but I had to keep going. Because I needed a bucket. How can you wash without a bucket? No peace for the wicked.

I go looking for a bucket. I see a citizen washing himself with three buckets. He's standing in one, washing his nut in another, and holding on to the third in case it got pinched.

I give the third one a tug, hoping, by the way, to get it for myself, but the citizen won't let go.

'Just what are you up to?' he says. 'Thieving other folk's buckets? I'll poke you between the eyes with it – then you'll know about it.'

I says to him: 'What do you think this is, the tsarist regime,' I says, 'poking people with buckets? You're an egoist,' I says. 'Other people,' I says, 'have to get washed as well, don't they? This isn't a theatre,' I says.

But he just turns his backside on me and goes on washing.

'No good standing over him,' I think. 'He'll be washing three days just to spite me.'

So on I go.

An hour later I saw a gent drop his guard and let go of his bucket. He'd bent down for the soap or was just daydreaming, I don't know. Anyway the point is, I got hold of his bucket.

Now I've a bucket but nowhere to sit. No peace for the wicked.

All right, I'm stood up on my hind legs, bucket in hand. I get on washing.

Meanwhile, all around, laundry's going on full steam ahead. One washing his pants, another scrubbing his drawers, somebody else wringing something out. I've just got washed, so to speak, and I'm filthy again. They're splashing like hell. And the laundrymen is making such a racket that I don't feel like washing anyway. You can't hear where you're rubbing the soap. No peace for the wicked.

'Sink the lot of them,' thinks I. 'I'll finish off at home.'

I go to the dressing room, I get my underwear on the ticket. I take a look and it's all mine. But the pants aren't.

'Citizens,' says I. 'There was a hole in mine just here. In these it's way over there.'

But the attendant says: 'We aren't appointed to supervise holes,' he says. 'This isn't a theatre,' he says.

Right. I put the pants on and go for my coat. They won't hand it over – they want the ticket. I'd forgotten it was still on my leg. So I had to

get undressed. I took my pants off and looked for the ticket. No ticket. The string's there, but no paper. It must have got washed off.

I gave the string to the attendant – he wasn't having any.

'I can't give things out for a bit of string. Any citizen could chop off a bit of string. The coat supply couldn't keep up. Wait about till the public has gone and I'll give you whichever one's left.'

So I says to him: 'Matey, suppose it's rubbish what gets left? This isn't a theatre,' I says. 'Give me my coat. I can identify it. One pocket,' I says, 'is ripped, and the other one's not there at all. With regards to the buttons, the top one's there,' I says, 'but for the rest don't hold your breath.'

Anyway, I got it back. And he didn't take the string.

I got dressed and went outside. Then I suddenly remember: I've forgotten the soap.

So in I go again. But they won't let me in with my coat on, will they? 'Take your clothes off,' they say.

So I says to them: 'Citizens, I can't get undressed three times. This isn't a theatre,' I says. 'At least let me have the price of the soap.'

They wouldn't.

If they wouldn't, they wouldn't. I went off without.

By now you'll be wanting to know, I expect: what bath-house is this, then? Where is it? What address?

The bath-house? Just an ordinary one. The sort that costs ten copecks to get in.

Translated by Alan Myers

2
Visions of Art

The fact that the single most important direction in Russian cultural theory during the early twentieth century came to be known as 'Formalism' is no accident. The introduction of sophisticated discussion of form not in terms of the old opposition between 'form and content' but in terms of textuality, the fabric of verbal and visual artefacts, was a major achievement of the Russian modernist movement. Russian romanticism can boast no original aestheticians such as Friedrich Schlegel or Novalis, and, with the rise of realism, critics (if not writers and artists) began to display a pronounced indifference to form, judging literature and painting alike by its relative richness in 'ideas' or 'thoughts', that is, its political commitment. The imperviousness of many commentators to what are now taken as the basic principles of literary criticism is striking: for example, of the various critics who discussed Evdokiya Rostopchina's poetry in the 1850s, only one, Nikolai Chernyshevsky, was prepared to question the assumption that a lyric poem written in the first person must be a piece of autobiography. And, although Tolstoy himself had defended War and Peace against attacks on the novel's plausibility by reference to an artist's freedom to exploit the expressive qualities of light and shade, his observations did little to change the dominant direction of literary discussion of his work. The Marxist Pavel Tkachov, for example, attacked Anna Karenina because Tolstoy had dared to waste so much sympathy on empty-headed members of the upper classes such as Vronsky and Anna, to apply his literary talents (taken as a given) to the depiction of inappropriate material.

The rebellion against content-driven criticism had several stages, beginning, in the 1890s, with the initiation of a new tradition stressing the creative character of reading, which, like writing itself, was seen as a form of translation. By no means accidentally, the initiators of this tradition, the early symbolists such as Valery Bryusov, were also often

gifted translators and pioneers of translation theory. However, symbolism's understanding of poetic language as rebus was itself soon to come under assault, when, during the so-called 'crisis of symbolism', younger poets attacked not only the restricted lexis of the symbolists (which Mandelstam was to compare with 'the vocabulary of a Polynesian'; he inaccurately supposed this to consist of 500 words), but also their neo-Platonic assumption that the visible and tangible world was but the shadow of a larger reality beyond. The proclamation of 'the word as such' meant that language was now perceived not as an inadequate medium for the expression of spiritual experience (as the symbolists had seen it), nor as merely a marker for some person or object in real life, but as an autonomous sphere of creative endeavour. The view of the word as 'transcendental signifier' was to provoke the composition of zaum, or 'transrational language', which is to say nonsense verse, on the part of Cubo-Futurists such as Kruchonykh and Khlebnikov, as well as the invention of theories in order to explain the sophisticated use of word-play, neologism, sound-chimes and other forms of linguistic innovation that were evident in the work of major modernist poets such as Mayakovsky, Mandelstam, Bely, Pasternak, and later Klyuev and Tsvetaeva. In its turn, theorization provoked the self-conscious adoption of strategies, or priyomy, as the Formalists named them, in new pieces of writing: Viktor Shklovsky's formulation of artistic creation as a manner of 'defamiliarizing' reality, or 'making it strange', or Yury Tynyanov's theory of 'serious parody' (a pioneering analysis of what is now known as intertextuality) inspired new literary practices as effectively as they described established ones. For visual artists too commentary on the arts and analysis of techniques were vital paths to artistic innovation: this is clear even in the writing of an artist committed to 'organic' art, such as the Suprematist Olga Rozanova.

All this marked a whole-hearted move away from the romantic notion of spontaneous creation ('inspiration') on the one hand, and from the realist assumption that great art should comment on reality or set up ideals for emulation (the Western understanding that realism meant mimesis was never universally accepted in Russia, with Pushkin's description of Balzac's writing as 'myopic' an excellent indication of how the long view into the future was usually preferred to the close study of the present). The writers quoted here were far from being in agreement on the purpose of art or on artistic methods – their points of disagreement are not only evident from the material in this section, but

are less decorously on display in the next, 'Altercations and Provocations'. However, they did share an overwhelming distaste for nineteenth-century realism, which is as clear in Léon Bakst's tribute to classical art as it is in the scorn that Rozanova pours on 'plagiarization' of reality. Emphasis on the need to intercept and transform reality before communicating it to a reader or viewer also led to a profound shift in attitudes to photography, which in the nineteenth century had been viewed as promising new possibilities of accurate observation and impartial recording of data, but in the twentieth began to be seen as offering an alternative form of perception, one more accurate than (in Dziga Vertov's view) and more challenging than (in Aleksandr Rodchenko's) the vistas created by the human eye itself.

Commitment to art went beyond the invention of new theories and the advocacy of new methods, however: it also inspired the composition of analytically 'soft', but captivating, tributes to art of the past (such as Aleksandr Blok's essay on Siena, a testament to early-twentieth-century Russian culture's fascination with Italy), and it generated the composition of numerous 'texts within texts', such as Vaginov's metafictional novel The Days and Labours of Svistonov, *an extract from which closes the section.*

Aleksandr Blok, most famous for his poetry's nebulous visions of the Eternal Feminine (see introduction to 'Men and Women', below), was also an exceptionally talented author of prose, whose idiosyncratic exactness of observation – as in this account of a visit to Siena in 1909 – makes it perhaps more palatable to a modern Western reader than the misty vagueness of his lyrical manner.

ALEKSANDR BLOK
'An Evening in Siena'

From 'Lightning-flashes of Art', *Collected Works* (Berlin, 1923)

The train crawled up the edge of a hill along a stripe of track between thick walls of grape-vines before burying itself in a tunnel. Once there, it stopped suddenly, then went into reverse before shunting gently to the top of the steep slope. Below, the way we had come wound in tight coils, falling gradually further and further into the distance; on the hilltop near by, a monastery came in sight. We had reached Siena from the south, in the pink twilight of a dying day.

La Toscana: an old hotel. A window is open in my little room at the top, and I hang out to fill my lungs with the cool mountain air after the hours in the stuffy railway carriage. But heavens! Now I see that the pink sky is about to lose its colour altogether. Everywhere you look are spiky towers, high and slender as all Italian Gothic structures are, impudently slender and so high they seem arrows aimed at the heart of God. Siena makes the most daring game you can imagine out of stern Gothic architecture: the town is an infant old before its time. There's an impudent slyness in the long eyes of the Sienese madonnas too; whether they're seen gazing at the Christ Child or breastfeeding him, or modestly receiving Gabriel's tidings, or simply looking into space, a sort of catlike affectionate craftiness peeks through. A storm may rage behind their shoulders, a tranquil evening may be falling: they always gaze in the same way with their long eyes, neither promising anything to us, nor disappointing us, just looking a little askance at the Guelphian antics of their busy living compatriots. And those living compatriots really once were up to their ears in fuss and bother, always eaten up with envy at the Ghibellines, always fighting with their neighbours the

Florentines. It was to make the Florentine Ghibellines jealous that the Sienese raised their 'Palazzo Pubblico', a palace the same size as the Florentine Palazzo Vecchio, and very similar in style. The only difference is that on the square outside you'll find not the *marzocco*, the Florentine lion with his lily, but a hungry she-wolf with prominent ribs and twin human infants sucking at her teats.

But the Florentine Palazzo Vecchio is the gloomy haunt of bats; somewhere there in a garret under the sky was where languid and green-sick Eleonora of Toledo took refuge with her naughty and cruel little son, a son who in time was to be strangled. There too was where Lorenzo il Magnifico died one thundery night, after having suffered a series of gloomy visions and portents. All of that has left traces that cannot be effaced, wrapping a building that in any case seems gloomy enough – it is one of the gloomiest places in Italy – in additional layers of mystery. The Sienese Palazzo, on the other hand, has nothing gloomy about it at all, either inside or outside; the walls of the Palazzo Vecchio are bare and empty, but those of the Palazzo Pubblico are covered in frescos by Sodoma, the most talented, if also the most vulgar, of Leonardo's pupils.

But it is not just the spiky outlines of the Siena towers that strike me, outlined against the pink evening sky. More startling still is the fact that the most imposing tower is hung with dozens of dish-shaped lamps. The wind is coming to life, and, when dusk falls, a brass band will play (but of course) on the piazza below.

A crowd of people bears me away from the door of the Toscana to the main street. Soon we reach a flight of steps going down to the left of the street, and I follow this covered alley (it would be called a *sottoportego* in Venice) down to the piazza itself.

Before me is the brilliant façade of the Palazzo, also lit up with row upon row of the dish-shaped lamps. Under the she-wolf, a brass band is playing restrainedly. The piazza is crescent-shaped, and grass has broken through the paving in places. The Palazzo stands at the lower end, its façade taking up most of the diameter of the crescent, and I can see the whole of it perfectly from where I stand at the highest point, next to the glorious fountain of Gaia.

This is where public meetings were once held. Now, the piazza is full of people once more: it's positively teeming. It's a warm evening, and the women are in light, bright dresses. The moon has a dull gleam, the old lamps gleam still more dully, the band is invisible behind the crowd,

and the music is unsophisticated. If you don't look too closely at the faces and the clothes, you can feel yourself transported back to the Middle Ages, as though this were an E. T. A. Hoffmann story come to life. The extreme naïvety of the Italian girls helps this impression: they have very obviously come here with the sole intention of showing themselves off, if they like their own appearance, or looking at other people if they don't. So the plain girls are enjoying themselves just as much as the pretty ones, and women rich and poor, beautiful and ugly, young and old, all parade up and down in the same way. They are amazingly clean and without a hint of an ulterior motive in their faces. I think you would need to be born Italian to enjoy such innocent pleasure.

The lamps are beginning to go out, the band stops playing, the girls go to their rest. It is dreadfully sad to be left on one's own in the small hours, standing here by the she-wolf. Innocently tipsy young men wander round in small groups singing songs. A shadow flashes past a window, then the light goes out. The only light left showing is that outside the Three Maidens tavern somewhere in a steep side-street.

<div align="right">Translated by Catriona Kelly</div>

Kuzmin's 'On Beautiful Clarity', often considered a manifesto for Acmeism, though in fact it was written three years before that movement took off, is in the first instance concerned with prose rather than poetry, and is a tribute to Kuzmin's love of eighteenth-century French culture rather than to the French symbolism that inspired Acmeists such as Nikolai Gumilyov. The essay is in any case remarkable as an exceptionally lucid statement of his aesthetic convictions by a conservative, or, as the Formalist Yury Tynyanov put it, 'archaizing', Russian modernist.

MIKHAIL KUZMIN
From 'On Beautiful Clarity: Remarks on Prose'

Apollon, 4 (1910)

When the dry land was gathered together to make the earth, and the waters suddenly girded the earth with seas and poured over it in all directions to form rivers and lakes, it was then that the world first left the state of chaos; it was divided into separate entities by the Spirit of God. And later – through the creation of boundaries, of clear furrows – there came about the complicated and beautiful world that, whether they accept it or not, artists strive to understand and in their own ways to see and record.

In every person's life there are moments when, as a child, he will suddenly say 'I – and the chair', 'I – and the cat', 'I – and the ball', and then later, when he is an adult: 'I – and the world'. Regardless of his future relationship to the world, this moment of division is always a profound turning point.

Art goes through stages that are somewhat similar, but periodically – one moment its treasures are being measured out, proportioned and formally developed, while the next moment forms that have attained perfection break under a new assault by the forces of chaos, a new barbarian invasion.

But if we look back, we can see that periods of artistic creativity that strive to achieve clarity stand resolute, like lighthouses that point the way to a single destination, and the pressure of destructive breakers

only gives a new shine to their eternal masonry and brings new precious materials into the treasure-house that the waves were attempting to overthrow.

There are artists who bring to others chaos, bewildered horror and the disintegration of their own spirit, and there are others who give the world their sense of harmony. There is no particular need to emphasize how much more elevated the latter are than the former (assuming talent is equal on both sides), and superior in terms of their healing powers; equally, it is not hard to guess why it is that, in troubled times, authors who bare their sores have more impact on the nerves, and sometimes even 'inflame the hearts' of their masochistic listeners. Without beginning to examine the fact that aesthetic, moral and religious duties oblige a person (and especially an artist) to seek and find within himself peace with his nature and with the world, we consider it indisputable that the creations of even the least reconciled, most opaque and formless writer are subject to the laws of clear harmony and architectonics. The most outlandish, confused and gloomy inventions of Edgar Allan Poe and the unbridled fantasy of Hoffmann are precious to us precisely because they are cast in crystalline forms. But what could we say about a tale of everyday Moscow life if it were clothed in such incomprehensible, murkily cosmic garb that we greeted the few intelligible lines like dear friends after a long separation? If a person were of a suspicious cast of mind, would he not say that the author is letting a fog descend so as to force the reader not to understand, because there is in fact nothing to understand? This non-correspondence of form and content, this shapelessness, this unnecessary fog and acrobatic syntax can be given a rather unattractive name . . . We shall delicately call it lack of taste.

Let your soul be whole or fragmented, let your philosophy be mystical, realist, sceptical or even idealist (if you are really unlucky), let the techniques of your work be impressionist, realist, naturalist, let the content be lyrical or plot-based, let your mood and impressions be what you like, but, I beg of you, be logical – may this *cri de cœur* be forgiven me! – logical in your initial idea, in the construction of your work, in your syntax.

٭

The techniques of prose language have perhaps not been elaborated to the same extent as the theories of verse and verse forms, but the ideas that have been worked out in the case of oratorical prose, i.e., prose

meant to be performed in front of listeners, are as fully applicable to
words that are not intended for reading aloud. In oratory we learn to
build periods, cadences, climaxes, conclusions and ornamentation by
means of rhetorical figures. We learn, as it were, to lay bricks in the
building whose architects we want to become; and we must have a keen
eye, a true hand and a clear sense of proportion, perspective and
harmony in order to achieve the desired result. It is important that a
poorly constructed vault should not bring the whole building crashing
down, that details should not obscure the whole, that even the most
unsymmetrical and troubling design should be realized by conscious
and logical means. Then we will have created that very same art of
which it was said: *ars longa, vita brevis.*

Quite apart from straightforward talent, the artist must have know-
ledge of his material and form, and of the correspondence between the
form and the content. The short story is not a form that requires, indeed
it does not even really allow, exclusively lyrical content: some kind of
story must be told (and, of course, this must not be a story about feelings
or impressions). The novel is even more demanding in its need for a
storyline element, and we must not forget that the novella and the novel
were nurtured in the Romance countries, where the prevailing view of
art is more than anywhere else Apollonian: a view of art that creates
distinctions, that shapes, that is precise and harmonious. And the models
for the short story and the novel, beginning with Apuleius and the Italian
and Spanish prose writers – and then via the Abbé Prévost, Le Sage,
Balzac and Flaubert through to Anatole France and, finally, the incom-
parable Henri de Régnier[1] – must of course be sought in Latin lands.
We have particular affection for the last of the authors named, not only
because he is the most contemporary, but because he is an unerring
master of style who never gives us grounds to fear that he will plant
pipes atop a building in the Empire style, or build a Gothic bell-tower
on a Greek portico.

At last we have uttered the word that is currently so misused both in
invective and in eulogy – the word 'style'. Style, stylish, stylist, stylizer
– it would seem that these are clear and well-defined concepts, but they
are used rather falsely all the same, and this creates confusion. When
the French call Anatole France a stylist the like of whom has not been
seen since Voltaire, they, of course, do not have in mind just his novellas
that draw on Italian history: he is a fine stylist in everything – in his
articles, in his contemporary novels, in anything you like. This means

that he preserves to the last degree the purity, logic and spirit of the French language, and at the same time conquers new territory without stretching this language beyond its natural limits. And in this sense Mallarmé, say, is by no means a stylist. To preserve the purity of the language does not mean somehow to remove its flesh and blood, to give it a sophisticated gloss, to turn it into kosher meat[2] – no, but neither does it mean to do violence to it. We must watch insistently over its character, its inclinations and caprices. Our capacity to do this may, roughly speaking, be called grammar (by this I mean that developed not through schooling but through experience), or the logic of one's native language. It is when we have this knowledge or sense of language as our foundation that achievements such as neologisms and semantic novelties become possible. And from this point of view we can undoubtedly say that Ostrovsky, Pechersky and particularly Leskov – that treasure-house of Russian speech whose works, like Dal's dictionary, ought always to be at hand[3] – are stylists; we would hesitate, however, to call Andrei Bely, Zinaida Gippius and Remizov stylists.

But the moment we take up the dictum *le style, c'est l'homme*, we become quite prepared to put these authors near the top of the list. Clearly, a quite different concept is being defined here, a relatively recent one, because, say, to distinguish between the authors of early nineteenth-century novellas according to their style would be rather difficult. It is obvious that this is a question of the individuality of the language, of the particular aroma, of the *je ne sais quoi* that ought to be present in every gifted writer, that is just as distinctive as his appearance, the sound of his voice, and so on. But given that this individuality is present in everyone (at least, in those who are gifted and have merit), there is no need to make a special point of it, to single it out, and we refuse to call an author a stylist if he develops 'his own' style to the detriment of the purity of language, especially as these two qualities can co-exist very happily, as is apparent from the examples given above.

The third notion of style, which has recently put down particularly strong roots precisely here in Russia, is closely linked to 'stylishness' and 'stylization'; let us consider this last word separately for a moment.

It seems to us that in the case of stylization we have to do with a particular, special correspondence between language and the form of the work in its historical and aesthetic dimension. Just as not any content will fit the form of terza rima, sonnet or rondo – our sense of artistic tact suggests to us a form appropriate to each of our thoughts and

feelings – so, to an even greater extent, does form play a role in prose works, where each object, time or epoch needs to be discussed in the appropriate language. Thus, while Pushkin's Russian preserves an immaculate purity and never loses its particular aroma, it none the less changes imperceptibly but manifestly depending on whether the poet is writing *The Queen of Spades*, *Scenes from the Age of Chivalry* or the fragment *Caesar was on a Journey*.[4] The same may be said of Leskov. This quality is valuable and almost essential for an artist who does not want to be restricted in his depictions to one milieu or epoch.

To sum up all that has been said, if I were able to give someone instructions, I would say the following: 'My friend, given that you have talent, that is, the ability to see the world in a new, quite individual way, the memory of an artist, the capacity to distinguish the necessary from the incidental, an inventiveness that is true to life, make sure you write logically, while respecting the purity of popular speech and possessing your own style; maintain a clear sense of the correspondence between the chosen form and the particular content, as well as the appropriate language, be a skilled architect both in the tiny details and in the overall design, be comprehensible in the way you express yourself.' To a dear friend I would add, whispering in his ear: 'If you are a conscientious artist, pray that your chaos (if you are chaotic) might be illuminated and ordered, or keep it in check for the time being by giving it a clear form: in a short story let a story be told, in a drama let there be action, save lyricism for verse, love the word as Flaubert did, be economical in your means and mean with your words, be precise and genuine – and then you will discover the secret of a marvellous thing – beautiful clarity, which I would call clarism.' But 'the path of art is long, and life is short', and are not all these exhortations simply well-intentioned wishes addressed to oneself?

<div align="right">Translated by Stephen Lovell</div>

Léon Bakst, best known in the West for the sumptuous stage designs that he undertook for Diaghilev's Ballets russes, was perhaps the most talented painter in the St Petersburg World of Art group. In this essay written for the second issue of Apollon, *a journal of literature and visual arts whose title indicated its commitment to neoclassicism, he takes a stand against the rapid turnover of avant-garde fashion in painting, but also against the championing of realism by contemporary art historians. He advocates a return to the values of a craft-based tradition of painting, which he sees as lasting from the Italian Renaissance to the early nineteenth century.*

LÉON BAKST
From 'The Paths of Classicism in Art'

Apollon, 2 (1909)

The Spring of the twentieth century has broken, and finds us with our artistic paths in total disrepair.

Much has melted away in the hot sun, and much has been swept away by the waters of the thaw. The warm air is misty, and swarming with new creatures beating their bright frail wings. They may live only a day; who knows?

New directions, new schools spring up with amazing speed. And until recently all you had to do was name the main four or five tendencies in art, and you had said all that you needed to.

But during the last decade art has been dominated not by representatives of particular directions, but by artistic schools taking their tone from the special talents of a leader or leaders with vividly expressed individual qualities.

It is worth listing the most important tendencies because that gives a striking impression of the different, brightly coloured banners that the progressive groups of artists have hung outside their strongholds, to whit:

Plein-airists, impressionists, pointillists, tachistes, divisionists, neo-impressionists, symbolists, individualists, intimists, visionists, sensualists, neoclassicists.

The other directions, as I have just mentioned, take their tone from the artists whose work gave the impulse for their foundation in the first

place. There's no point in listing them, because one could go on for ever; in any case, anyone who knows the biggest names in contemporary French art will be able to deduce as many different directions emanating from these.[1]

So as not to run off the point, and in order to convey my conclusions as strikingly as possible, I shall stick to discussing the French school, where an extremely characteristic process of evolution can be made out. This is derived not only from the multiplicity of talents that France can boast, but from the quarrelsome temperament of the French artistic reformers.

The influence of the schools, and of the programmes that the artists are campaigning for, means that the entire artistic world is always being confronted with some new point of view, with some novel set of demands imposed without discrimination on every painting.

Each new point of view is customarily summarized in a single catchphrase, which artists and critics first search for industriously, then work half to death, vulgarizing it and employing it everywhere, not realizing how quickly the catchphrase will fossilize into a system, become a yardstick by which every work is measured.

In the case of realism and plein-air painting, the catchphrase or yardstick in question was *c'est observé*, 'that's well observed'. Everything that wasn't the result of observation was branded as bogus, mannered, tasteless.

Courbet[2] used to say, 'If by some miracle I were ever given the chance to meet Guercino, I would murder him immediately as a punishment for painting those dreadful bogus daubs of his.'

More recent artists, of course, could think of many painters they would far sooner murder than Guercino, a true poet of tender intimacy.

Later, another fashionable new expression began to be bandied about. This was every bit as effective in allowing good paintings to be distinguished from bad, but now people said, 'How rich in feeling, in mood, it is.' Yesterday's masterpieces were baldly summed up in the repeated phrase: 'See how dispassionately nature is rendered.'

Then that expression faded, lost its glitter, in its turn, along with the artistic ideal it expressed. Once again a new catchphrase was found, providing a ready answer to the endless questions of those tiresome people who don't understand new kinds of art they haven't seen before.

'Hang on, please: you're a painter, aren't you? What's so special about this painting?'

(3)

And the answer came out pat, 'It's stylized.'

Capturing 'mood' in one's painting wasn't a problem that interested anyone any more; all the methods of doing this had been tried, and now they were abandoned. Everyone was mad for 'stylization'.

An important word was so conclusively abused, its significance so travestied by simple-minded and stereotypical usage, that in the end none of the profundity of the original concept remained.

The greatest artists responded to the new catchphrase by producing sincere paintings, but the minor figures exploited the fashion for stylization and turned out work that only imitated significant paintings of the past in the most superficial ways. Now another sacred word is starting to get worn out, to lose its charm through overuse, through being used as a label for sticking on anything that it seems to suit at a fleeting glance. I'm talking about 'mysticism'.

(4)

(5)

But, at the last minute, the day has been saved by a new phrase that really does excite us, a vital phrase close to our hearts. How an artist flushes with pleasure when someone says to him: 'How rhythmic your painting is, what a beautiful line you have!'

If one puts the catchphrases that I've mentioned together, the result is a potted history of the development of art over the last twenty-five years (albeit one that may sound a little eccentric).

This development, generated by a conflict of two warring tendencies, has proceeded at different rates, but unstoppably, since the end of the eighteenth century, since the moment, or rather since the epoch, when a great school of art became totally colourless, having squandered its resources on satisfying the caprice of an over-sophisticated public. This great school of art had a direct and almost unbroken line of descent stretching right back to the thirteenth century.

This catastrophic collapse of a great school of art, this dreadful cultural tragedy, is scarcely taken into account by art historians when they analyse the specificities and shortcomings of nineteenth-century art (you've only to look at Muther's *Geschichte der Malerei im XIX Jahrhundert*).[3] It's painted out, as it were, so that the myopic optimism of the historian as he writes of Manet and his successors can come into focus.

The idea that inspired my essay was that of the almost complete isolation and solipsism of nineteenth-century art – which derives from the fact that its heritage is so poor, that it has so few experiments to fall back on.

The ugly and often impotent forms that nineteenth-century art has adopted, at least at times, are to my mind the natural result of its forgetfulness of the traditions of that great school of the past, traditions that were passed down from generation to generation – a form of education that in Russia is now found, alas, only among tradesmen, such as glaziers and house-painters.

I do not speak sarcastically.

At the moment tradesmen's guilds are probably the only institutions in Europe where traditional methods of teaching art have remained as they were since time immemorial.

I want to recall an incident from my own life, an incident that illuminated for me both what a real artistic school actually is, and the fact that there was no such thing in nineteenth-century painting.

A while ago I had a commission to do a painting on glass (quite a big painting). It took a huge amount of time, effort and patience. When I finished the work I realized that the frame the painting had to go into was too small for it. The corners of the painting would have to be sliced off.

I'm sure that you can easily imagine my anxiety when the master glazier who had been recommended to me, an elderly man whose peasant origins were very obvious, first cut round the edges with a diamond and then proceeded to remove the unwanted pieces with pliers.

When the glazier had finished the job without anything untoward happening, I confessed that I had been worried how things would turn out. He smiled at me without saying anything, then took a long length of glass and used his diamond to cut a freehand curved line top to bottom; five seconds later he cut another curved line, this time in parallel to the first; then he took off the waste pieces with his pliers and left me with a long, ribbon-like length of glass, exactly parallel along the entire length of the curve. Overwhelmed, I said to the master that he had been taught everything in his workshop, while I'd learnt nothing in my academy. For me, that glazier was a truly great artist in his way, since he was someone who had added all the skill and traditional wisdom of his school to his own intrinsic ability.

Translated by Catriona Kelly

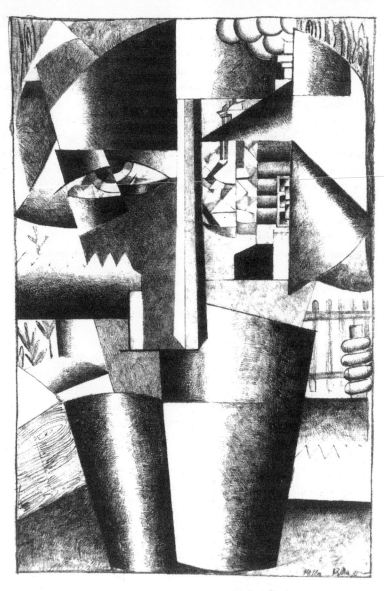

4. The eye of the maker: Kazimir Malevich's *Portrait of a Builder* (1911) uses the cubist technique of collage to turn a human figure into a metaphor for his craft.

Olga Rozanova, a futurist painter and illustrator who was later associated with Kazimir Malevich's Suprematist movement, was one of the few women artists who attempted to theorize what she was doing. Here, she sets out a tripartite model of artistic creation: intuition of natural data, transformation of these data according to an artist's personal experience, followed by the stage essential to the New Art, that of abstraction, or representation according to abstract theoretical assumptions. The phrasing of Rozanova's essay owes something to the contemporary fashion for half-baked scientific analogies, but the text is interesting because its opposition to the traditional Aristotelian view of nature as inert matter anticipates late-twentieth-century feminist theory.

OLGA ROZANOVA
From 'The Principles of the New Art and the Reasons Why It is Misunderstood'

Soyuz molodyozhi, 3 (1913)

The art of painting consists in the dissection down of the finished images presented to us by nature in order to establish the individual properties contained in these, followed by the creation of different images by forging new relations between these properties on the basis of one's personal attitude to them. The artist defines these properties by means of his visual faculty. To an imperceptive soul, the world is inert clay, or the back of a mirror; to souls themselves like mirrors, the world is a mirror in which reflections come and go without ceasing.

How does the world reveal itself to us? How does our soul reflect the world? To reflect, one must perceive. To perceive, one must touch and see. Only the intuitive principle allows the world fully to enter into us.

And only the abstract principle, which is to say, rational calculation, the consequence of our active striving to reproduce the world, has the power to construct a picture.

That is to say, the creative process consists of the following order of principles:

(1) the intuitive principle;
(2) the personal principle, i.e., transmutation of the visible according to one's personal attitude to this;
(3) the principle of abstract art.

The visible enchants us, the spectacular captivates us, fastening our gaze, and from these first moments of contact between the artist and nature arises the artist's striving to create. The desire to enter into the world and, in reflecting it, to reflect oneself, is an intuitive impulse that lays down the theme (a word that should be understood in its purely artistic sense).

Therefore, nature is just as much a part of the 'theme' as the artistic task that has been posed in the abstract. Nature is the starting point, the seed, from which a work of art develops, and the intuitive impulse is the first psychological phase of the creative process. But how does an artist make use of natural data, how does he transform the visible world and his own relationship to this?

A rearing horse, immobile cliffs, a delicate flower are all equally beautiful if they are all equally expressive. But what does an artist express by merely repeating them?

At best, he will unconsciously plagiarize nature; this is forgivable in an artist who does not know his own ends in life. At worst, however, he will produce a piece of plagiarism in the direct sense of the word, indulge in the kind of activity that people cling to only because they are too creatively enfeebled to manage anything else.

And so the artist must not be a passive imitator of nature; he must exactly express his own relationship to her. But here a question arises: how long and up to what point should nature's influence be allowed to make itself felt on an artist?

No slavish repetition of examples drawn from nature can communicate nature's full essence.

It is time, finally, to recognize this overtly, and to declare once and for all that new paths and new approaches are necessary in order to depict the world adequately.

Slavish photographers and artists will simply repeat nature's images when they attempt to portray these.

Artists of true individuality will reflect themselves in depicting nature.

From the properties of the world that reveals itself to them, they will select those that are to be the basis of the new world – the world of the

painting – and, renouncing the mere repetition of the visible, will inevitably create new images with which they will be compelled to reckon when striving to realize these on the canvas.

The intuitive principle (which is to say, the external stimulus to creation) and personal transmutation (the second stage of the creative process) have now done their work, allowing the significance of the abstract to come into play.

This last stage embraces the concept of creative calculation, that is, a purposive attitude to the artistic task. The abstract principle plays a significant role in the new art; it has brought together once and for all the concepts of artistic methods on the one hand, and artistic ends on the other. Contemporary art works are no longer mere copies of real objects; they have placed themselves on a different plane and have decisively overturned the concept of art that existed up to the present time.

The artist of the old art was fettered by nature and neglected the autonomous existence of his painting; as a result, his paintings were only pallid reminders of what he saw, tedious assemblages of ready-made and undissectable natural images, the fruits of a logic deriving from an orientation that was both static and anti-aesthetic. The old artist was enserfed to nature.

Only now does the artist create his paintings in a fully conscious way. Not only does he avoid copying nature, he also makes his representations complex by filtering them through the psychological world of contemporary artistic thought, through what he (the artist) sees, knows and remembers. And he also submits his conscious creation, as he transfers it to the canvas, to a further stage of constructive adaptation, which, in fact, is the most important thing in art, since only if this last stage is undergone does the concept of a painting, its self-sufficient and autonomous value, acquire its full and necessary force.

Ideally, the artist moves without interruption from one creative condition to another, and the intuitive, personal and abstract principles are linked organically, rather than mechanically. [. . .]

If members of the public and critics who have been indoctrinated in the psychology of the old concept of art do not make the effort to shift to the point of view required by the art of our day, this art will remain totally incomprehensible to them.

That view of beauty that exists in the minds of those of the public (the majority) who have been indoctrinated by studying the works made

by pseudo-artists on the basis of copies of nature depends on two concepts: the familiar and the comprehensible. When art created according to new principles shocks the public out of its torpid dependence on fixed opinions, this shift into a new condition provokes protest and hostility in those who have not developed their minds in preparation.

This is the only possible explanation for the monstrous accusations that have been levelled at the whole new generation of art and its representatives.

Accusations of 'careerism', 'commercialism', 'charlatanism' and perfidy of every imaginable kind.

Only the absence of any impulse to self-education can explain the disgusting outbursts of whinnying laughter at exhibitions of advanced work.

Only profound ignorance can be the reason behind the incomprehension of technical terms as used in the titles of paintings, and of the techniques used in the paintings themselves (for example, light-line, colour orchestration).

There is no doubt that if a person arrived at a concert, and, having read in the programme titles such as 'Fugue', 'Sonata', 'Symphony', and so on, began to guffaw loudly, and to brand denominations of that kind absurd and pretentious, people sitting round him would shrug their shoulders contemptuously, putting him in his place.

So what makes the usual type of visitor to Young Art exhibitions any different when he doubles up with laughter on seeing technical terminology in the catalogue and makes no effort to work out its actual meaning? [. . .]

Having determined the essential values of the new art, it is vital to note the extremely high level of development that has been reached by contemporary creative life. The fact is that the number and variety of different artistic paths is larger than has ever been known before.

But the art critics and the veterans of the old art still hold fast to their fatal dread of anything that is sublime and energetic, trembling anxiously lest anyone relieves them of their battered trunks of threadbare artistic achievements, brandishing these miserable achievements and their own established position, sparing no efforts to besmirch Young Art and to impede its triumphal procession. They even dare to call its seriousness into question.

It is time everyone realized that the future of art is safe only when the thirst for renewal in an artist's soul becomes overwhelming, when

his poverty-stricken personal taste loses its power over him and no longer forces him to sing along with everyone else.

What gives some artists the gall to feed off the artistic prejudice that they have hoarded like stores of rotting tinned food, and to keep on mumbling the same thing at fifty that they did at twenty, is their total lack of honesty and genuine love for art.

Every moment of the present is unlike any moment of the past, and moments of the future bear within them inexhaustible opportunities for new discoveries.

What else other than laziness can explain the spiritual death of the artists of the old art?

They're finished as innovators at hardly thirty years old; after that they just sing along.

Similarity is the apotheosis of banality.

There's nothing in the world more frightful than an artist with the kind of unchanging face that lets old friends and old buyers recognize him easily at every exhibition. There's nothing more frightful than the mask with which all so-called first-rate artists bedizen themselves, cutting off their ability to look forwards. And the dealers are just as cut off from the world; they are only interested in their own nest-eggs.

There is nothing more frightful than the inability to change when that inability is not an expression of the elemental force of individuality, but a tried and tested method of lining one's own pockets.

It is time we finally put a stop to the chorus of critical abuse and recognized that only the Young Artists exhibitions can be the basis for a renewal of art. Let us heap contempt on those who value only a good night's sleep and the regurgitation of their own experiences!

Translated by Catriona Kelly

Father Pavel Florensky, theologian and theoretical physicist, was an imaginative cultural theorist who drew on both sides of his intellectual background in order to invent what might be described as a Formalist poetics of symbolic art. His writings fuse neo-Platonic theory with insights drawn from mathematics and from the physical sciences. Here, he exploits the term 'reverse perspective' (umgekehrte Perspektive), coined by Oskar Wulff in 1907, in order to assault the progressivist notion that the 'discovery' of geometrical perspective during the Italian Renaissance represented an artistic advance, and a break with the 'primitive' perceptions of earlier artists.

PAVEL FLORENSKY
[Against Linear Perspective]

From *On Reverse Perspective*, in *Collected Works*, vol. 1 (Paris, YMCA Press, 1985)

I

The fact that the icons where the laws of perspective are disrupted most violently are those painted by the great masters, and that the ones in which those laws are most faithfully observed are the icons painted by masters of the second and third rank, might lead us to pose the following question: *is not the very question of whether icon-painting is a naïve form of art not itself naïve?* Further, the disruptions of perspective are so frequent and so insistent, so systematic, I would say, and so determinedly systematic, that involuntarily one wonders whether they might not be deliberate, might not be the expression of a *specific* system of perception and representation of reality.

As soon as that thought has made itself felt, observers of the icon are driven to a firm conclusion: that the disruptions of the laws of perspective in the icon emanate from the employment of a *conscious* strategy on the part of icon-painters; for better or worse, they are always premeditated and deliberate.

The impression that the laws of perspective are consciously disrupted is heightened by the *emphatic* nature of the foreshortening in the icon, by the special tonalities, or, as icon-painters themselves put it, *raskryshki,*

that are used to depict this. The peculiarity of the delineation is not allowed to slip past the consciousness through the employment of neutral colours, or colours whose effect is softened by their relation to the overall tonality of the piece; it emerges provocatively, as it were, almost clashing with this overall tonality. So, for example, the rear planes of palace buildings are not placed in shadow; on the contrary, they are often painted in brighter shades than the planes of those buildings' façades, and, moreover, shades from quite different parts of the spectrum. But what draws attention to itself most insistently in such cases is an object that in any case strives towards the foreground of the painting, seeks to occupy its artistic centre. This object is the Gospels, whose outline, usually painted in scarlet,[1] is the brightest point in the icon and thereby underlines the presence of supplementary planes in the harshest manner possible.

Such are the methods that are used for emphasis. These methods are all the more obviously conscious in that they run contrary to the tonalities generally used in icon-painting; therefore, there is no question of there being any intention to imitate ordinary reality in a naturalistic way. Real-life copies of the Gospels did *not* have a band round the outside in bright scarlet, and the side-walls of buildings were *not* painted in different colours from the façades; the peculiarity of the representations of these things in icons makes clear a striving to emphasize the supplementary character of these planes, the fact that they fall outside the viewpoint of linear perspective as such.

II

The strategies that I have just described are generally categorized by the terms *reverse perspective*, or *inverse perspective*, or sometimes *false* or *corrupt perspective*. But reverse perspective does not exhaust the multiple possibilities of line and colour in the icon. Other aspects of these include the use of *a number of different centres* in the representation: the composition suggests that the eye has shifted its position as it regards different objects included in the painting. Some parts of a room, for example, are delineated more or less in accordance with the demands of ordinary linear perspective, but each part has its own viewing point, its own *particular* perspectival centre, and sometimes also its own horizon, while other parts of the room are represented according to

the conventions of reverse perspective. This complex working-out of perspectival viewpoints is to be observed not only in the rendering of rooms, but also in the rendering of faces, although here it is not as insistently presented as in the rendering of inanimate objects, but with moderation and discretion, which is why it is sometimes interpreted as resulting from 'faults' in the drawing. However, in other instances all the schoolroom rules are overturned so boldly, the disruption of these so dominatingly underlined, and the icon that results is so expressive, so eloquent of its own artistic achievements, at least to any uncompromised artistic taste, that no doubt can remain: the 'incorrect' and contradictory details of the delineation are the result of a complex artistic *calculation*, which one can call impudent if one so wishes, but which can certainly not be described as naïve. [. . .]

Now, when we come on to the chiaroscuro of the icon, we find that the disposal of shadows in the icon is highly idiosyncratic, an effect that underlines and emphasizes the icon's lack of relation to naturalistic representation. The absence of any well-defined light focus, the contradictory nature of the lighting in different parts of the icon, the striving to emphasize forms that should be in shadow – all of these features occur not by chance, or because of an oversight on the part of a primitivist painter: they are artistic calculations that make an enormous contribution to the artistic expressiveness of the piece.

Among other similar means of artistic expressiveness one could also mention the lines used for so-called 'highlighting' (*razdelka*), which are painted in a colour *different* from that in which the section of the icon where they are placed is realized (usually, in fact, a glittering, metallic colour, such as gold, or much more rarely silver or gold leaf). By thus emphasizing the *colour* of the highlighting, we wish to make clear that the icon-painter has consciously drawn attention to this, although it does not correspond to anything visible in the physical world, for example, the folds of a garment or the outlines of a piece of furniture. On the contrary, this is a system of potential lines, of constructs, similar, for example, to the energy lines in an electric or magnetic field, or to systems of equipotential and isothermic and other such curves. The lines of the highlighting express the metaphysical schema of the given object, its dynamics, with all the more force the more visible they are; but they are in themselves invisible and are set down on the icon because the icon-painter intends to express by them the totality of actions performed by the viewing eye – the lines of the movements executed

by the eye as it views the icon. These lines construct a schema by which the object viewed may be reconstructed in the consciousness of the viewer; if one searches for their physical basis, then they must be understood as lines of energy, lines of tension, in other words, not as the creases that are created by tension, not *actual* creases, but potential creases, the folds that *could be created*. The highlighting lines placed on the supplementary planes of the composition communicate to the consciousness the structural character of these planes, and accordingly help the viewer not merely to observe these planes passively, but to understand their functional relation to the whole; they thereby provide material that allows the observer to grasp the fact that the foreshortening does not satisfy the demands of linear perspective. [. . .]

III

But now the question of the purpose and legitimacy of the disruptions of perspective that we have described arises. In other words, we need to examine the boundaries dictating how perspective is used, and the purpose behind its expression. Does perspective really represent the nature of things, as its advocates insist it does, and why should it be understood as an absolute requirement of artistic truth in all places and at all times? Or is it better understood as a schema, and only one of many such schemas of artistic representation, arising not from the single correct view of the world, but from one of many possible explications of the world, and one, moreover, connected with a quite specific feeling for, and understanding, of life? [. . .]

The absence of direct perspective in Egyptian art, and also in Chinese art (though the character of this is quite different), is more attributable to the maturity, and indeed superannuated over-maturity, of these two artistic traditions than its infantile lack of experience. It demonstrates a *liberation* from perspective, or a fundamental denial of the authority of perspective (one characteristic of subjectivism and illusionism) in favour of *religious objectivity and a supra-personal metaphysical world-view.* [. . .]

IV

Thus, perspective does *not* arise in pure art, and in its first manifestation is in no way associated with a living artistic perception of reality; it was an invention made in the field of the applied arts, or to be more exact, a theatrical technique harnessing art to its own ends. Whether these ends corresponded to the ends of pure art is a question that does not require answering. After all, the end of art is not to duplicate reality, but to communicate the profoundest possible idea of the architectonics, the material and the purpose of that reality, based on the artist's own grasp of the purpose, and of the material and the architectonics of that reality, a grasp that in its turn comes about in the course of his direct contact with that reality, as he learns how to enter into that reality by the medium of his own life and feeling. But theatrical decoration tries to *act as a substitute* for reality as far as possible, to replace reality with the appearance of reality; the aestheticism of that appearance of reality lies in the interconnectedness of its elements, but in no sense acts as a symbolic signalling of the primary image via the image that has been incarnated by artistic techniques. Decoration is a form of *deception*, albeit a beautiful form thereof; pure art expresses, or at any rate intends to express, the *truth* of life, it does not act as a substitute for life, but signals that life symbolically at the profoundest level of its reality. Decoration acts as a screen placed before the light of eternal life; pure art is a window that opens on to reality. For the rationally minded Anaxagoras and Democritus,[2] there was no such thing as a visual art that acted as a symbol of reality, nor was it desirable that there should be; similarly, for Wandererism (if one accepts the elevation into a historical category of that small-scale and local phenomenon of Russian life, the Wanderer movement[3]) it was not truth to life, but an external resemblance to life that was of importance. This external resemblance was useful in a pragmatic sense, for its relation to immediate social needs, which is to say that the Wanderers aimed at the imitation of life's surface, rather than the exposure of the sources of creativity themselves. In the Greek theatre a wall was represented symbolically, by means of a cloth and paintings; now the need for *illusion* started to be felt. These first theoreticians of perspective assumed that the spectator or the decorative artist was chained to the theatrical bench as Plato's prisoners were in their cave, and that he could not and should not have an

unmediated and living relationship to reality, that he was cut off, as it were, by a glass wall from the stage and was no more than a single immobile fixed eye, an eye unable to penetrate the very essence of life. Most importantly of all, they assumed him to be without free will, since in its essence the worldly theatre[4] compels a spectator to suspend his will, to look at the stage as some kind of 'unreality', something 'not as in actual fact', as a form of empty illusion. And in so doing, I repeat, those first theoreticians of perspective set down the rules for a form of illusion that tyrannized the spectator. Anaxagoras and Democritus replaced the living human being by spectators intoxicated on curare; what is more, they also explicated the methods by which those spectators might be deceived.

<div align="right">Translated by Catriona Kelly</div>

Osip Brik, who alongside Mayakovsky and Aleksandr Rodchenko was a member of the Left Front of Arts (Lef) movement, cannot be compared with Yury Tynyanov, Boris Eikhenbaum or Viktor Shklovsky in terms of his original contributions to the theorization of the literary process. However, his manifesto for Opoyaz (The Society for the Study of Poetic Language), first published in Lef's journal in 1923, sets out the Formalists' objectives clearly and laconically. These were: (a) to dethrone author-based and most particularly biographical criticism (the 'death of the author' was proclaimed in Russia some fifty years before it was by post-structuralists in France); (b) to introduce rigorous study of literary strategies and the social pressures that led to their evolution ('the laws of poetic production'); and (c) to affirm the special character of poetic language ('modern poetic creation'). Brik's manifesto also asserts the commitment of 1920s Formalists to the materialist study of literary texts and to an aesthetic of social relevance, though, as his concluding sneer at 'the Marxists' and his references to 'great poets' and 'creative personalities' reveal, this commitment was never wholehearted.

OSIP BRIK
'The So-called Formal Method'

Lef, 1 (1923)

Opoyaz and its so-called 'formal method' has become the bugbear of the priests and high priests of literature. Our bold attempt to approach the holy images of poetry from a scientific point of view has roused their vociferous displeasure. A 'league for the struggle against the formal method' has been formed, or rather a 'league for the struggle against the removal of poetic values'.

Opoyaz proposes that *there are no poets or literary figures, there is poetry and literature.* Everything that a poet writes is significant as part of his work in the common good – and quite insignificant as a manifestation of his 'I'. If the poetic work is understood as a 'human document', as a diary entry, then it is interesting to the author, to his wife, his relatives, friends and to maniacs such as those passionately seeking the answer to the question 'Did Pushkin smoke?' – and to no one else.

The poet is an expert at his job. And that's all. But in order to be a good craftsman, he must know the needs of those for whom he works, he has to live the same life as they do. Otherwise the work won't do, won't be any use.

The social role of the poet cannot be understood by an analysis of his individual qualities and habits. *It is essential to study on a mass scale the devices of poetic craft*, what distinguishes them from adjacent domains of human labour, and to study the laws of their historical development. Pushkin was not the creator of a school, but only its chief. Had Pushkin not existed *Evgeny Onegin* would all the same have been written. America would have been discovered even without Columbus.

We have no history of literature. There is the history of the 'generals' of literature. Opoyaz makes it possible to write a real history.

The poet is master of the word, language-maker, who serves his class, his social group. What he writes about is suggested to him by the consumer. *Poets do not invent themes, they take them from their environment.*

The poet begins by working over the theme, finding the suitable verbal forms for it.

To study poetry is to study the laws of this verbal work-over. *The history of poetry is the history of the development of the devices of verbal formation.*

Why poets took just these and not other themes can be explained by the fact of their belonging to a particular social group and has no relationship at all to their poetic work. This question is important for the biography of the poet, but the history of poetry is not the 'life of saint so and so' and should not be one.

Why poets used just these devices and not others in working over their themes, and what caused the appearance of a new device, why an old one dies out, this is what scientific poetics has to subject to careful research.

Opoyaz demarcates its work from the work of adjacent scientific disciplines, not in order to withdraw from 'this world' but in order in all clarity to pose and extend the most essential problems about man's literary activity.

Opoyaz studies the laws of poetic production. Who dares stop us?

What is Opoyaz contributing to the building of proletarian culture?

1. A scientific system instead of a chaotic conglomeration of facts and personal names.

2. The social evaluation of creative personalities instead of the idolatrous interpretation of the 'language of the gods'.

3. Knowledge of the laws of production instead of some 'mystical' penetration into the 'mysteries' of creation.

Opoyaz is the best teacher for our young proletarian writers.

Our proletarian poets are still sick with yearning for 'self-revelation'. They are breaking away from their class every minute. They do not want to be simply proletarian poets. They look for 'cosmic', 'planetary' and 'deep' themes. They think that, as regards theme, the poet must leap out of his milieu, that only then will he reveal himself and create something 'eternal'.

Opoyaz will show them that everything great was created in answer to current questions, that 'the eternal' today and in the past was a matter of current affairs, and that a great poet does not reveal himself, but only fulfils a social demand.

Opoyaz will help our comrades the proletarian poets to overcome the traditions of bourgeois literature, by showing scientifically its lack of vitality and its counter-Revolutionary nature.

Opoyaz will come to the aid of proletarian creation not with misty talk of the 'proletarian spirit' and 'communist consciousness' but with precise technical knowledge of the devices of modern poetic creation.

Opoyaz is the grave-digger of poetic idealism. It's no good fighting against it. And so much the worse for the Marxists.

Translated by Ann Shukman

*Mandelstam's 'On the Nature of the Word' takes a quite different view
of literary creation from that set out by Yury Tynyanov in the schematic
and cerebral Archaists and Innovators (1929), which argued that literary
innovation was the result of writers' attempts to break away from forms
of expression that had become static. Rather than an attempt to engage
with the past in a combative sense, the writing of poetry is, for Mandel-
stam, a reabsorption of self in the past, and most particularly in the
physical world of Ancient Greece, where words and objects (as in
Mandelstam's own poems about Hellenic topics) are totally identified
(Mandelstam also appears to be conducting a covert polemic with
Saussure's opposition between 'signifier', or the word as sound and sign,
and 'signified', or real phenomenon).*

OSIP MANDELSTAM
From *On the Nature of the Word*

(Kharkov, 1922)

A science based on the principle of connection, and not of
causality, delivers us from the foolish infinity of evolutionary theory,
not to mention its vulgar stooge – the theory of progress.

The movement of an infinite chain of phenomena without beginning
or end is precisely a foolish infinity, one that has nothing to say to an
intelligence seeking unity and connections. This infinity lulls scientific
thought to sleep with an easy and accessible evolutionism that provides,
it is true, the appearance of scientific generalization, but only at the
cost of refusing any possible synthesis or inner system.

The vagueness and lack of architectonics of European scientific
thought of the nineteenth century had by the beginning of the present
century completely demoralized that thought. Intelligence, which
equates not with knowledge and the sum of knowledge but with grasp,
device, method, had abandoned science – though fortunately it can exist
independently and can find sustenance anywhere. It would be pointless
to look for such intelligence in the scientific life of old Europe. The
free intelligence of man had become separated from science. It was to
be found everywhere but there: in poetry, in mysticism, in politics, in
theology. As far as scientific evolutionism with its theory of progress is

concerned, though it – unlike the new European science – never got
to the stage of cutting its own throat altogether, it persisted in the one
direction till it reached the shores of theosophy, an exhausted swimmer
reaching a cheerless shore. Theosophy is the direct descendant of the
old European science. It deserves to come to the same end. That
same foolish infinity, that same lack of backbone in its teaching about
reincarnation (*karma*), that same crude and naïve materialism in its
vulgar understanding of the supersensual world, that same absence of
will and taste with regard to the cognition of reality, and a kind of lazy
omnivorousness, a huge, heavy chewing of the cud, a cud intended
for thousands of stomachs, an interest in everything that borders on
indifference, and an omniscience that borders on complete nescience.

Evolutionary theory may be dangerous for literature, but the theory
of progress is fatal. If one listens to the historians of literature who view
these matters from the vantage point of evolutionism, then it transpires
that writers have no other care but how to make the way clear for those
who come after them and do not think at all about how they may fulfil
their own cherished business; or it transpires that they are all participants
in a competition to invent improvements for some kind of literary
mechanism, and, what is more, it is unclear where the judges are hiding
or what purpose the mechanism serves.

The theory of progress in literature is the most vulgar and the most
repulsive type of ignorance, one fit only for the schoolroom. Literary
forms replace one another, one set of forms gives way to another set.
But each change, each gain is accompanied by loss. There can be no
'better', no progress in literature, simply because there is no such thing
as a 'literary mechanism'; there is not even a starting line that one has to
gallop to quicker than all the others. The absurd theory of improvement is
not applicable even to the manner and form of individual writers, for
here too every gain is accompanied by loss. Where in the Tolstoy of *Anna
Karenina*, who made the psychological power and sense of structure of
Flaubert's novel his own, is the animal nose for nuance, the physiological
intuition of *War and Peace*? Where in *War and Peace* does the author
display the transparency of form, the 'clarism'[1] of *Childhood and Boy-
hood*? The author of *Boris Godunov*, even if he had wanted to, could
not have reproduced his Lyceum verses, just as now no one can write
an ode in the style of Derzhavin.[2] The question of who prefers what is
another matter altogether. Just as there are in existence two geometries,
Euclid's and Lobachevsky's,[3] so two histories of literature are possible,

written in two keys: one talking about the gains only, the other about the losses only, yet both will be talking about exactly the same thing.

The Russian language is a Hellenistic language. By virtue of a whole series of historical conditions, the vital forces of Hellenic culture, having conceded the West to Latin influences and having tarried only fleetingly in childless Byzantium, rushed to the bosom of Russian speech and imparted to this the self-assured secret of the Hellenistic world view, the secret of free incarnation; *therefore the Russian language became nothing less than sounding and speaking flesh.*

If Western cultures and histories lock up the language from without, fence it in with the walls of state and Church, and become saturated with it in order to decay slowly and grow mouldy at the due hour of its disintegration, Russian culture and history are washed and girded on all sides by the threatening and formless element of the Russian language, which cannot be accommodated within any state or Church forms.

The life of the language in Russian historical reality outweighs all other elements in the fullness of its manifestations, the fullness of being, a fullness that represents an unattainable pinnacle for all other aspects of Russian life. The Hellenistic nature of the Russian language may be identified with its receptiveness to real existence. The word in the Hellenistic understanding is active flesh that fulfils itself in an event. Therefore the Russian language is historical in its own right, since in its entirety it is a turbulent sea of events, the constant incarnation and activity of rational and breathing flesh. No other language resists more forcefully than Russian the urge towards appellative and applied usage. Russian nominalism, that is, the notion of the reality of the word as such, animates the spirit of our language and links it with the Hellenic philological culture not etymologically and not in a literary way, but through the principle of inner freedom, which is equally inherent in both.

Each and every kind of utilitarianism is a mortal sin against Hellenistic nature, against the Russian language, and it makes absolutely no differ-ence at all whether this takes the form of the tendency towards a telegraphic or stenographic code for the sake of economy and simplified expediency, or of a utilitarianism of a higher order, sacrificing the language to mystical intuition, anthroposophy, or any type of all-devouring, logophagic[4] thinking.

Hellenism is the conscious surrounding of man by utensils, instead of indifferent objects, the transformation of such objects into utensils, the humanization of the surrounding world, the act of warming it with the most subtle teleological warmth. Hellenism is any stove next to which a man sits and values its warmth as kindred to his own internal warmth. Finally, Hellenism is the funeral barque of the Egyptian dead, in which everything is placed that is necessary for the continuation of man's earthly journey, right down to an aromatic pitcher, a small mirror, and a comb. Hellenism is a system in the Bergsonian sense of the word, a system that a man unfolds around himself, like a fan of phenomena that has been freed from temporal dependence and that acquires internal connections through the human 'I'.

In the Hellenistic understanding the symbol is a utensil, and therefore every object brought into the sacred circle of man can become a utensil and, consequently, a symbol too. The question therefore arises: do we really need so deeply deliberate a symbolism in Russian poetry? Is it not a sin against the Hellenistic nature of our language, which creates images, like utensils, for the use of man?

In essence there is no difference at all between a word and an image. A word is already a sealed image: Please Do Not Touch. Such an image is not suitable for everyday use, just as no one would think of lighting up a cigarette from an icon lamp. Such sealed images are also very necessary. Man loves that which is forbidden, and even a savage places a magical prohibition, a 'taboo', on certain objects. But, on the other hand, a sealed image, an image taken out of circulation, is hostile to man; it is in its own way a scarecrow.

All that is transient is but a likeness. Let us take for example a rose and the sun, a dove and a girl. For a symbolist not one of these images is interesting in its own right, but only in as much as a rose is a likeness of the sun, the sun is a likeness of a rose, a dove is a likeness of a girl, and a girl is a likeness of a dove. The images have had their innards plucked out, like scarecrows, and are filled with a foreign content. Instead of a forest of symbols we have a workshop for stuffing scarecrows.

Translated by Andrew Reynolds

Dziga Vertov's anti-realist theories of documentary film-making, which held that the camera-operator should not attempt to imitate the viewpoint of the human eye, had much in common with Aleksandr Rodchenko's views on still photographs (see below). Both writers translated the Constructivists' interest in the machine into a 'machine aesthetic', and both were impatient with conventional art, which they saw as the hack-work of 'artists without a cause'. However, Vertov's article is distinguished from Rodchenko's by its tyrannical intonations: the directives issued by the Soviet of Three Cinematographers have an unpleasant ring of the judgements of anti-counter-Revolutionary three-man tribunals (troikas), especially taken together with Vertov's declaration that 'the death sentence pronounced by the Cine-Eyes on all films without exception is still valid today'.

DZIGA VERTOV
[Seeing Like a Camera]

From 'The Cine-Eyes. A Revolution', *Lef*, 3 (1923)

In fulfilment of the Resolution of the Soviet of Three of 10 April 1923 I am publishing the following extracts:

I

Observing the films that come to us from Western Europe and America and considering the evidence that we have of work and research abroad and in this country, I come to the following conclusion:

The death sentence pronounced by the Cine-Eyes on all films without exception is still valid today.

The most thorough investigation does not reveal a single film, a single piece of research that is correctly designed to *emancipate the camera*, which has been pitifully enslaved and subjugated to the imperfect and none too clever human eye. [. . .]

> LEGITIMIZED
> MYOPIA

Our starting point is: *the use of the camera as a Cine-Eye, more perfect than the human eye for examining the chaos of visual phenomena that resemble space.*

> MAKE WAY
> FOR THE
> MACHINE!

The Cine-Eye lives and moves in time and space, it perceives and fixes its impressions in a completely different way from that of the human eye. The position of our body during observation, the number of aspects of a particular visual phenomenon that we observe in a second is by no means obligatory for the camera, which will perceive more and better, the more it is perfected.

> DOWN WITH
> 16 FRAMES
> A SECOND!

We cannot make our eyes any better than they have been made but we can go on perfecting the camera for ever.

Until now a cameraman has never been rebuked for a running horse that moved unnaturally slowly across the screen (when the camera handle was cranked too fast) or for the opposite, a tractor that ploughed a field too quickly (when the camera handle was cranked too slowly), and so on.

> ACCIDENTAL
> DISLOCATION &
> CONCENTRATION OF
> DISLOCATION

These are of course accidental but we are preparing a system, a carefully considered system of such cases, a system of *apparent* irregularities that examine and organize phenomena.

Until now we have *coerced the film camera and forced it to copy the work done by our eyes.* And the better the copy, the more highly we thought of the photography.

> DON'T COPY THE
> EYES

From now on we are emancipating the camera and forcing it to work in the opposite direction, moving away from copying.

All the weaknesses of the human eye have been revealed. *We reaffirm the Cine-Eye that gropes its way through the chaos of movement for a counter-balance to its own movement; we maintain that the Cine-Eye, with its measure of time and space, is growing in strength and in its possibilities for self-assertion.*

> THE
> MACHINE
> & ITS CAREER

Translated by Richard Taylor

5. Schizophrenetic motion: A still from Dziga Vertov's *Man with a Movie Camera* (1928), in which split-screen framing is used to suggest the noise and bustle of Moscow streets.

ALEKSANDR RODCHENKO
From 'On Contemporary Photography'

Novyi Lef, 9 (1928)

My dear Kushner![1]
You have raised an interesting question regarding the viewpoints 'upwards from below and downwards from above', and I must reply, 'given that these viewpoints have been ascribed to me' (to adopt the 'educated' style of the magazine *Soviet Photography*).

I really am a proponent of these viewpoints above all others, and here is why.

Take the history of the visual arts, or the history of painting in all countries of the world, and you will see that all pictures, with insignificant exceptions, are painted either at belly-button height or from eye level.

You mustn't think from your first impressions that primitive art and icons give a bird's-eye view. All they do is raise the horizon to paint in more figures; but each one of these figures is seen from eye level. The overall effect corresponds neither to reality nor to a bird's-eye view. Although the view seems to be from above, each figure is presented quite conventionally, either *en face* or in profile. It's just that they are arranged one *over* the other, and not one *behind* the other, as in realist work.

You find the same thing with the Chinese. Although, to be honest, they do have one advantage: the object is shown at all kinds of angles of inclination, which vary as the viewpoint shifts (there is foreshortening), but the point of observation still remains halfway up.

Just look through the photographs in old issues of illustrated magazines – you'll see exactly the same thing. It is only in the last few years that you will sometimes see other camera viewpoints. I emphasize the word 'sometimes', as there are still very few of these new viewpoints.

I buy lots of foreign magazines and collect pictures, but I have notched up only about thirty photographs of this kind.

This oppressive, conventional pattern is symptomatic of a preconceived and stereotyped approach to the training of human beings' visual response and of the one-sided distortion of visual thought.

How did the history of inventions in the visual arts proceed? First there was the desire to produce a depiction so that it came out 'like real life', as in the pictures of Vereshchagin or Denner,[2] whose portraits

almost walked out of their frames, complete with every detail down to the pores on the skin. But, instead of being praised for this, they were attacked for being photographers.

The second option was an individual and psychological understanding of the world. In the paintings of Leonardo da Vinci, Rubens, and so on, the same type is depicted in different ways. In Leonardo da Vinci it is Mona Lisa, in Rubens it is the painter's wife.

The third option was mannerism, painting for painting's sake: Van Gogh, Cézanne, Matisse, Picasso, Braque.

And the final option was abstraction, removal of the subject, when an almost scientific interest was taken in the object.

Composition, texture, space, weight, and so on.

But ways of seeking new viewpoints, perspectives and foreshortenings have not been explored at all.

It would seem that painting has reached a dead-end. Or even if, as A KhR R [The Association of the Artists of Revolutionary Russia][3] would have it, it hasn't, then at any rate no effort is being made to explore new viewpoints.

The new instantaneous and real reflector of the world – photography – ought, you might think, given its many possibilities, to have got down to showing the world from multiple viewpoints; it should have trained people to see from all angles. But here the psychology of 'the belly-button view of painting' comes bearing down on photographers with the might of age-old authority, telling them how to do things in endless articles in magazines like *Soviet Photography* and *Trends in Photographic Culture*, and giving them as a model oil paintings depicting Virgin Maries and countesses.

What kind of Soviet photographers and reporters are we going to have if their visual thought is stifled by the prevailing wisdom of world art as expressed in compositions involving archangels, Jesus Christs and noble lords?

When I gave up painting to take up photography, I had no idea that painting had laid its heavy hand on photography.

Can you see now that the most interesting viewpoints for modern photography are downwards from above and upwards from below, and all other viewpoints except those from belly-button height? And that photographers need to keep their distance from painting?

I find it difficult to write, I have a visual way of thinking, thoughts come to me in separate chunks. But the thing is that no one is writing

about this – there aren't any articles on photography, its tasks and achievements. Even left-wing photographers such as Moholy-Nagy write individual articles with titles like 'How I Work', 'My Path', and so on. Magazine editors invite painters to write on trends in photography and take a feeble bureaucratic approach to serving the interests of amateur and press photographers.

The result of this is that press photographers stop sending in their pictures to the photography magazines, and these magazines are turning into something resembling the World of Art.[4]

The letter about me just published in *Soviet Photography* amounts to more than foolish slander. It's a kind of hand grenade thrown into the camp of the new photography. Its aim is, by discrediting me, to scare photographers who are working with the new viewpoints. *Soviet Photography*, in the person of Mikulin, announces to young photographers that they are working 'the Rodchenko way', thus indicating that it does not accept their new photographs.

At the same time, so as to show how cultured 'they' are all the same, magazines include a couple of pictures by new people abroad, albeit unsigned and without any indication of where they come from.

But let's get back to the main issue.

The modern city with its multi-storey blocks, purpose-built factories, foundries, plants, and so on, two- or three-storey shop-windows, trams, cars, illuminated signs and advertising boards, ocean liners, aeroplanes, everything that you described so wonderfully in your *103 Days in the West* – all this couldn't help but shift, although only slightly, the customary psychology of visual response.

It would seem that only the camera is capable of reflecting modern life.

But . . .

The antediluvian laws of visual thinking have always recognized photography as no more than some kind of low-level painting, etching and engraving with the corresponding reactionary perspectives. This tradition decrees that a 68-storey building in America be shot from belly-button height. But the belly-button in question happens to be located on the 34th storey. So people climb up the neighbouring building and take photos of the 68-storey giant from the 34th floor.

And if there *is* no neighbouring building, then the photo is retouched to achieve the 'appropriate' view of the façade, as in an 'artist's impression' of a projected building [. . .].

Buildings that you see from below, looking up as you go along the street; the street with its cars and pedestrians rushing around, which you examine from the upper floors; everything that you see from a tram or car window, that you see from above looking down in a hall or theatre – all this is transformed, straightened out into the classical view 'from belly-button height'.

Theatre-goers may view *Uncle Vanya* from the gallery, i.e., looking down from above, but in fact they transform what they see. Uncle Vanya stands before them in real life, as if viewed from their midriff.

I remember that when I first saw the Eiffel Tower in Paris from a distance I didn't like it at all. But one time I went right past it on a bus, and when I saw from the window the lines of iron disappearing upwards, to right and left, these viewpoints gave me the impression of a mountainous construction. The 'belly-button view' gives you the vague smut reproduced on all those tiresome postcards.

What use is a general view of some factory, if you look at it from a distant reference point halfway up instead of examining everything in detail – inside, downwards from above and upwards from below?

The camera itself was designed to provide a non-distorting perspective even when the perspective is in reality distorted.

If the street is narrow and you can't move backwards, then according to the 'rules' you need to raise the front plate with the lens and incline the back plate, and so on and so forth.

All this so as to create the 'correct' projection perspective.

It's only just recently, and even then in so-called amateur cameras, that short-focus lenses have begun to be used.

There are millions of stereotyped photographs floating around out there, and the only difference between them is that one is done better or worse than another, or that some are done in the style of an etching, others like Japanese engravings, still others in a 'Rembrandt' style.

Landscapes, human heads and naked women are called 'art photography', while pictures of current events are 'press photography'.

And press photography is somehow considered a lower form of photography. But, thanks to the competition between magazines and newspapers, thanks to the vigorous and important work that has been done, in circumstances where photographers have to take pictures at all costs, whatever the lighting and the viewing point, this applied, 'lower' form has generated a revolution in photography.

A new struggle has emerged – between pure and applied photography, between art and press photography.

Not everything is looking good in press photography. Here again conventions and false realism have corrupted those working in this important field. At a photography club picnic – I saw this myself – press photographers on the top of a hill began to stage dances and to set up groups in painterly poses.

It was interesting how the young women, desperate to be part of the 'posed' group, rushed off behind the car to do their hair and make themselves up.

'Let's get our photo taken!'

That way, it's not the photographer who takes his camera to the subject, but rather the subjects that come up to the camera, and the photographer sets them in poses according to the painterly canon.

Or how about the pictures in the magazine *Die Koralle* – now this is a chronicle, this is ethnography, this a true document. But everyone is posing. Just a minute or two before the photographer arrived, these people were doing their own things and standing in their usual places.

Just imagine what shots the photographer would get if he took his pictures unexpectedly and caught these people unawares.

The thing is, though, that catching people unawares is tricky, but taking pictures by posing them systematically is quick and easy. And you never have any misunderstandings with your consumer.

In magazines you come across pictures of small animals and insects taken close-up, at greater than their natural size. But here again the photographer doesn't approach them with a camera, but rather brings them to the camera.

People look for new subjects for pictures, but they take these pictures according to the old traditions.

Even mosquitoes have to be shot from belly-button height, along the lines of Repin's canonical *Zaporozhian Cossacks*.[5]

But it is possible to show an object from those viewpoints from which we look but do not see.

I'm not talking about ordinary things that can be shown quite unusually.

You mention Flach's bridge. Yes, it is remarkable, but the reason it's remarkable is that it's shot not from belly-button height but from ground level.

You say that Kaufman and Fridlyand's[6] pictures of the Shukhov Tower

are no good, that they look more like a bread basket than a truly remarkable construction? I quite agree, but . . . you can use any viewpoint to spoil the true impression, if the object is new and isn't laid out before you.

Here the error is Fridlyand's, not Kaufman's. Kaufman's picture is just one of many frames that he shot of the tower from various angles, and in the cinema these angles are always on the move; the camera turns and clouds pass over the tower.

Soviet Photography talks about 'the photo-picture' as if it is something self-enclosed and eternal.

On the contrary. You need to take several different photos of the object from various angles and positions, as if you were examining it all the way round and not peering into a single keyhole – doing not photo-paintings but photo-moments that have documentary, not artistic value.

To sum up: in order to teach people to see from new points of view, you have to photograph ordinary, extremely familiar objects from completely unusual viewpoints and in unusual positions, and new objects from various viewpoints, thereby giving a full impression of the object. [. . .]

We don't see what we're looking at.

We don't see the remarkable foreshortened perspectives and positions of objects.

We who have been taught to see only what we know well and what has been inculcated in us must discover the world of the seeable. We must revolutionize our visual thinking.

We must let the scales fall from our eyes; we must stop seeing 'from the belly-button'.

'Take photos from all points except the belly-button, until all viewpoints are recognized as valid.'

'And the most interesting viewpoints in the modern world are downwards from above and upwards from below and their diagonals.'

Rodchenko 18 August 1928

Translated by Stephen Lovell

In the 1920s a large number of 'how to' brochures were published on all subjects, from basic literacy to graphology. The title of Mayakovsky's How to Make Verses *appears to place it in this tradition, as do the analogies with factory production that are made throughout. However, the booklet was above all a defence of poetry as a craft, as well as a brilliant description by a major poet of his own method of writing poetry.*

VLADIMIR MAYAKOVSKY
From *How to Make Verses*

(Moscow, 1926)

So how do you make verses?

Work starts long before a writer receives the social command.[1]

Preparatory poetic work goes on all the time.

You can only compose a good piece of poetry by a fixed deadline if you have a stock of ready-prepared materials at your disposal.

For instance, just now (to cite an example that comes into my head as I write), I have nagging at the back of my mind an attractive surname: 'Von Glyceron' – it was some never-finished conversation about glycerine that started me off on that one.

Sometimes it's a good rhyme[2] that sparks things:

> (Like a stout round) drumlin
> (Stands the stern) Kremlin.

> (Visit Rome, ask the French, the) Athenians
> (To find a home for) Bohemians.

> (On a horse that puffs like a) grampus
> (I'll ride my way to) Atlanta,
> To Atlanta
> At a canter.

Or:

> [The nights of] September
> [Are the colour of] umber.

I also have at the back of my mind the rhythm of some silly American song (I'll need to modify it, adapt it so it fits Russian words, of course):

> Hard-hearted Hannah,
> The vamp of the savannah,
> The vamp of the savannah,
> Dee-dum.

And some tightly interwoven alliterations taken from a small ad I saw somewhere with the surname 'Nita Jo' on it:

> Where does Nita Jo hang out?
> Not in the jewellers down the street.

I also have themes – some clear, some vague – stored up in my stockroom:

(1) The rain in New York.

(2) A prostitute on the Boulevard des Capucines in Paris. A prostitute whose services are considered especially chic because she only has one leg. (I think the other was lopped off by a tram.)

(3) An old man who works as a lavatory attendant in Hessler's huge restaurant in Berlin.

(4) The October Revolution theme – a vast one this, which I'll never get to grips with unless I spend some time in the countryside.

All of these raw materials are stacked away in my head, or, if anything gets too complicated, I'll jot it down on paper.

I've no idea how they'll end up being used, but I know they all will be, one way or another.

This kind of preparatory work takes up almost all my time. I spend between ten and eighteen hours a day on it, and I'm pretty well always muttering away to myself. The need to concentrate like this explains why poets are so infamously absent-minded.

Preparing materials is such an arduous business that in ninety out of a hundred instances I can remember where rhymes, alliterations, images, and so on came to me[3] and where they reached their final form (not bad, considering I've been writing poetry for fifteen years).

Pavement.

Faces bent . . . (On a tram from Sukharevka Tower to Sretenie Gates, 1913).

Sullen rain. Eyes squint.

Behind. . . . (Strastnoi Monastery, 1912).

Stroke those desiccated black cats . . . (An oak tree in Kuntsevo, 1914).

Grifter.

Lefter (A cab on the embankment, 1917).

That son of a bitch Danthès.[4] (In a train near Mytishchi, 1924).

And so on, and so on.

Keeping a 'notebook' like this is one of the main essentials for making a poem in the right way.

Usually, people only mention it when a writer dies; the book knocks around in the trash for years, and then gets printed posthumously, in a section at the end of the collected works after the 'finished' things. But for a writer himself, his notebook is all or nothing.

Apprentice poets don't have a book like this because they don't have the experience or the practice behind them. Only a small number of their lines are *properly finished*, with the result that their poems as a whole are baggy and shapeless.

However able an apprentice poet is, he'll never write something really good straight away; on the other hand, early work is always 'fresher', since all the materials stored during the life that led up to it can go in there.

Only having a good stock of ready-prepared materials allows me to speed up the tempo of producing a piece of work; my normal output per day is about eight or ten decent lines.

A poet weighs up every encounter, every shop sign, every event, sifting through everything in terms of its suitability for being reworked in words.

When I was younger, I used to get so involved in all this that I was even wary of letting out any of the words and expressions I thought I might need for a poem at some stage in the future. It made me sulky, silent and dreary to be with.

In about 1913, on my way back from Saratov to Moscow, I attempted to demonstrate how besotted I was with a certain woman also travelling in the train by telling her I was 'not a man, but a cloud in trousers'. The minute the words were out of my mouth, I realized the phrase would

do for a poem: now maybe it would start doing the rounds and get cheapened for nothing? I got terribly anxious and kept on at the girl with leading questions. I only calmed down when I realized the phrase had gone in one ear and out the other.

Two years later 'A Cloud in Trousers' came in handy as the title of a whole narrative poem.

I thought for a couple of days about the tender feelings of a lonely man for the woman he loves.

How would he care for her, love her?

On the third night I lay down with a splitting headache; I still hadn't had a single idea. But then, that night, it came to me:

> Your body.
> I will care for it, love it
> As a soldier maimed in the war
> Useless, unloved
> Cares for
> His sole surviving leg.

Half awake, I leapt from my bed. With a spent match, I wrote on the lid of a cigarette packet, 'sole surviving leg', and fell asleep. The next morning I had to spend a couple of hours puzzling out why 'sole surviving leg' was written on the packet, and how on earth it had got there.

A rhyme that you're stalking, but haven't quite managed to grab by the tail, makes your life hardly worth living.

You talk without knowing what you're saying, you eat without knowing what you're eating; and you lie awake at night practically able to see that rhyme before your very eyes.

Shengeli's manual [*How to Write Articles, Verses and Stories*],[5] which has everything off pat, has made people see poetic work as something easy and undemanding. And some of his pupils have gone even further than their master. For instance, take this ad from the Kharkov newspaper *The Proletarian* (no. 256):[6]

HOW TO BE A WRITER.

SEND SAE WITH 50 COPECKS IN STAMPS TO THE

FOLLOWING ADDRESS:

PO BOX 11, SLAVYANSK RAILWAY STATION, DONETSK LINE

Wonderful, isn't it?

As a matter of fact, all this started well before the Revolution. *Leisure* magazine[7] used to offer a booklet by post: *How to be a Poet in Five Easy Lessons*.

But I think even the few examples I've given here should have been enough to make it clear that, on the contrary, poetry is one of the hardest jobs of work there is.

Translated by Catriona Kelly

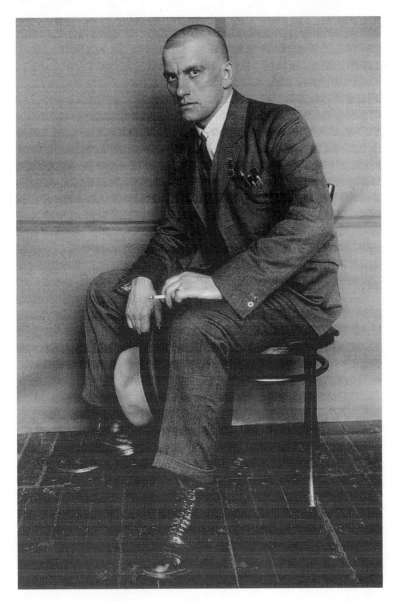

6. Icon of left arts: Aleksandr Rodchenko's portrait of Mayakovsky exploits camera-angle to impart a sense of the poet's dominating yet vulnerable personality.

In the early 1920s Eisenstein's interests in montage had been to a high degree driven by ideological considerations. In his article 'The Montage of Film Attractions' he had seen the juxtaposition of contrasting or similar images as a method of pointing up the political message in a given film. During the 1930s his views of montage's potential evolved; he began to emphasize the contribution made by it to the artistic value of the film, and to draw analogies between the composition of film texts and the composition of texts from other artistic modes, especially literature. Here, he applies his polymathic erudition to a discussion of montage in film and in poetry.

SERGEI EISENSTEIN
[Milton, Mayakovsky and Montage]

From *The Film Sense* (London, Faber & Faber, 1943)

*P*aradise Lost itself is a first-rate school in which to study montage and audio-visual relationships. I shall quote several passages from different parts of it – firstly, because Pushkin in translation can never succeed in giving the English or American reader the direct delight in the peculiarities of his composition obtained by the Russian reader from such passages as those analysed above. This the reader can successfully get from Milton. And secondly, because I doubt whether many of my British or American colleagues are in the habit of dipping often into *Paradise Lost*, although there is much in it that is very instructive for the film-maker.

Milton is particularly fine in battle scenes. Here his personal experience and eyewitness observations are frequently embodied. Hilaire Belloc justly wrote of him:

Everything martial, combining as such things do both sound and multitude, had appealed to Milton since the Civil Wars . . . His imagination seized especially upon the call of its music and the splendour of its colour . . .[1]

And, consequently, he frequently described the heavenly battles with such strongly earthly detail that he was often the subject of serious attacks and reproaches.

Studying the pages of his poem, and in each individual case analysing the determining qualities and expressive effects of each example, we become extraordinarily enriched in experience of the audio-visual distribution of images in his sound montage.

But here are the images themselves:

(The Approach of the 'Host of Satan')
> ... at last
> *Farr in th' Horizon to the North appeer'd*
> *From skirt to skirt a fierie Region, stretcht*
> *In battailous aspect, and neerer view*
> *Bristl'd with upright beams innumerable*
> *Of rigid Spears and Helmets throng'd, and Shields*
> *Various, with boastful Argument portraid,*
> *The Banded Powers of Satan hasting on*
> *With furious expedition ...*[2]

Note the cinematographic instruction in the third full line to *change the camera set-up*: 'neerer view'!

(The Corresponding Movement of the 'Heavenly Hosts')
> ... *that proud honour claim'd*
> *Azazel as his right, a Cherube tall:*
> *Who forthwith from the glittering Staff unfurl'd*
> *Th' Imperial Ensign, which full high advanc't*
> *Shon like a Meteor streaming to the Wind,*
> *With Gemms and Golden lustre rich imblaz'd,*
> *Seraphic arms and Trophies: all the while*
> *Sonorous mettal blowing Martial sounds:*
> *At which the universal Host upsent*
> *A shout that tore Hells Concave, and beyond*
> *Frighted the Reign of Chaos and old Night.*
> *All in a moment through the gloom were seen*
> *Ten thousand Banners rise into the Air*
> *With Orient Colours waving: with them rose*
> *A Forrest huge of Spears: and thronging Helms*
> *Appear'd, and serried Shields in thick array*
> *Of depth immeasurable: Anon they move*
> *In perfect Phalanx to the Dorian mood*

> *Of Flutes and soft Recorders; such as rais'd*
> *To hight of noblest temper Hero's old*
> *Arming to Battel . . .*[3]

And here is a section from the battle itself. I will give it in the same two types of transcription as I did the passage from Pushkin's *Poltava*. First, *as broken by Milton into lines*, and then arranged in accordance with the various compositional set-ups, as a shooting-script, where each number will indicate a new montage-piece, or shot.

First transcription:

> . . . in strength each armed hand
> I. A Legion, led in fight, yet Leader seemd
> II. Each Warrior single as in Chief, expert
> III. When to advance, or stand, or turn the sway
> IV. Of Battel, open when, and when to close
> V. The ridges of grim Warr; no thought of flight,
> VI. None of retreat, no unbecoming deed
> VII. That argu'd fear; each on himself reli'd,
> VIII. As onely in his arm the moment lay
> IX. Of victorie; deeds of eternal fame
> X. Were don, but infinite: for wide was spred
> XI. That Warr and various; somtimes on firm ground
> XII. A standing fight, then soaring on main wing
> XIII. Tormented all the Air; all Air seemd then
> XIV. Conflicting Fire: long time in eeven scale
> XV. The Battel hung . . .[4]

Second transcription:

> 1. led in fight, yet Leader seemd each Warrior single as in Chief,
> 2. expert when to advance,
> 3. or stand,
> 4. or turn the sway of Battel,
> 5. open when,
> 6. and when to close the ridges of grim Warr;
> 7. no thought of flight,
> 8. none of retreat, no unbecoming deed that argu'd fear;
> 9. each on himself reli'd, as onely in his arm the moment lay of victorie;

10. deeds of eternal fame were don, but infinite:
11. for wide was spred that Warr and various;
12. somtimes on firm ground a standing fight,
13. then soaring on main wing tormented all the Air;
14. all Air seemd then conflicting Fire:
15. long time in eeven scale the Battel hung . . .

As in the Pushkin quotation, here also there proves to be an identical number of lines and shots. Again as in Pushkin there is built up here a contrapuntal design of non-coincidences between the limits of the representations and the limits of the rhythmical articulations.

One is moved to exclaim, in the words of Milton himself – from another part of the poem:

> . . . *mazes intricate,*
> *Eccentric, intervolv'd yet regular*
> *Then most, when most irregular they seem . . .*[5]

[. . .] The formal outline of a poem usually observes the form of stanzas internally distributed according to metrical articulation – in lines. But poetry also provides us with another outline, which has a powerful advocate in Mayakovsky. In his 'chopped line' the articulation is carried through not to accord with the limits of the line, but with the limits of the 'shot'.

Mayakovsky does not work in lines:

> *Emptiness. Wing aloft,*
> *Into the stars carving your way.*

He works in shots:

> *Emptiness.*
> *Wing aloft,*
> *Into the stars carving your way.*[6]

Here Mayakovsky cuts his line just as an experienced film editor would in constructing a typical sequence of 'impact' (the *stars* – and Esenin). First – the one. Then – the other. Followed by the impact of one against the other.

1. *Emptiness* (if we were to film this 'shot', we should take the stars so as to emphasize the void, yet at the same time making their presence felt).
2. *Wing aloft.*
3. And only in the *third* shot do we plainly portray the contents of the first and second shots in the circumstances of impact.

As we can see, and as could be multiplied by other instances, Mayakovsky's creation is exceedingly graphic in this respect of montage. In general, however, in this direction it is more exciting to turn back to the classics, because they belong to a period when 'montage' in this sense was not dreamt of. Mayakovsky, after all, belongs to that period in which montage thinking and montage principles had become widely current in all the border-arts of literature: in the theatre, in the film, in photomontage, and so on. Consequently, examples of realistic montage writing taken from the treasury of our classic inheritance, where interactions of this nature with bordering spheres (for example, with the film), were either less, or else entirely non-, existent, are the more pointed and more interesting and, perhaps, the most instructive.

However, whether in picture, in sound or in picture-sound combinations, whether in the creation of an image, a situation, or in the 'magical' incarnation before our eyes of the images of the *dramatis personae* – whether in Milton or in Mayakovsky – everywhere we find similarly present this same method of montage.

<div align="right">Translated by Jay Leyda</div>

*After the rather solemn accounts of the purpose of art produced by some
of his contemporaries, it is something of a relief to read this irreverent
sketch of a writer's search for inspiration by Konstantin Vaginov, whose
inventive novels delineate the lives of Leningrad eccentrics in the 1920s
(the characters in* Harpogoniad *include a collector who specializes
in human detritus, such as toenail clippings). Vaginov is sometimes
described as a surrealist, but might equally well be called a pioneer of
post-modernism: his tales have striking affinities with those of Georges
Pérec.*

KONSTANTIN VAGINOV
[Svistonov Writing]

From *The Days and Labours of Svistonov* (Leningrad, 1929)

Svistonov was dreaming:

A man was hurrying along a street. Svistonov recognized himself. The
walls of the houses were semi-transparent, some houses were missing,
others were in ruins; behind the transparent walls sat peaceable folk.
Over there, they were still drinking at the oil-clothed table, and the
head of the family, a home worker, had pushed his chair back and was
plucking a guitar while regarding his elongated face in the samovar.
The children, kneeling on their chairs, head on fist, gazed by the hour
at the lamp, the stove, the angle of the floor. This was their relaxation
after the working day.

Behind another transparent wall, a clerk had given his face an Ameri-
can expression and was puffing a pipe, watching the smoke rise for
hours on end, or a drowsy fly crawling along the sill, or, in the window
opposite across the yard, a man devouring a newspaper searching for
some exciting murder.

Across the street, all the widows had got together to gossip about the
intimate details of their interrupted married lives.

Svistonov saw himself, now in the daytime, chasing after them all like
some fabulous wildfowl; stooping into a cellar like a hunter in a wolf's
lair to see if anybody was there or sitting in the garden chatting to the
newspaper-reader, or stopping a child on the street, giving him sweets,

and questioning him about his parents, or quietly slipping into a haber-
dashery shop to have a look round and talk of politics with the proprietor.
Or pretending to be a compassionate man, giving ten copecks to a
beggar and delighting in hearing his lying patter, or making himself out
to be a graphologist, doing the rounds of all the town notables.

In the morning, as he glanced at his watch, Svistonov completely
forgot it all. Trying not to wake his wife, he sat down to his editing half
dressed. He corrected and amended this and that, then hurried off to
the writer's club. The company was already gathered in their hats and
caps, trading gossip and the latest happenings. The editress, plump and
florid, was smoking at her weatherbeaten desk, sighing intermittently
and glancing aside as she read the manuscript. The various conversations,
high-spirited as they were at times, intrigued her but the footsteps and
fits of laughter hindered her from working. Svistonov greeted the editress
and those present. She proffered a hand and immersed herself in her
reading.

The writers sat on talking for around four hours, waiting for someone
to turn up, or waiting for the first person to rise. Having sat, like the
rest, and enjoyed the conversation like the rest, Svistonov disappeared
into the lift and found himself on 25 October Prospect. It was quite
late by now, and the writers and journalists were sauntering from the
publishers' to printing house and back again. Warmed by the spring
sun, they talked of how Kruglov wrote like Chesterton, how nice it
would be to go to the Crimea, that they ought to press for such and
such a book to come out annually. They went down into the Moscow
Stock Exchange, ate a meat pie, read the evening *Red Gazette*, looking
to see if they were mentioned in the news items, bought the Moscow
magazines and checked whether there was anything about them in the
gossip columns. When they found anything, they laughed. What rubbish
they wrote! Now and again some trainee reporter would ring up and
ask them what they were working on. Then the writers lied.

It was no easy business, sitting four hours in the editorial office –
might be five even. By five o'clock the writers had splitting headaches.
After arriving home and having dinner, they would lie down for an hour
or so, worn out. Towards evening, persuaded that the day was over and
they could work no more, they would go with their wives round to
friends for a cup of tea.

That night, when Svistonov had gone to bed, he thought about what
he might read: about ancient Russian utensils, perhaps, which might

come in handy for his new story, or why not take Guillaume de Rub-rouck's journey into Eastern lands in the year of grace 1253,[1] that chapter about the Tartar sorcerers and prophets pouring fresh koumiss into the ground. Or a volume of Bibelot's *Collection de l'histoire*.

But Svistonov couldn't be bothered to don his beaver-skin slippers, sewn for him during the time of the famine and all-round shortages. He didn't slide out from under the blanket, or get up on a chair, or swiftly pick out a book. Instead of that, he turned to his wife and began talking to her about the news he had heard in the editorial office.

'Lenochka,' said he, lighting a cigarette.

Lenochka let Panaeva's *Memoirs*[2] slip on to the blanket, before propping herself up on one elbow to gaze at her husband.

'Count Ekespar,' Svistonov drawled listlessly, 'used to call his gypsy lover Dulcinea. He divided his domains into satrapies and placed a satrap in charge of each satrapy. He used to issue his soldiers with the Genghis Khan ration – three sheep a month, and two sheep to the officers.'

'Really?' inquired Lenochka.

'He dreamt of forming a pan-Mongolian empire with German as the official state language and sending the hordes of various colours westward.'

'That's the sort of subject you should use yourself. An interesting novella would come out of it.'

'I haven't told you yet,' Svistonov was warming to his theme, 'that he proclaimed himself the Buddha, entered into correspondence with Chinese generals, and even found a pretender to the imperial throne, some anglicized Chinese prince living in America, who blushed if anyone called him a Chinaman.'

Svistonov stretched himself out under the blanket as he smoked, gazing at the ceiling, then turned over and started gazing at the wall.

'Ah, yes, what a pity I was never in Mongolia, Lenochka,' he said. 'Monasteries are the breath of life in this country. According to German fairy-tales, breath can't be created. Wonder if I should join Kozlov's expedition, get assigned by the evening *Red*.' He had already closed his eyes and was dropping off, when a thought related to hunting and hunters struck his mind at a tangent.

He felt moved to write. He picked up a book and started reading. Svistonov did not work methodically, no sudden vision of the world appeared before him, all did not become utterly clear, and it was not

then that he wrote it all down. On the contrary, all his things derived from messy notes in the margins of books, plagiarized comparisons, from skilfully copied pages, from overheard conversations and reworked gossip.

Svistonov lay in bed reading, i.e. writing, since for him it was one and the same thing. He marked out a paragraph in red, and in black imported it into his own manuscript, suitably refashioned. He never bothered about the sense of the whole, or how it fitted together. Coherence and meaning would come later.

Svistonov **read**:	Svistonov **wrote**:
In the wine-producing valley of the River Alazani, set among numerous vineyards, stands the capital of Telav, the former capital of the Kakhetian kingdom.	Chavchavadze was sitting in a Kakhetian cellar, singing songs of the wine-producing valley of the River Alazani, of the city of Telav, former capital of the Kakhetian kingdom. Chavchavadze was no fool and loved his homeland. His grandfather had been a cavalry captain in the Russian service. But no, no, he had to get back to his own people. Chavchavadze regarded with loathing the merchant sitting beside him, singing a Shamil song and playing the guitar. 'Money-grubber,' muttered Chavchavadze, 'base lackey.' The trader gave him a doleful look. 'No need for that,' he said, 'I'm a good man.'

After writing this fragment, Svistonov put the paper aside. 'Chavchavadze,' he repeated. 'Prince Chavchavadze. What on earth does the engineer Chavchavadze think of Moscow? All right,' he decided, and carried on reading about the death of King Irakli and the grief of his wife Daria.

The wives of the dignitaries sat on low divans, swathed from head to foot in long white veils, beating their breast and loudly mourning the passing of the king. Opposite the women, on the right hand of the throne, were disposed the state functionaries, in order of seniority, silent and with sorrowful faces. The senior ministers sat higher than all the rest, behind them the masters of ceremonies with their rods of office broken. Through the window of the room could be seen the king's favourite horse, standing at the palace gates, with its saddle on inside-out. Near the steed an official was sitting on the ground, his head bare.

'MAGNIFICENT,' thought Svistonov. 'Chavchavadze is the Georgian ambassador at the court of Paul I, Count Ekespar is a descendant of the Teutonic knights. Maybe not the Teutonic . . . Have to check that.'

Far vistas of the future work revealed themselves to Svistonov. 'A Pole,' he thought. 'There needs to be a Pole as well. And I'll have to invent an illegitimate son, one of the Bonapartes, commanding a Russian regiment in the eighties.'

<div align="right">Translated by Alan Myers</div>

3
Altercations and Provocations

Russian culture of the early twentieth century is in some ways intriguingly similar to Irish culture of the same day. This is not only because the 'Celtic Twilight' of the one was matched by the 'Slavonic Twilight' of the other, which glimmers, for instance, in the paintings of Mikhail Nesterov or Nicolas Roerich, or in the paintings and sculptures of Vrubel', or in Aleksandr Blok's cycle of lyric poems The Battle of Kulikovo *(1907). It is also because beneath the mists of theosophy and anthroposophy lay the sturdy granite of invective, a rich vein of denunciation and accusation stretching back through Archpriest Avvakum (who announced his intention to 'wipe his arse' with a decree of Tsar Aleksei Mikhailovich) to pre-Christian Russia, and abundantly preserved in Russian, as in Irish, folklore and popular culture.*

In Russia, as in Ireland, the leakage of invective into the literary language was aided by the populism of many younger intellectuals. Imagining themselves social outsiders (beggars, holy fools and hooligans), writers spoke in language that was as abject as the filthy rags that they adopted as costumes in their fictions. As early as 1909, as Sasha Chorny's parody 'An Ass in the Latest Style' makes clear, such masks had been adopted by dozens of unintelligent and untalented versifiers, but they remained popular for many years more, and are sometimes still affected in the late twentieth century.

Invective flourished not only in creative writing but in commentary on the arts. Literary disputants writing in the periodical press also often conducted themselves in the manner of gutter brawls, though, as the criticism of Sofiya Parnok, Nikolai Gumilyov or Zinaida Gippius also indicates, some preferred to dispatch their victims with poison in silver goblets rather than with flick-knives or axes.

As the juxtaposition in the title of a film made by Mayakovsky in 1916, The Young Lady and the Hooligan, *suggested, the purpose of*

invective was often to shock the bourgeoisie, the new rich of the 1890s and 1900s who had made their fortunes through the wealth brought by industry, a bourgeoisie that was also assiduously mocked for its supposed indifference to, hostility towards, or at best bumbling, if well-meaning, appreciation of art. The fact that it was new bourgeois, such as the Shchukins and the Morozovs, Moscow factory-owners, who were among the most prominent supporters of innovation in the visual arts, left artists and writers unmoved; they preferred to poke fun at the 'pharmacists' attending the Stray Dog Cabaret in St Petersburg, who were overcharged for their champagne so that the painters and poets at whom they came to goggle could drink at a subsidized rate. Fear of poshlost (banality and vulgarity) became something of a banality itself, and an unpleasant undertone of anti-Semitism is not absent from some of the criticism of financiers. The rather short-sighted endorsement of Bolshevism on the part of some Russian intellectuals, such as Blok or Mandelstam, is in part attributable to the fact that this stern new ideology promised to sweep commercialism away.

However, attacks on poshlost stemmed not simply from the association of ethical and aesthetic values, but also from a dislike for what was facile, shallow and twee. And this could prompt a covert admiration for more earthy and energetic forms of vulgarity. Tsvetaeva's sarcastic eulogy 'In Praise of the Rich', or Sologub's portrait of the ghastly social climber Peredonov in A Low-Grade Demon, betray a sort of reluctant admiration for the vitality of the monsters they expose. There is often a sense too of language in love with itself, which meant that the excoriations remain, in a fundamental sense, playful. None of the reviews included here destroyed the reputations of those who were assaulted (Parnok's 'noted names' remain so today, despite her doubts, and even Gumilyov's acid comments on D. S. Mirsky helped the latter find his real vocation, as a critic rather than as a poet). Abusive tirades might pretend to outraged spontaneity, but in actuality they were well-meditated perorations of mock indignation. This is not the routine blackening of his opponents indulged in by Lenin, where terms like 'blockhead' or 'scoundrel' are used to circumvent the need for intellectual engagement, and where vulgarisms rain down like hammer blows. Despite their tiffs, the writers and painters represented here held to an all-embracing camaraderie out of fear of 'pharmacists': Ilya Repin, the realist painter who acted as a scourge of younger and more adventurous painters, mixed amicably with the painters that he had castigated, joining them

at parties in the resort of Kuokkala, where he and the critic Kornei Chukovsky occupied next-door dachas.

After the Bolshevik Revolution in 1917, and especially after 1925, as cultural institutions began to be centralized, and the scramble for precedence in the new order began, the meaning of verbal assault became quite different. Even artists who attacked their fellows with honest intentions were likely to find themselves playing into the hands of apparatchiks and censors. A typical case was Mandelstam's description of Akhmatova as 'playing Saint Simeon Stylites on a piece of parquet', an all too effective articulation of the belief of many Bolshevik cultural commentators that Akhmatova was no more than a superannuated salon poet from whose sentimental and pious outpourings the Soviet reader should be spared. Gradually, criticism was drawn entirely into the service of Party agendas, with hostile reviews merely one of many forms of public denunciation, taking their tone from Pravda *leading articles and caricatures. Both the absence of humour and verbal inventiveness in many post-Revolutionary* ad hominem *attacks, and the appalling consequences that they signalled for their victims, preclude their inclusion in the light-hearted selection of literary and non-literary tiffs and exchanges of banter that follows. Instead, the selection concludes with Mandelstam's playful dismissal of literary Moscow, Mayakovsky's mock ode to Revolutionary hack poets too numerous and undistinguished to deserve naming, and Kharms's funny yet sinister playlet from* Incidents, *showing intellectuals confronted by indignant proletarians. In these three texts some continuity with pre-Revolutionary traditions can still be felt, for all that Kharms's playlet, at least, symbolically suggests that vehement expressions of disaffection, especially in the name of 'the Soviet People', could now spell catastrophe for their victims.*

*Zinaida Gippius, who wrote her reviews under the masculine pseudonym
'Antony Extreme' ('Anton Krainy'), was not only a talented poet and
fiction writer, but also one of the most widely feared critics of the Russian
modernist era. In the following review she excoriates the work of Gorky,
the leading contemporary exponent of politically engaged realist fiction,
as technically inept and ideologically crude.*

ZINAIDA GIPPIUS
'Choosing a Sack'

From *Literary Diary 1899–1907* (St Petersburg, 1908)

I

What am I to do? Literature, journalism, writers themselves
– we've all been split in two, and the separate halves tied up in two
sacks. On one is written 'Conservatives' and on the other 'Liberals'. A
journalist has only to open his mouth and he'll immediately find himself
bundled up in one sack or the other. Of course, there are also some
people who push their own way inside a sack and feel right at home
there. But if you hesitate, you get a shove from behind in any case. The
decadents are being left in peace for the time being, since everyone
thinks they're harmless – the rules weren't made for them. Let them
squabble among themselves about their own affairs; the main thing is
they shouldn't 'threaten morality'. But a journalist (and this does apply
particularly to journalists), a journalist who dares to talk of matters in
the public eye is never left to wander around in freedom: into the sack
with him!

There are some burning questions, some names, about which it is
quite impossible to voice one's own ideas. No one would listen to them:
they would simply wait to hear whether you were 'for' or 'against'. If
you're 'against', you go in the one sack, if you're 'for', you go in another,
and there you're supposed to sit, and don't you dare moan the company
doesn't suit you. You've brought it on yourself.

So what am I to do? I don't want to get put in a sack, and at the same
time I want to touch on one of those subjects that is most likely to
decide my fate. I want to take one of the 'sacred names' in vain: I want

to talk about Gorky. It might seem that no one is really all that interested in Gorky any more; it might seem that if I praise him and his acolytes, I won't inspire real indignation in anyone, and if I attack him, I won't tread on anyone's toes either. If Gorky ever was in full bloom as a writer and artist, he's certainly faded and forgotten now. No one notices what he does, no one even watches much. But Gorky is a 'social phenomenon'; among other things, he is one of the touchstones for the 'honesty' of a littérateur or other social activist's convictions. If I don't speak up for Gorky, it means that I approve of censorship, harassment of Jews, bureaucratic power, bribe-taking, public floggings – and so on, right up to serf ownership. And I'll find myself in a sack straight away, along with the editorial board of the *Russian Herald*, Gringmut and Prince Meshchersky,[1] no matter how much they and I object to an intimacy we all find equally uncongenial. But if I do speak up for Gorky & Co., I'll end up stuck with Batyushkov and the *Wide World*[2] set, the whole yellow-greyish run of *Education* magazine,[3] all the 'honest' workers known and unknown, because in acknowledging that 'a man is something to be proud of' I 'proudly walk the way of progress', and so on. Let Batyushkov shrink from me if he wants: we'll still end up stuck there together, in the one sack. [. . .]

So what am I to do about Gorky? I hate the idea of sitting in a sack along with Meshchersky, Menshchikov, with the Mr Oldthoughts[4] of *The Russian Herald*; I hate it even more than the idea of being under the yellow wing of *Education* magazine. But, all the same, for the sake of the few people who'll hold their tongues, and who might read this piece to the end, and who might even secretly think the same as I do – I'll plunge on with defining what I see as Maksim Gorky's importance as a 'social phenomenon', the importance of his followers and of his whole 'school'.

II

Hardly anyone talks now about Gorky's literary works. As I have already mentioned, Gorky the writer was long ago replaced for us by Gorky the activist. Having had any sense of literary perspective burned out of them long ago by the fire of their social passions, our critics and readers have got used to pairing him off: Gorky and Tolstoy, Gorky and Chekhov, Gorky and Goethe. They don't say 'Gorky and Dostoevsky' quite so

often, perhaps because people are less confident that Dostoevsky is good enough to measure up to the comparison. Of course, all this hardly matters. Tolstoy still has his Anna Karenina, and Gorky his Foma Gordeev,[5] and at the same time he hasn't stopped being Maksim Gorky, that extraordinarily interesting and significant figure of our age.

I need say only a few words about Gorky's writing; every detached, rational and cultivated reader will agree with them. It goes without saying that he is a writer of considerable abilities, even a writer of talent; but his language is careless, monotonous; highly expressive maybe – but always in the same way. Maksim Gorky has little feeling for nature, and even what he has is crude. He makes up words as he goes along and isn't bothered by making mistakes: he's quite capable of having his heroes pick apples and listen to nightingales on the same day. His romanticism and his lyricism are banal, they have a childlike clumsiness, they are even a little ridiculous; his 'old women Izergils'[6] are all the rage with schoolboys and first-year students at provincial universities. Gorky doesn't have any 'types' in his work. His characters don't have any characters. They're all either Chelkashes, or Foma Gordeevs, or Ilyas: they're Chelkasho–Fomo–Ilya, alias 'Orlov the husband'.[7] Here and there a striking turn of phrase, an interesting plot idea, shows that Gorky doesn't wholly lack observational skills. But he is incapable of artistic development; his latest stories are much the same as the earlier ones, or if anything a bit worse. And the monotony of the life he describes and the similarity of the language he uses strip Gorky's talent, undoubted, though mediocre, as it is, of consistent artistic interest.

1907

Translated by Catriona Kelly

Ardalion Peredonov, the anti-hero of Sologub's novel The Low-grade
Demon *(alternatively known in English as* The Petty Demon)*, is one
of the most memorably unpleasant characters in Russian literature.
Peredonov (whose name might be roughly rendered into English as
'Peregrine Dredgeworthy') is a squalid and self-serving petty tyrant
whose nearest ancestors are minor characters in Dostoevsky, such as
Rakitin in* The Brothers Karamazov. *The novel opens as Peredonov is
trying to claw his way from provincial teacher to school inspector with the
assistance of his aristocratic patron, who has, however, inconveniently
insisted that he marry his long-term mistress Varvara Maloshina (Bar-
bara Little) before she helps him to his new position. Peredonov goes to
inform Varvara of the news . . .*

FYODOR SOLOGUB
[Jam Turnovers and a Slanging Match]

From A *Low-grade Demon* (St Petersburg, 1907)

Varvara Maloshina, Peredonov's lady friend, was expecting him,
as carefully powdered and rouged as she was sloppily dressed.

Jam turnovers, Peredonov's favourite, had been baked for lunch.
Varvara rushed round the kitchen, legs overflowing from her high-heeled
shoes, hurrying to get everything done before he arrived. She was afraid
that her maid, pock-marked, fat Natalya, might filch a turnover (and
maybe not just a turnover), and so she stayed in the kitchen, keeping
an eye out. On her face, which still retained traces of its former attractive-
ness under the wrinkles, was fixed an unwavering expression of peevish
rapacity.

As always when he got back home, Peredonov felt cross and out of
sorts. He strode noisily into the dining room, flung his hat on to the
windowsill, and shouted: 'Well, girl, let's be having it!'

Varvara dashed precariously in from the kitchen with the food. Her
shoes nipped her feet – she was too vain to buy the right size. She
waited on Peredonov herself while he lunched. When she handed him
his coffee, Peredonov bent his nose towards the cup and took a great
sniff. Varvara said anxiously: 'What on earth are you doing, dear?[1] Does
the coffee smell funny?'

Peredonov looked morosely at her and said: 'Got to sniff it, you know. Suppose it's poisoned?'

'What on earth, dear?' Varvara was all consternation. 'Whatever put that into your head?'

'Given me a good dose of hemlock, have you, eh?' he snarled.

'But why should I try to poison you?' Varvara retorted. 'Come on, stop acting like something out of a Punch and Judy show.'

Peredonov went on sniffing for a good while more, though. Finally he calmed down and said: 'If it was poisoned, then there'd be a nasty stink. But you need to stick your nose right in the steam to check.'

He paused for a few moments, then suddenly said sourly: 'That princess!'

'What about the princess? What is it?' Varvara asked in a worried tone.

'Tell you what,' said Peredonov, 'she can get that job fixed up for me first, and then I'll get married. Go on, you write to her and tell her that.'

'But hang on a minute,' Varvara objected, 'the princess said she'd fix you up once I was married. So it's a bit awkward for me to write, isn't it?'

'Then tell her we already did tie the knot,' said Peredonov instantly, delighted with his own quick thinking.

This threw Varvara off her stride, but not for long. 'Why tell fibs?' she asked. 'It'll be easy enough for her to find out we didn't get married after all if she tries. No, it's high time you named the day: I've got to get on with getting my dress made.'

'What dress would that be?' asked Peredonov morosely.

'Well, I can hardly go down the aisle in this apron, can I?' snapped Varvara. 'Give me some cash, will you, Ardalion: I need it for the dress.'

'Wouldn't a shroud be more the thing at your time of life?' asked Peredonov spitefully.

'You're a swine, Ardalion!' Varvara yelled.

Suddenly Peredonov decided it was time he really wound Varvara up. He asked: 'Know where I was just now, Varvara?'

'Well, where?' she asked anxiously.

'At Vershina's,' he said, then guffawed loudly.

'You certainly keep some nice company! What d'you expect me to say, eh?' she shouted angrily.

'I saw Martha there,' Peredonov went on.

'What, that little frog-faced freckly-speckly thing?' asked Varvara,

beginning to lose her temper for good and all. 'It's not a mouth she's got on her: it's a pillar-box slit!'

'Well, she's a deal prettier than you, any rate,' said Peredonov. 'If I feel like it, I'll marry her instead.'

'Just you try,' yelled Varvara, by now scarlet and shaking with rage. 'Just you try, and I'll burn her eyes out with vitriol.'

'I couldn't give a fig for what you think,' said Peredonov calmly. 'In fact, I'll spit on you if I feel like it.'

'You'd never dare spit on me!' shouted Varvara.

'Oh, so I wouldn't, eh?' asked Peredonov.

He rose to his feet and, adopting a dull-witted, devil-may-care expression, spat directly into her face.

'You pig!' said Varvara – but fairly calmly, as though the spit had taken the heat out of her. She began rubbing at her face with a napkin.

Peredonov sat in silence. Recently, he'd been treating Varvara more roughly than usual. Not that he'd exactly behaved too well to her before that, mind you. Made bolder by his silence, she said more loudly: 'You really are a pig. Got me right full in the gob.'

From the hall came the sound of a bleating voice, as though a talking sheep had just arrived.

'Keep your voice down,' said Peredonov, 'it's visitors.'

Translated by Catriona Kelly

Light verse is not as well developed a tradition in the Russian-speaking world as in the Anglophone one, but Sasha Chorny (who might approximately be described as the Russian Ogden Nash) was a genius of the comic poem, biliously chronicling the absurdities of Russian suburbia, but also parodying the pretensions of modernist fashion. In 'An Ass in the Latest Style' he mocks stilizovannost', a term that implies not only the pastiching of a given style, but also affectation. The poem is spoken in the voice of a Russian poète maudit, or writer as urban roué, who concocts an absurd salad of clichés, from prostitution to circus gymnastics, in his laughable attempt to shock the reader.

SASHA CHORNY
'An Ass in the Latest Style (Aria for Abraded Voices)'

Struzhki almanac (St Petersburg, 1909)

My head's a burnt-out lantern with the panes in it all shattered,
Open at all four corners so the winds come swirling in:
At nights I hang around with females booze has battered,
Mornings I get the doctors to treat my itchy skin,
Rin-tin-tin!

In fact, I am a pustule on poetry's posterior,
And may the thunder smash me to four hundred tiny bits!
I'll tear off all my clothes and then you'll get to hear of me:
Or else I'll dress in rags, go begging on the streets.

Bananas, and those rhymes that just turn up are what I relish:
I feel like a gorilla: I have nerves as tough as steel.
So let the fogies pout and sulk at me: they're jealous.
Why bother when they shout, 'Your poetry is bilge!'

It's lies! I am a pimple on the bottom of Elysium,
A shiny crimson pimple, melodiously pink:
A pimple with a head that burns far whiter than magnesium:
I'm a glamorous, laid-back poser, I'm clapped out with the drink.

O, I'm garrulous and glorious, I'm full of hocus-pocus,
I'll buck and I'll kick out, give my own toes a bite;[1]
If you don't understand me, then you are stupid yokels:
Hell, I'll just spurn the mob. I'll write, I'll write, I'll write . . .

I'll use my legs to write, my nostrils and my belly,
I'll give my tuppenny thoughts the largest possible range:
I'll cook up lots of rhymes, and then I'll mix two eggs in,
And cartwheel through the house, then go out on the game.

Translated by Catriona Kelly

Though A Slap in the Face of Public Taste, *the introduction to a literary almanac with neo-primitivist illustrations issued in Moscow in 1912, was not the first manifesto put out by the Cubo-Futurist group Hylea (that honour falls to* A Fish-trap for Judges, *1909), its memorable title and hyperbolically provocative style have ensured it greater posthumous notoriety than any of the group's other mission-statements. A particular infamy was to be attained by Hylea's allusion to throwing Pushkin 'off the steamship of modernity' (that Tolstoy and Dostoevsky were to endure a similar fate was not nearly so provocative). Indignation was aroused not merely because the Pushkin jubilee in 1897 had elevated the poet to the status of a national symbol, but because the most prominent Russian symbolists, Valery Bryusov and Aleksandr Blok, had maintained personal cults of Pushkin as an artistic authority.*

DAVID BURLYUK, ALEKSEI KRUCHONYKH, VLADIMIR MAYAKOVSKY AND VELIMIR KHLEBNIKOV
'A Slap in the Face of Public Taste'

(Moscow, 1912)

To the Readers of our New First Unexpected.[1]

Only we are the face of our age. The bugle of time rings out in our verbal creations.

The past feels cramped. Academic art and Pushkin are harder to understand than Egyptian hieroglyphs.

Let us throw Pushkin, Dostoevsky, Tolstoy, and so on, and so on, off the steamship of modernity.

No one who fails to forget his first love will ever have a last love.

Who is so trusting and naïve that he would choose Balmont's perfumed depravity as their last love? Does a love like that reflect the masculine soul of today?

And who is so cowardly that he would be scared to tear off the paper armour with which warrior Bryusov has camouflaged his frock coat? Or are the *sunsets of pleasures yet unknown*[2] that decorate it too daunting?

Wash your hands after touching the filthy slime oozed out by the many Leonid Andreevs[3] of this world.

All those Maksim Gorkys, Kuprins, Bloks, Sologubs, Remizovs,

Averchenkos, Chornys, Kuzmins, Bunins, and so on, and so on, pine
for no more than a dacha on a riverbank somewhere.[4] That's the ambition
of every successful tailor too.

From the heights of skyscrapers we look down on their insignificance!
We decree that poets' rights be acknowledged:

1. the right to enrich the volume of vocabulary available by the
invention of new words at will (the Word is innovation);[5]

2. the right to hate pre-existing language;

3. the right to cast off from our proud brows the cheap wreath that
you have made for yourselves, a wreath constructed not from laurels
but from the bristles of scrubbing-brushes;[6]

4. the right to stand proud on the rock of 'We' amidst the ocean of
cat-calls and shouts of 'disgusting!'

Certainly, for the meantime traces of your filthy 'common sense' and
'good taste' remain in our verses, but they throb for all that with the
first lightning-flashes of the New Future Beauty of the Self-Sufficient
(self-created) Word.

<div style="text-align: right">

D. Burlyuk
Aleksandr Kruchonykh
V. Mayakovsky
Viktor Khlebnikov[7]

</div>

Translated by Catriona Kelly

7. Modernist court jester: Boris Grigoriev's exquisite and witty drawing of David Burlyuk captures the essence of the man – jack of all arts, egotist and charlatan.

As a reviewer, Sofiya Parnok could be every bit as tart as Zinaida Gippius, with whom she also shared the use of a masculine pseudonym (in Parnok's case, 'Andrei Polyanin', or 'Andrew Field'). Of Bely's Petersburg, *for example, she memorably if wrongly remarked: 'Prose as bad as this can only have been written by a poet.' In the following review, first published in the literary journal* Northern Notes (Severnye zapiski) *in 1913, Parnok began with a fairly conventional (and, with historical hindsight, unintentionally comical) lamentation for the doldrums in which Russian poetry, she alleged, was now languishing, but then proceeded to spirited and exhilaratingly personal attacks on early work by three fashionable (and later famous) contemporaries: Nikolai Klyuev, whose third collection,* True Stories of the Forest (Lesnye byli), *came out in 1913; Anna Akhmatova, whose first book,* Evening (Vecher), *had appeared in 1912; and the Ego-Futurist Igor Severyanin, who had published a volume with the typically pretentious title* The Thunder-foaming Goblet (Gromokipyashchii kubok) *in 1913.*

SOFIYA PARNOK
From 'Noted Names'

Severnye zapiski, 4 (1913)

We have reached a melancholy page in the history of Russian poetry. The artistic slogans come and go, the one-day wonders appear and disappear again, and critics, those astronomers of the Parnassian night skies, still mark the passage of transparent comets. But an acute eye can see that the poetry of the younger generation has come to a halt, has frozen solid in its pose of frenzied activity. Though it has attained a high level of poetic technique, the new poetry reveals to us the extreme nervous tension and impotence of the individuals who create it. Examples of this new poetry are distinguished by the skilful employment of rhyme, metre, rhythm and style, but we do not find in them that ideal equivalence of object expressed and means of expression that gives a work of art its uniquely truthful and compulsive rhythm, we do not find in them the spirit of the poet – that fusion of soul and intellect that comprises the uniquely truthful and compulsive style of a work of art. Those who are currently engaged in writing poetry have

borrowed from real poets their magnificent language, but they have not appropriated that which cannot be borrowed, that which makes an artistic creation living, breathing and radiant: the flame of genuine feeling and of genuine thought transformed in the crucible of artistic principle.

And hand-in-hand with an artistically unprincipled poetry rushes its co-conspirator, contemporary criticism, at once finicking and undemanding in any deep sense, spying out metrical beauties and blemishes and expressing enthusiasm or indignation over these. A strange, uneasy feeling is aroused in us by these paeans of praise and tirades of condemnation. Can the existence of Pushkin, Goethe and Dante have been forgotten, we wonder? [. . .]

Among the many actors presently glittering on the Russian poetic stage, three in particular have found favour with our critical Olympians and are likely to interest lovers of verse. Poets who have won the attention of Russia's entire reading public – Valery Bryusov, Fyodor Sologub and Mikhail Kuzmin – have welcomed the newcomers by writing prefaces to their collections. Nikolai Klyuev is brilliantly introduced by Bryusov; Anna Akhmatova is brought gallantly before us by Mikhail Kuzmin, as though she were a débutante at her first ball; and Fyodor Sologub announces in a tone of capricious insistence that, yes, he really is determined to like Igor Severyanin's poetry. [. . .]

Having overcome the roughness of versification and degree of rhythmic torpor [that marked his earlier verse, Klyuev] now, in *True Stories of the Forest*, displays a masterly ability in the execution of ideas that are almost always aesthetically refined, if nothing else. But an undesirable aftertaste of aesthetic pretension both of material and of execution is, in our view, highly characteristic of this poet. As we wander the 'savage forest' of Klyuev's poetry, we feel much the same as we do when entering Kuzmin's 'English park'; the stamp of authorial taste has been placed on everything. And unfortunately Nikolai Klyuev's taste, for all its eccentricity in some respects, shows a distinct lack of sophistication; this is why, in our view, the expressive abilities with which he is so richly endowed almost always push him towards 'painterliness'. This 'painterliness' seems most acceptable in his landscape poems, and his depictions of peasant life – that is to say, in the poems where what is being portrayed requires an exact and specific coloration. But even in his strictly lyrical poems, the poet is inclined to place 'splashes of bright colour' on his canvas, to strike a pose. For instance, he begins:

> The joyful communicant of nature,
> I pray to the clouds,

But he cannot keep the 'painterly' details out, adding:

> I am wearing a monk's surplice
> And a novice's skullcap.

Such 'prettification' embarrasses and distresses the reader. After all, Nikolai Klyuev's eye for nature, his sensitivity to its details, is not in question, which makes this tendency to affectation all the more irritating. [. . .]

Anna Akhmatova's verses are as typical of modern poetry as they are of women's writing in general. The poetess's field of vision is not just small: it can only be described as miniature. The private corner that Akhmatova has barricaded off from the world is so egotistically secluded, so crammed with souvenirs and bric-à-brac of all kinds, that a reader feels claustrophobic, ill at ease, and sometimes just plain bored, in the way a visitor might in someone else's over-intimate bedroom. In that claustrophobic space, imprisoned in that tiny personal life, 'rings the frail voice', the morbidly weak voice of a woman who, according to her own confession, 'has turned into a toy', who lives 'like a cuckoo in a clock' that 'comes out and cuckoos when the clock is wound'. In this 'toytown' world, 'riding crops', 'gloves on the wrong hand', 'sashes', 'Sèvres figurines', 'pink cockatoos' and 'hothouse roses' naturally attain a vast size and significance, in this world a week is a stretch of time equivalent to at least a year in ours: we hear of 'many weeks of peace', love lasts for 'whole weeks', and the poetess is genuinely astonished that someone has been pining for her 'three whole weeks'. To be sure, this specificity of perception represents a characteristic particularity of Akhmatova's poetry; but readers for whom a week is merely a unit of time equivalent to seven days are unlikely to find that this poetry detains them for 'many weeks'. Of all the poems included in *Evening*, the most finished from a poetic point of view is the little eight-line piece evoking Pushkin, 'The dusky youth wandered along the avenues'; unfortunately, however, these lines are not typical of Akhmatova's work.

What is frightful about Igor Severyanin's poetry is not his linguistic harshness or the vulgarity of his neologisms (for all that the latter do indicate that this poet has a worrying lack of sensitivity to the spirit of

his native language). These faults can be attributed to the dandified bad manners of callow artistic youth. So what if a room 'mornings' and 'evenings', eyes 'twang', legs 'approximate', so what if 'Mirra Lokhvitskaya's lakeside chateau is all violeted and berosed'? And perhaps Severyanin's revolting 'revereurs' and 'revereuses' really do exist, along with his 'excessories', 'startlelettes' and all those other treasures of Severyaninese? And in time Severyanin may 'slough off his old skin'; his artistic temperament, which is already clear in what we read now, may extract him from the swamp of idiotic experimentation. But what *is* genuinely frightful about Severyanin's work is the attraction towards flat-footed prosaicism that is evident everywhere, in lines such as 'I've got everyone into a right mess', or 'I'm having a fine time here' [. . .] There are countless examples of phrases such as these; even Severyanin's best poems are riddled with them; and they are most indicative. Prosaicism of this kind is not something superficial; it is a disease gnawing at the innards of the creative spirit. If we bear in mind his extreme lack of taste, then it seems more than doubtful whether 'Igor Severyanin the genius' will ever make a real poet.

But let us hope that the poets who have heralded the débuts of Nikolai Klyuev, Anna Akhmatova and Igor Severyanin turn out to be more perceptive than we have shown ourselves to be here, and that we have the 'unhoped-for joy'[1] of eventually being able to concur with Valery Bryusov, Mikhail Kuzmin and Fyodor Sologub.

Translated by Catriona Kelly

Given the acerbity of his criticism (of which this sample is typical), it is perhaps surprising that Nikolai Gumilyov only ever fought one duel (and that over an affair of the heart) and, unlike Aleksei Tolstoy, never had his face slapped in public. No doubt his wretched victims were too ashamed to show themselves in company after his reviews had appeared; certainly, some never published poetry again.

NIKOLAI GUMILYOV
[No-hopers, Amateurs and Those Who Make So Bold]

From 'Letters on Russian Poetry', no. 18, *Apollon*, 4 (1911)

Before me I have twenty books of verse, almost all of them by young or unknown poets (and 'unknown' is putting it mildly). However broadly we understand the luckless word 'literature', four of these still stand outside it. Three are by Modest Druzhinin,[1] who utterly lacks not only a poetic temperament and technical knowledge of how to do creative work, but also an elementary sense of irony. Therefore, he is capable of addressing his beloved with a 'Prayer' such as the following:

> Why hold on to your innocence so tightly,
> And rend yourself with passion, vainly too?
> Pay nature's due, fulfil your obligation,
> And grant that I may have my way with you.

The other one is K. E. Antonov's *Blessed Distances*. This person[2] has simply failed to assimilate how and when to employ 'the words of the Lord'. His ill-rhymed lines seethe with expressions like 'the devotee of dread debauch', 'he thinks a view about himself', etc.

I propose to divide the remaining books into those by amateurs, those by people who make so bold, and those by actual writers.

Let us begin with the amateurs. Not for the life of me could I understand why work of this kind ever sees the light of day, were it not for the fact that the authors themselves have obligingly supplied explanations, in verse or prose. Thus, one of them, duly acknowledging

his inability to write and declining approval in advance, hopes that his verse will have an effect on one of his lady friends. Another tells us that in going into print he is obeying the wishes of his wife, who has since passed away. A third tries to justify himself by claiming to be the first person to think of 'illustrating a musical composition by means of verse' (I can't vouch for how well this notion comes off). And so on. [. . .]

Sergei Alyakrinsky[3] with his *Chains of Fire*, is a modernist. Therefore, when you come across one of his slovenly rhymes he will tell you it's an assonance; if you question him about a line of his that doesn't fit any metrical scheme, however recherché, he will declare that its rhythm is music to his ears; if you say you're puzzled by the expression 'the radiate summons of the day' he'll turn his back on you. There is much here to bewilder the modest reader. But leaf through his book and you will be reassured. He has no conception of what assonance is, he is utterly innocent of rhythmical innovation, his soul has experienced nothing more refined than yours has – he's a typical amateur, except that he's imitating not Nadson[4] but Balmont and Blok. He has extended the most questionable characteristics of these two talents, made their obscure expressions more obscure; hoping to scare you, he bellows where they raised their voices. He himself was sure he wasn't going to be understood – after all, even Bryusov wasn't understood at first. And there always might turn out to be a critic, one not well educated enough to concern himself with anything complicated, who would declare him to be the only genuine poet among all the versifiers bearing their 'vernal tidings' to the world. And then for one whole season he would become the young talent glittering his way around the editorial offices. There have been such cases and there continue to be. I hope, though, that he won't be one of them. There's a terrible want of passion in this freebooting onslaught on Russian literature of his. [. . .]

The impression A. M. Fyodorov[5] makes is that of a poetic eunuch. His high notes keep turning into squeaks, and not just of a womanly kind but precisely of an old-womanly kind; he has a castrated view of the world, which for him is either 'a vale of grief and sadness' or a 'soundless prayer', or it simply falls apart into a series of details not connected by any general development. His assertions that his soul is akin to – of all things – Imatra Falls[6] do not undermine this opinion; on the contrary, they bear it out. The lines where he imitates Bunin,[7] however, sometimes do rise to the level of real literature.

More refined, more novel, but still of the same sort are the *Poems* of

Prince D. Svyatopolk-Mirsky.[8] As one reads them one wonders whether the author really intended to narrow his horizon to this extent, to reject all piquant emotion and stimulating images, and to select only the most inexpressive epithets so that nothing might divert his thought from the smooth succession of finely chiselled and full-sounding stanzas. It's as if he is still afraid to admit to himself that he is a poet; for the time being I have no desire to be more daring than he is. [. . .]

The culminating point of this year's making so bold is of course the collection called *A Trap for Judges*, which is printed on the reverse side of wallpaper, without the letter 'yat' or hard signs,[9] and with some other tricks to boot. Of the five poets whose work appears in it, there are only two who genuinely make so bold – Vasilii Kamensky and V. Khlebnikov. The others are simply hopeless.

Vasilii Kamensky talks about Russian nature. For him it is unencompassable, and so he can only deal with certain details. The relationship of big branches to small ones, the call of a cuckoo in the woods, the play of tiny fish by a dam – these are the themes of his poems, and just as well too, because he does not have to strain his voice, so everything he says comes out naturally. The reader will have no difficulty with anything here, not even his innumerable neologisms, some of which are very daring, and will take away from this cycle of poems an impression of fresh and joyful innovation.

V. Khlebnikov is a visionary. His images are convincing in their absurdity and his ideas in their paradoxicality. One has the impression that he dreams his poems and then writes them down, retaining the complete lack of connections in the sequence of events. In this respect one could compare him with Aleksei Remizov, who also writes down his dreams. But Remizov is a theorist who simplifies his contours and draws a thick black border around his lines so as to emphasize the significance of his 'dream' logic; Khlebnikov retains all the nuances, which is why his lines gain in profundity while losing in literariness. From the dream-world too come his sometimes completely incomprehensible neologisms, his rhymes that seem to be dragged in by the hair, his turns of phrase that offend even the most indulgent taste. But there again, anything can happen in a dream, and everything in a dream is significant and has its own validity.

Marina Tsvetaeva (*Evening Album*) is inwardly talented and inwardly distinctive. No matter that her book is dedicated to 'the bright memory of Maria Bashkirtseva', that its epigraph is taken from Rostand, that the

word 'mama' appears on nearly every page. All this only makes one think of how young this poetess is, something confirmed by her own confessional lines. There is much that is new in this book – the bold (sometimes excessive) intimacy is new; the themes are new, e.g., being in love as a child; the direct, unreflective fondness for the trifles of life is new. All the most important laws of poetry have here been instinctively hit upon, so it seems, with the result that this sweet little book of maidenly confessions is also a book of splendid verse.

Translated by G. S. Smith

The veteran realist painter Ilya Repin belonged, in the 1860s, to the Peredvizhniki, or Wanderers, a group of painters that challenged academic convention and initiated a new, raw manner of painting landscape and genre scenes. However, by the late nineteenth century the formerly radical Wanderers had themselves become pillars of academic painting. In the early twentieth century Repin was notorious for his intemperate attacks on every form of experimentation in art. The review from which the extract below was taken assaulted the Izdebsky Salon, a gallery in Odessa that showed Western and Russian avant-garde art.

ILYA REPIN
[Unbridled Roisterers]

From 'The Izdebsky Salon', *Birzhevye vedomosti*, 20 May 1910

Here we are being confronted with the whole hell of cynical Western mediocrity, of hooligans, unbridled roisterers, who give free rein to their curvets of colour chucked on to the canvas.

I am fully convinced that only a talentless boor or a psychologically sick individual can be a deliberate decadent. In the boor's barbaric soul you can clearly see a frigid eunuch of art; he is on the market for the sake of scandalous success, that's clear.

For the true chosen ones a passionate love of art chains them to their adored subject [. . .] they sacrifice their soul for the attainment of perfection in art.

Art is God's most superb gift to Man, his holy of holies. And here is the Devil creeping into this holy of holies, cynically spitting on the essence of beauty, life, nature. The profundity, poetry and conceptual grandeur of Superior Reason in art are gradually being replaced by the stupidity of shameless clowns.

<div align="right">Translated by Elizabeth Valkenier</div>

The painter, poet and art critic Maksimilian Voloshin was one of the most gifted commentators on the visual arts in early-twentieth-century Russia. In his study On Repin *(O Repine), Voloshin traced the reason for the conflict between Repin and the avant-garde painters to the difference between their approaches to painting: Repin wanted the new art to be seen as 'nothing but smuts', in Voloshin's words, because it invalidated his own. However, Voloshin's own sympathies were more inclined to the moderate modernism of the World of Art painters than to the most experimental tendencies, such as neo-primitivism, as the following rather patronizing comments on the 'Donkey's Tail' exhibition, which included the work of Goncharova, Larionov and others, make clear.*

MAKSIMILIAN VOLOSHIN
'The Donkey's Tail'

Apollon, 7 (1912)

The Kriksy-Variksy galloped into town over the steep hills, broke into the priest's orchard, hacked off the priest's dog's tail, crowded in among the raspberry canes and set fire to the tail, then began playing around with it . . .[1]

Exactly the same thing has happened in real life as in Aleksei Remizov's story about devilment on Saint John's Eve. Larionov and Goncharova are Remizov's 'Kriksy-Variksy', and the 'Knave of Diamonds' is 'the priest's dog', only the tail that gets cut off has been renamed the 'Donkey's Tail' to make it sound grander. The 'raspberry canes' are represented by the new exhibition hall at the School of Art and Sculpture [in Moscow], and it was 'set fire to' on the day the exhibition opened – so thoroughly, in fact, that the fire brigade had to be called out.[2]

It is difficult to determine what kind of aesthetic disagreements prompted the schism between the Knave of Diamonds and the Donkey's Tail groups, since both these two exhibiting societies share what is to all intents and purposes the one 'artistic platform'.[3] All the evidence suggests

that these artistic Kriksy-Variksy cut the tail off their village priest's dog with exactly the same purpose that Remizov's Alcibiades chopped the tail off his: that is, to get everyone talking about the incident.

And in fact everyone was talking about the 'tail', and the exhibition was packed on the day it opened. However, people were disappointed. They had been expecting something even more lurid and shocking; the Donkey's Tail did not live up to its name.

As far as shocking the public goes, the Burlyuks [of the Knave of Diamonds group] are the most adept by far. As David Burlyuk himself boastfully relates, when he first heard about the cubists, he made a dismissive gesture and said: 'So what? No one will ever manage to produce work as radical as my brother's and mine.' And for all the proud statements made by Larionov at the time of the split with Knave of Diamonds to the effect that 'you're just imitating what I do', the public still considers Burlyuk more radical than Larionov. In short: the Muscovites decided that the Donkey's Tail by no means lived up to its name and that the painters in the group were just arrogant.

However, the censorship took the exhibition rather more seriously, and interpreted the symbolism of the Donkey's Tail in quite a different way. Hence the decree that a series of paintings by Goncharova depicting the saints in the manner of a popular *lubok* print should be removed from the exhibition, since it was considered disrespectful to associate representations of the saints with the sign of the Donkey's Tail (or D T). This gave the exhibition its imprimatur as 'iconoclastic'.

But the censors' reaction did the D T organizers too much honour: in actual fact the artistic side of the exhibition was not at all inflammatory or shocking. The impudence of the Donkey's Tail is largely a literary impudence: it is easier to appreciate it when one reads their catalogue than when one sees their paintings.

The material here includes 'The Artistic Possibilities of the Peacock'. (The peacock in Chinese art – the peacock in futurist art, the peacock in Byzantine art, the peacock in Russian popular prints, and so on.) You'll find titles such as 'The Smoker (Done in the Style of a Russian Painted Tray)', 'Boys Bathing (a Mediated Representation)', 'Portrait of Larionov and His Platoon Commander', 'Photographic Study of Snow Melting in Spring', 'Mistress and Maid (from a Trip to Turkey that Never Happened)', 'Woman in a Blue Corset (from a Newspaper Advertisement)', 'Treating Corns in the Bath-house', 'The Hairdresser *en famille*: Portrait of Georgy Chulkov'.[4] And so on . . .

But all these enticing descriptions promise far more than is delivered by the actual paintings.

In reality, what you see is broad-brush handling, in the manner of a study in oils; the work often displays talent, but is painted with studied carelessness; the paintings seem to have happened by accident, but there is also the sense that the painters are laughing at the observers from behind their easels. Another element that the DT painters have in common with each other is their passion for scenes of military encampments and moments from the lives of the common soldiery, and for representations of hairdressers, prostitutes and people who cut out corns in the bath-house.

Their colours are drawn from the subjects that they represent: they portray hairdressers in what look like thick pink lipsticks, hair pomades, brilliantines and hair tonics, soldiers in paint that resembles tar, mud, coarse-grained leather, and so on. This allows them to capture the aroma of what they paint – so much so, indeed, that observers are left feeling disgusted and even nauseous. An observer familiar with artistic life has no difficulty in guessing the provenance of the Donkey's Tail exhibition. This is an exhibition of work by *rapins*. *Rapin* is the [French] word for an apprentice painter who has got through the first stage of naïve enthusiasm for his artistic studies and has reached the stage of a negative reaction against these, which is expressed in criticism and mockery of his teachers (from whom he, however, continues to learn). He therefore paints crude but cheerful parodies and caricatures characterized by cynicism towards appropriate tonalities and by a provocatively ultra-realist style. A *rapin* already has all the technical knowledge that a studio can give him, and has learnt to despise that knowledge. But he is still not an artist, because he has not yet left the studio and has not yet grown out of his jokey, court-fool attitude to life. *Rapinisme* is a well-known and psychologically unavoidable moment in the life of almost every talented artist.

The pictures that we see exhibited at the Donkey's Tail, with their soldiers, hairdressers, people cutting out corns, and so on, could be seen in any of the big Paris academies, and they would be painted in exactly the same expressive manner, using the same techniques. The only difference is that in Paris they would be painted directly on the walls, rather than hung on them.

The very name 'donkey's tail', which the Moscow artists brandish like a battle standard, has been adopted by them in memory of a notorious

prank on the part of some *rapins* from Montmartre, who exhibited a painting at one of the Salons des indépendants that had been executed with a donkey's tail dipped in paint.[5]

That said, the Paris *rapins* do not organize their own exhibitions and so their works of art can only be seen by visitors to the academies. But in Russia this class, or perhaps it would be more accurate to say age-group, of painters is only just acquiring self-consciousness; it is scarcely surprising that they wish to establish their right to exist, and there is nothing harmful in this. If one regards exhibitions such as the Donkey's Tail from this point of view, then everything falls into place and they acquire their proper historical significance. After all, Russia still does not have a single art school of real authority,[6] one in which painters who have not yet reached a full and serious sense of their relationship to the world, painters such as Larionov and Goncharova, might conclude the days of their apprenticeship and work out their frustrations in conflicts with their teachers. Therefore, they work these out as free citizens and turn their *farces d'ateliers* [studio pranks] into exhibitions.

If we bear in mind the significance of the Donkey's Tail at this level, we will find much that is interesting and indicative of talent at the exhibition. Even Goncharova's incredible fecundity as a painter – she exhibited more than *fifty* (!) canvases, all of them fairly large and all apparently painted after she had seen the latest World of Art exhibition – even this becomes comprehensible if seen from the point of view of *rapinisme*. The 'Tails' are not searching for anything and they are not working to a fixed plan – they are experimenting. And every experiment is put on show. To be sure, however, among them are some very successful and expressive pieces, such as Goncharova's 'The Ice-breakers' and 'Thunder', Larionov's 'Sonya the Sutler' and 'Soldiers Bathing', and almost all Viktor Bart's[7] drawings.

Translated by Catriona Kelly

8. Spaghetti made of Leonardo da Vinci: This 1913 caricature from 'A Futurist's Day' by Vladimir Makletsov (born 1884) shows a young tearaway demonstrating his contempt for a great artist of the past. The portrait on the wall is inscribed with the word 'ego', suggesting that the sally is primarily directed against Igor Severyanin and other members of the Ego-Futurist group.

The Eccentrism manifesto of 1922 was in the spirit of pre-Revolutionary
futurist statements such as A Slap in the Face of Public Taste. *However,*
the Eccentrics (the future film directors Kozintsev, Trauberg and Yutkev-
ich, as well as the theatre director Kryzhitsky) laid much greater empha-
sis on mass culture as inspiration for the creation of new, anti-bourgeois
art forms.

SERGEI YUTKEVICH

[We Prefer a Pinkerton Cover to the Concoctions of Picasso]

From Grigory Kozintsev, Georgy Kryzhitsky, Lev Trauberg, Sergei
Yutkevich, *Eccentrism* (Petrograd, 1922)

WE
VALUE ART AS AN INEXHAUSTIBLE
BATTERING-RAM
SHATTERING THE WALLS OF CUSTOM
AND DOGMA.
But we also have our forerunners!
THEY ARE:

The geniuses who created the posters for cinema, circus and variety
theatres, the unknown authors of dust-jackets for adventure stories
about kings, detectives and adventurers; like the clown's grimaces, we
spurn Your High Art as if it were an elasticated trampoline in order to
perfect our own intrepid *salto* of Eccentrism!

The only thing that has escaped the corrupting scalpel of analysis and
intellect is the POSTER. Subject and form are indivisible. What is
there to celebrate in them?

Risk, bravery, violence, chase, revolution, gold, blood, laxative pills,
Charles Chaplin, wrecks on land, sea and in the air, surprise cigars,
operetta prima donnas, adventures of all sorts, skating-rinks, American
boots, horses, struggle, *chansonettes*, a *salto* on a bicycle and thousands
and thousands of events that make our Today beautiful.

ALL THE TWO HUNDRED TOMES OF THE PHILO-
SOPHY OF GERMAN EXPRESSIONISM ARE NOT AS
EXPRESSIVE AS A CIRCUS POSTER!!!
We prefer a Pinkerton cover to the concoctions of Picasso!!!

Translated by Richard Taylor

One of the longest-running arguments in post-Petrine Russian culture concerns the question of which is preferable, St Petersburg or Moscow. Inhabitants of the two cities have been equally vehement in praising their own place of residence and denigrating its rival. In his short essay 'Literary Moscow', most of which appears below, Mandelstam, a true Petersburger, castigates the vulgarity and artificiality of Moscow literature, as well as the city's 'Asiatic' and 'feminine' character, while reluctantly admitting the energy of Russia's older capital, restored to its role as the centre of government four years before his essay was written.

OSIP MANDELSTAM
From 'Literary Moscow'

Rossiya, 3 (1922)

Moscow: Peking. Here we have the triumph of a continent, the spirit of the Middle Kingdom; this is where the heavy cables of railway lines have tangled themselves into a great knot; this is where the Eurasian continent holds its ever recurring name-day feasts.

Anyone who does not feel bored in the Middle Kingdom is a welcome guest in Moscow. Some people like the scent of the ocean; others prefer the scent of the world at large.

Moscow is where cabbies hold tea-drinking symposiums, sitting like Greek philosophers in the taverns; Moscow is where American detective films are projected at night on to the flat roofs of stumpy skyscrapers; Moscow is where you see a respectable young man standing on the boulevard and singing an aria from *Tannhäuser* to earn his daily bread, while the passers-by display no interest at all; Moscow is where an artist of the old school will knock you up a portrait in half an hour, a portrait good enough to take a silver medal at art school; Moscow is where little boys selling cigarettes run round in packs, like the dogs of Constantinople, so they've no need to fear any competition; Moscow is where men from Yaroslavl sell cakes and where visitors from the Caucasus have sat down on the floor to enjoy the cool in a provision shop. Moscow is where no one would ever go to a literary discussion in the summer, unless he was a member of the Writers' Union and had to, and where Dolidze[1] emigrates (spiritually at least) to Azurkety for the

entire summer; after all, he's been planning the trip for twelve years.

Moscow is where, when Mayakovsky held a reading of poets in alphabetical order of author at the Polytechnical Museum,[2] young people in the audience volunteered to read the poems they'd written when the turn of these came round, not wanting Mayakovsky to wear his voice out. That could only happen in Moscow: this is the only place in the entire world where people are ready to fling themselves to the ground at the approach of a mighty voice, lying flat like shields to ease the path of its chariot wheels.

Moscow was where Khlebnikov could lie up like a wild wood creature hidden in its burrow from human eyes, before he finally exchanged the hard beds of Moscow flop-houses for a green grave in Novgorod Province, but Moscow was also where I. A. Aksyonov,[3] writing in the humblest literary almanac imaginable, placed a glorious wreath of analytical criticism upon the grave of the poet, using Einstein's Theory of Relativity to illumine Khlebnikov's archaic world, and tracing the ideals reflected in his poetry to Old Russian culture of the sixteenth and seventeenth centuries, while the ever so erudite *Literary Herald* in Petersburg could only find it in itself to print a mean-minded, snooty note drawing attention to literature's great loss. You can see it better from outside: things have gone wrong with Petersburg: it's forgotten the language of contemporaneity, the language of wild honey.

But the saddest language in Moscow is that of Marina Tsvetaeva, which chimes all too harmoniously with the bogus sonorities of the Petersburg poetess Anna Radlova.[4] The worst thing about literary Moscow is the women's poetry. The last few years have shown us that the only individual of the feminine gender who has been able to enter the closed circle of poetic creativity, and attain the rights of a new muse, is Russian scientific poetics,[5] a figure called into being by Potebnya and Andrei Bely, who found new strength in the Formalist school of Eikhenbaum, Zhirmunsky and Shklovsky. What women poets have made their own is the whole vast domain of parody, and they take their objects equally from among inventions and reminiscences.[6] The average Moscow poetess is handicapped by metaphor; she is a low-class Isis,[7] condemned perpetually to search for the lost lower limbs of a simile, which if found, she fondly assumes, would return to her complete image, or Osiris, its original wholeness and unity.

Adalis[8] and Marina Tsvetaeva are prophetesses, and Sofiya Parnok belongs in this category too. They have turned prophecy into a cottage

industry. At a moment when male poets have dropped their elevated tone, their dreadful vacuous rhetoric, and begun to make use of the resources of their own voices, women's poetry continues to resonate with throbbing descants, offending the reader's ear and his sense of poetic history at one and the same time. The tastelessness and lack of historical veracity in Marina Tsvetaeva's poems about Russia, with their false-folksy and bogus Muscovite phrasing, make these far inferior to the work of Adalis, whose voice at times attains a masculine power and authenticity.

Invention and reminiscence go hand in hand in poetry: to reminisce is to invent, and the poet who reminisces is also an inventor. The fundamental sickness of Moscow poetry is amnesia, forgetfulness for this double truth. Moscow is determined to invent no matter what.

Poetry breathes through its mouth and nose at the same time; in the same way it lives both by reminiscence and invention. Only a fakir can avoid breathing through the one or the other. The thirst for the poetic breath of reminiscence has made itself felt in the way that Moscow received Khodasevich when he visited; though he's been writing poetry for at least twenty-five years (and let's thank God that he has), he was welcomed like a young poet who's only just started publishing. [. . .]

So what's happening in the camp of pure invention? Here, if you discount Kruchonykh (who is a totally insignificant and unimpressive figure, not because he's a leftist and an extremist, but because there's such a thing in the world as utter garbage – and even if Kruchonykh's highly pathetic and tense attitude to poetry makes him interesting, it only makes him interesting as a personality, not as a writer), what's left is Mayakovsky fretting over the simple but enormous problem of 'poetry for all, not just for the chosen few'. A broadening of poetry in the extensive sense, a broadening of the area of its address, of course leads to a decline in its intensity and in the sophistication of its content, to a dilution of poetic culture. Mayakovsky is wonderfully well informed about the richness and complexity of world poetry, but when he founded his school of 'poetry for all', he had to junk everything incomprehensible, which in fact means everything that demands even the smallest amount of preparatory knowledge in the reader. But to address a reader who hasn't the smallest amount of preparatory knowledge of poetry in your work is a painful task: you might as well impale yourself backside-down on a sharp stick. It is likely that a reader of the unprepared kind will understand nothing in any case, unless you remove your poetry so far

from the sphere of culture that it stops being 'poetry' in any case (at which point, such is the oddity of human nature, it really will become accessible to an unlimited number of readers). And the poetry that Mayakovsky writes is extremely cultivated: a sophisticated form of accentual verse, its lines broken in two by the use of heavy antithesis, and which is laden with hyperbolic metaphors and characterized by a repetitive line-break [*pauznik*]. Mayakovsky is wrong to impoverish himself. Any moment now he's going to turn into a poetess; he's halfway there already.

If Mayakovsky's poetry displays our age's striving to universal accessibility, then Aseev's[9] verses express its mania for organization. The brilliant rationalistic expressivity of his language gives his work the militaristic air of a political demonstration.[10] Yet Aseev's machine-age poetry is also identical to the snuff-box poetry of the eighteenth century. A sentimental rationalism and an organizational rationalism are the same thing in the end. A purely rational, machine-constructed, electromechanical, radioactive, in short, technological poetry is impossible for a reason close to the heart of both a poet and a mechanic: a rationalistic, machine-constructed poetry does not build up energy, does not generate energy, as a natural, irrational poetry does: it simply consumes energy. A category is like a factory: you only get out what you put in. A spring cannot generate more energy than its mechanism has been set to generate. That is why Aseev's rationalistic poetry is not rational, why it is sterile and sexless. A machine may live a profound and inspired life, but you'll never get any seed out of it.

The fervour for invention characteristic of poetic Moscow is already dying down: all the patents have already been applied for, and no new applications have been made for some time. The double truth of invention and reminiscence is as essential as bread. That is why there isn't a single poetic school in the genuine sense in Moscow, not a single lively circle of poets even: because all the organizations lie to one side or another of a dividing line down the middle of truth.

Invention and reminiscence are the two dynamics that drive the poetry of Boris Pasternak. Let us hope that his poetry is properly analysed in the near future, and doesn't become the subject of the sort of lyrical maunderings that have been poured out on the subject of all Russian poets beginning with Blok.

Cities of world importance, such as Paris, Moscow and London, adopt an extraordinarily tactful attitude to literature. They allow it to hide away in a crack somewhere, to go missing without trace, to live without

official documents, or on false papers, to have no fixed address. It's absurd to talk of Moscow literature, just as it is of world literature. The first, Moscow literature, exists only in the imagination of people writing overviews, just as the second exists only as the name of a well-respected Petersburg publishing house.[11] A person who isn't in the know might think there was no literature in Moscow. Whenever he runs into a poet, the poet shrugs, mutters that he's in a terrible hurry and slips through the green gates of the boulevard gardens, serenaded as he goes by the small boys selling cigarettes, who have the most remarkable powers of weighing people up and guessing the qualities that lie deep within them.

Translated by Catriona Kelly

It is sometimes argued that Mayakovsky declined catastrophically as a poet after the Revolution, producing yards of verse to order in the service of the new regime. While few would now wish to defend, say, the epic poem Vladimir Ilich Lenin, *it is important to remember that Mayakovsky's post-Revolutionary work includes some superb pieces, such as the narrative poem* About That *and the agonized last testament* At the Top of My Voice. *And Mayakovsky was himself sensitive to the fact that ideological rectitude was not the same thing as artistic merit, as is clear not only from his treatise on the craft of poetry,* How to Make Verses, *but also from his savage parody of Revolutionary clichés in 'The First of May'.*

VLADIMIR MAYAKOVSKY
'The First of May'

Lef, 2 (1923)

Poets
 are a canny lot.
Want poetry?
 Fine.
You've only to supply
 one thing:
 the rhymes.

There's no subject
attracting
 drivel in larger quantities
than May.

 See, here are the nouns:
 Names
 Flames
 Nations
 Liberations
 Stars
 Hurrahs
 Dreams
 Reams

and the images *Like a* (wait for it!)
 Fairy Tale.
Adjectives: *Red*
 Dead
 Vernal
 Eternal
 Confounded
 Unbounded.

See how,
 dressed in its shrivelled sandals
 of rhyme,
swathed in its Ancient
 Greek toga of 'likes',
yes! even now,
 dragging its sad attributes
down the paper,
 poetry limps on its wrinkled old thighs.
Enough of pampering
 these brats in their nappies:
which is to say:
 us,
the five-year-plan sons
 of the new dawn.
See us,
 still crammed in our cots,
and feeding our faces,
 not knowing we're born!
We could do with
 a greeting
 fit for the moment.
Forget the rhythm
 never mind the rhyme.

The First of May.
Long live December!
May! No, you'll never
smarm up to us with stuff like that.
Long live Siberian frosts!
Let's turn May into steel.

Forced labour,
the granite of prison cells
have done more than all the Springs in the world
to toughen the hands
of men raised by the forests.
We lift hands high
holding our Maytide banner:
Long live December!

The First of May.
Down with affection!
And long live hate!
The hate of millions for the few hundred,
the hate that welds solidarity together.
Proletarians –
let it whistle like a bullet:
– Long live hate!
The First of May.
The earth, senselessly spewing out new growth,
Spring, coming whenever it wants – send them to hell!
The earth's powers, so pitiful, submit to our calculations.
Long live intelligence! Let's hear the call!
Intelligence,
using winters and autumns
to turn May blue as ice
once and for all.
Love live artificial May –
the May the futurists made!

You say it simply,

 you say it in fancy words,
whichever way,

 the poetry muzzle clamps over your mouth.[1]
The future's hard to get hold of.

 Grab the hem
of its garment –

 that'll do us for now.

 Translated by Catriona Kelly

9. Educational force-feeding: Pavel Filonov was a visionary artist whose attitude to the bureaucratization of culture is vividly expressed in this caricature of art training. The items of food and drink under the arm of the prone figure with the paunch, who is digesting young artists, include 'Non-Objective Suprematist Salami' and 'Association of Artists of Revolutionary Russia Red Champagne – For the Komsomol'. The geometrical shape in the right-hand bottom corner is inscribed 'Memorial to the Victims of Art'.

Marina Tsvetaeva's 'In Praise of the Rich' is one of a series of similarly named sarcastic poems written in the early 1920s; they also include 'In Praise of Aphrodite'. In both cases Tsvetaeva's aggressive stance has undertones of ambivalence; her own susceptibility to erotic love made her a well-informed enemy of Aphrodite, and, in the same way, her assault on 'the rich' here was sharpened by the fact that she had herself, before the Revolution, enjoyed a substantial private income and all the trappings of haut bourgeois comfort.

MARINA TSVETAEVA

'In Praise of the Rich'

From *After Russia* (Paris, 1928)

None the less – having already warned you
That we stand, you and I, poles apart,
That my place is below with the rabble,
With the saints of this world who sit honoured

In the dust from the wheels of chariots,
At the table of hunchbacks and freaks . . .
None the less, from the roof of the bell-tower
I declare: I *love* the rich!

For their root,[1] that is rotting, eroding,
Corrupting the soul in the cradle,
For that air of distractedly dipping
In and out of a pocket.

For the barest murmur from their lips
Obeyed as a sharp command is,
And because, they won't be let into heaven,
And because, they won't look into your eyes.

For their secrets – sent by courier!
For their passions – by errand boy!
For the affliction of nights they must bear with
(They're not kissing and drinking from choice!)

And because, with their pondering, sighing,
Their gilding, soft padding and yawning,
They cannot – in my insolence – buy me,
I insist: I *love* the rich!

And moreover, in spite of their pampered skin,
Bloated, glutted (they spend in a wink!)
For some sort of – sudden – dejection,
Some sort of look, like a dog's,

Full of doubt . . .
 Could the pivot
Have swung to nothing! Are the weights playing up?
And because, among the outcast, disinherited,
None – none are so orphaned in the world!

There is that dreary little fable
About camels going through needles.
. . . For their gaze, as though deathly shocked,
As they apologize, in sickness

And in bankruptcy . . . 'I'd lend it to you. Gladly.
Only . . .'
 For that quiet aside, through pursed lips:
'The carats are weighed – our brotherhood sealed . . .'
I take my oath: I *love* the rich!

30 September 1922

Translated by Mimi Khalvati

In the West, Daniil Kharms is often labelled a surrealist or absurdist. However, for anyone who has seen transcripts of the interrogations to which victims were subjected during the Great Terror of 1937–8, or forced themselves to read the vulgar tirades of Vyshinsky, the state prosecutor at the show trials of Bukharin and other supposed opponents of Stalin, the playlet here (written in the late 1930s, though not published in Kharms's lifetime) has an altogether darker resonance.

DANIIL KHARMS

'Four Illustrations of How a New Idea Gobsmacks a Person Who is Unprepared for It'

From *Incidents*, in *Flight to the Heavens* (Leningrad, 1988)

I

W RITER: I'm a writer.
READER: I think you're s . . t!

The writer stands stock still for a few minutes, shocked by this new idea, then falls down dead. He is carted out.

II

ARTIST: I'm an artist.
WORKER: I think you're s . . t!

> The artist goes white as a sheet,
> Starts trembling like a reed,
> Then unexpectedly falls down dead.
> He is carted out.

III

COMPOSER: I'm a composer.
VANYA RUBLYOV: I think you're a c . . . !

The composer starts panting like an overworked donkey. He is unexpectedly carted out.

IV

CHEMISTRY PROFESSOR: I'm a chemistry professor.
PHYSICIST: I think you're a c . . . !

The chemistry professor, not saying another word, thumps down heavily on the ground.

Translated by Catriona Kelly

4
Men and Women

The issue of women's liberation could be described as one of the test cases of nineteenth-century Russian intelligentsia life. That is to say, it was one of those burning questions whose treatment on the part of a commentator, as Zinaida Gippius argued in her review 'Choosing a Sack' (see 'Altercations and Provocations'), led him or her to be bundled into a sack marked 'Conservatives' or a sack marked 'Liberals'. Since the 1840s, when Russian radicals had become enthusiasts for feminism under the influence of French utopian socialism, political and economic liberation for women had been necessary tenets of all right-thinking persons of the left, however hotly their views were questioned by conservative writers, such as Tolstoy in Anna Karenina *or Dostoevsky in* A Writer's Diary. *After the 1905 revolution, however, as political liberation for women came to seem a real possibility, there was an increasing tendency even among some self-styled socialists, such as Vyacheslav Ivanov, to question whether the ballot box would bring women genuine freedom. For their part, women writers associated with the modernist movement, such as Gippius, Akhmatova or Tsvetaeva, were mostly extremely cool towards political feminism, with Gippius describing the 'woman question' as 'really quite revolting' in 1918, at the point when women were finally granted the vote, and Tsvetaeva in 1921 claiming an interest only in the most militant – and desperate – kinds of female self-assertion, such as the doomed 'Women's Battalion', a company of women soldiers responsible for the last and hopeless defence of the Winter Palace in October 1917.*

The mystical symbolist strand of the modernist movement, to which Ivanov, for example, belonged, held masculinity and femininity to be transcendent essences; the feminine was (as is usual with essentialism of this kind) associated with intuition, and in particular a privileged access to the spiritual domain. This association had its most influential

expression in the religious philosopher Vladimir Solovyov's concept of Sophia, or 'divine wisdom', a faculty mediating between humanity and the divinity. By extension, the Eternal Feminine was a quality revered by mystical symbolist poets, who sometimes credited real women with a capacity to express this rather nebulous principle in life. Nadezhda Mandelstam acidly recorded in her second book of memoirs, Hope Abandoned, *meeting women whose demeanour was still marked even in the 1920s by their pre-Revolutionary status as muses and goddesses, and Aleksandr Blok's marriage was blighted by the poet's conviction that his wife and childhood sweetheart, Lyubov Mendeleeva, was an incarnation of the 'Beautiful Lady' of Blok's early verse. All this meant that when post-symbolist groups, such as the Acmeists and the Cubo-Futurists, rebelled against symbolism, a defiant misogyny was often part of their rebellion: it can be seen, for example, in Osip Mandelstam's comments in 'Literary Moscow' (in 'Altercations or Provocations'), or Vadim Shershenevich's description of images in conventional poetry as lying down as neatly 'as convent schoolgirls retiring to bed in the dormitory of the reader's mind' (see 'New Worlds'). Yet at the same time the post-symbolist discussion of the literary language was extremely stimulating to women's creativity. The sharper and more critical attitude to women's writing (which was no longer seen as the precious, albeit abstruse, ravings of sibyls or enchantresses) put those of real talent, such as Akhmatova, Tsvetaeva or Sofiya Parnok, on their mettle.*

Apart from fostering women's writing, the modernist movement also changed Russian culture in that a totally different attitude to the expression of sexual relations was imported with the Decadent move-ment. The Russian radicals of the nineteenth century, though vehement secularists, had inherited from Orthodox Christian culture a suspicion towards things of the flesh that is expressed, for example, in the oddly prudish tone of Nikolai Chernyshevsky's famous tract What is to be Done *(1863). This advocates a woman's right to end a sexually unsatisfactory relationship by emphasizing that the exchange of partners by the heroine, Vera, is perfectly agreeable to both the men involved. That is, Vera's sexual conduct is allowable because it does not engage the passions, and hence does not threaten male control. With the rise of decadence, however, appeared a more threatening kind of woman, a sexually rapacious femme fatale determined to ensure her own pleasure (or pain) at all costs. Disturbingly, sexual voraciousness was often combined with precocity, with Lidiya Zinovieva-Annibal's short-story cycle* The Tragic

Menagerie (1907), *a particularly striking representation of a child's discovery of physical pleasure.*

The year 1907 was very much a turning-point in the public representation of sexuality, owing to the abolition of pre-emptive censorship on books, which meant that material could only be branded subversive after its publication. In the same year two landmark homoerotic texts also reached the Russian reader: the first of these, Thirty-three Freaks (*also by Zinovieva-Annibal), depicted a middle-aged woman's obsessive love for a younger one, while Mikhail Kuzmin's* Wings *showed a schoolmaster and his young pupils striving to express Platonic love in the original sense of the term. Four years later, in 1911, Vasily Rozanov's* People of the Lunar Light *represented sexual identity as fixed randomly along a continuum running from 'masculine' to 'feminine', and in a note embroidering this theme (and included here) Rozanov was later sympathetically to record the agonies suffered by those whom Christianity had condemned to live a life of secrecy for centuries. The years immediately after the Bolshevik Revolution, when laws prohibiting male homosexuality between consenting partners were abolished, allowed new freedom to homosexual writers as well as homosexuals more generally. However, as Mikhail Kuzmin's moving poem 'But I . . .' makes clear, institutionalized discrimination remained common, with homosexual encounters clandestine and confined to recognized haunts of ill repute in the major cities. And in 1928, with the beginning of the so-called 'Cultural Revolution', sexual puritanism again began to make itself felt, a process culminating in the outlawing of male homosexuality once more in 1933. Though lesbianism was never expressly forbidden by law, either before or after the October Revolution, it was no more (indeed, perhaps less) socially acceptable than male homosexuality. Marina Tsvetaeva did not publish the scorching love poems that she wrote to Sofiya Parnok during their affair in 1915, and Parnok herself complained to a friend, Lev Gornung, in the mid 1920s that her most explicit poems addressed to other women were never uttered aloud, let alone written down. Yet the story of homosexual writing in the modernist era is not simply one of censorship, suffering and silence: some of the work collected here, such as Nikolai Klyuev's extraordinarily rich and sensual lament for his one-time lover, Sergei Esenin, is at least as erotically frank as anything written by other modernist writers to commemorate heterosexual passion.*

Vyacheslav Ivanov's 'On the Dignity of Women' represents an interesting attempt to marry biological essentialism and socialism. Ivanov's emphasis on women's superior spiritual powers is typical of mystical symbolism. But he begins his essay by expressing a commitment to equal rights for women, and the reference in the passage here to a primal war between the sexes ended by matriarchal rule, which in its turn was overthrown by patriarchal rule, draws directly on August Bebel's Woman and Socialism *and on Engels's* Marriage, Property and the Family.

VYACHESLAV IVANOV
From 'On the Dignity of Women'

Slovo, 650 (1908)

Always preserving access to unconscious life through the secret of her sex, woman is acknowledged by almost everyone to be especially gifted with those powers that reside in the subconscious and are sapped by the growth of individual consciousness, which is to say the powers of instinct and clairvoyance. [. . .] It is scarcely surprising that the further we recede into history, the more magnificent is the vision that appears to us of this prophetess of the fundamental, of the primary secrets of existence; this sovereign over the life that creeps from those dark maws, the door-keeper of births and funerals; she who gives birth to, who feeds and who nurtures the infant, who mourns the dead and helps them on their way; she who is the helper, the confidante of two different goddesses, the dark Earth and the radiant Moon, who listens for their voices within herself; the priestess and the enchantress, the wise woman and the witch mixing her poisons, the first teacher of spells and prophecy, of poetry and ecstasy.

The evolution of woman resembles a curved piece of wood whose ends have been pressed together by force since the prehistoric apogee of her powers, the matriarchy, reaching their narrowest point at the time of her total enserfment by man – an enserfment visible, for example, in Islam – and which began to spring outwards a little around the present time. The era when there was greatest awareness of the unconscious, and most fidelity to the dark Earth that repudiates all individualism, was also the era when there was maternal rule; a victory of women and

the enslavement of the male sex had, it is reasonable to suppose, concluded the original war between the sexes. There are many traces of the male reaction to this matriarchy, a reaction enacted by priests such as Orpheus, which brought about male dominance and the imposition of patriarchal order. The warring Amazons were annihilated by the heroes; young men such as Orestes arose as conquerors and avengers of their fathers; prophetesses had to make common cause with priests who became the interpreters of their visions and thus their controllers. Here and there polyandry survived as a remnant of matriarchy, but the rise of patriarchy, along with the institution of monogamy as an attestation of respect to woman, the fallen sovereign, sealed the final victory of the priests, the creators of harmony and rhythm in the chaos of prehistoric social relations.

<div style="text-align: right">Translated by Catriona Kelly</div>

The poet Aleksandr Blok was one of the symbolists most enraptured by visions of the Eternal Feminine. In this short essay he evokes the other-worldly feelings provoked in him by a papyrus from Hellenistic Egypt (the origins of the painting are significant, since Cairo had been the site of one of the 'Three Meetings' depicted by Vladimir Solovyov in a famous poem about his encounters with the Eternal Feminine).

ALEKSANDR BLOK
'The Gaze of the Egyptian Girl'

From 'Lightning-flashes of Art', *Collected Works*, vol. 5 (Berlin, 1923)

In the Egyptian section of the Archaeological Museum in Florence is preserved the portrait of a young girl painted on papyrus. The portrait dates from the Alexandrian period – it is almost Grecian in style. Some people have supposed it to represent Queen Cleopatra. If that supposition were correct, the value of the papyrus, which is creased and broken in two places, would increase tenfold, so it is said. But when I look at the Egyptian's photograph, I think that cannot be right.

After all, who cares whether she was a queen or a slave-girl? Or rather, is it not clear at the first glance that this is a queen? Perhaps not the perfidious 'queen of queens' of 1st-century Egypt, but a powerful and frightening monarch for all that; indeed, a more powerful and frightening one than Cleopatra.

An archaeologist is always to some extent both a poet and a lover. He shares the passionate captivity of Caesar,[1] the disgrace of Axium.[2] And in order to conceal the shame that he feels in his study, he hides behind the shades of the Emperor and of the triumvir, trying to justify his own fate through theirs.

But what the artist depicted here was in no sense a historical person-age, even if we allow that the Queen of Egypt may have posed for him. He communicated much more.

On her slender neck, the Egyptian Girl wears a simple necklace of square-cut dark stones. She has ornaments in her ears, rather heavy ones by the look of them. Her black wavy hair covers her ears and part

of her forehead in a dark nimbus; on top it is caught up in braids that are fastened with four frontlet chains, apparently of gold; on the lowest of the four, in the middle of her forehead, shines a precious stone. That is all the jewellery that she has, all of it very simple, despite its high value; her undergarment is very light, perhaps even transparent, and her overgarment is held together by narrow black ribbons over her shoulders.

The Egyptian's features are far from conforming to any canonical standards of beauty. Her forehead seems too high; no wonder that she has dressed her hair over it. Her oval cheeks have something Mongol about them, a suggestion of the quality that made Pushkin 'forget himself in a hot-blooded dream' in a 'nomad wagon'[3] and dreamingly cover the manuscripts of his poems with drawings of profiles. The Egyptian's nose is straight but rather too soft; the whole lower part of her face is strikingly underdeveloped, with a formless chin and narrow, clumsily shaped lips. Her eyebrows are extraordinarily thick and wide, and meet over the bridge of her nose.

But the main irregularity in her face is her eyes. 'I have never seen such enormous eyes,' is what anyone would say the first time he saw the painting. That's not quite correct: eyes of those dimensions are possible in real life, though they are rare; the only thing that is strangely oversized is the eye-socket; the eyelashes are very long and very fluffy, the eyelids very heavy. However, it is not even this, but the gaze itself that is striking.

The look in the eyes dominates the entire face, indeed, as far as one can tell the body and everything surrounding it as well. It expresses both total indifference and determination; it is quite beyond such concepts as modesty, shame or impudence; the only thing that one can say about these eyes is that the look in them is and always will be as it was in life. One cannot imagine them closed, lowered, sleeping. There is no exhaustion in them, no maternal feeling, no pleasure, no sadness, no desire. The only thing that one can see in them is echoing and insatiable hunger, hunger for the tomb, a hunger experienced both within and beyond life. But no Roman emperor, no Hyperborean barbarian,[4] no Olympian god, even, can satisfy that hunger even partially. The gaze in the eyes is as terrible and as languorous as the scent of the lotus, and, like that scent, it finds no response. From century to century, from era to era.

Those eyes are surrounded by black circles. One of these (the left

one, as always) is markedly smaller than the other. That is a physiological peculiarity of all passionate natures; it emanates from constant tension, from the hopeless desire to find, to see things that do not exist in this world.

Translated by Catriona Kelly

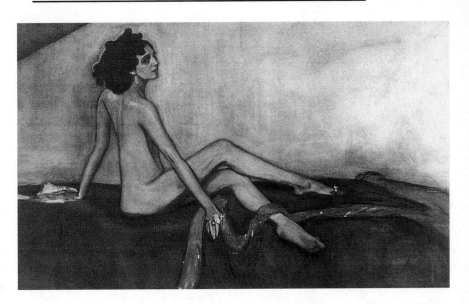

10. Decadent *femme fatale*: The hollow-eyed beauty of Ida Rubinstein, an actress and dancer, and favourite of artists in the 1910s, is portrayed here by the post-impressionist painter Valentin Serov.

*This review article by Nadezhda Lvova, written shortly before the
writer's suicide in 1913, is a unique document in the history of Russian
modernism because it raises the question of 'women's language'. However
conventional Lvova's polarization between 'irrational' femininity and
'rational' masculinity, her implicit distinction between biological femin-
inity and femininity as a textual strategy is not, and looks forward to
the theories of écriture féminine evolved by French feminists in the
1970s. Significantly, the 'woman poet' whom Lvova praises most highly
in the body of the review is not Anna Akhmatova, Marina Tsvetaeva or
Elizaveta Kuzmina-Karavaeva (1891–1945), but 'Nelli', a pseudonym
of the indubitably male Valery Bryusov, Lvova's lover.*

NADEZHDA LVOVA
From 'The Cold of Morning: A Few Words about Women's Writing'

Zhatva, 5 (1914)

It is probable that the twentieth century will go down to history
as 'the century of woman', the century when woman's creative potential
was awakened. Never before has woman spoken so loudly. Never has
her voice been listened to with such attention. It is hard to prophesy
where that elemental force, a force that has seized all spheres of life,
will choose to expend itself, or indeed whether it will make its mark in
this all too 'masculine' culture of ours. At all events, we can study only
one aspect of the question here, but that is the one where the shift in
feminine consciousness has perhaps made itself felt to a greater degree
than it has anywhere else. We are speaking of literature, and in particular
poetry.

The fact that woman has made her entry into literature has been
recognized once and for all in the West, where critical essays are now
studded with the names of women. And in Russia, where it would be
hard to find even half a dozen names of women poets working in the
nineteenth century,[1] the numbers have now become so large that they
are hard to count. Yes, woman has made her entry into poetry and,
what is more, made it at a moment when poetry had reached a dead-end

– and not just Russian poetry but poetry in general. After all, who can deny that the anxious searchings, the negations of contemporaneity, the recognition that we cannot go on in the old way are evident in the West as well as here? And it seems to us that this sense of having reached a dead-end is the result of the *masculine* character of modern poetry. Man is the ruler of the poetic world, enjoying full proprietorial rights in this. His soul, his opinions, his strivings, his *world-view* make up the content of poetry. If we take rationality to be the basis of the masculine soul, then we have to say that our poetry, indeed our culture in general, is wasting away from a surfeit of rationality. We all want to show off our intellects, to parade our knowledge, our cultivation, and everyone who has glanced through the work of poets from the last century knows where that leads.

It seems to us that the only salvation is to introduce the feminine principle into poetry. This principle, in our view, is opposed to the masculine principle in that it represents elementalism, the spontaneous immediacy of perceptions and experiences, the perception of life not by means of the intellect but by means of *feeling* or, to be more accurate, by feeling first of all, and only then by the intellect. [. . .]

My readers may object that creativity as such cannot be either masculine or feminine in nature, that it must be unified and universal, synthesizing personal feelings and experiences and extending these so that they become part of the common experience of humanity. Of course, this view is eminently well founded, and I agree with René Ghil[2] that creativity should represent wholeness, synthesis, universality. But, at the same time, if we demand individual techniques from every poet, if we want the 'I' of the poet to ring unmuffled by synthesis, then we should seek for distinctly feminine techniques and themes in women's poetry. [. . .]

Regrettably we are forced to admit that in the majority of cases women's poetry does not cross the boundary, does not become part of humanity's common experience, does not reach that great synthesis; for the most part the poetry that we have analysed here is so narrowly personal that we are tempted to repeat the harsh words of Valery Bryusov, 'her verses could be interesting only to her closest friends'.[3]

What techniques, then, do these women writers employ in order to communicate their experiences? We are forced to acknowledge that in this sphere also, the sphere of form (which is perhaps the most vital), these women poets have almost nothing to contribute. Their rhythms,

their measures, their verse constructions, are identical to those used by all the poets of the younger generation, whom they also exactly resemble in their desire to be 'intellectual and cultivated'. Of course, a slight sense of individuality and femininity does emanate from these books, but only a slight one, not at all what is needed . . . [. . .]

Generally, we can see that these books by women writers are typically feminine in terms of their ambitions, their 'content'. Alongside the masculine world-view expressed in poetry is appearing a world-view that is 'feminine' in the sense that we have chosen to give the term here. It is interesting that the verses of some male poets also have an overtly feminine coloration. The most striking example of this trend is Igor Severyanin, whose feelings for the world, and his perception of it, are exclusively feminine.

Yet for these, their own, 'feminine' experiences, women have not yet managed to find 'their own' language, a language adequate to the task, they have not managed to clothe their experiences in a form of *their own*. All the poets that we have looked at are 'noted names' in their own ways. And what do we find? All of them employ verse masterfully, using all sorts of assonances and alliterations, all kinds of recherché metaphors . . . But so often a poem or fragment could perfectly well bear the name of some famous poet or other, so often established boundaries are carefully observed – when those boundaries should be broken.

Still, they are making the effort. And often this poetry does exude a bracing freshness, there is a sense that only one more step needs to be made and the goal will be reached. It remains unclear what the new dawn of Russian poetry will bring us, that dawn to which we strive, which we passionately await. At all events, women's voices now resound in the great choir – some, to be sure, more confidently, more independently, than others – and perhaps (who can tell?) these women's voices have more right than others to cry out to all awaiting the dawn:

We are the cold of morning!

Translated by Catriona Kelly

*The one-line poem below, a laconic manifesto for Russian decadence,
achieved a scandalous notoriety when first published in one of the early
symbolist almanacs.*

VALERY BRYUSOV

'Prologue, no. 6'

From *Juvenilia, Russkie simvolisty*, 3 (Moscow, 1895)

O, cover up your pale legs!

Translated by Catriona Kelly

The publication of Boris Pasternak's third collection, My Sister Life, *in 1922 created a literary sensation, turning Pasternak from a well-regarded minor futurist into a writer generally acknowledged as one of the major forces in Russian literature. The poem below – whose title refers to a range of hills just to the south of Moscow, overlooking what is now the site of Moscow University – comes from a subdivision of the collection entitled 'Songs in Letters, to Keep Her from being Bored', but is typical of* My Sister Life *in that its intensely felt eroticism is directed as much at the natural setting as at the human addressee.*

BORIS PASTERNAK
'Sparrow Hills'

From *My Sister Life* (Moscow, 1922)

Put your breast under kisses, as under a tap!
For summer will not always bubble up,
And we cannot pump out the accordion's roar
Night after night round the dusty floor.

I've heard tell of old age. Terrible prophecies!
No breaker will throw up its hands to the stars.
They say things you can't believe. No face in the grass,
No heart in the ponds, no God in the trees.

Stir up your soul then! Make it all foam today.
Where are your eyes? This is the world's high noon.
Up there, thoughts cluster in a fleecy spray
Of cloud, heat and woodpeckers, pine-needle and cone.

At this point the tramlines of town break off.
Beyond, the pines serve. Beyond, rails cannot pass.
Beyond, it is Sunday. Breaking off branches,
The glade runs for cover, slipping on grass.

Scattering noons and Trinity and country walks –
The world is always like this, the wood believes.
So the thicket devised it, so the clearing was told,
So it pours from the clouds – on us in our shirt-sleeves.

1917

Translated by Jon Stallworthy and Peter France

All her life, Marina Tsvetaeva was a passionate believer in the ideal of romantic love, an ideal that survived repeated disillusion. Her emotions were all-consuming not only in the sense of their enormity, but also in the sense that they reduced their object to ashes: few if any of Tsvetaeva's grandes passions were reciprocated in the same spirit, many were not consummated, and some remained long-distance epistolary friendships. Tsvetaeva's relationship with Boris Pasternak, the addressee of this 1923 poem, was of the long-distance kind; however, the governing image is of telegraph wires, seen by Tsvetaeva as an immediate form of communication akin to telepathy that could short-circuit geographical distance.

MARINA TSVETAEVA
'Wires, no. 3'

From *After Russia* (Paris, 1928)

Everything's upside down – I've turned out the lot
(you're way out of sight, so semaphore's hopeless) –
I'm calling on caterwauling (a whole chorus) to help me:

so listen to my break – my shameless solo,
my flying colours, my fireworks – I'm getting high[1] –
can you hear my torch song singeing all the wires?

Sad telegraph poles – these wires they carry never touch –
but while the cold stars shine above them
they're wiring you my soul so palpable you'll taste my broken lips.

As long as this scorched earth beneath our feet is soil
as long as wild nights ebb to dawn
I shall chain you, fix you, wire you – heart to heart.

I'm wiring you through cataclysms, revolutions, acts of God,
through all the rigged, fixed, trumped-up lies –
my smothered cries, my wild – my savage passion.

Those mortal wires strung out against the sky may rust and twist
but mine is fixed – and I'll break through to you
till sound waves turn to water, till light years fade away.

19 March 1923

Translated by Sarah Maguire

The original title of the poem by Mandelstam below, addressed to the beautiful actress Olga Arbenina, was 'The Trojan Horse'. However, pedantic attempts to identify the speaker with one or other Trojan (or Greek) hero would traduce the spirit of the poem, whose identification of Greece and St Petersburg is fluid, depending on general themes of love, betrayal and loss.

OSIP MANDELSTAM
'Because I had to let go your arms'

Novyi Giperborei, 1 (1921)

Because I had to let go your arms,
Because I turned traitor to your tender salty lips,
I must wait for dawn in the dense acropolis.
How I abhor these odorous ancient timbers.

Achaean men in the dark fit out the Horse.
Cut harshly into walls with toothed saws.
There is no way to lay the blood's dry murmur,
And for you no name, no sound, no sculpture.

How could I think that you would come back, how could I dare!
Why, before it was time, did I tear myself from you?
The black has not cleared, the cock has not crowed,
The hot axe not yet cut into wood.

The walls ooze resin like transparent tears,
The town feels its wooden ribs,
But blood has rushed to the attack, has gushed to the ladders,
And three times in dreams they kissed their dear ones' lips.[1]

Where is dear Troy – where the imperial, where the maidenly
 house?
Priam's lofty starling-coop will be a ruin.
And arrows fall like wooden un-wet rain,
And arrows, like a nut-grove, grow from the ground.

The last star-pricks are dying out painlessly
As morning, a grey swallow, raps at the window.
And lethargic day like an ox woken in straw
Stirs from long sleep across the rough haycocks.

1920

Translated by James Greene

Lidiya Zinovieva-Annibal, the wife of the poet Vyacheslav Ivanov, was a remarkable woman even by the standards of early-twentieth-century St Petersburg literary life. The co-organizer of Ivanov's famous 'Tower' (a sort of modernist literary salon), she was also a prose-writer and dramatist. The Tragic Menagerie *is a fictionalized autobiography that chronicles the early life of a dauntingly precocious adolescent girl, Vera, whose self-consciousness and appetite for transgression (including sexual transgression) make her the successor of Dostoevsky's Lise in* The Brothers Karamazov. *The following section of the text shows how Vera's determination to become the owner of a horsewhip becomes an obsession that governs her life and brings her into conflict with her governess, Aleksandra Ivanovna, an upright and slightly priggish young woman of left-populist convictions.*

LIDIYA ZINOVIEVA-ANNIBAL
From 'The Whip'

From *The Tragic Menagerie* (St Petersburg, 1907)

And then it turned out that nothing was impossible: you had only to feel desire.

Treasures were everywhere.

My mother kept a chest on her windowsill, under her hat-box, and the chest was full of honey-cakes. Slowly, patiently, calmly I emptied it, visiting every day till I had eaten every one. No one found out.

The day began with honey-cakes; it stretched on, minute following minute, each minute separate from the next, each minute outside memory. As a minute passed and was consigned to oblivion, the next greedy minute approached: its eyes met my own, insatiable, cold, glittering fearlessly. Then we winked at one another, making a pact: I would forget what I had done till I died. This was freedom.

I began lying, relishing the thought that this was a mortal sin. It was easy to do it; I had become crafty in my godlessness, instructed by my desires. I hardly ever got found out, and my empty eyes, inscrutable under their glittering surface, burned on in cold joy.

I loved lies. They ruptured everything that was connected to something else by ties of memory or love, everything that dies, in

the due course of things, and achieves purification, everything that cares for the dead while still living, that knows what is still whole, that has not tired of bearing aloft the sacred chain suspended between beginning and beginning, the chain of terrible but sacred and unalienable necessity. Lies ruptured all this, setting up empty freedom in its place.

I was punished less often now, no doubt because my lies often got me out of trouble; when they did not, I had somehow ceased to care in any case. As I stood in the corner, or sat locked up in the schoolroom, amusing thoughts came to me unhindered: I had no shame.

I played almost no games with Volodya now; all our games had been absorbed into that one game. Our eyes glittered in agony as we looked at each other; I was his instructor in deceit.

All this was happening on the inside. I remember no resounding events, no obvious feats of boldness or of impudence. But the inward gaze had altered.

Sometimes horror would grip me.

I did not spare Volodya either. I got him blamed for an exercise book that I had scrawled on. My handwriting notebook[1] was covered in the heads of horses, wearing horns and crudely drawn in blood. It was my idea; it was all my own work.

This was what happened. I began to feel bored as I was forming the elegant curlicued letters, so bored that I was afraid I should never throw off that thick, grey, unchangingly dull sense of boredom. But faint lightning-flashes cut through the grey dullness as they do through a dull grey sky –

The flashes of my desires. But they too were quite hopeless, as I desired only what did not exist. Clearly despite my dull-wittedness, so clearly it reduced me to tears, I realized that I did not desire anything that existed, but only what never had.

So then I took a pen-knife and cut into my arm next to the wrist, where blue veins show just under the skin. The pain burned and chafed; I let out an unpleasant-sounding croak, then, taking fright at the sound that I had made, flung down the knife. The trickle of blood oozed slowly, drop by drop, as I pressed down on the wound.

Then I suddenly felt like marking the clean sheets of my handwriting notebook, and, dipping a quill into the blood, I drew a horse.

I drew it starting with the head, but it did not come out right, so I had to start all over again; the blood clotted and I had to suck the salty

iron-tasting nib to liquefy it. And so all my ungainly horse-heads, painted in blood, ended up with ears that looked like horns.

And then *she*[2] asked: 'Who scrawled those red devils in the book?'

Delighted and amused, I said, with no idea why, without even pausing for thought: 'Volodya did.'

Then I began snivelling, squeezing tears from the corners of my eyes.

She still had her doubts. She came right up to me and stared into my tear-filled eyes, then said: 'Do you give your word it wasn't you?'

'Word of honour.'

'What sort of nasty paint is that, in any case? It looks just like blood.'

I continued swearing blind on my word of honour and lifted my proud head high, flashing radiant, empty, impudent and greedy eyes.

I did not always think of my eyes at that stage. But when I was looking in the mirror and combing my long, fine, tangled, ash-blonde hair, I would think how beautiful was the combination of glittering eyes and pale hair.

Why is it wrong to give one's word of honour, if lying is permitted? It makes no difference. I have always loved things in their entirety.

Why is it wrong to betray Volodya, if there is no connection between things, and if it is important to feel good?

He can betray me, if he feels like it: I won't take offence.

Once I went to a shop with Aleksandra Ivanovna to buy an exercise book. There were little wooden boxes holding something and I desperately wanted to know what. I pushed my muff down the counter and reached towards them. When we left the shop, I held two of the little boxes clutched in my slightly trembling fingers.

Back home, I divided up the spoils, keeping one box for myself and giving another to Aleksandra Ivanovna as a gift and an insult. She gave me a very sharp look when I presented her with it, but she did take it.

In the little boxes were Chinese flowers.[3] They bloom if you put them in water.

Tanya the maid got the sack. Kolya noticed that money had been taken from his bedside table and reported it to my mother. And then there were the missing honey-cakes, and sugar gone from the pantry, and ten-copeck pieces missing from everyone's bedrooms. My pile of silver on top of my chest of drawers had mounted to five roubles fifty.

I lay in wait for Kolya too.

We crammed ourselves into the narrow sleigh. He held me round the waist. Thick cloth in front of our faces blocked the view. When you

craned your neck to look round it, needle-sharp, freezing snow crystals flew into your face from under the horses' shoes. The wind drew your skin uncomfortably tight over your face.

It hurt, but it was exciting.

And then the smell of tanned leather, the shine of polished brass, the bridles, the harness, the saddles!

It was paradise!

I was excited; so excited that I must have stopped noticing anything. But then I suddenly caught sight of the whip.

It was right in front of me; Kolya was holding it. I must have been a little afraid; after all, there is something fearful about being granted a wish that has ruled your life.

I had lived for my desire, after all; and what now?

The whip was made from a branch. I ran my finger down the shining, lacquered shaft, stroking the knobbles where the side-branches had been cut off.

Kolya thrust it into my hand. It felt light; the shaft of branch swung high and the coiled, narrow lash on the end bobbed out like a long, supple, coiled tongue. The silk tassel caressed my cheek, then flew away to the side, into space.

I waved my free hand, the hand that had been squeezing the supple handle, and pushed it forward decisively, giving a great sweep, then suddenly pushed my arm back, bending at the elbow. As I caught the whip again, I heard a dry sharp crack from the silk tassel on the end of the long, thin lash, and the lash, very long and artfully curled, cut through the air, whining and whistling.

We had reached our destination. I passed the whip to someone else, suddenly feeling subdued and low-spirited.

Translated by Catriona Kelly

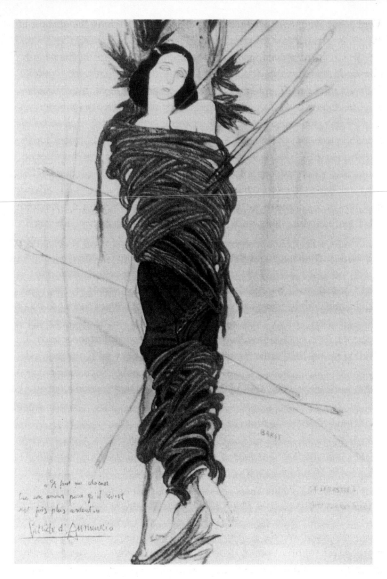

11. Androgynous saint: A costume design by Léon Bakst for the role of Saint Sébastien (played by Ida Rubinstein) in Gabriele D'Annunzio's *Le Martyre de Saint Sébastien*, staged in Paris by Ida Rubinstein's company in 1911 and 1922.

Vasily Rozanov, who favoured romantic forms, such as the essay and the fragment, in his writings, was a brilliant and controversial eccentric whose stance was, and is, hard to classify according to normal boundaries. He was an anti-Semite who admired traditional Jewish culture for its warm family relations and lack of sexual puritanism, and an advocate of sexual liberation for women and of tolerance for homosexuality. At the same time he was an entrenched patriarch convinced of women and homosexuals' essential difference from heterosexual males. In the following discussion of homosexuality, first published in a footnote to his miscellany Literary Exiles, *the various contradictory strands in his personality are apparent; however, the note is also an interesting and persuasive discussion of changing attitudes to homosexual behaviour over the course of history, a sort of forerunner to Michel Foucault's* History of Sexuality.

VASILY ROZANOV

[People Whose Sex is Naturally Different, or Homosexuals (*utriusque naturae [sexus] homo*)]

From *Literary Exiles* (St Petersburg, 1913)

I must have told Strakhov that Leontiev was an *utriusque naturae (sexus) homo* – that is, someone attracted to individuals from his own sex.[1] Now, after having written *People of the Lunar Light*,[2] I regard the whole subject with complete serenity; I simply feel 'it's not my business', and don't engage in further condemnation of any kind. In the classical world this phenomenon was considered totally acceptable and was subject to overt regulation by the law; Plato (himself a person of this type) gave it a philosophical and religious justification. But later, under the influence of the Bible, which propounded a philoprogenitive creed, people *utriusque sexus* came to be considered inimical in the highest degree. The Talmud has a passage speaking of the inhabitants of Sodom to the following effect, '*they forgot God on account of their happiness*', and generally discussing that kind of person (*and no disgust is evident*); but even so, the case of Sodom and Gomorrah meant that something

very like an iron curtain came down before that phenomenon, cutting it off from observers and listeners, from legislators, tsars, scholars and priests. Yet the phenomenon itself continued to exist, though it *was never named by its full name or spoken aloud* – and the silence hanging over it was the reason behind the terrible hostility generally felt towards it, the hostility and contempt, anger and repulsion, the reason why this 'sin' was held a more frightful one that parricide or infanticide. Later, there were attempts to defend it, whose failure deepened still further the contempt with which it was regarded. In such a way, centuries of *utter darkness* closed over 'androphilia', in case of men, and 'gynophilia', in the case of women. Until, finally, Weininger's famous book *Sex and Character* appeared.[3] At the beginning of the book Weininger referred to the 'narrow pelvis', or 'flat pelvis', which is found so commonly in women; this he (with the penetrating insight of genius) referred to simply as 'a masculine pelvis'. A woman with a pelvis of this kind is incapable of giving birth; the infant must be cut to pieces and dragged from her still-born. 'What can this be?' Weininger asked. And he continued: *suppose it were a fact of nature* – suppose these symptoms, which are very commonly found and which are never subject to moral condemnation, were the beginning of a metamorphosis of woman into man? That this being 'with all the sexual equipment of a woman, but who is unable to *give birth*', '*ought not to conceive* in the first place'? So what are they supposed to do, what *are* they in actual fact? The answer came to the reader in an insistent whisper: 'what they are supposed to do', what they in fact do, 'is' something associated with that phenomenon never mentioned by name. Sodomy had emerged from its midnight darkness. And I think the second important step here was my book *People of the Lunar Light*. Reading Weininger, I got as far as 'women with narrow pelvises' and was so overwhelmed that 'I acceded to the rest without further ado'; as I flicked through the rest of the book, I did no more than run my eyes over his *always accurate and striking observations*, taking note of his *volo*[4] and his 'moral judgements', which arose from his own *personal* nature as *a sodomite* (there is no doubt that Weininger was a sodomite), a nature that was totally foreign to me. However, *People of the Lunar Light* arose quite independently from Weininger's *Sex and Character*. It laid bare the enormous *religious* role of these people without a name – people *without the capability and the vocation* of reproduction (an analogy with the natural world is barren flowers, containing no pollen), and the staggering effect of this religious

role on the structure, the direction, the character and the orientation of civilization, of world history as a whole. Without a shadow of exaggeration I can say that *People of the Lunar Light* achieves a radical reworking of the whole concept of *world history*, casts a totally novel *light* on this. The most elevated phenomena, the most highly regarded by all the world, had as their *root*, their *seed*, that phenomenon damned from the time of Sodom and Gomorrah, whose positive and beneficent effects had never been considered by anyone. Certain phenomena 'sank down', and at the same time 'androphilia' and 'gynophilia' began to rise to the top, eventually *reaching the same level*, until they, like two buckets rising on a chain from a well, caught on each other's edges and poured their contents one into the other. This 'pouring of water from one bucket into another' in essence transformed the world's system of values, and now it is impossible not to name that 'magic bucket', 'magic vessel', where everything *has flowed together* and which has *made everything radiant*. It is both *prima philosophia* and *primum movens*.[5] 'The other sex' (*utriusque sexus*) is the source of the genius of such people as Socrates and Plato, and also of our own Leontiev's genius. These people are the geniuses of *secret things*, of *things unknown*; from birth they are the maguses and the priests (I don't mean this in the ecclesiastical sense, of course) of humanity, its leaders, legislators, prophets, clairvoyants. Raphael was one of them – never mind his (childless) carryings-on with La Fornarina – so was Michelangelo, so was Leonardo da Vinci, and Shakespeare; Goethe was as well (*in part*). Now everything has changed. What 'could not be named aloud' has been illuminated as *a personal idiosyncrasy* characterizing humanity's foremost geniuses. It's obvious that there's nothing to 'blame' Leontiev for. I am prepared to write this quite openly, since without any doubt a reassessment of this colossally significant phenomenon is about to begin; new standards and new laws for it, new ideas about it, are urgently required.

Translated by Catriona Kelly

The following short memoir of Mikhail Kuzmin's childhood and youth was composed as an entry in his diary for 1906, the year he began this unique document. A reconstruction from memory of events lying decades in the past, it is none the less among other things an extraordinarily vivid and frank account of Kuzmin's adolescent sexuality, presenting his early discovery of his homosexuality without any of the coyness or collusiveness that most other Russian writers would have considered appropriate to such a topic. Hence, while not entirely accurate as to dates, the piece has the ring of emotional authenticity. In the original, the piece is set out without paragraph divisions, but for the sake of comprehensibility these have been introduced in the translation.

MIKHAIL KUZMIN
From 'Histoire édifiante de mes commencements'[1]

From *Diary*, first published in *Mikhail Kuzmin and Twentieth-century Russian Culture* (Leningrad, 1990)

I was born on 6 October 1875[2] in Yaroslavl, the next to last son in a large family. When I was born my father was sixty and my mother forty-two. My grandmother on my mother's side was a Frenchwoman called Montgaultier, the granddaughter of Auphrène, a French actor of Catherine the Great's time. All the others were Russians, from the Yaroslavl and Vologda provinces. I remember my father in my childhood as a man in old age, and everyone in the town thought he was my grandfather rather than my father. In his youth he was very handsome in the way of southern or western men;[3] he had been in the navy and then he served as an election official, and people said he had led quite a wild life, but by the time he was old he was a capricious, spoilt, difficult and despotic character. My mother was, I think, a little frivolous and loved dancing; just before her wedding she fell in love with a former suitor who then refused to have her, and after that she spent her life surrounded by children, timid and silent; she avoided her acquaintances and eventually became stubborn both in matters of the heart and of the understanding. I spent the first eighteen months or so of my life in

Yaroslavl and then we all moved to Saratov, where I lived until the autumn of 1884, at which point my father, who had been made redundant, moved at my mother's request to St Petersburg – she had always wanted to go back to St Petersburg, where she came from. I started the *gimnaziya*[4] before we left Saratov.

One thing I remember about my early childhood is being ill, for a very long time; I remember lying on that big double bed with my mother looking at me and my thinking I could see some sort of horror in her eyes; I remember delirium, and how weak I was after I got better, when I had to use a walking stick. I remember the death of my younger brother and seeing him in his coffin, I remember the maid having epilepsy, my sister's husband going mad, and my mother having chicken-pox. I was soon left on my own – my brothers were in Kazan at cadet college, my sisters in St Petersburg at secondary school, and then they got married. All my friends were girls, not boys, and I loved playing with dolls, theatricals, reading and playing light medleys from old Italian operas, which my father admired, especially Rossini.

My friends were Marusya Larionova, Zina Dobrokhotova and Katya Tsarevskaya; I felt a kind of adoration for the boys at my school and eventually fell in love with Valentin Zaitsev, who was in the lower sixth, and later he became my mentor; and, by the way, I was in love with one of my aunties as well. I suffered terribly from jealousy, something that subsequently I've felt only very recently.

My middle brother was aged sixteen or seventeen and still at a scientific secondary school – this was about two years before we moved, and he might have been a senior cadet by then. Sometimes when we were playing in the ravines (this being when we were at the dacha), hidden from chance observers, he would get me to play a game called 'tigers', where we would take turns ambushing and jumping on each other, and the attacker could then do anything he liked with his prey. I understand now that it was only a ruse to make me perform on him with my timid hands and body the things that his bold and trembling hands would do to me, but at the time the lowered eyelids, the tremor on his motionless sunburnt face (which I can still clearly remember to this day), the arousal that I felt in a confused way – it all made me so terrified that I ran off home over the hills. I can remember very well that as I was running I felt for the first time that sweet, dull sensation that it later turned out to be possible to stimulate deliberately; this was what later, in St Petersburg, brought me to masturbation. My brother was afraid

I would tell the people at home and he got angry with me, but I started spending my free time with Sasha Toplyakovsky, who was five years older than me. My brother had a friend he was in love with that he got rid of because the friend started being too nice to me. I understood nothing at the time. I quarrelled and scrapped with my brother because he was always accusing me of being the favourite and a prig and all that. He would make scenes with father and mother because they were unfair to him and right up to the end he was on bad terms with mother.

Almost all our sisters went against father's wishes and there were long periods when he would have nothing to do with them and couldn't stand the sight of them. In short: I grew up a solitary child in a family that was unfriendly and rather difficult, obtuse and stubborn on both sides. I studied at the School of Music and, as always with a child in the provinces, I was thought to be really promising. My earliest favourites were Faust, Schubert, Rossini, Meyerbeer and Weber. That was my parents' taste, though. As for literature, I immersed myself in Shake-speare, *Don Quixote* and Walter Scott, but I didn't read travel books. I knew very little that was Russian and I was indifferent to religion, like all the rest of my family. In the autumn of 1884 the three of us set out for St Petersburg – father, mother and I. After that I lived all the time with my mother until she died.

1884–1894

Life in Petersburg was very uncomfortable, what with the small flat off an inner courtyard, my father's illness and his operation, the obligatory visits to relatives, not doing well at the *gimnaziya*, the lack of light, and the hurdy-gurdies that used to go round the courtyards – it all made me more depressed than I can say. For the first year we lived on the Mokhovaya, and from then on we were always on Vasilievsky Island. We saw a lot of the Myasoedovs; their daughter is now the only close woman friend I've got. I can't remember that time very well.

My father moved to a big flat and then died shortly after falling out with my aunt. I remember him dying. My mother had got tired and lay down for a nap, the maid was sitting by the bed, I was reading *The Cornfield*,[5] where it said that some cannibals had swallowed medicine that was for external application only, and I laughed out loud. 'What's the matter, little Misha?' asked Nastasya. 'I'm just reading something funny.' 'But your

daddy's going to die, listen to him wheezing, and mind you don't wake the mistress.' 'He's always wheezing, I'll just finish what I'm reading.' My father really was breathing heavily and wheezing. 'Misha, dearest . . .' 'What is it now?' Then suddenly there came a wheeze that was louder and harsher, and then another – and then all was quiet. Nastasya cried out loudly, 'Mistress, the master's gone!' I sat down on the divan and mother burst out crying and put her arms round me. As for me, I didn't cry at any time. My aunt, who hadn't visited us one single time while my father had been ill, sobbed loudly, holding on to the coffin. The Myasoedovs looked after me for days on end and tried to take me out of myself.

Things started going badly after that, and we moved yet again, into a small flat in the same building. Soon we were joined from Siberia by my elder sister, the mother of Seryozha.[6] It was terribly cramped, with the baby crying and the wet-nurse having first call on everything. My schoolwork was not going well, but I loved going to school because I loved doing languages and I loved my school chums.

It was then that I had my first liaison, with a pupil who was older than I was, tall, half German, with eyes that were almost white, so bright, innocent and debauched were they, and fair hair. He was a good dancer and apart from breaks between classes we saw each other at dancing lessons, and later I used to visit him at home.

My sister, who had remained in the city, started living on her own, giving lessons, letting rooms, and organizing student parties with beer, sausage and the singing of songs like 'On the Volga a crag . . .', 'My cape I donned . . .' that were favourites with students and chambermaids.[7] I used to visit her and go to her parties, even though they were not my sort of thing at all and I found them unbearably boring. (That was later on, though.) This was also the time that I had my first bout of religiosity, which was directed mainly towards fasts, services and rituals. Along with this I got enthusiastic about the classics and started using make-up on my eyelashes and eyebrows, but later I stopped doing this. In summer we lived in Sestroretsk, which at that time was a little village out in the wilds, and my imagination transformed it into Ancient Greece.

When I was in the fifth form we were joined by Chicherin,[8] who soon made friends with me and whose family had an enormous influence on me. I loved spending my free time in a large, *comme il faut*, old-fashioned upper-class family that enjoyed every creature comfort. Chicherin and I had in common that we adored music; we loved going to the Belyaev concerts[9] together, we studied Mozart, and went to galleries and theatres.

I was starting to write music and we used to play our compositions to the members of our families. First I wrote a few romances (they were worth while melodically but unimaginably bad in other respects), and then I turned to opera and wrote all the introductory music for *Don Juan* and *Cleopatra*; eventually I wrote the libretto as well as the music for *King Lear* after Gozzi. This was my first literary venture. After that I got carried away with the German and French romantics – Hoffmann, J.-P. Richter, de la Motte Fouqué, Tieck, Weber, Berlioz, and so on, I was terribly carried away by all of them.

One summer I lived in Reval, and, because Yusha dreamt up the idea that he was in love with the Myasoedov girl, I made it look as if I were in love with Kseniya Podgurskaya, a girl of about sixteen with the manners of a lady of the regiment. This was the most childish of all my adventures.

Soon we left the *gimnaziya*. My religious mood passed (it had gone so far that I started saying I wanted to be a priest, and at the *gimnaziya* they made fun of me because of that, and also because of my regrettable passion for Stolitsa,[10] and also my liaison with Kondratiev and later with others, my classmates this time), and now I was all for the newer French composers. I was intolerant, over-sensitive, coarse, and passionate. That summer, when I was staying with Chicherin's uncle, B. N. Chicherin,[11] I was preparing for the Conservatoire, being rude to everybody, saying things for the sake of shocking people and trying to behave as eccentrically as I could. Everybody tried to persuade me to go to the university, but I would snort and pronounce paradoxes. At the Conservatoire I took solfeggio with Lyadov, harmony with Solovyov, and counterpoint and fugue with Rimsky-Korsakov. It was at this point I made friends with Yurkevich, and once more I was jealous, I made scenes, and then I quarrelled with him.

In 1893 I met a man I fell deeply in love with, and with him my liaison promised to be lasting.[12] He was four years older than me, a cavalry officer. It was very difficult to find the time to make the journey to see him, to keep secret where I had been with him, and so on, but this was one of the happiest times of my life and during it I wrote masses of music, inspired by Massenet, Delibes and Bizet. This was an enchanting time, the more so because I acquired a circle of high-spirited friends from my own old *gimnaziya*, younger than me, who were now students: Senyavin, Ginze, Repinsky. My mother did not altogether approve of my way of life.

Strange as it may seem, my attempt to poison myself happened at this time. I don't understand what led me to take this action; perhaps I was hoping someone would save me. I think what made me do it was my lack of understanding of life, my thinking of my position as something extraordinary, my dissatisfaction with the Conservatoire, the impossibility of being able to live on a large-enough scale, romanticism and frivolity. I had confessed my liaison with Prince Georges to Chicherin, Sinyavin and my cousin Fyodorov, who was an officer, and he took an extremely serious view of it. I bought up all the laurel water I could find, wrote a farewell letter, and drank it down. It was very pleasant physically, but a horror of death overcame me, and I woke my mother. Then it was all 'Misha, what on earth made you do this?', running up and down stairs, doors banging, tears, the doctor; we took a hansom to the hospital, I behaved as if I were drunk and talked loudly in French.

At the hospital they used a machine to make me throw up (revolting), gave me a bath, and laid me down on a bed on which someone had died that morning. That night a man who had swallowed ammonium kept yelling and jumping up, and one night porter said to the other: 'What a handsome patient they've got here, the only problem is that he's not a Russian.'

My mother visited the next morning; I only spent a few days there before being discharged, but for a time I was not allowed to go to classes and I left the Conservatoire. I felt twice as much in love as before, and I confessed everything to my mother, and she started being tender and frank with me, and we spent a lot of time conversing at night or in the evening over a game of picquet. I don't know why, but we always spoke French. The next spring I went to Egypt with Prince Georges. We visited Constantinople, Athens, Smyrna, Alexandria, Cairo and Memphis. It was a fairy-tale journey, enchanting because of the sense of first-time coming together, and full of unprecedented sights for me. On the return journey he had to visit Vienna, where he had an auntie, and I came back on my own. In Vienna my friend died from heart disease, and I tried to lose myself in intensive work. I started studying at Köner's[13] and every step I took was observed ecstatically by Chicherin, with whom this was my honeymoon year.

1906

Translated by G. S. Smith

12. Greek lovers: This atypical drawing by Pavel Filinov, usually a devotee of Russian folk motifs, transforms two Russian village youths into denizens of some Hellenistic settlement in the early Christian era.

Nikolai Klyuev's tribute to his former lover Sergei Esenin is one of the great poems of homosexual love in the Russian language. In it, Klyuev mourns not only the destruction of Esenin but also of the Russian peasantry, whose despoliation is exemplified in the catastrophic fate of this country boy corrupted by city life.

NIKOLAI KLYUEV
From *Lament for Esenin*

(Moscow, 1926)

My young memory perishes under iron,
And my frail body wilts . . .
– Lament of Vasilyok, ancient prince of Rostov

We, storks caught by the snowstorm,
Said early that which we had to say.
Even as we left our distant native land
We could hear the jangle of the white forest's chain mail.

Devil, remember Esenin in a funeral feast
Of coals and lumps of used soap from the bath-house!
In my wooden trough drunkenly bubbles
The rising dough of weddings and crimson games.

In my new hut the bunks have ruffles
And the icon lamps never go out.
I have swept up words from under the bench's raging blackness
For you, my owl fledgling, my little bird!

You came from Ryazan with a handkerchief from Bukhara;
Unwashed it was, not rinsed or soaped.
You called my open shirt an *ulus*[1]
My teeth – herds of wild horses, my beard – a falcon.

I moulded your soul as a swallow its nest,
Fastened thoughts to it with spit, words with tears,
You were the offertory candle of my dawn,
But you flickered out, fled from me along the paths of scoundrels.

Anguish it was for an old man of the forest
Whose birch-white hair fluttered in the forest;
The sheep bar cried smoke, and spinning wheels
Cast straw in the air – like swan down.

 ° ° °

From under a mare's head, over rotting moss
There stretched a cursed, drunken path.
At your lacquered heels loped a lean, loathsome cat.
There was no salvation from it –

Neither by cross, nor pestle, nor pain;
At wedding and grave it was always at your throat.
You were covered by the scab of merry boredom
And sank your boats in the tavern's wave!

It was for your sins, for betraying your cradle
And the gods of the Russian stove, Medost and Vlas.
And a nauseated dawn embroidered on the river's satin
A deep and bloody face.

Beloved child, dear blasphemer,
A coffin lid covers all sins.
Forgive this old hog
For not watering you with a boar's strength.

Lost to you was a golden lot:
To guard as a fat bee secret places, honey logs,
To kiss only the loaf, the sun and the sky's blue light.
But you dropped the mane of the Khozars[2] – a brother's word.

With you I would lie in an honest coffin,
In the yellow sands, but with no rope around the neck!
Is it true on Russian paths
There grow flowers bluer than your eyes?

I grieve like the bitter grass . . .
I am widowed without you, like the stove without a broom,
Like Nastenka's room with its silks and canvas
Guarded by an empty, idle lace frame!

Translated by John Glad

Mikhail Kuzmin's poem 'But I . . .', in contravention of Kuzmin's 1910
strictures on the need to match 'form' and 'content' (in 'On Beautiful
Clarity': see 'Visions of Art' above), depends for its startling and poignant
effect on the use of a polished verse form for a notably bleak and realistic
depiction of an encounter between two men in the Tauride Garden,
then a favourite cruising ground for St Petersburg gays and round the
corner from Kuzmin's flat in Ryleev (Spasskaya) Street.

MIKHAIL KUZMIN

'But I . . .'

From 'For August', *The Trout Breaks the Ice* (Leningrad, 1929)

At the end of the prospect stands a park:
Some practise there the amorous arts,
For others: well, it's just a park.

Whether they sit, whether they stand,
Their looks betray what they have in hand:
They only seem to sit and stand.

No matter how I come and go,
The park lies on my route, and so
I must walk by, wherever I go.

The nights get darker in August,
Under the trees is even darker.
I didn't mean to visit the park.
I found a companion by accident.
He was tall, in a grey cloth cap,
In a shabby but stylish coat.
We didn't speak when getting acquainted
So I didn't hear his voice:
But I think it would have been hoarse.

'Just round the corner is my flat –
It's a mess, I'd better tell you that –
We'll be there in five minutes flat.'

A thin smile twists his heavy jaw –
(Hey, didn't I meet you once before?)
Our hopes, our fears, gripped in Time's jaws.

My head was clear; I was not drunk,
But a fog rose up as along we slunk,
Mouths, bodies said: You're roaring drunk!

He stripped and lay down like a child.
Philosophical as well as wild,
My heart rebuked the heartless child.

Translated by Catriona Kelly

Sofiya Parnok's frank expression of lesbian sexuality makes her unique among early twentieth-century Russian poets. In the cycle The Silver-grey Rose, *written not long before her untimely death from Graves' disease, she commemorates her last lover, Nina Vedeneeva, a physicist, who was in her late forties when the two women began their relationship.*

SOFIYA PARNOK
'Night. And it's snowing'

From *The Silver-grey Rose* (1932), *Collected Works* (Ann Arbor, Ardis, 1979)

Night. And it's snowing,
Moscow sleeps . . . But I . . .
Oh, but I feel sleepless,
my love!
Oh, the night's so stifling,
my blood wants to sing . . .
Listen, listen, listen!
My love:
in your petals glisten
silver streaks of frost.
You're the one my song's for
my silver rose.
Oh, rose of December,
you shine under snow,
giving me sweet comfort
that can't console.

Translated by Diana Burgin

5
Origins

It has been plausibly suggested that the 'discovery of childhood'
in Russia began only in the 1840s, with the publication of the first part
of Tolstoy's fictionalized autobiography, Childhood, Boyhood, Youth.
Certainly, for most Russian writers of earlier generations (with the
exception of some women writers, such as the early-nineteenth-century
poet Anna Bunina), childhood was taken for granted, rather than being
seen as a unique and significant stage in the formation of the human
personality. The immediate and exceptional popularity of Tolstoy's
Childhood *was to initiate a whole tradition of lyrical memoirs recalling*
idyllic childhoods on country estates, which persisted even after the
Revolution, in the work of émigré writers such as Mariamna Davydova,
whose picture-book memoir, On the Estate, *reflected a final and belated*
afterglow of the pre-Revolutionary gentry chronicle.

Many modernist writers shared the comfortable circumstances in
which Tolstoy's hero, Nikolenka, was reared; but autobiographies such
as Nabokov's Speak, Memory *introduced to established tradition an*
important novelty: childhood was now seen as the primary phase in
shaping a writer's consciousness. Nabokov's emphasis on the artistry of
memory, which is present not only in the studied lushness of his writing,
but also in the recurrent motifs of visual illusion that thread through
his life history (magic lanterns, stereoscopes, trick pictures), is something
quite absent from Childhood. *On the contrary, Tolstoy is eager to vouch*
for the ordinariness of Nikolenka's experience, even stressing his total lack
of artistic talent (a frightful bit of doggerel written for his grandmother's
birthday is mercilessly cited). However, if Nabokov's insistence on the
extraordinary nature of his experiences is typical of Russian modernism,
the sensibility of his memoir, its determination to charm the reader as
well as to assault with intimations of burgeoning genius, is not. Far
more characteristic was an association of childhood with strangeness,

with stark beginnings, the painful birth of an at first uncontrollable consciousness. Bely's Kotik Letaev, for all the cosy sentimentality of the pet-name invoked in the title (Pussykins Letaev), at times uses imagery that is uncomfortably reminiscent of the death scene in Death of Ivan Ilich.

For other authors and painters, childhood could become the raw material of neo-primitivism, and be interpreted as a state of existence that allowed a chink to open upon forgotten and savage worlds. The link between visions of the past and visions of childhood is particularly clear in Khlebnikov's short poem 'Fore-Father', but it is also made in the brilliant and moving short prose autobiography of Nikolai Klyuev, for whom recollections of childhood are also the last rites of a dying culture.

The expansion of ethnographic expertise in the late nineteenth century had meant that even those who lacked Khlebnikov's or Klyuev's first-hand experience of peasant life could no longer see this as a charming pastoral vision. Rather than the haven of nymphs and shepherdesses, the Russian countryside now seemed the haunt of demons, spirits, shamans and witches, as well as of a human population that was separated from primal paganism by the thinnest possible layer of idiosyncratically absorbed Christianity. Populist folklore collectors, themselves usually lukewarm at best towards the Orthodox Church, actively sought out 'survivals of the past', such as the fertility cults of Saint John's (Midsummer) Night, which in turn became the inspiration of art works (most famously, Stravinsky's and Roerich's The Rite of Spring). Appropriation of the heritage of classical Greece and Rome had also altered significantly: it was the influence of Nietzsche's Birth of Tragedy, with its celebration of the Dionysiac, as well as the excavations round the Black Sea, which had made Russians aware of classical cultures in their own territory. Artists and writers varied as to whether they preferred to see themselves as Greek or Roman settlers on the fringes of barbarian culture (a self-image that appealed to Mandelstam) or as bloodthirsty Scythians bent on the destruction of Western civilization (as in Blok's Scythians and Prokofiev's work of that name), but, whichever way, a sense of 'domestic Hellenism' (to borrow Mandelstam's phrase) had facilitated original and idiosyncratic contributions to neoclassical tradition, and Greek and Roman authors were no longer interpreted solely through the prism of French or German literature, even if some writers (such as Innokenty Annensky) were attracted above all by the patina of cultural use that overlaid Greek and Roman texts.

Nabokov's nostalgia for Russia was focused above all on landscape: the city vistas of St Petersburg, on the one hand, and on the other the 'grassy wonderland' of the Nabokovs' country estate at Vyra, whose meadows and woods had given the first inspiration to this intense yet scrupulous observer of the natural world.

VLADIMIR NABOKOV
From *Speak, Memory: An Autobiography Revisited*

(London, Weidenfeld & Nicolson, 1967)

The 'English' park that separated our house from the hayfields was an extensive and elaborate affair with labyrinthine paths, Turgenevian benches, and imported oaks among the endemic firs and birches. The struggle that had gone on since my grandfather's time to keep the park from reverting to the wild state always fell short of complete success. No gardener could cope with the hillocks of frizzly black earth that the pink hands of moles kept heaping on the tidy sand of the main walk. Weeds and fungi, and ridgelike tree roots crossed and recrossed the sun-flecked trails. Bears had been eliminated in the eighties, but an occasional moose still visited the grounds. On a picturesque boulder, a little mountain ash and a still smaller aspen had climbed, holding hands, like two clumsy, shy children. Other, more elusive trespassers – lost picnickers or merry villagers – would drive our hoary gamekeeper Ivan crazy by scrawling ribald words on the benches and gates. The disintegrating process continues still, in a different sense, for when, nowadays, I attempt to follow in memory the winding paths from one given point to another, I notice with alarm that there are many gaps, due to oblivion or ignorance, akin to the *terra incognita* blanks map-makers of old used to call 'sleeping beauties'.

Beyond the park, there were fields, with a continuous shimmer of butterfly wings over a shimmer of flowers – daisies, bluebells, scabious, and others – which now rapidly pass by me in a kind of coloured haze like those lovely, lush meadows, never to be explored, that one sees from the diner on a transcontinental journey. At the end of this grassy

wonderland, the forest rose like a wall. There I roamed, scanning the
tree trunks (the enchanted, the silent part of a tree) for certain tiny
moths, called Pugs in England – delicate little creatures that cling in the
daytime to speckled surfaces, with which their flat wings and turned-up
abdomens blend. There, at the bottom of that sea of sunshot greenery,
I slowly spun round the great boles. Nothing in the world would have
seemed sweeter to me than to be able to add, by a stroke of luck, some
remarkable new species to the long list of Pugs already named by others.
And my pied imagination, ostensibly, and almost grotesquely, grovelling
to my desire (but all the time, in ghostly conspiracies behind the scenes,
coolly planning the most distant events of my destiny), kept providing
me with hallucinatory samples of small print: '. . . the only specimen so
far known . . .' '. . . the only specimen known of *Eupithecia petropolitan-
ata* was taken by a Russian schoolboy . . .' '. . . by a young Russian
collector . . .' '. . . by myself in the Government of St Petersburg, Tsarskoe
Selo District, in 1910 . . . 1911 . . . 1912 . . . 1913 . . .' And then, thirty
years later, that blessed black night in the Wasatch Range.

At first – when I was, say, eight or nine – I seldom roamed farther
than the fields and woods between Vyra and Batovo. Later, when aiming
at a particular spot half a dozen miles or more distant, I would use a
bicycle to get there with my net strapped to the frame; but not many
forest paths were passable on wheels; it was possible to ride there on
horseback, of course, but, because of our ferocious Russian tabanids,
one could not leave a horse haltered in a wood for any length of time:
my spirited bay almost climbed up the tree it was tied to one day trying
to elude them: big fellows with watered-silk eyes and tiger bodies, and
grey little runts with an even more painful proboscis, but much more
sluggish: to dispatch two or three of these dingy tipplers with one crush
of the gloved hand as they glued themselves to the neck of my mount
afforded me a wonderful empathic relief (which a dipterist might not
appreciate). Anyway, on my butterfly hunts I always preferred hiking
to any other form of locomotion (except, naturally, a flying seat gliding
leisurely over the plant mats and rocks of an unexplored mountain, or
hovering just above the flowery roof of a rain forest); for when you walk,
especially in a region you have studied well, there is an exquisite pleasure
in departing from one's itinerary to visit, here and there by the wayside,
this glade, that glen, this or that combination of soil and flora – to drop
in, as it were, on a familiar butterfly in his particular habitat, in order
to see if he has emerged, and if so, how he is doing.

There came a July day – around 1910, I suppose – when I felt the urge to explore the vast marshland beyond the Oredezh. After skirting the river for three or four miles, I found a rickety footbridge. While crossing over, I could see the huts of a hamlet on my left, apple-trees, rows of tawny pine logs lying on a green bank, and the bright patches made on the turf by the scattered clothes of peasant girls, who, stark naked in shallow water, romped and yelled, heeding me as little as if I were the discarnate carrier of my present reminiscences.

On the other side of the river, a dense crowd of small, bright blue male butterflies that had been tippling on the rich, trampled mud and cow dung through which I trudged rose all together into the spangled air and settled again as soon as I had passed.

After making my way through some pine groves and alder scrub I came to the bog. No sooner had my ear caught the hum of diptera around me, the guttural cry of a snipe overhead, the gulping sound of the morass under my foot, than I knew I would find here quite special arctic butterflies, whose pictures, or, still better, non-illustrated descriptions I had worshipped for several seasons. And the next moment I was among them. Over the small shrubs of bog bilberry with fruit of a dim, dreamy blue, over the brown eye of stagnant water, over moss and mire, over the flower spikes of the fragrant bog orchid (the *nochnaya fialka* of Russian poets), a dusky little Fritillary bearing the name of a Norse goddess passed in low, skimming flight. Pretty Cordigera, a gemlike moth, buzzed all over its uliginose food plant. I pursued rose-margined Sulphurs, grey-marbled Satyrs. Unmindful of the mosquitoes that furred my forearms, I stopped with a grunt of delight to snuff out the life of some silver-studded lepidopteron throbbing in the folds of my net. Through the smells of the bog, I caught the subtle perfume of butterfly wings on my fingers, a perfume which varies with the species – vanilla, or lemon, or musk, or a musty, sweetish odour difficult to define. Still unsated, I pressed forward. At last I saw I had come to the end of the marsh. The rising ground beyond was a paradise of lupines, columbines, and pentstemons. Mariposa lilies bloomed under Ponderosa pines. In the distance, fleeting cloud shadows dappled the dull green of slopes above timber line, and the grey and white of Longs Peak.

I confess I do not believe in time. I like to fold my magic carpet, after use, in such a way as to superimpose one part of the pattern upon another. Let visitors trip. And the highest enjoyment of timelessness – in a landscape selected at random – is when I stand among rare butterflies

and their food plants. This is ecstasy, and behind the ecstasy is something else, which is hard to explain. It is like a momentary vacuum into which rushes all that I love. A sense of oneness with sun and stone. A thrill of gratitude to whom it may concern – to the contrapuntal genius of human fate or to tender ghosts humouring a lucky mortal.

The title of Bely's Kotik Letaev is symbolic: the hero of this fictional autobiography is caught between two identities: that of Kotik (the name means Pussykins), the small child in a well-off upper-middle-class household, whose external life is that of toys, minor illnesses and aunties; and that of Letaev (derived from letat, 'to fly'), the precocious interior sensibility that gives an occultic and often sinister significance to ordinary and apparently innocuous phenomena. Names of everyday objects, heard for the first time, resound like incantatory formula; the family doctor seems demonic, a tiresome old aunt a dangerous witch; and, in his thoughts, the small child goes through a reverse-birth experience every bit as terrifying as that endured by Tolstoy's Ivan Ilich.

ANDREI BELY
[Entering into Life]

From *Kotik Letaev*, *Skify*, 1–2 (1917–18)

This was the way I entered into life – corridor, vault and gloom; loathsome creatures chasing after me . . .

 . . . and this image is related to the image of wandering along the corridors of a temple accompanied by a bull-headed man with a staff . . .[1]

It was the voice of my mother that incised all this into me, saying: 'He's burning up, he's on fire!'

I was told later that I was incessantly ill, with dysentery, scarlet fever and measles; and it was exactly at that time that there was . . .

Doctor Dorionov.

I can remember that little room, but I can't remember the objects in it; there was total disorder, though; everything was scattered, scrambled, scrabbled, just like . . . in my soul, which was trembling, alarmed, scarified, because . . .

 . . . inside it was my grandmother, shaking with the frights, but concealing it from me and infecting me with the frights – she's sitting there filling *papirosy*,[2] no bonnet on, bald; and her forehead

wrinkles when, eyes looking over her spectacles, she looks at me without raising her eyes – in a brown housecoat that stands out against the wall of tobacco smoke; the housecoat and the bald head in the weak glow of the candle seem to me ominous. I know that it's all rather nasty, even very nasty indeed; but why – that I cannot understand; whether it is because my grandmother is exposed to me in an unseemly manner (instead of her bonnet with its purple ribbons I see her head, totally naked), or because one entire half of the wall is entirely missing – not four walls but three walls; the fourth is gaping wide with the dark-bottomed grimace of its many rooms –

– all those rooms, roo-
ms, rooms! –

– and if you stepped into them you could never return, but instead you'd be grabbed by certain objects, by which exactly is still not clear, but they would seem to be armchairs in greyish, severe dust-covers, jutting out in the deaf-mute darkness; but what matters is not the armchairs but as it were the extensions of the air's matter and the manifest possibility of feeling the chill coursing of a draught from room to room and seeing something skip into the mirror – an armchair. Nasty rooms, in short!

Meanwhile, someone who realizes how unthinkable it is to be found there – someone, in spite of everything, has still taken up residence, and is moving about among the armchairs as if nothing were the matter, sitting down, then walking about a bit, then making a loud noise for a while, and then directing his vacant tread, which can barely be made out from here, towards the distant emptiness . . .

If one is completely quiet, the footsteps will not want to come near because there's more room for them to knock-knock over there on their own than to torment us with the awful possibility of living through their approach; and – this is what matters most – to feel that the wall is indivisible from the footsteps; one can go on living in this situation; one can also maybe even move about as well; but without making the slightest sound; if you do, he'll start that tapping of his, and shifting from one foot to the other, and it'll get louder and be transformed into claps of thunder.

I sense the impossibility any longer of not making the slightest sound, and I want to make one, and grandmother shudders like an aspen leaf and threatens me with her hand: 'None of that, oh, no-no-no!'

I make a loud click and ouch! what have I done!

It's starting to happen, it already has happened, because the man who was living there has been summoned by the noise and now he's on his way, and he's getting more powerful, from ever so far away he's responding to my summons, and ti-te-ta-to-tu! he's footstepping it out for me, that same man (but who he was, I don't know) . . . This came to pass a great multitude of times, out of the darkness would barge the thundering of that incoherent, severe gait; if only I could run as far as my bed and if only I could snuggle down and fall asleep, then nothing would happen, everything would come to an end, as I was falling asleep I would hear the thundering break down into a quiet whistle and the occasional snoring of someone who was calmingly asleep . . .

Too late . . .

there ran out from the sooty-

black thundering towards

me

an altogether prosaic stout man, fair-haired with a short neck, hale and hearty, and then his corporation would rotate, and his gold-rimmed spectacles would twinkle at me, and also his golden beard; then later on he appeared in reality – this was Artyom Dosifeevich Dorionov, the doctor; I was told later that I never stopped being ill, and I certainly was ill then. I remember that Dr Dorionov wore galoshes of enormous size, with soles made of something hard, and when he entered the front hall they thundered; I always used to recognize him by this thunder-bearing tread, by his enormous racoon coat hanging in the hall, and by his harsh ring at the front door; just before he appeared, there would rise up within me aching pains in my legs; he prescribed cod-liver oil, and while doing so he would slap himself on the knees, his genial chuckles threatening to overwhelm him; I think he kept canaries at home; and when he heard the song:

> The swallow with its blue-grey wing
> Beneath my slanting window –

his eyes would run with tears; he would play draughts with my father, and he would make fun of grandmother, saying that we lived not on the surface of the globe but inside it.

I think that the pursuit and the thundering is the pulsation of the body; consciousness, as it enters the body, experiences it as a clumsy giant; the events of this dream are explicable to me in this way

And, I think . . .

And I think . . .

Passageways, rooms, corridors remind us of our bodies, prefigure our bodies for us; they demonstrate our bodies to us; they are the organs of our bodies . . . of a universe whose corpse is the world that we see; we have cast it off from us, and outside us it has grown stiff; this is the bones of earlier forms of life, over which we walk; the world that we see is the corpse of the distant past; we make our way down to it from our real existence in order to refashion its forms; thus we enter the gates of birth; passageways, rooms, corridors remind us of our past, they prefigure our past for us; they are the organs of our past life . . .

the passageways, rooms, corridors that arose before me in the first moments of consciousness relocate me into the most ancient era of life, the caveman period; I live a life of black emptinesses hollowed out of the mountains with beings running about in the darkness gripped with fear, and with fires; the beings hide out in the depths of these holes because at their entrances are winged monsters; I experience the cave era; I experience the catacombs; I experience . . . Egypt beneath the pyramids, and we're living inside the body of the Sphinx; the rooms and corridors are the hollows inside the bones of the Sphinx's body; if I should bore through the wall, I wouldn't come out on the Arbat,[3] and I wouldn't come out in Moscow at all; perhaps . . . I would see the expanse of the Libyan desert; and among it a Lion lying in wait for me . . .

Imagine the human skull,

it's enormous, enormous, enormous, exceeding all measure and all temples; imagine . . . It rises up before you, its nostrilled whiteness rises up like a temple chiselled into a mountain; this mighty temple with its white cupola emerges from the gloom before you; the curves of its walls are inimitable; its honed flat surfaces are inimitable; and inimitable are the architraves of the columns at its entrance, as of a colossal, honed mouth; the multitooth-columned mouth opens the way to the immeasurable gloom-shrouded halls, the compartments of the skull, the rocky peaks rising to the gloom of the vault, the bony vaults

call to each other with a hollow noise; and lower their embraces; and they form an enormous polyphony, the cosmos coming into being; and the ledges fall away ponderously and perpendicularly; the leer and grimace of the precipices make multiseeing holes, fall away, descending in rapid criss-crossings to the labyrinth of the semicircular canals; you go out into the place of the altar, above the ossis sphenodei . . . To this place the priest will come; and you await; before you is the interior of the frontal bone, and suddenly it splits asunder, and into the breach in this grey-black, whistled, wind-licked world rush walls of light and torrents; and in whorls of clamouring, singing rays they fall, they start lashing your face:

'He's coming, he's coming, here he is'

– and tumbling away from beneath your feet are the flowing locks of a diamond torrent, into the cave-whorls of the brain . . . And you can see Him entering . . . He stands amid the lucid roar of the rays, amid the clean facets of the walls; everything is whiteness and diamonds; and he looks . . . The Very One . . . And with that same glance . . . which you recognize as . . . that which was in your soul as something authentically familiar, most intimately your own, completely unforgettable . . .

A voice, saying

'It is I' . . .

It's here, it's here, it's here – it's here, 'I' . . .

Translated by G. S. Smith

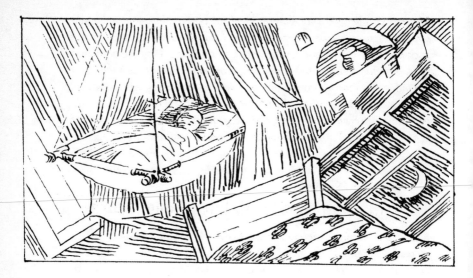

13. Cradle above the abyss: Kuzma Petrov-Vodkin's drawing for his autobiography *Khlynovsk* uses 'spherical perspective', a technique modelled on icon-painting, to suggest the fragmentary images of very early memory.

Marina Tsvetaeva's long biographical article on the painter Natalya Goncharova, written in 1929, is one of the most remarkable tributes ever written by one modernist artist to another. Tsvetaeva portrays Goncharova as her artistic 'double', working in paint rather than in language, but sharing Tsvetaeva's own interest in folklore, her 'masculine' cast of mind and her ambiguous attitude to byt *(everyday life), at once revelling in the earthiness of 'calvings, foalings, births' and aspiring to the eschatological domain of wind, air and sea.*

MARINA TSVETAEVA

[The Childhood of Natalya Goncharova]

From 'Natalya Goncharova', *Volya Rossii*, 5–9 (1929)

Natalya Goncharova was born in central Russia, right in the heart, in Lodyzhino village, Tula Province. In Tolstoy–Turgenev country. Yasnaya Polyana is close, Bezhin Lug[1] still closer. And the tavern in the district capital, Cherm, is where Ivan and Alyosha Karamazov have their heart-to-heart.[2] She and her brother (a year older) were brought up on her grandmother's estate. The grandmother was a bit of a recluse; she never went out – but the whole village would come out to her. In the evenings everyone would gather on the porch to talk: calvings, foalings, births, aches, pains, and how to cure them. The grandmother lived in a half-finished house, Goncharova's parents and the children lived opposite, in a half-demolished one. Why half finished? Why half demolished? And so her childhood ran on, between beginnings and survivals. Two houses, neither of them whole: but two. Her Paris house, the house in the street like a gully, is an elementary deduction. A tent would be an elementary deduction too – or any house bar the luxurious barracks of fashionable modern life. All this echoes in the way she lives. And the inverse lesson learnt from her cradle was: finish what's unfinished! Goncharova's finished 'cathedrals' shout no to all unfinished houses.

'Do you have things you particularly love?' 'I have things I particularly hate. Unfinished things. I turn their faces to the wall so no one can see them, so I can't see them myself. And then, when the moment comes, I turn them back and start all over again.'

To the question that no one ever answers straight away, and some not at all, not because they haven't an answer, but because they haven't thought about it ('but I don't have an earliest memory!' – I've heard it with my own ears), Goncharova answered immediately, exactly: 'My earliest memory? Well, you know the room I told you about, the white one: my brother and I are sitting there at a round table, looking at pictures. A fat book, lots of pictures. How old? Two.'

'And this must be my second earliest, if not my earliest. I spent my whole childhood in the country, but I don't remember any of the winters. I must have been taken for walks, and so on, But I don't remember a thing. This I do remember, though: the threshing floor in spring. I'm being led by the hand, through the puddles. And in one puddle, under the ice and snow' (her voice drops, her eyes sparkle, she's looking straight at me but not seeing me, she's seeing this) 'are – shoots. Green pointed shoots. Lots of grain gets scattered on a threshing floor: these were the first shoots to break through.'

Well, nothing could be more satisfactory than that: her two earliest memories at once, the whole of Goncharova in her cradle – the power of nature and the pull of craft. A fa-at book! Lo-ots of pictures! And don't those green shoots grow all the way through the book of her creation: of her being?

'I never liked dolls, no. I did like cats. But what I loved was making little gardens. (I always loved doing things.) I'd cut bushes and trees out of paper and plant them out in a box. The four sides were walls. A perfect garden.'

'Wouldn't you love to have a tree like that now, one of those little ones?'

￮

'I went to the *gimnaziya*[3] straight from the village. I got it in the neck from everyone, for everything. All the time. Especially from the grammar master, for my spelling.'

'Was it so very bad?'

'It was Tula spelling. I spoke Tula dialect – *h* instead of *f* and all that – and that was how I wrote, too. It must have looked dreadful.'

'It must.'

'And the form mistress gave me hell too. For having ringlets. Only the front part of my hair was curly, that was what confused them: the rest of my hair was as straight as straight, but the front used to go into

two ringlets. I'd try to comb it out, smooth it down . . . Time after time, "Goncharova, go to the headmistress's study at once!" "What, at the curling-tongs again?" And they'd brush it out with a wet brush until my scalp ached. I'd go out like a drowned rat, but I did have to laugh; well, you know what happens to curly hair when it gets wet! And sure enough, as soon as the next break came . . .

'"But your hair's curling, it's curling again!"'

It makes me sad to think of those schoolmarms suspecting that wild young thing of abusing the curling-tongs; no doubt years of teaching nature study had made them forget that some hair curls as naturally as hops, and that you can't do anything with hair like that, any more than you can with hops. Except pull it out by the roots, of course.

How trivial all this is – the fights, the 'chapel',[4] the ringlets. None of it will last; only the 'cathedrals' will. But I want this to last as well.

Do artists have a biography – outside their craft itself, that is? And if they do, does it matter? Does it matter where their craft comes from? And is that where it does come from?

Is there a Goncharova beyond her canvases? No, but there was one before her canvases. A Goncharova before Goncharova, all that time when 'Goncharova' sounded no different from Petrova or Kuznetsova, or, if it did, then only because it echoed the other Natalya Goncharova (her ancestor of unhappy memory).[5] There's no pre-cathedral Goncharova – the cathedrals were all inside her from the moment she was born, and before (oh, the capaciousness of the womb; it could make room for the whole of Napoleon, from Ajaccio to St Helena!) – but there is a pre-canvas Goncharova, a dumb Goncharova, with a brushless hand – and so no hand at all. There were obstacles in the way of the cathedrals – that's what biography means. – How life stopped Goncharova being Goncharova.

Favourable conditions? There are none such, for an artist. Life itself is an 'unfavourable condition'. Every act of creation (I used the word 'artist' earlier because we haven't the German word *Künstler*) is a rebellion against, a remoulding of, a reworking of life – no matter how happy that life is. If not in the teeth of rivals, then in the teeth of ancestors, if not of hostility – life-denying, then of goodwill – life-sapping. Life doesn't make good raw material for art. Brutal as it may seem, the most unfavourable conditions can be the most favourable. (Remember the sailor's prayer: 'Lord, send me a shore to push off from, a sandbank to float free from, and a storm to withstand!')

The very first canvas was an end to that Goncharova, an end to biography. She found a voice (a gaze, I want to say) – were the facts to speak for it? They've a role in a time without words, as a primary source, from then on only as a sort of schoolboy crib, and often a confusing one at that, like Derzhavin's notes to his own poems.[6] Curious, but far from vital. You can do without. And – the poems know better!

If they do have a value, then it's only the value they have with any human life – or maybe less, because they're less indicative. A non-artist lives wholly in life, stakes all on life, life as it is. The stake here's on life as it should be.

The canvas says *sum, ergo sum.* The path to it is – the future.

Some facts are our contemporaries; others our ancestors, they came before us. 'Before I was Goncharova' (before I was for myself, not for others; Goncharova not as a name, Goncharova as a force). The whole of childhood and adolescence is like that. Ancestors, predecessors, forebears. You have to listen to them. The grandparents on their grand-children-to-come. Goncharova as a tiny grandmother to her present self, blind but with the second sight. The hand of Goncharova knew what it was doing as it planted her little garden, though Goncharova herself, at five, did not. The meeting of knowledge and consciousness, of Goncharova's hand and head made her first canvas. Goncharova's hand planting the garden was a hand from the future. Forebears have the second sight. Her hand is cleverer than she is. But later – during her youth – the hand (instinct) gave way. The best illustration of this is Goncharova finishing art school – as a sculptor. Taking a branch for the main trunk. The hand that had, all by itself, painted trees in all the seven times seven colours of the rainbow, had gone blind and reached for the crutch of form. (Grandmother is sleeping, her granddaughter's playing alone.)

If childhood is blind truth, adolescence is sighted error, illusion. Never judge anyone on their adolescence. (Pushkin, who was pudgy and played in the dirt till he was seven, seems to be an exception. But how do we know what he was thinking, or better, what was thinking in him, while he was playing in the dirt? There aren't any witnesses. And what follows – about not judging by adolescence – applies more to Pushkin than to anyone. With the exception of a few poems, Pushkin in adolescence – I'll take it upon myself to say this – simply repels one.)

Later, the harmonies will come together again – as they did with Goncharova. Consciousness has caught up with instinct: not so much a harmony as a fusion. With the first canvas (the fact or act of the first canvas, whatever it was like), Goncharova became a seeing power, an almost divine thing.

Childhood is the history of my truths, adolescence of my mistakes. They both have value: the first is the time of 'God and me', the second the time of 'me and the world'. But when you're looking for the Goncharova of now, you must go back to her childhood, or even her infancy. The roots are there. It may seem odd, but artists are like that: roots first, then branches, and only then the trunk.

Translated by Catriona Kelly

One of the reasons why childhood appealed to Russian modernists was because it seemed to offer liberation from the constraints of gender. Here, Pasternak gives an extraordinarily imaginative depiction of the rich interior life of a young girl growing up in a well-off family just before the Revolution changed the pattern of Russian middle-class childhoods for ever.

BORIS PASTERNAK
From 'Zhenya Luvers's Childhood'

Short Stories (Moscow, 1925)

Zhenya Luvers was born and brought up in Perm. Just as her little boats and dolls had once done, so later on her memories too sank deep into the shaggy bearskins of which there were many in the house. Her father was business manager of the Lunyev mines and had a large clientele among the Chusovaya factory-owners.

The bearskins had been gifts. They were deep brown and sumptuous. The white she-bear in her nursery was like an enormous chrysanthemum shedding petals. This was the one acquired specially for 'young Zhenya's room', admired and bargained for at the shop and delivered by special messenger.

In summer they lived at their dacha on the far bank of the Kama. In those days Zhenya was put to bed early. She could not see the lights of Motovilikha. But once something scared the angora cat, and it stirred suddenly in its sleep and woke her up. Then she had seen grown-ups on the balcony. The alder overhanging the railings was dense and iridescent as ink. The tea in the glasses was red, the cuffs and cards were yellow, and the cloth was green. It was like a delirium – except that this one had its name, which even Zhenya knew: they were playing cards.

However, there was no way of determining what was happening far, far away on the other bank. This had no name, and no precise colour or definite outline. And as it stirred it was familiar and dear, it was not delirious like the thing that muttered and swirled in clouds of tobacco smoke, throwing fresh and flighty shadows on the russet beams of the gallery. Zhenya burst into tears. Father came in and explained things

to her. The English governess turned her face to the wall. Father's explanation was brief: 'That is Motovilikha. For shame! A big girl like you! . . . Go to sleep!'

The little girl understood nothing and contentedly swallowed a rolling tear. In fact that was all she needed to know: what the mysterious thing was called – Motovilikha. That night it still explained everything, because that night a name still had a complete and childlike reassuring significance.

But next morning she started asking questions – what Motovilikha was and what they did there at night – and she learnt that Motovilikha was a factory, a government factory, and that cast iron was made there, and from cast iron . . . But that no longer concerned her. She was more interested in knowing whether the things called 'factories' were special countries, and who lived there . . . But she did not ask these questions and for some reason deliberately concealed them.

That morning she emerged from the state of infancy she had still been in at night. For the first time in her life she suspected there was something that things kept to themselves – or if they revealed it, then only to people who knew how to shout and punish, smoke and bolt doors. For the first time, just like this new Motovilikha, she did not say everything she thought. What was most stirring, essential and vital she kept to herself.

Years passed. Ever since their birth, the children had got so used to their father's absences that in their eyes it was a special feature of fatherdom to lunch only seldom and never to have dinner. More and more often they played, squabbled, wrote and had their meals in completely empty, solemnly deserted rooms. And the cold instructions of the English governess could never replace the presence of their mother, who filled the house with the sweet oppression of her ready anger and obstinacy, like some native electricity. The quiet northern daylight streamed through the curtains. It was unsmiling. The oaken sideboard seemed grey. The silver lay piled there, heavy and severe. The lavender-washed hands of the English governess moved above the tablecloth. She always served everyone his fair portion and had an inexhaustible supply of patience; her sense of justice was every bit as germane to her as her room, and her books were always clean and tidy. The maid who brought the food stood waiting in the dining room and only went away to the kitchen to fetch the next course. It was all pleasant and comfortable, but dreadfully sad.

But for the little girl these were years of suspicion, solitude, a sense of sin, and what in French might be called *christianisme* (because none of this could be called Christianity). And it therefore sometimes seemed to her that matters could not improve – nor, indeed, ought they to, in view of her perversity and impenitence, and it all served her right. Yet, in fact – although the children were never aware of it – in fact, it was quite the reverse: their whole beings were shuddering and fermenting, utterly bewildered by their parents' attitude to them whenever they were there – whenever they returned 'to the house', rather than returning 'home'.

Father's rare jokes invariably failed and sometimes they were quite misplaced. He was aware of this and sensed that the children realized it too, and a suspicion of sad embarrassment never left his face. But when he was irritated he became a stranger – a stranger totally and at the very instant when he lost his self-control. And the stranger awoke no feeling in them. The children never answered him back.

Translated by Christopher Barnes

Before the Revolution, Russia's Jews were marginalized not only by official regulations that severely restricted where they might reside and limited their access to education, but by the secular character of Russian intellectual culture, which associated religious beliefs and practices with cultural backwardness. It was difficult, therefore, for Jewish writers to view childhood as a lost Golden Age. Mandelstam's Noise of Time, written, according to the author's own opening remarks, out of hatred for the era into which he was born, is marked by an ambivalent sensibility: Jewish culture is seen both as a picturesque intimation of oriental luxury and sensuality, and as an expression of intellectual impoverishment and of petit bourgeois concern with money and possessions.

OSIP MANDELSTAM
'Judaic Chaos'

From *The Noise of Time* (Leningrad, 1925)

There is a Jewish quarter[1] in Petersburg: it begins just behind the Mariinsky Theatre, where the ticket touts freeze, beyond the prison angel of the Litovsky Castle, which was burned down in the Revolution. There on Torgovaya Street one sees Jewish shop signs with pictures of a bull and a cow, women with an abundance of false hair showing under their kerchiefs, and, mincing along in overcoats reaching down to the ground, old men full of experience and philoprogeneity. The synagogue, with its conical caps and onion domes, loses itself like some elegant exotic fig-tree amongst the shabby buildings. Velveteen berets with pompoms, attendants and choristers on the point of physical exhaustion, clusters of seven-branched candelabra, tall velvet headdresses. The Jewish ship, with its sonorous alto choirs and the astonishing voices of its children, lays on all sail, split as it is by some ancient storm into male and female halves. Having blundered into the women's balcony, I edged along stealthily as a thief, hiding behind rafters. The cantor, like Samson, collapsed the leonine building, he was answered by the velvet headdress, and the awesome equilibrium of vowels and consonants in the impeccably enunciated words imparted to the chants an invincible power. But how offensive was the crude speech of the rabbi – though it was not ungrammatical; how vulgar when he uttered the words 'His Imperial

Highness', how utterly vulgar all that he said! And all of a sudden two top-hatted gentlemen, splendidly dressed and glossy with wealth, with the refined movements of men of the world, would touch the heavy book, step out of the circle and on behalf of everyone, with the authorization and commission of everyone, perform some honorary ritual, the principal thing in the ceremony. Who is that? Baron Ginzberg. And that? Varshavsky.

In my childhood I absolutely never heard Yiddish; only later did I hear an abundance of that melodious, always surprised and disappointed, interrogative language with its sharp accents on the weakly stressed syllables. The speech of the father and the speech of the mother – does not our language feed throughout all its long life on the confluence of these two, do they not compose its character? The speech of my mother was clear and sonorous without the least foreign admixture, with rather wide and too open vowels – the literary Great Russian language.[2] Her vocabulary was poor and restricted, the locutions were trite, but it was a language, it had roots and confidence. Mother loved to speak and took joy in the roots and sounds of her Great Russian speech, impoverished by intellectual clichés. Was she not the first of her whole family to achieve pure and clear Russian sounds? My father had absolutely no language; his speech was tongue-tie and languageless. The Russian speech of a Polish Jew? No. The speech of a German Jew? No again. Perhaps a special Courland accent.[3] I never heard such. A completely abstract, counterfeit language, the ornate and twisted speech of an autodidact, where normal words are intertwined with the ancient philosophical terms of Herder, Leibniz and Spinoza, the capricious syntax of a Talmudist, the artificial, not always finished sentence: it was anything in the world, but not a language, neither Russian nor German.

In essence, my father transferred me to a totally alien century and distant, although completely un-Jewish, atmosphere. It was, if you will, the purest eighteenth or even seventeenth century of an enlightened ghetto somewhere in Hamburg. Religious interests had been eliminated completely. The philosophy of the Enlightenment was transformed into intricate Talmudist pantheism. Somewhere in the vicinity Spinoza is breeding his spiders in a jar. One has a presentiment of Rousseau and his natural man. Everything fantastically abstract, intricate and schematic. A fourteen-year-old boy, whom they had been training as a rabbi and had forbidden to read worldly books, runs off to Berlin and ends up in a higher Talmudic school, where there had gathered a number

of such stubborn, rational youths, who had aspired in godforsaken backwaters to be geniuses. Instead of the Talmud, he reads Schiller – and mark you, he reads it as a new book. Having held out here for a while, he falls out of this strange university back into the seething world of the seventies in order to remember the conspiratorial dairy shop on Karavannaya[4] whence a bomb was tossed under Alexander, and in a glove-making shop and in a leather factory he expounds to the paunchy and astonished customers the philosophical ideals of the eighteenth century.

Translated by Clarence Brown

Boris Pasternak's second collection, Over the Barriers, *was first published in 1917, but appeared in a reworked edition – toning down some of the startling imagery of the original version – twelve years later. Here, Pasternak recalls his first encounter with the formidable mountains separating European Russia and Asia as a violent confrontation with natural upheaval, a moment of poetic couvade.*

BORIS PASTERNAK
'The Urals for the First Time'

From *Over the Barriers* (Moscow, 1929)

Without obstetrician, in darkness, unconscious,
The towering Urals, hands clawing the night,
Yelled out in travail and fainting away,
Blinded by agony, gave birth to light.

In thunder, the masses and bronzes of mountains,
Accidentally struck, avalanched down.
The train went on panting. And somewhere this made
The spectres of firs go shyly to ground.

The smoke-haze at dawn was a soporific,
Administered slyly – to mountain and factory –
By men lighting stoves, by sulphurous dragons,
As thieves slip a drug in a traveller's tea.

They came to in fire. From the crimson horizon
Down to their timberline destination,
Asians were skiing with crowns for the pines
And summoning them to their coronation.

And the pines, shaggy monarchs, in order of precedence
Rising up, stepped out, row on row
On to a damascened cloth-of-gold carpet
Spread with the orange of crusted snow.

<div align="right">1916</div>

<div align="center">Translated by Jon Stallworthy and Peter France</div>

14. Primitivist Venus: Varvara Stepanova's sketch of a reclining female nude has the powerful solidity of a prehistoric fertility goddess.

Sergei Eisenstein's memoirs (written when the director was confined to bed after a heart attack precipitated by stress in the aftermath of the criticism inspired by Ivan the Terrible Part II) *are typical of the Russian modernist era in that they show how the working methods of the mature artist were generated. In the extracts below, the principles of composition recall Eisenstein's famous theories of montage. Each 'shot' is carefully composed and selected for its symbolic (sometimes Freudian) resonance, and the juxtaposition of one image to contiguous images is highly charged. The 'camera' of Eisenstein's memory jumps about, interlinking different historical eras, and time is sometimes made to run rapidly forwards and backwards – as in the 'anti-Proustian' reminiscence of zabaglione in the first extract, 'Souvenirs d'enfance', in which a childhood memory of eating the substance appears to predict a later memory of Pirandello, rather than the adult sensation's recalling the childhood one.*

SERGEI EISENSTEIN
[A Baltic Childhood]

From *Memoirs*, vol. 1 (Moscow, *Trud* and Muzei kino, 1997)

I *Souvenirs d'enfance*

My first childhood experience was . . . a close-up.

My first memory is a branch of bird-cherry or lilac sticking in through my nursery window.

On the coast at Riga. The Baltic.

At the dacha. In Majorenhof.

Long ago.

That's to say, in my very early childhood – I must have been two or three: according to family records, we stayed at Majorenhof in the summers of 1900 and 1901.

I can remember toys of some kind lying on the floor and highlights made by the sun at the bottom of the nursery wall.

But it's the branch that I can remember clearly.

I have some other memories; these must date to when I was about six years old.

Another dacha at the seaside.

It has to be 1904: Uncle Mitya has come to say goodbye. And he was killed in the battle of Mukden, during the Russo-Japanese War.

Apart from my uncle (a young but dashing officer with a thrillingly curved and shining sabre) I remember the wooden chips, coloured a rich shade of crimson, like blood, with which the paths were scattered, and the whitewashed stones along their edges. And I remember the woman next door.

Slender, with a prominent parting in her black hair.

But I especially remember her Japanese kimono, in the softest shades of sky-blue and rose-pink, and how it kept flying apart (was the kimono war booty? Her husband had fought in that war too.) She seemed to be made of a little head at the top and yawning edges of material at the bottom, nothing more.

I also remember a *son et lumière* in the park: I think it must have been Saint Olga's Day, the name-day of some cousin of mine, and they were performing *His Batman Did It*. The first play I ever saw, I expect, because I remember feeling slightly scared as well as excited, probably because another of my uncles (Uncle Lelya, mother's youngest brother, this time) had painted a black moustache on to his upper lip with coal.

I also remember a gramophone with a huge pink ribbed horn singing hoarsely:

> See that bedbug! Here's my hat –
> I will squash that bedbug flat!
> How I'd like to do it!
> How I'd like to do it!

And from the street beside the dacha the voice of an elderly Latvian flower-seller mixing up her Russian words: 'Norgetmehots' (Forget-me-nots). Followed by a balloon-seller: 'Balloons, buy my fine balloons! Luftballons!'

But more clearly than anything, I remember some fantastically delicious pears in a sweet sauce tasting like an Italian zabaglione. Later, I was to eat just such a zabaglione with Pirandello at a little Italian trattoria in Charlottenburg, Berlin. But that would be much later: twenty-five years later.

II Toys

Vierecke's shop on a Riga street-corner was a paradise for children.
There were lead soldiers from Nuremberg (quite flat) in bast boxes.
 'Gurkhas.'
 'Jungle troops.'
 'Red Indians.'
 'Napoleon's army.'
 Even better was the huge oddments box, from which you could buy
by the piece.
 Backdrops with landscapes on for the tops of tables. With the most
complicated intersections of perspective on them.
 My favourites: 'The Red Indian Swimming' (a half-length) from
Pencroff.
 And also 'Humpty-Dumpty's Circus', a collection of figures with
jointed limbs. A donkey and a clown that you could put in any pose you
wanted.
 Andrei Mentelievich Markov, known as Andryusha, the son of
Mentely Feodosievich Markov, the head of the Riga–Orel Railway
Line.
 My friend: we hung around Riga together.
 Then the family were transferred to Petersburg: an official flat in the
Nikolai Station.
 Next to the archway on to Old Nevsky: it was a big room with lofts
above.
 The lofts were covered in sand, and in them was laid out a model
railway so big it made your head spin.
 It had real points. Signals. Bridges over rivers made of glass and
sky-blue paper. Stations. Glowing lights.
 Technology has never interested me. For instance, I've never grubbed
around inside watches.
 That's probably why I've been so fond of 'technology' in another area
– art – and why I've so often grubbed around in the psychological
problems associated with that.
 When I was playing with Andryusha, I made up a special game with
a comical passenger (any toy figure that came to hand would do) who
kept being late for his train, falling under the wheels, changing the
points by mistake and generally behaving like a clown out of the music

hall, galloping along the track trying to catch the 'mail train' and getting everything all mixed up.

Another of my friends was French; I can't remember his first name or his last name, but I do remember that his father owned a nib factory.

I'll never forget the pounding noise of the machines coating the finished nibs with greasy iron filings so they didn't rust. Although that's also why a fresh 'oily' nib won't write when you first get it, why the ink won't stay on.

The factory-owning dad was red-haired, fat, bristly, like a much stouter and jowlier version of Zola in late middle age.

A trio of amateur dramatics performances on Sundays: the French boy, Alyosha Bertels and me, all acting.

The 'happy end' of one of them.

Alyosha *en travesti*.[1]

The French boy dressed up as an English bobby. And me, for some reason got up as a fantasy version of a . . . rabbi (!), marrying the two of them.

<div align="right">Translated by Catriona Kelly</div>

For upper-class city-dwellers, the contact with 'the Russian People' that was seen as essential by populist sentiment meant above all contact with servants, and in particular wet-nurses and nannies. The tributes of Pushkin to his nurse Arina Rodionovna initiated a literary tradition to which Khodasevich contributes here. However, Khodasevich – whose father was Jewish and mother Polish – celebrates his nurse less as a communicator of folklore than as someone whose selfless and absolute devotion to the child in her care (the third stanza refers obliquely to the fact that Kúzina's own son had died in infancy while she was feeding Khodasevich) not only ensured his physical survival, but gave him the gift of Russian as 'mother tongue'.

VLADISLAV KHODASEVICH
'No, a Tula peasant woman, not my mother'

From *The Heavy Lyre* (Moscow and Petrograd, 1922)

No, a Tula peasant woman, not my mother,
Elena Kúzina, breastfed me. She would keep
My swaddling-clothes warming on the stove-top
And bless me to ensure I'd sleep in peace.

She knew no fairy-tales and sang no folk-songs[1]
But in her enticing trunk, cross-banded with white tin,
She kept a store of delicacies for me:
Gingerbread men, and horse-shaped peppermints.

Although she never taught me any prayers
She shared whatever she did have to give:
Her bitter motherhood and all its cares,
Quite simply everything for which she lived.[2]

Once, when I'd fallen from an upper window
But got up safe and sound (a day I vividly recall!)
At Iverskie Gates[3] she placed a copeck candle
To thank Our Lady for the miracle.

Tormenting nurse's teats with my lips' thirsting,
I sucked out and so earned the agonizing right
To damn you, loving, and to love you, cursing,
Russia, my country, 'empire of thunderous might'.[4]

Taught by your wonder-working genius,
I serve each day the happiness of song:
I have completed my heroic mission
And craft my poems in your magic tongue.

I guard that tongue, passed to me down the ages,
More jealously and with a greater zeal
Than your sickly sons of blood, with their weak patronage,
Who do not feel the half of what I feel.

The years rush by. Who cares about the future?
The past has burnt to ashes in my soul.[5]
But I have a joy that I will not repudiate:
There is a refuge I can call my own.

For in a heart the worms have now devoured
Her love for me lives on, undying, deep:
Near the Khodýnka dead, guests of the last Tsar,[5]
Elena Kúzina, my wet-nurse, sleeps.

Translated by Andrew Reynolds

The revolt against realism that was a defining element in the Russian modernist movement led writers not only to search for artistic traditions that eschewed verisimilitude (such as icon-painting and Renaissance mannerism), but also to re-examine the work of artists who had previously been valued by Russian critical tradition as bytopisateli *(depictors of domestic detail). Of these, the most important were Gogol and Dostoevsky. Vyacheslav Ivanov's study of the latter relates Dostoevsky's work to Nietzsche's concept of the Dionysiac principle – the sexual frenzy and ecstatic religiosity that, for Nietzsche, was at least as important an element in Ancient Greek culture as the 'Apollonian' harmony, balance and sweet reason associated in cliché with the classical world.*

VYACHESLAV IVANOV
[Dostoevsky and the Dionysiac]

From *Freedom and the Tragic Life* (London, Harvill, 1952)

Dostoevsky's urge at any cost to reveal innermost states of the soul through manifestations resembling those of stagecraft has, in its turn, a damaging effect upon his epical calm and clarity. The overemphasis inherent in this mode of presentation conveys an impression of morbidity, even where the experience depicted, however confused it may be, is in itself in no way morbid. The pathetic element is carried to a point at which it threatens to deteriorate into over-excitement, or even into hysteria. Those characters in the novel who most deeply suffer from the tragic dichotomy, act and behave as if in a continual state of alternately calm and turbulent ecstasy.

In sharp contrast to the over-excited tone of the conversations, the style of the narrative is businesslike and sober, reminiscent of a court of law; and, when the whole novel is a study in criminology, the reader often feels as if he were present at a distressing, prolonged and extremely complicated trial. One must, however, pay this price for the enjoyment – painful, yet so uniquely deep and moving – that one derives from the magnificent works of this singular genius.

In the works of Tolstoy, Dostoevsky's great contemporary and rival, everything is bathed in a diffused light that prevents us from becoming

so absorbed in the particular as completely to forget the vast surrounding areas of the whole. In Dostoevsky's works, on the contrary, dark shadows fall, one upon the other, in the corners of gloomy dungeons; whilst a deliberately contrived illumination is glimmeringly refracted upon the vaults and around the recesses. Just so must the labyrinth appear to him who explores the casemates of the spirit, causing the light of his torch to fall upon hundreds of faces that flicker before its flickering flame – faces into whose eyes he gazes with his grave, searching, penetrating gaze.

For Dostoevsky, the watcher and spy upon the occult depths of our souls, needs no daylight. On purpose he veils his poetic creations in half-darkness; so that, like the ancient Furies, he may steal by night upon the culprit, catch him hidden behind a ledge of rock, and then suddenly shed a lurid glare upon the pale and swooning murderer, staring involuntarily at the motionless and blood-drenched body of his victim.

Dostoevsky's Muse resembles, in her ecstatic nature and power of divination, the Dionysiac Maenad, possessed by her god, who 'with loudly beating heart (παλλομένη κραδίην) follows her wild career'; and she also resembles that other manifestation of this Maenad – the snake-haired daughter of darkness, the bloodhound-bitch of the Goddess of Night, the avenging Fury – acquainted with destiny, inexorable and unresting – carrying a torch in one hand, and a scourge of serpents in the other.

<div align="right">Translated by Norman Cameron</div>

Innokenty Annensky's 'What is Poetry', whose first sentence, rather endearingly, is 'I do not know the answer to that question', was written in 1903, though not published until 1911, two years after the author's death. In it Annensky, the Russian translator of Euripides, accepted the symbolist creed of poetry's universality, but reworked this in order to suggest the multiplicity of interpretations that a symbol may undergo as it passes through history. Annensky's work exercised a strong influence on post-symbolist writers, in particular Mandelstam, whose admiration for 'domestic Hellenism' is closely related to the determinedly unpedantic view of classical texts that Annensky, despite spending a lifetime as a schoolmaster, advocated in his writings.

INNOKENTY ANNENSKY
[Homer's Catalogue of Ships]

From 'What is Poetry?', *Apollon*, 6 (1911)

Acertain old German scholar requested that his dying moments should be made beautiful with readings from *The Iliad*; even the catalogue of ships would do. But that assemblage of legends about Agamemnon's comrades-in-arms strikes most of us nowadays as fairly tedious; even the bare list of names can invoke our boredom. What the respected *Gelehrter* found so attractive in them, I cannot say: was it the recollection of his own ideas and writings, or possibly the memory of his early youth, first love, the moon over Göttingen and the horse-chestnut trees? But I can easily grasp that even the catalogue of ships was real poetry in the days when it could still *inspire*. The names of the commanders that sailed to Ilion, those names that now say nothing to us, the very sounds of those names, which have now fallen silent and vanished for ever, once resounded in those lines' solemn cadence (which we also cannot now comprehend); they once drew behind them, in the imagination of the Ancient Hellene, living chains of flowering legends, legends that in our day have become the property of dark blue dictionaries published in Leipzig.[1] It is scarcely surprising that once even those *symbolic names*, set to music, called up before their listeners a whole world of sensation and recollection, in which battle cries mingled with the sounds of glory, and the shine of golden

spears and purple sails with the noise of the dark Aegean waves?

Our wonder at the heroic figures of an Odysseus, an Achilles, still unites us to some extent with Homer's ancient admirers, but it would be simply absurd to reduce living poetry, its shine and scent, to the scholiastics of Cornelius or Overbeck.[2]

But does that mean that Homer's symbols, his real poetry, have perished? No: it simply means that we read a new Homer when we read the old lines, and a 'new one', perhaps, in the sense of one who is a variant of the 'eternal' Homer.

When people ceased hearing the splash of water on the Achaean oars in the soft rush of the hexameter, or the panting of the men at their oars, or the menace of approaching fate, the terror of the fate that had them in its grip, they began to search for new symbols in Homer, to infuse his works with new psychological content. *The Odyssey* in Voss's[3] translation is a wonderful thing, but antiquity is refracted in it through the prism of the German pastoral. Every now and then, the echoing tread of placid chestnut cows with black eyes breaks through the hex-ameters, and one smells steam coming off new milk, glimpses green braces and large reddened hands, good Hans in his wooden clogs; see the smoke of someone's pipe slowly rising, and now here comes the pastor in his black hat, swinging his stick and stooping slightly as he passes the churchyard railings.

But the virtues of the pastoral are hardly more comprehensible to the troubled soul of twentieth-century man than the martial glory of the epic; in that man Homer's symbols arouse quite different aesthetic emotions. Achilles tantalizes our imagination with his mysterious and tragic beauty. Circe, the enchantress, appears before us with a cat's spine, like something out of Burne-Jones, and we can see Helen only through the prism of Goethe and Leconte de Lisle.[4]

Not one great work of poetry is uttered in a final sense during the lifetime of the poet who wrote it, but, in recompense, his symbols long retain questions that draw human thoughts. Not only a poet, a critic and an artist, but every spectator and reader constantly re-creates Hamlet.

A poet does not create images; he presents problems that resound down the centuries. A vast gulf lies between Dante's Beatrice and Fra Beato's[5] *Madonna of the Stars*, for all the similarity of the concepts that inspired them. Have you ever pondered the question of why it is impossible to illustrate poetry? Of course, Botticelli's pencil drawings

are far more interesting than Gustave Doré's luxurious banalities, with the same tempest in the background of every one. But even in the exaggeratedly stern lines of the quattrocentista we see not so much Dante as Botticelli's love for Dante. And even if Dante Gabriel Rossetti himself tried to capture Ophelia[6] for us with his brush, though he might make you succumb to the enchantment of his vision, would he really stop you from taking offence on account of that eternal Ophelia who can exist only symbolically, in the immortal illusion of words?

Poetic creations are planned in and for eternity. Souls enter into those castles of the air from every direction, capriciously adding more and more new galleries to them, and wandering within for centuries on end, meeting each other by chance, if at all.

Translated by Catriona Kelly

Mandelstam, like Shakespeare, had 'little Latin and less Greek', but this impeded neither his passion for classical culture, nor his intuitive and penetrating understanding of Latin and Greek poetry, which are particularly evident in Tristia, *his second collection of poems. Though the following piece was intended as a riposte to Annensky's observations in [Homer's Catalogue of Ships] in 'What is Poetry' (see above), it can also be considered (quite fortuitously) a response to Keats's 'On First Looking into Chapman's Homer', a poem that Mandelstam is most unlikely ever to have read.*

OSIP MANDELSTAM
'Insomnia. Taut sails. And Homer in the night'

From *Tristia* (Petrograd, 1922)

Insomnia. Taut sails. And Homer in the night.
The catalogue of ships; I've read half through the muster,
That long-extended flock, those cranes in straggling cluster
That once upon a time from Hellas rose in flight.

A wedge of cranes holds course for territories new –
The heads of Grecian kings with spray divine are misted –
But whither do you sail? Had Helen not existed,
Ah, men of Achaea, would Troy mean much to you?

Thus Homer, and the sea – all things love sets in motion.
To which shall I give ear? Now Homer says no more,
The dark, declaiming waves, that melancholy roar,
Bring surging round my bed the thunder of the ocean.

Translated by Alan Myers

Mikhail Bakhtin's immensely influential study of Rabelais and 'carnival culture' combines the nostalgic search for a utopia in the past that also characterizes Aleksandr Chayanov's Journey of My Brother Aleksei *with a neo-primitivist enthusiasm for the visceral and anti-individualist character of the late medieval world in which Rabelais lived. In the following passage Bakhtin celebrates the protean solidarity of the carnival crowd (compare Aleksandr Blok's essay on Siena in 'Visions of Art').*

MIKHAIL BAKHTIN
[The Carnival Crowd]

From *The Œuvre of François Rabelais* (Moscow, 1965)

The carnivalesque crowd in the market place or in the streets is not merely a crowd. It is the people as a whole, but organized *in their own way*, the way of the people. It is outside of and contrary to all existing forms of coercive socioeconomic and political organization, which is suspended for the time of the festivity.

This festive organization of the crowd must be first of all concrete and sensual. Even the pressing throng, the physical contact of bodies, acquires a certain meaning. The individual feels that he is an indissoluble part of the collectivity, a member of the people's mass body. In this whole the individual body ceases to a certain extent to be itself; it is possible, so to say, to exchange bodies, to be renewed (through change of costume and mask). At the same time the people become aware of their sensual, material bodily unity and community.

During his Italian journey Goethe visited the amphitheatre of Verona. It was, of course, deserted. Apropos of this visit, Goethe expressed an interesting idea concerning the self-awareness that this amphitheatre brought to the people; thanks to it, they could perceive the concrete, sensual, visible form of their mass and unity.

Crowded together, its members are astonished at themselves. They are accustomed at other times to seeing each other running hither and thither in confusion, bustling about without order or discipline. Now this many-headed, many-minded, fickle, blundering monster suddenly sees itself united as one noble assembly, welded into one mass, a single body animated by a single spirit.

A similar sense of unity was brought to the people by all the forms and images of medieval popular-festive life. But the unity did not have such a simple geometric character. It was more complex and differentiated; most important of all, it had a historic nature. The body of the people on carnival square is first of all aware of its unity in time; it is conscious of its uninterrupted continuity within time, of its relative historic immortality. Therefore the people do not perceive a static image of their unity (*eine Gestalt*) but instead the uninterrupted continuity of their becoming and growth, of the unfinished metamorphosis of death and renewal. For all these images have a dual body; everywhere the genital element is emphasized: pregnancy, giving birth, the procreative force (Pulcinella's double hump, the protruding belly).

❊

Carnival, with all its images, indecencies and curses, affirms the people's immortal, indestructible character. In the world of carnival the awareness of the people's immortality is combined with the realization that established authority and truth are relative.

Popular-festive forms look into the future. They present the victory of this future, of the Golden Age, over the past. This is the victory of all the people's material abundance, freedom, equality, brotherhood. The victory of the future is ensured by the people's immortality. The birth of the new, of the greater and the better, is as indispensable and as inevitable as the death of the old. The one is transferred to the other, the better turns the worse into ridicule and kills it. In the whole of the world and of the people there is no room for fear. For fear can only enter a part that has been separated from the whole, the dying link torn from the link that is born. The whole of the people and of the world is triumphantly gay and fearless. This whole speaks in all carnival images; it reigns in the very atmosphere of this feast, making everyone participate in this awareness.

Translated by Hélène Iswolsky

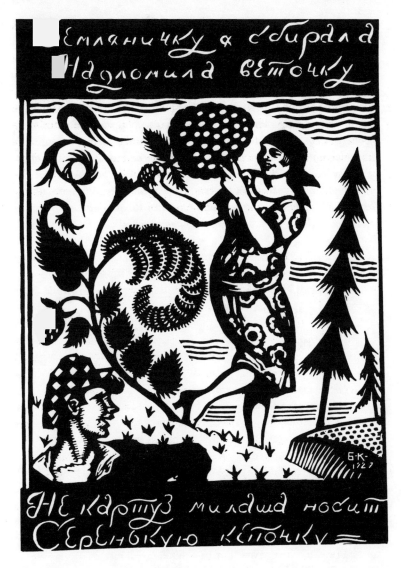

15. Gather ye strawberries while ye may: Boris Kustodiev's updated *lubok* (popular print), decorated with a *chastushka* (rhyming ditty), is one product of the upsurge of interest in urban popular culture that came about during the early Soviet period.

After the October Revolution, Aleksandr Blok, whose earlier work had epitomized the refined pessimism of St Petersburg modernism, went through a surge of enthusiasm for Bolshevik power, which he at first understood as a triumph of popular feeling that would invigorate Russian culture and return it to its energetic barbarian roots. His two very different narrative poems of 1918, 'The Twelve' and 'Scythians', express this understanding (which was soon replaced by disillusion) in very different ways. 'The Twelve', set in contemporary St Petersburg, sees the violence of a detachment of Red Guards as an indirect manifestation of the providential purpose of the Christian God. 'Scythians', on the other hand, asserts Russia's supremacy over decadent Western culture through an aetiological myth linking modern Russian national identity with that of the non-Indo-European pagan nomadic tribes of the Black Sea steppes.

ALEKSANDR BLOK
'Scythians'

(Petrograd, 1918)

Panmongolism! The name, though savage,
yet rings caressful in my ear.
 – Vladimir Solovyov

Mere millions – you. We – teem, and teem, and teem.
 You want to fight? Come on, then – try it!
We're – Scythians – yes! With Asiatic mien
 We watch you, gloating, through our slit-squint eyelids.

For you – long years. For us – alone one hour.
 We, like brute serfs, in blind obedience,
Have held our shield between two warring powers –
 The Mongols and the Europeans!

For years, long years, your ancient furnace forged
 And dulled the avalanches' rumble,
And what a wanton tale of woe was yours
 When Lisbon and Messina crumbled![1]

A thousand years you've watched this East of ours,
 Amassed and melted down our jewels,
Contemptuously, have counted but the hour
 When you could train your guns on to us!

That hour has struck. Misfortune beats her wings,
 You multiply your insults daily.
The day will come when nothing more remains,
 Not one trace, of your *Paestums*,[2] maybe!

Old world! Before you fall in ruins – think,
 While yet you writhe in sweetest torture,
How Oedipus, before the ageless Sphinx's
 Enigma, once, was moved to caution!

So, Russia – Sphinx – triumphant, sorrowed too –
 With black blood flows, in fearful wildness,
Her eyes glare deep, glare deep, glare deep at you,
 With hatred and – with loving-kindness!

Yes, so to love, as lies within our blood,
 Not one of you has loved in ages!
You have forgotten that there is such love
 That burns and, burning, lays in ashes!

We love them all – cold numbers' heartless heat,
 The gift of heavenly visions in us,
We understand them all – keen Gallic wit
 And gloomy-weighed Germanic genius.

Remember all – the streets of Paris's hell,
 The gentle coolnesses of Venice,
The lemon groves – their distant, perfumed smell –
 And, smoke-enswathed, Cologne's immenseness . . .

We love the flesh – its taste, its pinkish tone,
　　The scent of flesh too – choking, deathsome . . .
Are we to blame, then, if we crunch your bones
　　When our unwieldy paws caress them?

It's nothing new for us to seize the rein,
　　To curb our prancing, fiery chargers,
To bend their stubborn will, to break them in,
　　And let them know that we're the masters . . .

Come on, then, come! – into the arms of peace.
　　Have done with war and all its horrors.
Before it's all too late – now, comrades, sheathe
　　Your age-old sword, and we'll be – brothers!

And if not – well, we've nothing left to lose,
　　We too can be perfidious traitors.
For years, long years, you'll stand – accursed, accused
　　Of crippled coming generations.

We'll blaze a trail – we'll beat a broad-flung track
　　Through the dense woods that fringe, behind you,
The gentle brow of Europe. We'll be back –
　　Our Asiatic mugs will find you.

Come on, then – on, unto the Urals. We'll
　　Prepare meanwhile the field of battle
Where cold machines of calculated steel
　　Shall meet the savage Mongol rabble.

But as for us – we'll no more be your shield;
　　Ourselves no longer sword unsheathing,
Through narrow eyes we'll scan the battlefield
　　And watch the mortal combat seething.

We shall not turn aside when raging Huns
　　Go delving into dead men's pockets,
Turn churches into stables, burn the towns,
　　And roast their white-flesh comrades' bodies . . .

For the last time – Old world, come to! The feast
 Of peace-fraternal toil awaits you.
For the last time – the fair, fraternal feast.
 And our barbarian lyre invites you.

 Translated by Robin Kemball

*Here Khlebnikov eschews personal biography, even in the most mytholo-
gized form, and looks back to prehistoric Russia in his search for origins.*

VELIMIR KHLEBNIKOV

'Fore-Father'

From *Lyric Verses and Narrative Poems*, vol. 5 (Leningrad, 1933)

A sack of great seals is on the hunter's shoulder,
His crumpled cloak of fish-skins cascades.
In his quiver, a shrivelled sturgeon, are arrows
Mounted with eagle feathers, shafts straight and slender;
A stone, a toothed flint, makes his nose a beak, and eagle feathers
 are twinned at his tail.
The hunter's great stern eyes are staring, the hunter's flowing
 locks are cruel.
A bow is in his hand, the string taut, pulled carefully forward,
Like the divine eye in a dream, it is ready to rush into singing
 death: Zing!
On rude, round soles, in rude round straps, are his legs.

Translated by Catriona Kelly

Nikolai Klyuev was born in northern Russia, the heartland of the country's traditional culture (it was a source of pride to northern peasants that they had never been enserfed). In this account of his life, Klyuev not only expresses his emotional allegiance with the northern landscape, but also constructs an extraordinarily compressed piece of mythologized autobiography, mixing facts (his move to St Petersburg) with invention (Klyuev is now known never to have visited India).

NIKOLAI KLYUEV
[My Grandfather Kept a Dancing Bear]

Krasnaya panorama, 36 (1926)

My late pa used to say that his pa, that's to say my grandpa, earned his bread by going round with a dancing bear. He took the bear to fairs; he would play his fife, and his clever shaggy friend would dance to the music of the fife. My grandpa's helper was another peasant man, Fyodor the Stork, two yards high if he was an inch; Fyodor would bang the drum and dance like a stork to its beat. The Belozersk Fairs, out Kirillovsk way, brought grandpa round two hundred gold roubles a year.

That's the way my grandpa Timofei lived. He married off his daughters, my aunts, to good solid husbands. And he didn't have to live on small beer and radishes himself; at parish festivals he had a kaftan of Irbitsk cloth to wear, with a finely pleated collar, and a wide girdle from Bukhara to put on over it, and a shirt of fine-wove linen, buttoning at the side.

What brought death and ruin to my grandpa was the decree. A decree came down that dancing bears were to be taken to the district centre and put to death. The skin of my grandpa's breadwinner hung for a long time on the wall of his shack; then in the end it turned to dust.

But the fife the bear danced to still lives on in my songs; it yodels in my dreams and my speech, scattering notes like golden grain. I'm a peasant man myself, but a peasant man of a special breed: my bones are small, my skin white, and my hair soft. I'm six foot tall, thirty-five inches round the chest, and my head measures twenty inches round. My voice is clear, and I speak in a measured way, without spitting or yelping; my eyes are sharp of sight and dove-grey of hue; it's a cool eye,

you can take me or leave me. I'm no drunkard, and not one for smoking, but I've a sweet tooth: I like Tver gingerbread, and blue-black raisins in strained honey, and brewer's wort, and tarts with bramble jam,[1] and boiled sweets, and lollipops of every kind.

I'm quiet and orderly in my ways. I keep my quarters so clean they shine like a silver comb. I polish the table with sand and birch-bark: it's whiter than a walrus tusk.

My life has followed the path that the great Tartar Khan Baty took: from frozen Konevets (the head of the horse, *kon'*) to the porphyry bulls of Shiva.[2] Many tears, many secrets, has that path passed over. The labours I undertook as I crossed the Russian land, my time working the soil, my stay in prison, my first taste of city life, with its people made of stone and paper, the Revolution – all of it is there in my books, where every word has the backing of the life I have lived, where everything bows down before Andrei Rublyov's singing testament,[3] the contour of his thoughts, shot through with the love of Saint Francis of Assisi, a father's love for his son.

Of all the things on the earth, I love fire the best. My favourite poets are Roman the Sweet Singer,[4] Verlaine and King David. My most beloved bird is the lark, most beloved season the fall, colour, a melting dark blue, precious stone, the sapphire. Cornflowers are my flowers, the flute is my little muse.

<div align="right">Translated by Catriona Kelly</div>

6
The Last Circle

One of the differences between Russian culture of the early twentieth century and its counterparts in other European countries is that the First World War, whatever its effects in hastening revolution, had considerably less of an impact on painting and literature than it did in other countries. This is largely, of course, because the catastrophes that were to follow – not only the Revolution of 1917, but the Civil War, the 1921 famine, the Red Terror, the Cultural Revolution, the Stalin Terror and the Second World War – were still more costly in terms of human suffering. However, it was also because the majority of talented painters and writers survived the First World War unscathed. There is no Russian equivalent of Wilfred Owen or Georg Trakl, major poets who were also casualties of combat; many wartime texts were composed a long way beyond the front line, and most were relatively undistinguished (with the exception, perhaps, of Anna Akhmatova's dignified mini-cycle 'July, 1914', an agonized prayer for Russia's survival written at a point when many writers, from Gippius to Mayakovsky, were busy indulging themselves in fandangos of patriotism).

With the advent of Soviet power, however, writers and artists were to find themselves very much at the front line, not simply because the Civil War caught them up as participants on both sides (with, for example, Nikolai Gumilyov fighting for the Whites, while Isaak Babel accompanied the Red Cavalry to Poland), but also because the attention given by the Bolshevik regime to culture as a vehicle for political propaganda and the dissemination of social ideals meant that literature, painting and music were ideologized as never before. While it is perfectly true that, as G. S. Smith has pointed out in an essay on Joseph Brodsky, artists and writers suffered no more than many other categories of Soviet citizen, from Esperanto activists to radio operators on the Soviet railways, they were more visible because they were distinguished from

others by their ability to commemorate suffering. The 1930s poetry of Mandelstam speaks with the suppressed breath of all those waiting for the knock on the door, while the foreword to Akhmatova's Requiem *assigns the poet the duty to survive and to report how the Terror was experienced at second hand, by those waiting in queues for news of arrested relatives. At the same time it was not only professional writers who produced memorable testimony of accursed times: among those who later sat down their recollections of Soviet injustice (many of them women) was, for example, the Ukrainian journalist Hava Volovich, who as a teenager witnessed the horrors of collectivization in the Ukraine.*

After the Revolution, the poetry of the symbolists, most particularly Blok, came to seem prophetic in its expression of the pervasiveness of brutality and its insistence on the frailty of life. What was more, the symbolists' emphasis on death as at once the only significant moment in life, yet also an event of utter insignificance in metaphysical terms (or important only because it at last offered translation to the 'other world' of spirituality) was a source of strength, in that it allowed writers to visualize individual annihilation with dignified stoicism. Comparisons with Dante's Inferno *not only adduced an elevated parallel for the torment that writers suffered, but also suggested that suffering might be a punishment for sin. However, neither stoicism nor religious self-blame detracted from the indignation with which some protested against the annihilation of their community and of their culture. The destruction brought by the Bolshevik Revolution was seen by Blok in 'The Twelve' and Khlebnikov in* Night Search *(1921) as heralding a new and better age, but the magnificent repudiation of the Revolution as a barbarian onslaught was just as common as the celebration of violence. If Remizov's 'Lay of the Ruin of Russia' draws on a medieval tradition of texts bewailing Russia's destruction as the result of attack by nomad tribes to suggest the strangeness of Bolshevism, its non-native origins, some other texts, such as Platonov's 'The Sluices of Epifan' (1927) raised the uncomfortable question of whether the sufferings of Russia might not be self-inflicted; in this story the horrible martyrdom of a British engineer in the reign of Peter the Great stands for the hopelessness of the modernizing project in a landscape that is hostile both in a physical and in a cultural sense.*

Chroniclers of violence by no means always chose to speak from the viewpoint of the victim. Babel's alter ego Lyutov is at most an equivocal participant in violence, his label-name (which translates as 'Savage')

seeming ironic rather than apt, but the central character of Vladimir Zazubrin's horrible story 'The Chip' is an architect of the Red Terror in the Russian provinces. The unnerving flatness of Zazubrin's narration effectively suggests the professional detachment of the abattoir worker, but is found in other texts without this psychological motivation: the suffering and brutality depicted defied easy emotionalism. Indeed, many who endured the grimmest hours of Russian history were sustained by black humour as well as – or indeed rather than – lamentation. Therefore, the selection of texts here includes Khodasevich's studiedly flippant anticipation of the end of a futile life in 'Diary Entry', while Daniil Kharms's story 'Pakin and Rakukin', in which violent death is presented as fairground slapstick, rounds off the section.

After the 1905 revolution, Aleksandr Blok began to anticipate the destruc-
tion of Russian intellectual culture with growing urgency. In the essay
from which the extract below is taken, a classic of neo-Slavophile popul-
ism, he laments the split between the 'Tartar' (that is, sophisticated,
crafty and immoral) intelligentsia and the truly Russian 'People' (the
spelling with a capital letter is here used to suggest the symbolic resonance
of the Russian word narod, *which signifies both 'people' and 'nation').*
Though some of Blok's assertions – for instance, the statement that
drunkenness and debauchery were not characteristic of the 'People' –
were the products of fond self-delusion, his writings were unusually
honest in recognizing the genuine groundswell of anger and frustration
in the Russian lower classes of his day.

ALEKSANDR BLOK
From 'The People and the Intelligentsia'

Zolotoe runo, 1 (1909)

Love of the People awoke in the Russian intellectual in the time
of Catherine the Great, and it has not weakened since. Material was
and still is collected in order to study 'folklore'; bookcases are crammed
full of collections of Russian songs, folk epics, legends, spells and
lamentations; Russian mythology, rites, weddings and funerals are
researched; the intelligentsia feels sorrow for the people; it 'goes to the
People', is filled with hopes and then falls into despair; in the last resort,
intellectuals perish, go to the scaffold and endure starvation for the
cause of the People.[1] Maybe, at last, they have even *understood the soul*
of the People; but in what way have they understood it? Deciding that
you understand *everything* and love *everything* – even what is inimical
to you, even what requires you to renounce all you hold most dearly –
is this not equivalent to understanding *nothing* and loving *nothing*?

What has just been said concerns the 'intelligentsia'. One cannot say
that it has been sitting idle all the time. It has devoted its will, heart
and mind to studying the People. But in the other camp we encounter
the same old slightly sardonic smile, the same old silent way of 'keeping
your thoughts to yourself', the same gratitude for 'instruction' and
apologies for 'backwardness' that seem to be saying 'this is just for now'.

Dreadful laziness and dreadful torpor, as we always used to think; or else the slow awakening of a giant, as we are beginning to think ever more frequently. A waking giant with a sort of smirk on its lips. Intellectuals don't laugh like that, even though it would seem that they are acquainted with all kinds of laughter; but, in the face of the peasant's smirk, which is quite unlike the irony we learnt from Heine and the Jews, or Gogolian 'laughter through tears', or Vladimir Solovyov's chuckle, our laughter dies instantly on our lips; we feel scared and deeply uncomfortable.

Is what I say really the case, have I not just invented this terrible divide, is it not the product of an idle imagination? Sometimes you have your doubts, but apparently this is really the way things are, that is, it seems that these are not only two concepts but two realities: the People and the intelligentsia; 150 million versus a few hundred thousand; groups who have no understanding of each other in the fundamentals.

The few hundred thousand are in frantic ferment, there is an unceasing succession of movements, moods and fighting banners. Over our cities there sounds a persistent rumble that even an experienced ear cannot make sense of; it is the same rumble that was heard above the Tartar camp the night before the battle of Kulikovo Field, as it is said in the legend. There is a creaking of countless carts on the other side of the Nepryadva,[2] a continuous human groaning, and geese and swans anxiously splash and cry out.

Amongst the tens of millions slumber and quiet seem to reign. But Dmitry Donskoi's camp was likewise enveloped in silence; the voivode Bobrok, however, began to weep after pressing his ear to the ground: he heard how the widow was weeping inconsolably, how the mother was convulsed against her son's stirrup. A distant and ominous flash of lightning blazed over the Russian camp.

Between these two camps – the People and the intelligentsia – there lies a boundary line along which they can meet and try to reach an understanding. No such line of connection existed between the Russians and the Tartars, who were two openly hostile camps; but how slender this line is today between two camps that are, in secret, just as hostile to each other! How strange and unusual it is when they come together here! Can there be any 'tribes, dialects, estates' that are not represented along this boundary? The worker, the sectarian, the tramp and the peasant come together with the writer and public figure, the bureaucrat and the revolutionary. But the line is all too slender; as before, the two camps do

not see each other and do not want to know one another; just as before, the majority of the people and the greater part of the intelligentsia treat those who want peace and agreement as traitors and turncoats.

Is this boundary line not as slender as the misty Nepryadva? The night before the battle the river was transparent as it wound its way between the two camps; but the night after the battle and for seven nights thereafter it ran red with Russian and Tartar blood.

This slender line of accord between the People and the intelligentsia sometimes brings forth great men and great causes. These men and these causes always seem to testify that the hostility is ancient, that the question of rapprochement is not an abstract but a practical question, that it needs to be resolved in some special way that we do not yet know. Men who come from the People and have all the depth of the popular spirit quickly become hostile to us; they are hostile because, in some quite essential sense, they are beyond our understanding.

Lomonosov,[3] as is well known, was hated and persecuted in his time by the scholarly establishment; folk storytellers are to us no more than entertaining oddities; the principles of Slavophilism, which had deep roots in the People, were always, fatefully, incompatible with the principles treasured by the intelligentsia; Samarin was right when he wrote to Aksakov[4] about the 'infrangible boundary' separating the 'Slavophiles' from the 'Westernizers'. Before our very eyes the intelligentsia, which had allowed Dostoevsky to die in poverty, took an obvious, though carefully concealed, loathing to Mendeleev.[5]

In its own way the intelligentsia was right; between it and those such as Dostoevsky and Mendeleev lay the very same 'infrangible boundary' (Pushkin's phrase[6]) that defines Russia's tragedy. In recent times this tragedy has been expressed most acutely in the irreconcilability of two principles – the Mendeleevan and the Tolstoyan; this opposition is actually much sharper and more troubling than the opposition between Tolstoy and Dostoevsky that was pointed out by Merezhkovsky.[7]

The last important figure to appear on the boundary line linking the people and the intelligentsia was the figure of Maksim Gorky. He underlines yet again that intellectuals are scared and bewildered by what he loves and how he loves. He loves the same Russia that we love, but the love he feels is different and incomprehensible. His heroes, who are inhabited by the same love, are alien to us; they are taciturn people who 'keep their thoughts to themselves', whose smile promises we know not what. Gorky's spirit is not that of an intellectual; 'we' love

the same thing, but in different ways; and he is made immune to the destructive poison of 'our' love by the vaccine of his own 'healthy blood'.

Baronov's paper,[8] which is primarily 'literary', makes the point that the People should not be worshipped; I think there are not too many of us who do worship the People; we are not savages enough to create an idol out of what is unknown and terrifying. But if we have not for a long time bowed down before the People, neither can we retreat from it or wave it away: for our love and our designs have been pulled in this direction from time immemorial.

So what is to be done?

'We should not worship the People, but just work on it, drag it out of the putrid all-Russian swamp (once we've dragged ourselves out, of course),' says Baronov.

This is the only extra-literary part of his paper. There is no indication of paths to take or means of action. And indeed these paths, which Russian literature is dedicated to searching for, cannot be identified by a single person.

You need to love Russia, to 'travel around Russia until you haven't a penny left', as Gogol wrote just before his death.[9] How can you start loving your brothers? How can you start loving people? The soul wants to love only the beautiful, and poor human beings are so imperfect, and there is so little in them that is beautiful! How is this to be done? Thank God first of all for the fact that you are Russian. For the Russian the path to take is now opening up, and this path is Russia herself. If a Russian can only love Russia, then he will love everything in Russia. God Himself brings us to this love. Without the sickness and suffering that has accumulated in such enormous quantities inside Russia and for which we ourselves are to blame, none of us would feel any compassion for Russia. And compassion is already the 'beginning of love' . . . 'Our monastery is Russia! Clothe yourselves mentally in a monk's habit and, after mortifying yourself completely – for your own sake, rather than for Russia's – go forth and be active in her. Russia is now calling her sons even more strongly than at any time in the past. Her soul is already sick and she is crying out from spiritual sickness. My friend! either your heart is unfeeling, or you do not know what Russia means for a Russian!'

Can these words be understood by an intellectual? Alas, even now they will seem to him the ravings of a dying man, they will call forth just the same hysterical and abusive shouts that were directed at Gogol by Belinsky, the 'father of the Russian intelligentsia'.[10]

It is really true that we do not understand these words on compassion as the beginning of love, on God leading us to love, on Russia as a monastery for whose sake we need to 'mortify all of ourselves for ourselves'. We do not understand because we no longer know love that is born of compassion, because the question of God seems to us to be 'the most uninteresting question of our times',[11] as Merezhkovsky wrote, and because, in order to 'mortify ourselves', to renounce all that is dearest and most personal to us, we need to know in whose name we are doing this. None of these three things could be understood by the 'man of the nineteenth century' about whom Gogol wrote, still less can they be understood by a man of the twentieth century, who sees growing before him 'only a gigantic image of boredom that every day grows to a still more incredible size' . . . 'Life is becoming staler and staler . . . Everything is dead, the grave is everywhere' (Gogol).[12]

Or is the line separating the intelligentsia from Russia really infrangible? While this barrier is still in place, the intelligentsia will be condemned to wander, to move round a vicious circle; it has no reason to renounce itself until it believes that such self-renunciation is an immediate and vital necessity. It is not only that self-renunciation is impossible for the intelligentsia, but that the intelligentsia is still capable of asserting its weaknesses – even as far as the weakness of suicide. What can I reply to someone who has been driven to suicide by the demands of individualism, demonism, aesthetics or, finally, the quite non-abstract, commonplace demands of despair and anguish, if I myself love aesthetics, individualism and despair, or, to put it more briefly, if I myself am an intellectual? If there is nothing inside me that I can love more than my individualist's infatuation with my own anguish, which, like a shadow, always doggedly follows on the heels of this infatuation?

Members of the intelligentsia who find salvation in the positive principles of scholarship, public work and art are growing ever fewer; we observe and hear about this every day. This is natural, there is nothing that can be done about it. We need some other, higher principle. Given that there is no such principle, it is replaced by various forms of rebellion and riotous behaviour, from the vulgar 'theomachy' of the Decadents to undistinguished and shameless self-destruction – all kinds of debauchery, drunkenness and suicide.

In the People we find nothing of the kind. A person who condemns himself to one of the activities enumerated above by this very fact leaves the world of the people and becomes an intellectual in spirit. The actual

soul of the People is sickened by such things. If the intelligentsia is increasingly being taken over by the 'will to death', the People has from time immemorial borne within it the 'will to life'. This makes it clear why even unbelievers rush to the People and try to find vital forces within it: this is simply an instinct for self-preservation. Yet when they do so rush, they run into smirking silence, contempt and patronizing pity, into the 'infrangible boundary'; and perhaps even that is not the most terrifying and unexpected thing they will encounter.

Gogol and many other Russian writers liked to imagine Russia as the embodiment of silence and torpor; but this torpor is coming to an end; the silence is being replaced by a distant and growing rumble that is unlike the cacophonous rumble of the city. Gogol it was who imagined Russia as a flying troika. 'Rus', where on earth are you rushing? Give me an answer.' But there is no answer, just 'the harness bell resounding with a marvellous ring'.[13]

That rumble, which is growing so quickly, which we hear more and more clearly every year, is actually the 'marvellous ring' of the troika bell. What if the troika, around which the 'shredded air thunders and becomes wind', is *flying straight at us*? By rushing towards the People, we are throwing ourselves under the wild hoofs of the troika horses – to our certain death.

Why is it that we are ever more frequently visited by two feelings: the oblivion of rapture and the oblivion of anguish, despair, indifference? Soon there will be no room for other feelings. Is it not because darkness reigns around us? In this darkness we all lose our sense of other people, we sense only ourselves. We can already imagine, as we do in terrifying dreams or nightmares, that the darkness is caused by the shaggy chest of the shaft-horse looming above, whose heavy hoofs are ready to come down on us.

November 1908

Translated by Stephen Lovell

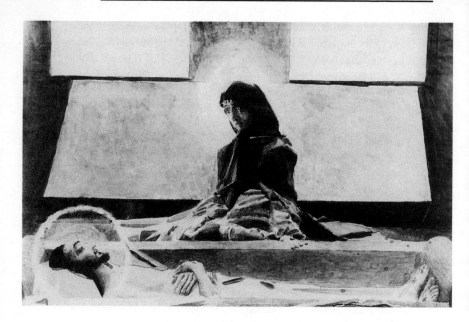

16. Symbolist *pietà*: Mikhail Vrubel's beautiful sketch 'The Lamentation', a design for a fresco in the Saint Vladimir Cathedral, Kiev, is not a canonical icon either in terms of subject or of handling, but it vividly expresses the melancholy religiosity of the Russian *fin de siècle*.

Many of the accounts in this section deal with violence as the instrument of political repression. However, as was recalled by the painter Kuzma Petrov-Vodkin, brought up in the provincial town of Khvalynsk (disguised in his memoirs as Khlynovsk), working-class Russians were as likely to suffer at the hands of their own families as at the hands of the police.

KUZMA PETROV-VODKIN
[Noises in the Night]

From *Khlynovsk* (Leningrad, 1930)

Wife-beating was something that happened all the time in Khlynovsk. It was such a familiar noise in the night that I once fell into a misunderstanding along the following lines.

One evening when I was staying at Samarkand, I got back to town fairly late after a visit to Zeravshan. As I walked down Chupanata Hill, I could see the city glimmering faintly in the distance over the edge of the dip where it lay, surrounded by outlying settlements.

Just then a woman's wailing rose up to me from the nearest settlement. A minute later, it was answered by other wailing. The wails were full of such distress they tore at my heart.

Like a hammer the thought fell on my brain: so the Tadzhiks beat their wives too.

And I felt the dull ache of returning childhood memories.

The misunderstanding was only cleared up when I finally made out some shapes in the place where the wails were coming from and realized that I had heard two jackals howling.

Their voices sounded uncannily like women's as they wailed at the moon behind its greyish membrane of dust raised by the heat of the day and still not settled. One could sense them wondering aloud, jaws chattering with hunger, whether they would manage to eat their fill, to sate themselves on carrion or human refuse.

Would they win their deadly fight with the wolfhounds in the village, and succeed in taking possession of their prey?

Jackals hunt in packs, brothers and sisters together, to stop themselves feeling afraid.

In their howling you could sense the ugly fear of the trapped hunter, a fear so dark and terrible that even death seems joyful by comparison.

It was rather the same in Khlynovsk.

On a July night you go walking along some miserable street. The tumbledown houses, collapsed as though from exhaustion, reflect the silver light of a tooth-marked shred of moon. A velvety and overwhelming arch of sky bears down on the little town.

And you think your callow thoughts about victories to come, how life is about to open up before you, hard work will seem as involving and carefree as a game, and man will bring joy to man. A great new plan for human existence will be set in place. You'll do everything in your power to be a leader in the fight for human happiness . . .

The arch of the sky suddenly lightens, the pulse of your blood and the movement of the earth thrum to the same rhythm.

Everything seems possible. There are no impediments to your desires.

You feel a rush of love for the sleeping town with its humdrum daily routines of work and rest, interrupted by occasional disasters.

But then just at that moment the howl of a woman breaks out, rising above the roof-tops.

If only it were not a human voice!

If only it were not someone's mother, someone's sister, someone's daughter!

And once more the velvety arch of the sky bears down, once more the stifling July heat closes in, and there is nowhere to go, nothing you can do to help, and you yourself start inwardly to bare your teeth, to howl from pity and from fear at the nightmare that is being alive.

Translated by Catriona Kelly

Unlike some other symbolist poets, such as Valery Bryusov and Aleksandr Blok, Zinaida Gippius was from the first antagonistic to the Bolshevik Revolution (indeed, her hostility was so fiercely, and so openly, expressed that her work remained unpublishable until the very last days of Soviet rule). Her Petersburg Diaries of 1917 and 1918, and her powerful civic poetry of the same period, give a vivid account of the day-to-day misery endured by intellectuals living in fear of house searches and confiscations. It was, however, the later tragedy of the Second World War that formed the background to the exceptionally bleak vision below.

ZINAIDA GIPPIUS
'The waves of other-worldly nausea foam up'

From *The Last Circle (and a New Dante in Hell)*, Vozrozhdenie, 198–9 (1968)

The waves of other-worldly nausea foam up,
Break into spray and scatter in black mist,
And into darkness, into outermost darkness,
As they return to subterranean ocean.

We call it pain here, sorrowful and heartfelt,
But it's not pain, for pain is something else.
For subterranean and endless nausea
There are no earthly words, for words are not enough.

A living net of hopes is cast beneath us,
Delivering us from every kind of pain –
Hope for a new encounter, friendship or oblivion
Or, finally, the hope that we shall die.

Be grateful, Dante, that you did not learn all
About the dwelling of the dead, through your friend's care,
That your companion drew you from the circle,

The ultimate one, and you did not see it.
And even if you hadn't died of terror,
You still would not have told us what you saw.

<div align="right">Translated by Simon Karlinsky</div>

Aleksei Remizov was one of the most remarkable stylists of the Russian modernist movement. The archaic sonority of the lament that follows draws on the Apocalypse and medieval Russian tradition, and in particular the fifteenth-century Lay of the Ruin of Ryazan, *in order to represent the Bolshevik Revolution as the triumph of barbarians, heirs to the Tartars.*

ALEKSEI REMIZOV

From *The Lay of the Ruin of Russia*, in *Russia in the Whirlwind*

(Paris, Tair, 1927)

Broad is unbounded Rus, I see thy bonny-belled Kremlin, thy gold-roofed Cathedral of the Annunciation snow-white as the breast of a maiden unspotted, but no silver tribute is promised to me, nor does the bonny bell ring.

Or is it drowned out by the whistle of those unbearable bullets that have stripped the world's heart of pity, the heart of all the earth?

All I hear is war-whoops –

Thou art on fire, Rus has burst into flame, and the charred logs fly.

For time out of mind it was otherwise: all knew for sure that thou wert upstanding, that thou would go on standing wide and unbounded, and not be downcast even in all thy travail and all thy passions.

And were the scab of pestilence to cover thy body, the wind would blow away even that scab of pestilence, and thou wouldst rise again, bright once more and yet more bright, joyful once more and yet more joyful – rise again above thy forests, thy feather-grass steppe, the steppe burbling with joy.

°

O blind leaders, what have you brought to pass?

That blood spilled on brotherly fields has stripped the pity from the human heart, and you have uprooted its soul.

And now it is war-whoops that I hear –

My Rus, thou art on fire!

My Rus, thou hast fallen, and there is no raising thee, thou canst not rise!

My Rus, my Russian land, my motherland, stripped of pity by the blood of brotherly fields, thou hast been set on fire and art on fire!

Translated by G. S. Smith

Babel's cycle of stories about the Russian Civil War, Red Cavalry, *is set
on the Russian–Polish frontier. The narrator, whose* nom de guerre *is
Lyutov (Savage), shares many facts of his biography with Babel: he is
a sensitive, intellectual Jew without previous military experience or
expertise in horsemanship who is posted as a political agitator to a
regiment of anti-Semitic, anti-intellectual Cossacks. Lyutov finds himself
constantly subjected to tests of his manhood: at an early stage he passes
one test by brutally slaughtering a goose, but in the story that follows
he is unable to call up the capacity to kill when circumstances demand
that he should.*

ISAAK BABEL
'The Death of Dolgushov'

From *Red Cavalry* (Moscow, 1926)

The veils of battle were advancing towards the town. At midday
Korochaev charged past us in a black felt cloak – a disgraced *nachdiv*
4,[1] fighting alone and searching for death. As he rode by he shouted to
me: 'Our communications are broken. Radziwiłłów and Brody are on
fire! . . .'

And off he galloped – fluttering, entirely black, with pupils of coal.

On a plain as smooth as a board the brigades were regrouping. The
sun was rolling through a crimson dust. In the ditches wounded men
were eating. Nurses lay on the grass, singing in low voices. Afonka's
reconnaissance troops were scouring the field, looking for corpses and
uniforms. Afonka rode by two paces from me and said, without turning
his head: 'They've given us a bloody nose. Two times two. There's talk
about the *nachdiv*, he's being relieved of his command. The men are
worried . . .'

The Poles had come up to the forest, about three *versts* away from
where we were, and had set up machine-guns somewhere near by.
The bullets were whining and shrieking. Their lament was growing
unendurably loud. The bullets wounded the earth and swarmed in it,
trembling with impatience. Vytyagaichenko, the regimental com-
mander, who was snoring in the blazing sun, cried out in his sleep and
woke up. He mounted his horse and rode over to the leading squadron.

His face was crumpled, with red stripes left by his uncomfortable sleep, and his pockets were full of plums.

'The sons of bitches,' he said angrily and spat a plum stone from his mouth. 'What a filthy waste of time. Timoshka, hoist the flag!'

'What, are we off, then?' asked Timoshka, taking the pole from his stirrup and unfolding the banner, on which there was a star and some writing about the Third International.

'We're going to see what's going on over there,' said Vytyagaichenko, and suddenly he shouted wildly, 'All right, lassies, on your horsies! Call your people together, squadron leaders! . . .'

The buglers sounded the alarm. The squadrons formed up into a column. Out of one of the ditches crawled a wounded man and, shading his eyes with his hand, said to Vytyagaichenko:

'Taras Grigorievich, I've been asked to speak for us all. It seems as though we're going to stay here . . .'

'You'll be left behind . . .' muttered Vytyagaichenko, and he made his horse rear up on its hind legs.

'There's a kind of hope among us, Taras Grigorievich, that we won't be left behind,' the wounded man said as he rode off.

'Stop your whining,' said Vytyagaichenko, turning round. 'Never fear, I won't leave you in the lurch.' And he gave the order to draw rein.

And immediately there rang out the wailing and womanish voice of Afonka Bida, my friend: 'Don't lead us there at the gallop, Taras Grigorievich, it's five *versts*; how will we be able to fight if our horses are all worn out . . . ? There's no point in rushing – you'll be there in plenty of time to pick pears with the Mother of God . . .'

'Quick march!' Vytyagaichenko ordered, without raising his eyes.

The regiment moved off.

'If the rumour about the *nachdiv* is right,' Afonka whispered, hanging back, 'and he is being relieved of his command, then all hell's going to break loose. Full stop.'

Tears trickled from his eyes. I stared at Afonka in utter amazement. He spun round like a top, clutched his cap, gave a hoarse cry and a whoop, and went charging off.

Grishchuk with his stupid *tachanka*[2] and I – we were left alone and till evening rushed about between the fiery walls. The divisional staff had disappeared. No other unit would take us in. The Poles entered Brody and were repulsed by a counter-attack. We drove up to the

town cemetery. A Polish mounted patrol sprang out from behind the gravestones and, shouldering their rifles, began to fire at us. Grishchuk turned around. His *tachanka* cried out with all its four wheels.

'Grishchuk!' I shouted through the whistling and the wind.

'Monkey tricks,' he replied sadly.

'It's all up with us!' I exclaimed, seized by the ecstasy of ruin. 'It's all up with us, father!'

'Why do women go to all that effort,' he replied, even more sadly, 'why the matchmakings and the marriages, why do the godfathers carouse at weddings . . .'

A pink tail shone in the sky and died. The Milky Way came out among the stars.

'It makes me want to laugh,' said Grishchuk sorrowfully, and he pointed with his whip at a man who was sitting by the side of the road. 'It makes me want to laugh, why do women go to all that effort . . .'

The man who was sitting by the side of the road was Dolgushov, the telephonist. His legs spread apart, he was staring at us.

'Here, look,' said Dolgushov, when we drove up, 'I'm finished . . . Understand?'

'Yes,' Grishchuk replied, stopping the horses.

'You'll have to spend a cartridge on me,' Dolgushov said sternly.

He sat leaning against a tree. His boots stuck out in opposite directions. Without lowering his eyes from me, he carefully loosened his shirt. His stomach had been torn out, his intestines had sagged down on to his knees, and the beating of his heart was visible.

'If the Poles come, they'll make a right ninny of me. Here's my passport, write to my mother and give her the particulars . . .'

'No,' I replied hollowly, and gave my horse a dig of the spurs.

Dolgushov spread out his blue palms on the earth and examined them with suspicion.

'You're running away,' he muttered, as he crawled down. 'Run, then, cur.'

The perspiration was crawling over my body. The machine-guns were chattering faster and faster, with hysterical obstinacy. Encircled by the halo of the sunset, Afonka Bida galloped up to us.

'We're giving them a fair old peppering,' he shouted merrily. 'What's going on over here, then?'

I showed him Dolgushov and rode away.

They spoke briefly – I could not hear the words. Dolgushov handed

the platoon commander his little book. Afonka stuck it in his boot and shot Dolgushov in the mouth.

'Afonya,' I said with a pathetic smile and rode over to the Cossack. 'You see, I couldn't do it.'

'Go away,' he replied, turning pale, 'or I'll kill you. You four-eyed lot have as much pity for us as a cat has for a mouse.'

And he cocked the trigger.

I rode off quickly, without turning round, my spine sensing coldness and death.

'Get out of here!' Grishchuk shouted from behind. 'Stop playing the fool!' And he grabbed Afonka by the arm.

'That damned lackey,' Afonka barked, 'he's not going to get away from me . . .'

Grishchuk caught up with me at the turning. There was no sign of Afonka. He had ridden away in the other direction.

'You see, Grishchuk?' I said. 'Today I have lost Afonka, my best friend . . .'

Grishchuk took out a wrinkled apple from under the seat.

'Eat it,' he told me. 'Eat it, please.'

And I accepted charity from Grishchuk and ate his apple with sadness and reverence.

Brody, August 1920

Translated by David McDuff

Vladimir Zazubrin's 'The Chip' depicts the terror of the early Soviet years through the eyes of an official in the Cheka (the 'Emergency Committee' set up by the Bolsheviks in order to control so-called counter-Revolutionary activity). The brutality of the Cheka's activities was unmentionable in print during most of Soviet history, and the story, though written in 1923, appeared for the first time during the glasnost era.

VLADIMIR ZAZUBRIN
[Just Another Day's Work]

From 'The Chip', *Sibirskie ogni*, 2 (1989)

The moon was pale with fever. Its fever, and the freezing cold air, made the moon shiver slightly. Its breath formed a shimmering, glistening gossamer-like haze. Above the earth, this haze became clouds of dirty cotton-wool, while down below it swirled along the ground like fresh milk.

Frozen blue snowdrifts covered the earth like rows of hunchbacked figures in the milky mist. Enveloped in blue snow, slivers of which lay on the windowsills and hung down from the roofs, were the frozen, many-eyed walls of the white, three-storey building with a bluish tinge.

With a look of feverish haste written on their pale faces, two men, standing on a wagon, and dressed in different yellow sheepskin coats (although at night they wore black ones), would send nooses down into the cellar's black throat, and then wait with backs arched and arms stretched out in front of them.

The cellar would call out with a sigh, or a cough: 'Pu-u-u-ull.'

And then up would come the corpses, hauled up on the ropes, as if exhaled or spat out of the smoke-filled throat like phlegm or thick, warm saliva, blue, yellow and blood-red in colour. Once loaded on to the wagon, they were trampled on like phlegm or saliva, and spread all over the floor. When the pile of blue, frozen corpses, bent double like bulging snowdrifts, reached higher than the sides of the wagon, they were covered with a grey tarpaulin, which spread over them like a thick mist. Then the wagon would move its steel feet, extricating them from the deep blue snow, breaking the drifts' hunched backs and crunching

through their white bones. Finally, it would set off through the prison gates with its iron frame clanging and its engine snorting in quick, short breaths, its whole bulk dripping with the dark, ruddy sweat of oil and blood. Shrouded in its grey mist, each grey wagon would make its way to the cemetery, rocking the streets and the houses as it rumbled past. Those who lived along its path knew only too well what it was and where it was going. Dragged from their beds by the commotion, they would press their sleepy noses against ice-cold windows, their faces freezing to the glass. And their trembling knees and their shaking bed and the rattle of the crockery and the window-frames would make these people cover their heavy, festering eyes in fear, as from their stinking, sleep-filled mouths came the helpless, spiteful, horrified whisper 'The Cheka . . . It's from the Cheka . . . It's the Cheka transporting its cargo.'

Back in the yard, Srubov, Solomin, Mudynya, Bozhe, Nepomnyash-chikh, Khudonogov, the commandant, two men with shovels and the guards (guards who now had no one else to guard) – all of them, like the wagons, crunched through the hunched backs of the snowdrifts (although *their* feet were not made of steel but were animate, human feet, and by now extremely weary). Solomin walked next to Srubov and ahead of the others. He had blood on the right sleeve of his overcoat, on the right side of his chest and on his right cheek. In the moonlight it looked like soot. He spoke in a weak but cheerful voice – the voice of one who has undertaken an enormous task, which, although difficult, nevertheless serves an important purpose.

'Yer know that tall, 'andsome one – the one that got shot in the mouth? It would 'ave bin good to pair 'im off with that blue-eyed bit. Would 'ave given good stock, tha' would.'

Srubov looked at him. Solomin spoke quietly, his arms outstretched like an earnest businessman. 'What's he talking about?' Srubov wondered to himself, before it struck him – Solomin was talking about people. With his tired eyes, all Srubov could make out was the bunch of crucifixes, miniature icons and amulets in Solomin's left hand.

'What have you got those for, Efim?'

Solomin smiled brightly. 'Toys for the kids, Comrade Srubov. Can't get toys anywhere these days. Just ain't any.'

Srubov remembered his own son, Yury, little Yurasik, dear little Yukhasik.

The men behind him were laughing and swearing. They were talking about the prisoners they had just shot.

'The priest signed the confession – and the General did too . . .'

Srubov gave a sleepy yawn. He turned round to look at them with his pale, white face.

'The cheerful sort, like that geezer in the pince-nez, are always easier to kill. But them what whine . . .'

It was Naum Nepomnyashchikh. Bozhe only half agreed with him.

'They're always so club-footed, though . . .'

They spoke brashly, their heads raised in cheerful self-confidence.

Srubov's tired brain had to make a considerable effort to grasp what they said. He realized that it was all just empty talk, mere bravado. They were all exhausted. They were straining their necks in an effort to hold up their leaden heads. And they were only using vulgar language in order to cheer themselves up. A foreign word suddenly appeared in Srubov's memory – they were all *doped*.

It took Srubov a long time to reach his office. He closed the door and locked it behind him. He turned the key in the lock and examined the door handle. It was clean; there were no marks on it. He held his hands under the light – there was no blood on them, either. He sat in the armchair and then jumped up again, bending over to look at the seat – that was clean too. There was no blood on his coat, or on his fur hat. Opening the safe, he reached behind a pile of papers and pulled out a quarter-litre bottle of spirits. He poured himself exactly half a tea glass of the liquid, which he then diluted with some boiled water from a carafe. Standing in front of the fire, he shook the muddy liquid and peered closely through the glass – there was no red in it. The liquid gradually became clear. Srubov raised the glass to his lips, before the same word once again triggered itself off in his memory – *doped*.

It was only when Srubov had finished his drink and taken a few paces up and down the room that he noticed he had left behind him a red dotted line that formed a neat, sharp-pointed triangle from the door to the table, from the table to the safe, and from there back again to the door.

Just at that moment the bronze knick-knacks on his writing table began to stare at him impertinently, and the metal couch raised its thin bent legs off the floor in a gesture of distaste. The figure of Marx, hanging on the wall, stuck out his white, shirt-clad chest. Catching sight of him, Srubov flew into a rage. 'To hell with you and your white shirts, Comrade Marx.'

Angrily, painfully, Srubov picked up the bottle and the glass and

walked heavily over to the couch. 'Just look at you, you tight-fisted aristocrat. Just what you deserve.' He deliberately kept his boots on. He stretched himself out and knocked the pen-holder on his desk with the heel of his boot. The ash-blue upholstery was covered with mud, blood and something wet that looked like snow. Srubov put the quarter-litre bottle and his glass down on the floor beside him. He longed to plunge into a river, or the sea, and wash himself spotlessly clean. As he lay on the couch, he finished off his drink. The liquid burnt his mouth, like pure, neat alcohol. And his brain, intoxicated from the spirits, from the charcoal fumes in the cellar, from the fatigue, and from insomnia, produced drunken thoughts that were almost completely nonsensical, almost totally incoherent.

'Just why does Marx have a white shirt, anyway?'

Translated by Graham Roberts

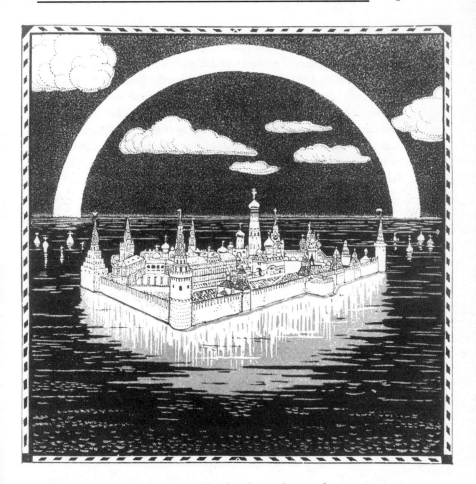

17. The killer state: Mstislav Dobuzhinsky's 'The Pacification' was an immediate and angry response to the brutal suppression of strikes and uprisings by the tsarist regime in 1905. However, the image of the Kremlin as an ark floating on a deluge of blood now works as a powerful encapsulation of twentieth-century Russian history in a broader sense.

Hava Volovich, the author of the passage below, had a very different background from the majority of writers included in this anthology. From a peasant family in the small Ukrainian town of Mena, she went through factory school and then worked on the local newspaper as a printer, and finally as a journalist. Her memoirs have no trace of Soviet journalese, however; they are written in a style close to that of the spoken language, and give a gripping account of the 'journey through hell' experienced by Volovich and many in her generation. Even before her arrest and lengthy stay in the prison camps of the far north, Volovich had witnessed the horrors of the artificial famine caused by the collectivization of agriculture in the Ukraine, which she recounts here.

HAVA VOLOVICH
[Eyes Like Glass Buttons]

In S. Vilensky (ed.), *It Still Smarts: Women's Memoirs of the Gulag* (Moscow, 1989)

The sister of a friend of mine, a girl of fifteen, 'fell in love with' a policeman. 'Love' isn't the right word, of course: Dunya was trying to find a way to keep from starving. At sixteen she gave birth to a baby daughter, and her husband sent them off home to his father, who was a parish priest in some distant village.

A year later, back Dunya came to her mother. Her husband's parents had been sent into exile, but, since her marriage hadn't been officially registered (she was then under-age), she was left behind. Dunya had been cast to the four winds. The village authorities wouldn't let her leave with one crumb of bread or a single stitch of clothing. One of the activists grabbed the blanket the baby was wrapped in, tipped the child out on the bare bedstead and flung the blanket on to the pile of confiscated goods.

You can get used to your own troubles, as you can to a chronic illness. It's other people's misfortunes that sometimes make you cry. No, it wasn't Dunya's troubles that got to me. She left her baby with her mother and went off to find something better. Her father died, and the whole family was starving to death. If the mother got hold of any food, she gave it to her own children. She gave Vera, her granddaughter, nothing: that way she'd die quicker.

Verochka turned into a living skeleton, with a coat of whitish fluff coating her yellow shrunken skin. Day after day she lay in her cot, eyes wide open like shining glass buttons on her corpse's face. But still she would not die. Her mouth, which hadn't yet learnt to form the word 'mama', whispered 'issi' – she wanted something to eat.

I was the only person in my family who was getting a ration – thirty pounds of flour a month. It was a reasonable amount for one, but far too little for a family of seven. The only way we could make it last two weeks was by preparing a thin gruel with it, flavoured with goosefoot and sorrel. But often even this miserable meal stuck in our throats. Crowds of starving people from villages further south would gather around the window, rending our hearts with their long-drawn-out piteous wails of 'Give us, give us, hungry!'

I saved Verochka a small share of my food if we had anything to eat at home. She would fasten her skinny hands (they were like chicken-feet) on the bowl and swallow the contents in seconds. Then she would point at the window. My friend would carry her out and put her down on the grass in the sun. Verochka would roll over on her belly in an instant. With her yellow old woman's hands, she'd start snatching at the grass and stuffing it in her mouth.

That child was made of iron!

A grass diet finished off many, many other children and adults. But Verochka survived; she lived on into better times and turned into the most gorgeous little girl. (Later on, when I saw people in the camps with pellagra, I remembered Verochka lying on the grass, and marvelled at how her infant brain had hit on this way of staving off malnutrition.)

As I set the texts letter by letter, I would think about what they said, and try to grasp what it all meant. 'Grain levy.' 'Voluntary norm.'[1] The phrases were commonplaces of the time. But what terrible things they concealed.

'Voluntary norm' meant collective farms ruined before they'd had a chance to get started. 'Grain levy' meant crowds of starving people wandering from place to place in search of food. It meant hundreds of deserted villages. It meant corpses on the streets, abandoned children, heaps of naked skeletons on hospital wagons (no one even bothered to cover them with a sheet) that were carted straight to the graveyard, then tipped like rubbish into the same pit.

I always tried to use the long way back from work, round by the vegetable gardens and the cemetery, rather than going the more direct

way down the main street. I couldn't bear having to avoid the eyes of starving people all the time. But once I saw a little boy about six years old by the cemetery fence. His greenish puffy face was covered in cracks, out of which some kind of liquid was oozing; his bloated, cracked legs were running in it too. Something green and wet was trickling down from under his homespun trousers. It must have been the grass he'd just eaten. His stomach had atrophied, and he could no longer digest anything at all.

The boy stood immobile. From his half-open mouth came a thin cry: 'Ee-ee-ee!' It wasn't a call for help; he didn't expect that from anyone. He'd seen adults – who were supposed to take care of children, not exterminate them – come and snatch his family's last crust of bread, condemning them to death by starvation. People were enemies; he was afraid of them. And so he'd come away from the busy streets, where there was nothing for him, to the cemetery fence, perhaps hoping to find something to eat. But it was death that had found him.

Translated by Catriona Kelly

*In Britain, astonishing numbers of otherwise sober-minded individuals
are reputed to dream about being invited to tea with the Queen. In
Russia, the nocturnal subconscious is at least as likely to fantasize about
audiences with writers as with political figures. This extract from Yury
Olesha's memoir of Mayakovsky begins with just such a fantasy; all the
more unexpected, then, is the grim record of a real-life encounter with
the poet that follows.*

YURY OLESHA
[Two Visions of Mayakovsky]

From *Selected Works* (Moscow, 1956)

I had a dream that I was talking to Mayakovsky face to face.
There was no one else in the room and we were sitting close together.
I could see his face right before me and I was telling him that, over and
above his great narrative poems, this book (I was holding a book), this
book, I was saying, this book . . . I can't remember what I said next but
it was something wildly enthusiastic. I also told him I was writing a book
about him. He liked that. I put especial emphasis on what I was saying
because I somehow knew that he was dead. His face was kind and sad;
there were even tears in his eyes.

The day Mayakovsky died – the evening of that day – we all gathered
in the flat on Gendrikovsky Lane[1] (where the Mayakovsky Museum now
is, only then it was still the Briks' private flat). Suddenly, loud bangs
started coming from Mayakovsky's room – very loud, obscenely loud,
in fact; you'd have thought it must have been wood they were chopping.
But they were cutting open Mayakovsky's skull to get his brain out. We
sat in total, horrified silence. Then out of the room came a man in a
white coat and rubber boots – either a police official or a medical orderly
of some kind, I suppose; at any rate, a complete stranger to us all. He
was carrying a bowl covered with a white cloth that was raised to a
pyramidal shape in the middle. It looked as though he were carrying a
curd cheese *pashka*.[2] But it was Mayakovsky's brain in the bowl.

Translated by Catriona Kelly

The First of May, celebrated as 'labour day' by workers all over Europe in the late nineteenth and early twentieth centuries, was naturally adopted by the Soviet government as one of the most important days in the new calendar of festivals. For Osip and Nadezhda Mandelstam, however, the day had a personal resonance directly antagonistic to the collective rejoicing sponsored by the state.

NADEZHDA MANDELSTAM
From 'The First of May'

From *Memoirs* (New York, Atheneum Publishers, 1970)

As the first of May came nearer, the whole rest home was spring-cleaned and got ready for the holiday. People were already trying to guess what they would be given for dinner on the day itself. There were rumours that ice-cream would be on the menu. M. was dying to get away, and I tried to calm him down, pointing out that he could scarcely walk to the station on foot, and that in any case it would all be over in a couple of days.

On one of the last days before the end of April, M. and I went over to the dining room – it was in a separate building not far from the main one. On the way we saw two cars standing outside the doctor's house and trembled at the sight of them – this was the effect cars always had on us. Right by the dining room we ran into the doctor with two strangers. They were large, beefy and well-groomed types – very different from the sort who came to stay in a rest home. One was in military dress and the other in civilian clothes. They were obviously officials, but not local ones by the look of them. I decided they must have come to inspect the place. 'I wonder if they've come to check up on me,' M. said suddenly. 'Did you notice how he looked at me?' Sure enough, the one in civilian clothes had looked around at us and then said something to the doctor. But we soon forgot all about them. It was more natural to assume that they were a couple of inspectors from local Party head-quarters who had come to see how the rest home was preparing to celebrate May Day. In a life such as ours we were always having fits of panic – everybody was constantly on the watch for signs of imminent disaster, and, whether our fears were justified or not, they kept us in a

state bordering on dementia. We tried so much not to give way to these fears that bouts of cold terror were always succeeded by moods of recklessness, during which we were quite capable of talking with police spies as though they were bosom friends.

On the first of May we didn't go out, except to the dining room for our meals, and the whole day we could hear sounds of revelry – shouting, singing and sometimes fighting. One of the other inmates, a woman textile worker from a factory near Moscow, took refuge with us. M. sat and joked with her, and I was terrified in case he said the wrong thing and she went off to denounce him. They got talking about the arrests, and she mentioned somebody at her factory who had been picked up, saying what a good person he was and how kind he had been to the workers. M. started questioning her about the man. When she had gone I told him at great length how foolish he was to be so indiscreet. He assured me he would mend his ways and never say another word to strangers. I shall never forget how I then said: 'You'll have to go all the way to Siberia before you mend your ways . . .'

That night I dreamt of icons – this is always regarded as a bad omen. I started out of my sleep in tears and woke M. as well. 'What have we got to be afraid of now?' he asked. 'The worst is over.' And we went back to sleep. I had never before dreamt of icons, nor have I since – we had never possessed any icons of our own, and the old ones that we loved had only artistic meaning for us.

In the morning we were wakened by somebody knocking quietly on the door. M. got up to open the door and three people came in: two men in military uniform and the doctor. M. began to dress. I put on a dressing-gown and sat on the bed. 'Do you know when it was signed?' M. asked me, looking at the warrant. It appeared that it had been signed about a week previously. 'It's not our fault,' one of the men in uniform explained, 'we have too much to do.' He complained that they had to work while people were on the spree over the holiday – it had been very difficult to get a truck in Charusti because everybody was off duty.

Coming to my senses, I began to get M.'s things together. One of them said to me in their usual way: 'Why so much stuff? He won't be in long – they'll just ask a few questions and let him go.'

There was no search. They just emptied the contents of our suitcase into a sack they had brought with them, and that was all. Suddenly I said: 'We live in Furmanov Street in Moscow. All our papers are there.' In fact there was nothing in our apartment, and I said this simply to

distract attention from the room in Kalinin where there really was a basket full of papers. 'What do we need your papers for?' one of the men said amiably, and he asked M. to come with them. 'Come with me in the truck as far as Charusti,' M. said to me. 'That's not allowed,' one of them said, and they left. All this took twenty minutes, or even less.

The doctor went out with them. I heard the truck start up outside, but I just remained sitting on the bed, unable to move. I didn't even close the door behind them. When the truck had left, the doctor came back into the room. 'That's the way things are now,' he said. 'Don't despair – it may be all right in the end.' And he added the usual phrase about how I should keep my strength up for when I needed it. I asked him about the people we had seen with him the day before. He said they were officials from the district centre, and that they had asked to see the list of people staying in the rest home. 'But it never occurred to me that they were looking for you,' he said. It was not the first time they had come to check the list the day before someone was arrested, and once they had called by phone to ask whether everybody was present. The great man-hunt also had its techniques: they always wanted to make sure a person was at home before coming to arrest him. The doctor was an old communist and a very decent person. To get away from everything he had hidden away here in this simple workers' rest home where he was responsible for the administration as well as the medical treatment of the inmates. But the life outside had nevertheless invaded his refuge – there was no escaping it.

In the morning the woman textile worker I had been so afraid of the evening before came to me and wept, cursing the 'sons of bitches' for all she was worth. To get back to Moscow I would have to sell off my things. I had given what little money we had to M. The woman now helped me to sell my stuff and to pack for the journey. I had to wait an agonizingly long time for the cart that was to take me to the station. When it eventually came, I had to share it with an engineer who had come to the rest home just for the May Day holiday to visit his father, who was staying there. The doctor said goodbye to me in my room, and only the woman textile worker came outside to see me off. On the way, as we rattled along in the cart, the engineer told me that he and his two brothers all worked in the automobile industry, so that if one of them was arrested, the other two would be picked up as well – they should have been more careful and gone into different things, as it would be a terrible blow for their father if they all three disappeared. I decided

he must be a Chekist and would probably take me straight to the Lubyanka. But I didn't care any more.

M. and I had first met on May Day in 1919, when he told me that the Bolsheviks had responded to the murder of Uritsky with a 'hecatomb of corpses'. We parted on May Day 1938, when he was led away, pushed from behind by two soldiers. We had no time to say anything to each other – we were interrupted when we tried to say goodbye.

In Moscow I went straight to my brother and said: 'Osya's been picked up.' He went at once to tell the Shklovskys, and I went to Kalinin to get the basket full of manuscripts we had left with Tatiana Vasilievna. If I had delayed for a few more days, the contents of the basket would have been thrown into a sack (like the stuff from our suitcase in Samatikha) and I myself would have been taken away in a Black Maria – which at that moment I might have preferred to remaining 'free'. But then what would have happened to M.'s poetry?

Translated by Max Hayward

Even those Soviet citizens who escaped imprisonment, or the incarceration of their relations, endured considerable hardship in the early 1930s, a time of repeated and severe food shortages as well as of social and cultural upheaval. The poet Sofiya Parnok, in poor health and forced to support herself by translation, gives voice here to a despair that was felt by many.

SOFIYA PARNOK
[The Ice Hole]

From *Collected Works*, S. Polyakova (ed.) (Ann Arbor, Ardis, 1979)

They've cut a hole through
the dark blue thickness of ice:
an air vent for big fish and little,
water for water hoistings,
a way out for a weary woman traveller,
if, in the end, life turned out
not to be travelling her road,
if she had nowhere to go.

1931

Translated by Diana Burgin

Kolyma, in the far north-east of the Soviet Union, was the setting of some of the Soviet Union's grimmest labour camps. The degradation and misery endured by prisoners there is unflinchingly recorded by Varlam Shalamov.

VARLAM SHALAMOV
'In the Night'

From *Kolyma Tales* (first Russian edition London, 1978)

Supper was over. Slowly Glebov licked the bowl and brushed the bread crumbs methodically from the table into his left palm. Without swallowing, he felt each miniature fragment of bread in his mouth coated greedily with a thick layer of saliva. Glebov couldn't have said whether it tasted good or not. Taste was an entirely different thing, not worthy to be compared with this passionate sensation that made all else recede into oblivion. Glebov was in no hurry to swallow; the bread itself melted in his mouth and quickly vanished.

Bagretsov's cavernous, gleaming eyes stared into Glebov's mouth without interruption. None of them had enough will-power to take his eyes from food disappearing in another's mouth. Glebov swallowed his saliva, and Bagretsov immediately shifted his gaze to the horizon – to the large orange moon crawling out on to the sky.

'It's time,' said Bagretsov. Slowly they set out along a path leading to a large rock and climbed up on to a small terrace encircling the hill. Although the sun had just set, cold had already settled into the rocks that in the daytime burnt the soles of feet that were bare inside the rubber galoshes. Glebov buttoned his quilted jacket. Walking provided no warmth.

'Is it much farther?' he asked in a whisper.

'Some way,' Bagretsov answered quietly.

They sat down to rest. They had nothing to say or even think of – everything was clear and simple. In a flat area at the end of the terrace were mounds of stone dug from the ground and drying moss that had been ripped from its bed.

'I could have handled this myself,' Bagretsov smiled wryly. 'But it's

more cheerful work if there are two of us. Then too I figured you were an old friend . . .'

They had both been brought on the same ship the previous year.

Bagretsov stopped: 'Get down or they'll see us.'

They lay down and began to toss the stones to the side. None of the rocks was too big for two men to lift since the people who had heaped them up that morning were no stronger than Glebov.

Bagretsov swore quietly. He had cut his finger and the blood was flowing. He sprinkled sand on the wound, ripped a piece of wadding from his jacket, and pressed it against the cut, but the blood wouldn't stop.

'Poor coagulation,' Glebov said indifferently.

'Are you a doctor?' asked Bagretsov, sucking the wound.

Glebov remained silent. The time when he had been a doctor seemed very far away. Had it ever existed? Too often the world beyond the mountains and seas seemed unreal, like something out of a dream. Real were the minute, the hour, the day – from reveille to the end of work. He never guessed further, nor did he have the strength to guess. Nor did anyone else.

He didn't know the past of the people who surrounded him and didn't want to know. But then, if tomorrow Bagretsov were to declare himself a doctor of philosophy or a marshal of aviation, Glebov would believe him without a second thought. Had he himself really been a doctor? Not only the habit of judgement was lost, but even the habit of observation. Glebov watched Bagretsov suck the blood from his finger but said nothing. The circumstance slid across his consciousness, but he couldn't find or even seek within himself the will to answer. The consciousness that remained to him – the consciousness that was perhaps no longer human – had too few facets and was now directed towards one goal only, that of removing the stones as quickly as possible.

'Is it deep?' Glebov asked when they stopped to rest.

'How can it be deep?' Bagretsov replied.

And Glebov realized his question was absurd, that of course the hole couldn't be deep.

'Here he is,' Bagretsov said. He reached out to touch a human toe. The big toe peered out from under the rocks and was perfectly visible in the moonlight. The toe was different from Glebov's and Bagretsov's toes – but not in that it was lifeless and stiff; there was very little difference in this regard. The nail of the dead toe was clipped, and the

toe itself was fuller and softer than Glebov's. They quickly tossed aside the remaining stones heaped over the body.

'He's a young one,' Bagretsov said.

Together the two of them dragged the corpse from the grave.

'He's so big and healthy,' Glebov said, panting.

'If he weren't so fattened up,' Bagretsov said, 'they would have buried him the way they bury us, and there would have been no reason for us to come here today.'

They straightened out the corpse and pulled off the shirt.

'You know, the shorts are like new,' Bagretsov said with satisfaction.

Glebov hid the underwear under his jacket.

'Better to wear it,' Bagretsov said.

'No, I don't want to,' Glebov muttered.

They put the corpse back in the grave and heaped it over with rocks.

The blue light of the rising moon fell on the rocks and the scant forest of the taiga, revealing each projecting rock, each tree in a peculiar fashion, different from the way they looked by day. Everything seemed real but different than in the daytime. It was as if the world had a second face, a nocturnal face.

The dead man's underwear was warm under Glebov's jacket and no longer seemed alien.

'I need a smoke,' Glebov said in a dreamlike fashion.

'Tomorrow you'll get your smoke.'

Bagretsov smiled. Tomorrow they would sell the underwear, trade it for bread, maybe even get some tobacco . . .

Translated by John Glad

*An important motif in Mandelstam's formidably difficult late poetry is
that of a death imposed yet willed. Sometimes this is evoked through
references to animals hunted for their fur, but, in the cycle from which
these four short poems are taken, it is suggested by allusion to the
anonymous dead: the* bratskie mogily, *communal graves of unknown
soldiers or of camp prisoners, on the one hand, and the heroic feats of
fighter pilots, whose deaths exemplify the lure of the void, on the other.*

OSIP MANDELSTAM
From 'The Unknown Soldier'

Literaturnaya Gruziya, 1 (1967): a slightly different version was first
published in *Sobranie sochinenii v 3 tomakh*, vol. 1 (Washington,
Inter-Language Literary Associates, 1967)

I

May this air be called as witness,
Its long-range heart-beats, pestilent
Even in dug-outs, active, omnivorous –
Ocean, windowless element . . .

Tell-tales all, these stars: what is this
Constant need to look (with what intent?)
At the condemnation of judge and witness,
At the ocean, windowless element?

The rain recalls, reluctant sower
The nameless manna that it strewed:
How the forest crosses showered
The ocean, the blade of battlefield.

People will grow cold and starve,
Be forced to kill, so cold, so weak,
And in his all too well-known grave
The unknown soldier sleeps.

Tell me, weakly swallow who's
Forgotten how to fly, how can
I come to terms with this airy grave
Without a sail, a rudder or wings?

And I shall give you account in lieu
Of Lermontov,[1] how only the grave
Cures curves bred in the backbone. Oh the pull
Of pits of air for the brave!

II

Like the creeping threat of ripening grapes
These worlds eye us, intent on wrath,
They hang like cities, sacked and riven,
Golden slips of tongue, slanderous conversations,
Berries of cold appalling venom,
The tensile constellation's tents –
The golden oil-drops of constellations.

IV

This pottage, this Arabian gruel,
Is ground up from the speed of light:
Flexing its cross-grained soles
A ray tramples my eyes.

The herds sent to the slaughter
Have trodden a path through the waste.
On behalf of each earthen fortress
Farewell, goodnight, all the best.

Battle-scarred yet immaculate sky,
Sky of countless discounted deaths –
My lips fly off in the dark
After you, from you, and away.

Across craters, embankments and rocks,
Over which once dawdled and hazed
– Of graves sullen and tumbled – the pock-
marked and humble genius – of graves.

VI

Must the skull be made for this
In full-headed breeding – chin to pate
So soldiers cannot choose but penetrate
Its hard-achieved eye-pits?
From living the skull develops
In full-headed breeding – pate to chin –
The purity of its seams self-teasing,
Like a cupola's knowing gleam,
It foams with thought, is its own dream.
Fatherland of fatherlands, cup of cups,
Bonnet sewn with a hem of stars,
Cap of happiness – Shakespeare's old man.[2]

VIII

Aortas ripen as blood pours
And the ranked whispers filter through:
– I was born in eighteen ninety-four,
Born in eighteen ninety-two.
And clutching in my fist my rubbed
Year of birth, I stand with the herd
And whisper with bloodless tongue:
I was born between the second and third
Of January, ninety-one,
A most suspicious year,
At night, and the centuries gird
Me about with fire.

February–March 1937. Voronezh

Translated by Andrew Reynolds

18. Death of a civil servant: One of Varvara Stepanova's eerie designs for Meyerhold's typically uncompromising production of Aleksandr Sukhovo-Kobylin's nineteenth-century comedy *The Death of Tarelkin*, a satire on the tsarist bureaucracy.

Akhmatova's most famous response to the Great Terror is her cycle
Requiem, in which she spoke from the perspective of one of Stalin's
innocent victims. In this poem, first published twenty-three years after
her death, she turns accuser, upbraiding those who refused to credit
Stalin's crimes even after Khrushchev's denunciation of him in 1956,
and the publication of Solzhenitsyn's One Day in the Life of Ivan
Denisovich *(which appeared in the year that the poem below was*
written).

ANNA AKHMATOVA
'To the Defenders of Stalin'

From *I am Your Voice*, V. Chernykh (ed.) (Moscow, 1989)

There are those who shouted: 'Release
Barabbas for us on this feast,'
Those who ordered Socrates to drink poison
In the bare, narrow prison.

They are the ones who should pour this drink
Into their own innocently slandering mouths,
These sweet lovers of torture,
Experts in the manufacture of orphans.

1962

Translated by Judith Hemschemeyer

Vladislav Khodasevich, whom Nabokov described in Speak, Memory *as 'this bitter man, wrought of irony and metallic-like genius', was too sceptical and lacking in cordiality to become a member of any of the various symbolist or post-symbolist literary circles; however, his work was in a sense an embodiment of the Gallic direction in Acmeism set out by Nikolai Gumilyov in 'The Legacy of Symbolism and Acmeism'. This poem, a savagely humorous meditation on the purpose of human existence (none), is typical of Khodasevich's later work.*

VLADISLAV KHODASEVICH
'Diary Entry'

Dni, 995 (2 May 1926)

They tell you life is a plum
Ripe for picking. Try that in the scrum
Between font and morgue
As you rush to gorge
On excitement, or waste in a slum!

The weight of what you don't know
Stifles fantasy's feeble glow;
After a while your mind
Loses its edge, you'll find,
Like a worker earnestly reading *How to* . . .

It's time to have been, not to be,
It's time not to wake, but to sleep,
Curled up in the eiderdown
Of time without end, with your brow
Smooth as a baby's: to sleep as you slept (where else?) in the
 womb.

<div align="right">1–2 September 1925. Meudon</div>

<div align="center">Translated by Catriona Kelly</div>

The final story in Daniil Kharms's Incidents *is typical of the collection both because it handles disturbing material in a bleakly humorous manner, and because its final phrase (borrowed into Russian from English) sums up Kharms's view of the world that he lived in.*

DANIIL KHARMS
'Pakin and Rakukin'

From *Incidents*, in *Flight to the Heavens* (Leningrad, 1988)

'Not so much of the high and mighty, you!' said Pakin to Rakukin.

Rakukin wrinkled his nose and eyed Pakin with disfavour.

'What are you staring at? Don't you recognize me?' asked Pakin.

Rakukin gnawed his lip and, with an irritable twirl of his swivel chair, began looking in the other direction.

'What an idiot! I've a good mind to take a stick to the back of his neck.'

Rakukin rose and made to leave the room, but Pakin leapt to his feet and caught him up, saying: 'Wait a minute! What's your hurry? Just sit yourself down and I'll show you something.'

Rakukin halted and gave Pakin a mistrustful look.

'You don't believe me?' asked Pakin.

'I believe you,' said Rakukin.

'Then sit down, here, in this armchair,' said Pakin.

And Rakukin sat back down again in his swivel chair.

'Well, then,' said Pakin, 'why are you sitting in that chair like an idiot?'

Rakukin shifted his feet and started blinking rapidly.

'Don't blink,' said Pakin.

Rakukin stopped blinking, hunched himself up and drew his head into his shoulders.

'Sit up straight,' said Pakin.

Rakukin, still hunched, stuck out his stomach and extended his neck.

'God,' said Pakin, 'I've got a good mind to slap you round the chops!'

Rakukin gave a hiccup, blew out his cheeks and then gingerly expelled air through his nostrils.

'Cut the high and mighty stuff!' Pakin told Rakukin.

Rakukin extended his neck even more and once again started blinking with extreme rapidity.

Pakin told him: 'Rakukin, if you don't stop blinking this instant, I'm going to kick you in the chest.'

Rakukin twisted up his jaw to stop himself blinking, extended his neck even further, and threw his head backwards.

'God, what a grisly sight you are,' said Pakin. 'Face like a chicken and your neck's all blue, it's revolting!'

Meanwhile, Rakukin's head was sagging further and further, until it finally lost its tension and flopped right down on to his back.

'What the . . . !' exclaimed Pakin. 'What the hell's going on?'

From Pakin's viewpoint, it looked as though Rakukin was sitting there with no head at all. Rakukin's Adam's apple projected upwards, for all the world like a nose.

'Hey, Rakukin!' said Pakin.

Rakukin said nothing.

'Rakukin!' repeated Pakin.

Rakukin made no response and remained motionless.

'So,' said Pakin. 'Rakukin's kicked the bucket.'

Pakin crossed himself and left the room on tiptoe.

About fourteen minutes later a small soul slid out from Rakukin's body and glanced wrathfully at the place where Pakin had recently been sitting. But now the tall figure of the angel of death emerged from a cupboard and, taking Rakukin's soul by the hand, led it off somewhere, straight through the houses and walls. Rakukin's soul trotted after the angel of death, constantly looking back in anger. But presently the angel of death put on speed, and Rakukin's soul, bobbing and stumbling, disappeared into the distance, round the bend.

Translated by Alan Myers

7
Exile

Prior to the Gorbachev era, when the relaxation of censorship allowed the official publication of many non-Soviet Russian writers of the twentieth century in their home country for the first time, the questions of whether it was possible to use the generalizing term 'Russian culture', and whether there was one 'Russian literature' or two, used to exercise minds severely. If émigrés such as Nabokov, whose curious syllabus for a Russian modernism course was quoted at the beginning of this book, saw most Soviet literature as barely worthy of the name, the converse applied in the 'Soviet motherland' itself, where the myth that no work of quality could ever be produced by an artist in exile was assiduously cultivated, and widely believed. As recently as 1991, I was told by a well-known Russian poet living in Moscow that there were no émigré poets of talent; when I mentioned the case of Marina Tsvetaeva, I was told flatly that she was, of course, not an émigré poet. Though she had written most of her best work in Prague and Paris, the fact that Tsvetaeva had returned to Russia in time to die had allowed her to be posthumously reabsorbed into Soviet culture.

Over the last ten years the cessation of old hostilities has made cultural passport control of this kind seem increasingly foolish. It is now widely accepted that the history of Russian twentieth-century literature includes not only such re-immigrants as Tsvetaeva, but such recalcitrant non-returners as Nabokov and Khodasevich, to name only two of the most famous writers in exile. The reason for including a section on 'exile' here is not so much to provide space for a group of writers who have sometimes got left out of general anthologies of Russian twentieth-century literature (since émigré and Soviet writers and painters have appeared alongside each other throughout the book), but because the state of exile has inspired some of the most distinguished work by Russian artists and writers from Pushkin to Brodsky.

Among the Russian romantics, exile was usually the occasion for meditations on the nature of political and personal freedom; though this understanding of exile persisted into the twentieth century, the fact that many Russians were now domiciled not in the Russian empire but in Western Europe, Asia or America, outside their native linguistic environment, has forged a crucial relationship between language and identity. The result was to increase the sensitivity to the linguistic fabric of the text that was already evident in the pre-Revolutionary modernist movement. Emphasis on the importance of language is as crucial in the work of a popular prose writer such as Nadezhda Teffi as it is in the writing of sophisticated poets such as Tsvetaeva, Khodasevich or Anna Prismanova. Anxiety about losing the ability to articulate was common, but the heteroglossia, or varied linguistic environment, of emigration could also produce a creative distance from the native instrument, as Nabokov showed in The Gift, one of the most important metafictional novels in the Russian language.

The question of language exemplifies the point that exile was more than a state: it was a trope, a literary tradition with its own stereotypes and recurrent concerns. Accordingly, writers resident in the Soviet Union who were hostile to official policy often thought of themselves as suffering 'internal exile', a condition that is alluded to, for example, in Akhmatova's many references to the fate of Dante, expelled from his native Florence. During the 1920s, 1930s and 1940s writers such as Akhmatova (who came from a generation in which foreign travel had, unusually in terms of Russian history, been taken for granted) took as close an interest as they could in the fate of Russians abroad. Akhmatova's rebuff to migrants, 'I am not with those who have left my native land/ To be torn apart by enemies' (1918), written in the immediate aftermath of the Revolution and at the onset of the Civil War, is much better known than her more conciliatory poem 'The Willow'. However, the latter is more characteristic not only in terms of Akhmatova's work, but of the attitude of many intelligent individuals on both sides who saw the diaspora as a tragedy rather than as an opportunity for self-righteous promotion of one's own community to the status of the elect. Few émigrés suffered as much as their counterparts in Russia (a rare exception being the theologian and religious poet Mother Maria Skobtsova, who died in Buchenwald), and though poverty and hardship were rife, even practical conditions were often better than in Russia itself (the supposedly dirt-poor family in Teffi's 'Huron' would have been envied by many Soviet

citizens because they had an individual flat with several rooms, and Nina Berberova's account of Russian Paris indicates that many émigrés were reduced to the level of the petite bourgeoisie rather than the proletariat). But sustaining devotion to artistic culture was common to both Soviet and non-Soviet Russians, as was a sense of irretrievable loss, as modernist artists suffered political repression on the one hand, and a gradual erosion through the assimilation of younger émigrés into receiving cultures on the other.

Of all the Russian émigré communities, the largest and liveliest was in
Paris. Nadezhda Teffi's introduction to one of her collections of acidly
humorous short stories presents the Paris Russians from the point of
view of an ethnographer cataloguing the customs of an exotic tribe.

NADEZHDA TEFFI
[A Small Town on the Seine]

From *The Small Town* (Paris, N. P. Karabasnikov, 1927)

It wasn't a very big town: population about forty thousand, one
church, and more eating-houses than you could count.

A river flowed through the middle. Long ago it was called the
Sequanne; later it became the Seine, but when the town was founded,
the inhabitants started calling the river 'their little Nevka'.[1] But the old
name lived on in folklore, as can be seen from a saying that was much
in use among the town-dwellers: 'they've sold us all down the Seine'.[2]
This can be translated as: we don't live too well.

Everyone lived packed up together: either in Passy village, or in a
place they called Reevegosh.[3] They had various trades. The younger
people mainly hired themselves out as chauffeurs. People of mature
years opened eating-houses and waited tables; the brunettes posed as
gypsies, Georgians and Armenians, the blondes as Ukrainians.

The women spent their time running up dresses and hats for each
other. The men spent their time running up debts.

Apart from human beings of the male and female gender, the town
also contained a large population of generals and ministers. Only a few
of these drove taxi cabs: the majority lived off credit and their memoirs.

The purpose of these memoirs was to glorify the name of the writer
and heap confusion on his enemies. The memoirs differed significantly
one from another in that some were typed and others written in longhand.

Life was very monotonous.

Every now and again someone would open a little theatre in the town.
There would be shows of dancing plates and magic clocks. The citizens
of the town all wanted free tickets; however, they were never pleased with
what they saw. The theatre management would obediently distribute the
free tickets, then drown quietly under the deluge of the audience's abuse.

The town had its own newspaper too. All the inhabitants thought they should get it for nothing, but the newspaper was tougher than the theatres; it resisted these pressures and managed to stay alive.

There was not much interest in public affairs. Generally, people would meet to share a tureen of Russian bortsch, but only in small groups, because everyone hated each other so much that you could never have got two dozen people together without one dozen being the other dozen's sworn enemies. Or becoming their sworn enemies, if they were not already.

The location of the town was most peculiar. It was surrounded not by forests or valleys, but by the streets of the most impressive capital city of the world, full of wonderful museums, art galleries and theatres. But the town-dwellers did not mix with the inhabitants of the capital and spurned the fruits of a foreign culture. They even had their own little shops. Hardly anyone visited the museums and galleries. They had no time, and they could not see the point: 'that's not meant for poor folks like us'.

At first, the inhabitants of the capital took an interest in the town-dwellers, studying their customs, their art, their way of life, just as they once had those of the Aztecs.

A vanishing tribe . . . The descendants of those great and glorious people who . . . to whom . . . of whom humanity is so proud!

But then their enthusiasm faded away.

The town-dwellers made fairly good chauffeurs and hand-embroiderers for our ateliers. Their dancing was so amusing and their music so intriguing . . .

The town-dwellers spoke a strange patois; however, specialists in linguistics were able to discern without too much difficulty that this had Slavonic roots.

The town-dwellers were delighted when someone from their tribe was discovered to be a thief, a con-man or a traitor. They also liked curd cheese and long conversations on the telephone.

They were extremely bitter, and had never been known to laugh.

Translated by Catriona Kelly

The following extract from Nina Berberova's memoirs, which documents the actual day-to-day existence of the impoverished Russian refugees in Paris, makes an appropriate companion piece to Teffi's ironic generalizations above.

NINA BERBEROVA
[Russian Paris]

From *The Italics are Mine* (Russian edition published Munich, 1972)

Two suburbs of Paris in its south-western corner merged into one: at first there was Billancourt and also Boulogne. Then it became Boulogne–Billancourt, department of the Seine – the same as Paris, of course. The word 'Boulogne' rang out smartly: it recalled the Bois de Boulogne, suggesting it was near. In Boulogne there was a stadium, and there were races. In Billancourt there was the Renault automobile plant, a cemetery, a river and dirty, poor, neglected blocks. People went from Paris to Boulogne along a wide green avenue, to Billancourt along a dusty ugly commercial street. In Boulogne streets were named at random, in Billancourt each street was dedicated to a figure of the working-class movement, from the Commune to our own times. There were expensive restaurants in Boulogne, and taverns, Russian and French bars in Billancourt. Lev Shestov and, for a while, Remizov lived in Boulogne; we and the Zaitsevs were in Billancourt. There were a number of suburbs where Russians lived: Berdyaev lived in Clamart, Tsvetaeva in Meudon. In Noisy, Old Believers lived, in Ozoire General Skoblin, who had kidnapped General Miller.[1] In Asnières there was even a gypsy camp, where gypsies (who spoke Russian among themselves) lived in their covered wagons. When we began to settle in the suburbs, they still were suburbs; in a few years they became part of the city, joining Paris.

Now the city pushes people out. Then it did not let people in. In all those houses we passed, built two hundred, one hundred or fifty years ago, there was no room for us. Old flats were passed on from father to son, from mother to daughter. They were crowded: a bathtub sometimes stood in the kitchen (more often than not there was one entrance of course), and under the tub a gas pipe ran with holes for flames, so that the water was heated in it as in a saucepan. In other houses there were

wide staircases and high ceilings, french windows from ceiling to floor. We never got a chance to go in there. Houses built at the end of the last and at the beginning of this century were in their own way luxurious, with stone balconies and a *lanterne* at the entrance; they were grey and somehow paunchy. To penetrate and settle in them you had to pay a lot of money. At that time, after World War One, they built houses differently: whole blocks of cages, seven storeys high, often without lifts, where the walls were studded with the ends of nails hammered in by your neighbour; if a nail fell out, you could see your neighbour's life through the opening. There was a long wait for these cages.

In Billancourt there was a street with Russian signs everywhere, and in the spring, as in the south of Russia, it smelt of lilac, dust and rubbish. At night (on rue Traversière) there was noise, a din in the Russian cabaret. It was set up as a reflection of a Montmartre honky-tonk, where a gypsy chorus performed; or noise from some other night club, where Circassian dancers, with tight waists and a knife in their teeth, danced in sheepskin hats (which had then come into fashion with Parisian women and were called *Shapska russe*). Sounds came also from another place, where Vertinsky's songs were performed (till he left for the Soviet Union), some romances of old were sung with tears, and glasses broken – by Frenchmen, Englishmen and Americans, who learnt to do it all by themselves, having either heard (third hand) of the behaviour of Mitya Karamazov, or having perhaps read about it.[2] [. . .]

On tables with filthy paper tablecloths stood cheap lamps with pink lamp shades, beside cracked plates, crooked forks, dull knives. You drank vodka, munched on cucumber and herring. Vodka was called 'our beloved native wine', herring was called 'mother herring'. There was a strong smell and thunder from the kitchen, blinis steamed and smoked, voices yelled out; the Crimean retreat was recalled, the evacuation to Gallipoli. The waitresses, one prettier than the next, slipped with bottles and plates among the tables. They were all 'Marya Petrovnas', 'Irochkas', 'Tanyas', whom everyone had known almost since childhood, and yet after the fifth glass they seemed mysterious and accessible, like those who 'breathed perfume and mists' in someone's verse (or perhaps in a romance?) once upon a time – the devil knows where and when.

On the corner was the hairdresser's where I had my hair cut, and for me there was no tipping: 'We read your stories, we are very grateful to you, you do not scorn our way of life.' Beyond it was the children's Sunday school (near the Russian church installed in a former bistro).

On Sundays children sang there in chorus, lifting up their hands, kneeling, pale and thin. The little boys were valued more highly than the girls: they were future soldiers of France and for them the parents were given French citizenship. Little girls could not help their parents to emerge from the predicament of stateless émigrés. Children burr when they pronounce the Russian *r*,[3] Daddy is at Renault or a taxi-driver, or a waiter at La Maisonnette (near the Champs-Elysées); Mummy embroiders linen or makes hats; the older sister is a model at Chanel's; the brother is an errand boy in Pyshman's grocery store. In the summer the children would go to camp, and at sunrise gather at the tricoloured Russian flag and sing the Lord's Prayer. Their teacher complains that they do not understand Griboedov's *Woe from Wit*, especially when it comes to old colloquialisms.[4] One must explain every word. The teacher, also pale and skinny, seems to be the daughter of the priest, or rather the daughter of one of the priests: in Billancourt there were a number of Orthodox churches, one in the former bistro, another in a backyard in an abandoned garage, a third in an unused (for lack of clientele) old Catholic church.

A factory whistle sounds. Twenty-five thousand workers flow through wide iron gates on to the square. Every fourth man is a high-ranking officer of the White Army, military in bearing, his hands roughened by work. These are family people, obedient taxpayers and readers of the Russian daily newspapers, members of every conceivable Russian military organization who keep their regimental distinctions, Saint George Crosses and medals, epaulettes, and dirks at the bottom of what are still Russian trunks, together with faded photographs – chiefly group ones. About them it is known: (a) they are never strike instigators, (b) they rarely turn to the factory dispensary fund, for they enjoy iron health, evidently acquired as the result of training in two wars – World and Civil, and (c) they are exceptionally docile where the law and the police are concerned – crime among them is minimal. A throat-cutting was exceptional. Murder out of jealousy – one in ten years. According to statistics, counterfeiters or seducers of under-age girls – none.

Translated by Philippe Radley

The anxiety about the future of Russian literature in emigration that is expressed in this article by Khodasevich was common enough in the émigré press. However, Khodasevich's solution – that émigré writers should begin to take conscious advantage of their dislocated and marginal status – was both unusual and prescient.

VLADISLAV KHODASEVICH
[The Reasons for the Decline of Émigré Literature]

From 'Literature in Exile', *Voskresenie*, 27 April 1933

One cannot make a theoretical case why émigré literature should not, as a matter of principle, exist. On the contrary, that its existence precisely *is* possible appears to be demonstrated by the large numbers of Russian books, magazines and newspapers currently appearing outside the boundaries of Russia. Yet this is where we come to a most disagreeable fact, and one that can neither be covered up nor passed over in silence, firstly out of respect for the truth, and secondly because recognizing and naming it, trying to understand its causes, may even do some good. I am talking about the decline of Russian literature abroad, a decline recognized by all who are not living wholly in the world of illusions and who have not lost the facility to judge what is going on around them.

Yes, magazines and books are still being published, but there are fewer of them every day. Yes, writers are still writing, but the quantity and quality of their work is going down (I should point out that I'm speaking generally, without reference to individual cases). The pace of literary activity has ebbed noticeably, and émigré literature is in decline, and agonizing over that decline. About a year ago the critic M. L. Slonim[1] rather triumphantly heralded the supposed 'death of émigré literature'. He attributed this death (which he announced a little prematurely) to the fact that there could in fact be no such thing as an émigré literature. I will allow myself to formulate things a little differently. If the end is in sight for émigré literature, this is not because it is 'émigré', that is, produced by writers living in emigration, but because it has

remained in a deep sense too little marked by, or even totally unmarked by, emigration – that is, if one understands 'emigration' in its full sense. Émigré literature may have a new passport, but does it have a new soul? Unhappily, one is forced to suspect that the answer is no.

To become a political émigré, one only needs to leave one's country of origin. If this act is to be more than straightforward flight to somewhere where life is pleasanter and safer, then it must also be justified externally, in terms of our behaviour, and internally, in terms of our consciousness. Without an elevated sense of mission, of purpose, there is no 'emigration' as such, merely hordes of refugees seeking a better home.

I have no doubt that most – if not all – the writers of the older generation, the founders of émigré literature, did have such a sense of mission, and indeed that they still have. But the problem is that this sense failed to make an impact precisely on the area where it should have been most active.

'The Russian literary tradition, like Russian culture generally, is being persecuted, wiped out, by the Soviet government. The Russian emigration should take care to preserve it for future generations.' That's the signature tune of the Russian emigration; it has been sung again and again in various keys by different émigré writers. In essence, it's hard to take issue with it. The problem is that a perfectly sensible message has been incorrectly interpreted, and this is what has reduced émigré literature to the miserable state that it is now in.

Every kind of literature can only preserve itself by remaining in a state of inner dynamism. Literature remains alive and capable of life while certain processes, in a sense akin to respiration or circulation of the blood, remain active. The occasional alteration of forms and ideas is not only a sign of life; it is an essential prerequisite of life. If this process stops, if the blood coagulates, then death and putrefaction follow.

If I may allow myself another comparison: the interior life of literature makes itself felt in occasional sparks and explosions like those observable in an internal combustion engine. The spirit of literature is a spirit of constant explosion and self-renewal. Therefore, 'preserving the literary tradition' should mean no more than making sure that the explosions occur at proper intervals and with due purpose, that they do not destroy the entire mechanism in which they occur. It should refer to conservative and not to reactionary activity. Its purpose is not to interfere with the small explosions and revolutions that allow literature to move forward,

but, on the contrary, to preserve the conditions in which the explosions may happen constantly, in an unimpeded and purposive manner. The literary conservative is a fervent arsonist: he preserves rather than putting out the flame.

But this is exactly what the representatives of the older generation who have dominated literary life from the first days of emigration fail to understand. It would be invidious to single out particular individuals. It's highly probable that no single writer is individually responsible. All of them (or most of them, and especially at the beginning) put as much effort in as talent would allow. Some excellent and some good things did get written, and we shouldn't forget it. But the people who wrote them had brought a ready-made set of images and ideas from Russia, those they had already used to ensure themselves a reputation; they had a little store of techniques that they were used to employing. Since emigrating, their work has chugged along just as before, and not a single nut or bolt has been changed. Their fragmentary denunciations of the Bolsheviks and nostalgic memories of lost delights could not generate new ideas appropriate to recent events. Their works may say 'Berlin' or 'Paris' on the title-pages, but they could just as well have been written in Moscow or Petersburg. They seem simply to have transferred their desks from the Arbat to Auteuil, leaving their inkpots and pencils miraculously undisturbed, and settled down to work as if nothing had happened. M. L. Slonim argues that émigré literature is starved of new ideas because it is written in emigration. Not at all: it is starved of new ideas because it is not of the emigration in a genuine sense, because it has not discovered within itself the emotional force that would allow it to evolve new feelings, new ideas and new literary forms. It has not yet been able to experience its own tragedy in a full sense; it has been searching out crumbs of comfort, a cosy nook amid the tempests, and has paid for this by becoming smug, complacent, self-satisfied – by becoming petit bourgeois, in short. Émigré literature has even seen the 'stability' of its creations as a virtue, wrongly identifying this with the preservation of tradition, and not realizing that reaction has now taken the place of conservatism, that soon literature will be stifled to death.

Translated by Catriona Kelly

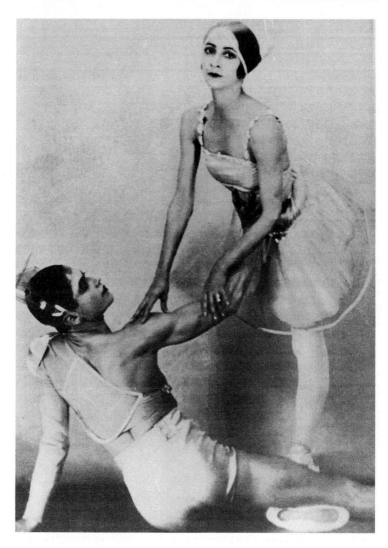

19. The sorrows of separation: At its best, the art of the Russian emigration had a poignant refinement that extended and deepened the traditions of Saint Petersburg modernism, as is shown by this beautiful scene from Balanchine's ballet *La Chatte* (1927), designed by Naum Gabo and Antoine Pevsner, and danced here by Olga Spessiva and Serge Lifar. The ballet was a kind of cross-species version of *Swan Lake*, depicting the doomed love of a young man for a she-cat.

Few subjects were more inspiring to Nabokov's satirical genius than the solemn pretensions of artistically untalented admirers of the arts. In the masterpiece of his Berlin years, The Gift, *written in 1938–9, the set-pieces of émigré literary life include this wonderfully parodistic account of a session attended by the novel's hero, the young writer Fyodor Godunov-Cherdyntsev, in the drawing room of some fellow émigrés.*

VLADIMIR NABOKOV
[A Literary Soirée in Berlin]

From *The Gift* (first complete edition New York, 1952)

The meeting was at the smallish, pathetically ornate flat of some relatives of Lyubov Markovna's. A red-haired girl in a green dress that ended above her knees was helping the Estonian maid (who was conversing with her in a loud whisper) to serve the tea. Among the familiar crowd, which contained few new faces, Fyodor at once descried Koncheev, who was attending for the first time. He looked at the round-shouldered, almost humpbacked figure of this unpleasantly quiet man whose mysteriously growing talent could have been checked only by a ring-ful of poison in a glass of wine – this all-comprehending man with whom he had never yet had a chance to have the good talk he dreamt of having some day and in whose presence he, writhing, burning and hopelessly summoning his own poems to come to his aid, felt himself a mere contemporary. That young face was of the central Russian type and seemed a little common, common in a kind of oddly old-fashioned way; it was bounded above by wavy hair and below by starched collar wings, and at first in the presence of this man, Fyodor experienced a glum discomfort . . . But three ladies were smiling at him from the sofa, Chernyshevsky was salaaming to him from afar, Getz was raising like a banner a magazine he had brought for him, which continued Koncheev's 'Beginning of a Long Poem' and an article by Christopher Mortus entitled 'The Voice of Pushkin's Mary in Contemporary Poetry'. Behind him somebody pronounced with the intonation of an explanatory response, 'Godunov-Cherdyntsev'. Never mind, never mind, Fyodor thought rapidly, smiling to himself, looking around and tapping the end of a cigarette against his eagle-emblazoned cigarette case, never

mind, we'll still clink eggs some day, he and I, and we'll see whose will crack.

Tamara was indicating a vacant chair to him, and as he made his way to it he again thought he heard the sonorous ring of his name. When young people of his age, lovers of poetry, followed him on occasion with that special gaze that glides like a swallow across a poet's mirrory heart, he would feel inside him the chill of a quickening, bracing pride; it was the forerunner of his future fame; but there was also another, earthly fame – the faithful echo of the past: he was proud of the attention of his young coevals, but no less proud of the curiosity of older people who saw in him the son of a great explorer, a courageous eccentric who had discovered new animals in Tibet, the Pamirs and other blue lands.

'Here,' said Mme Chernyshevsky with her dewy smile, 'I want you to meet . . .' She introduced him to one Skvortsov, who had recently escaped from Moscow; he was a friendly fellow, had raylike lines around his eyes, a pear-shaped nose, a thin beard and a dapper, youthful, melodiously talkative little wife in a silk shawl – in short, a couple of that more or less academic type that was so familiar to Fyodor through his memory of the people who used to flicker around his father. Skvortsov in courteous and correct terms began by expressing his amazement at the total lack of information abroad about the circumstances surrounding the death of Konstantin Kirillovich: 'We'd thought,' his wife put in, 'that if nobody knew anything back home, that was to be expected.' 'Yes,' Skvortsov continued, 'I recall terribly clearly how one day I happened to be present at a dinner in honour of your father, and how Kozlov – Pyotr Kuzmich – the explorer, remarked wittily that Godunov-Cherdyntsev looked upon Central Asia as his private game reserve. Yes . . . That was quite a time ago, I don't think you were born then.'

At this point Fyodor suddenly noticed that Mme Chernyshevsky was directing a sorrowful, meaningful, sympathy-laden gaze at him. Curtly interrupting Skvortsov, he began questioning him, without much interest, about Russia. 'How shall I put it . . .' replied the latter. 'You see, it's like this . . .'

'Hello, hello, dear Fyodor Konstantinovich!' A fat lawyer who resembled an overfed turtle shouted this over Fyodor's head although already shaking his hand while pushing through the crowd, and by now he was already greeting someone else. Then Vasiliev rose from his seat and, leaning lightly on the table for a moment with splayed fingers, in a position peculiar to shopkeepers and orators, announced that the

meeting was opened. 'Mr Busch,' he added, 'will now read us his new, philosophical tragedy.'

Herman Ivanovich Busch, an elderly, shy, solidly built, likeable gentleman from Riga, with a head that looked like Beethoven's, seated himself at the little Empire table, emitted a throaty rumble and unfolded his manuscript; his hands trembled perceptibly and continued to tremble throughout the reading.

From the very beginning it was apparent that the road led to disaster. The Rigan's farcical accent and bizarre solecisms were incompatible with the obscurity of his meaning. When, already in the Prologue, there appeared a 'Lone Companion' (*odinokii sputnik* instead of *odinokii putnik*, 'lone wayfarer') walking along that road, Fyodor still hoped against hope that this was a metaphysical paradox and not a traitorous *lapsus*. The Chief of the Town Guard, not admitting the traveller, repeated several times that he 'would not pass definitely' (rhyming with 'nightly'). The town was a coastal one (the lone companion was coming from the Hinterland) and the crew of a Greek vessel was carousing there. This conversation went on in the Street of Sin:[1]

FIRST PROSTITUTE: All is water. That is what my client Thales says.
SECOND PROSTITUTE: All is air, young Anaximenes told me.
THIRD PROSTITUTE: All is number. My bald Pythagoras cannot be wrong.
FOURTH PROSTITUTE: Heraclitus caresses me whispering 'All is fire.'
LONE COMPANION (*enters*): All is fate.

There were also two choruses, one of which somehow managed to represent the de Broglie's waves and the logic of history, while the other chorus, the good one, argued with it. 'First Sailor, Second Sailor, Third Sailor,' continued Busch, enumerating the conversing characters in his nervous bass voice edged with moisture. There also appeared three flower vendors: a 'Lilies' Woman', a 'Violets' Woman' and a 'Woman of Different Flowers'. Suddenly something gave: little landslides began among the audience.

Before long, certain power lines formed in various directions all across the room – a network of exchanged glances between three or four, then five or six, then ten people, which represented a third of the gathering. Koncheev slowly and carefully took a large volume from the bookshelf

near which he was sitting (Fyodor noticed that it was an album of Persian miniatures), and just as slowly turning it this way and that in his lap, he began to glance through it with myopic eyes. Mme Chernyshevsky wore a surprised and hurt expression, but, in keeping with her secret ethics, somehow tied up with the memory of her son, she was forcing herself to listen. Busch was reading rapidly, his glossy jowls gyrated, the horseshoe in his black tie sparkled, while beneath the table his feet stood pigeon-toed – and, as the idiotic symbolism of the tragedy became ever deeper, more involved and less comprehensible, the painfully repressed, subterraneously raging hilarity more and more desperately needed an outlet, and many were already bending over, afraid to look, and when the Dance of the Maskers began in the square, someone – Getz it was – coughed, and together with the cough there issued a certain additional whoop, whereupon Getz covered his face with his hands and after a while emerged again with a senselessly bright countenance and humid, bald head, while on the couch Tamara had simply lain down and was rocking as if in the throes of labour, while Fyodor, who was deprived of protection, shed floods of tears, tortured by the forced noiselessness of what was going on inside him. Unexpectedly Vasiliev turned in his chair so ponderously that a leg collapsed with a crack and Vasiliev lurched forward with a changed expression, but did not fall, and this event, not funny in itself, served as a pretext for an elemental, orgiastic explosion to interrupt the reading, and, while Vasiliev was transferring his bulk to another chair, Herman Ivanovich Busch, knitting his magnificent but quite unfruitful brow, jotted something on the manuscript with a pencil stub, and in the relieved calm an unidentified woman uttered something in a separate final moan, but Busch was already going on:

LILIES' WOMAN: You're all upset about something today, sister.
WOMAN OF DIFFERENT FLOWERS: Yes, the fortuneteller told me that my daughter would marry yesterday's passer-by.
DAUGHTER: Oh, I did not even notice him.
LILIES' WOMAN: And he did not notice her.

'Hear, hear!' chimed in the Chorus, as in the British Parliament. Again there was a slight commotion: an empty cigarette box, on which the fat lawyer had written something, began a journey across the whole room, and everybody followed the stages of its trip; something extremely funny

must have been written on it, but no one read it and it was passed
dutifully from hand to hand, destined for Fyodor, and when it finally
reached him, he read on it: *Later I want to discuss a certain little affair
with you.*

Translated by Michael Scammell

After visiting Paris in 1922 Mayakovsky wrote a series of articles for the Soviet press reporting on the current state of French avant-garde culture (lacklustre, according to him) and referring dismissively to the Russian émigrés as a set of miserable has-beens; the only talented individuals were longing to return to the motherland as soon as they could. This comforting fiction was to persist in Soviet culture for the next six decades. But Mayakovsky's desire to contribute to the Soviet propaganda war did not stop him from producing some refreshingly unexpected vignettes of émigré life, including the following description of a visit to Stravinsky's studio.

VLADIMIR MAYAKOVSKY
[Stravinsky and the Pianola]

From 'Music', *Izvestiya*, 29 March 1923

I've been at loggerheads with music for a long time. [David] Burlyuk and I became futurists out of despair. After we'd sat out most of a Rakhmaninov evening at the Assembly of the Nobility [in St Petersburg], *Island of the Dead* made us take to our heels, boiling with disgust at being forced to swallow all that classical carrion.

I'd expected more of the same (quite rightly) in Paris, and only endured the tempests of piano-playing because I got caught in them willy-nilly.

But now we were visiting Stravinsky. The thing that impressed me most was where he lived – in the Pleyel pianola factory. The Pleyel pianola is an improved kind that is making bigger and bigger inroads on the world market, slowly forcing out real pianists and pianos. The factory is interesting because it gives you contact with music in the form of industrial production rather than 'heavenly sounds'. The production line involves everything from musicians to the vans used for transport.

The courtyard of the building is part of the factory as well: it's full of vans loaded with pianolas ready for transport. At the back is a howling, yowling and thundering three-storey building. Its enormous ground floor is full of pianolas, their flanks shining. At each end stand nice, respectable little Parisian couples listening to musical automatons, musical boxes and musical knick-knacks of all kinds so that they can choose

what to buy. On the first floor is the most popular concert hall in Paris. Of course, it can't be used before the end of the working day; you'd have trouble even sitting in it. The heart-rending wails of the pianolas can be heard quite clearly through tightly closed doors. Monsieur Léon, the factory director, a member of the Légion d'honneur, fusses about the hall or sits purring smugly to himself. At the very top of the house is Stravinsky's tiny attic, crammed full of pianos and pianolas. This is where he sits writing his symphonies, but also pieces for the pianola factory, which he then tries out himself on the pianola. He is all over the pianola: 'You can write for eight hands, you can write for sixteen hands – in fact, you could write for twenty-two hands if you felt like it!'

Translated by Catriona Kelly

By as early as 1887, the fiftieth anniversary of Pushkin's death, there was already a burgeoning 'Pushkin industry', embracing purely money-making enterprises such as Pushkin brand bars of chocolate and vodka, as well as the publication of presentation editions. Each successive Pushkin anniversary was more elaborate, a high point being reached in 1937, at the centenary of Pushkin's death, when Soviet and émigré Russians vied with each other to pay tribute to 'the father of Russian literature' (a curiously pompous term for a man who had died when he was only thirty-six). The opening poem from Marina Tsvetaeva's cycle 'Verses to Pushkin', first published in that year, is, as Michael Glenny put it, 'addressed not so much to Pushkin as to Pushkin's academic embalmers' (and, one might add, to patriotic journalists and café cultural pundits as well). It is also an excellent illustration of Tsvetaeva's contempt for literary pieties, whether Soviet or émigré Russian.

MARINA TSVETAEVA
'Verses to Pushkin, no. 1'

Sovremennye zapiski, 63 (1937)

Scourge of gendarmes, god of students,
Loathed by husbands, loved by wives;
Pushkin as a statue? Never!
No Stone Guest he, with his jibes,

Flashing teeth and saucy grin. What,
Pushkin as Commendatore?

Critic nagging, finger wagging:
'But (sob) what of Pushkin's fine
Sense of measure?' You forget his
Sensual pleasure, as the waves

Pounding granite! Can this salty
Pushkin ever be a text-book?

Legs a-straddle by the fireplace,
Warming them: or bounding up,
Leaping on the Tsar's own table!
Self-willed African, the sheer

Comic genius of his age – this
Pushkin in the role of tutor?

Black's ingrained; it can't be whitewashed,
Useless to apply the brush.
Russian classic, yes; but Pushkin
Called the Afric sky his own,

Roundly cursed the grim Nevá; no,
Pushkin's surely no arch-Russian.

Let us too pronounce a speech in
Honour of his jubilee:
'Praise the swarthy, red-cheeked poet,
Handsome does as handsome is;

None more lively, more alive than
Pushkin!' He – a mausoleum?

Sergeant-major-like, they bellow:
'Pushkin present – atten-*shun*!'
Where's the hellfire pouring from his
Lips, or where the coarse abuse?

Pushkin, nature's rebel – how can
Thin-lipped dons claim Pushkin's mantle?

Little midgets! Ah, how dare you
Brand that forehead – olive-blue,
Soaring, boundless – desecrate his
Brow with faded tinsel crowns,

Symbols of those dreary virtues –
'Golden mean' and 'middle way'?

'Pushkin: "toga", Pushkin: "cassock",
Pushkin: "yardstick", Pushkin: "peak" . . .'
Pushkin, Pushkin, Pushkin – noble
Surname! Noble as a damnéd
Tinker's curse, you squawking parrots!

Pushkin? Horrors!

1931

Translated by Michael Glenny

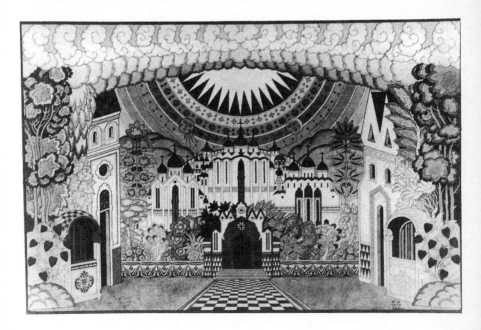

20. The invisible city: Ivan Bilibin's sketch for a drop-curtain for Rimsky-Korsakov's opera *The Tale of the Invisible City of Kitezh* (1929). For those unable to return to Russia, there was a particular poignancy in the legend of Kitezh, the 'lost city' of peasant myth.

The Paris émigré poet Anna Prismanova was brought up in Libau (now known as Liepaja) on the Baltic coast of Latvia. In an important cycle of poems written in the 1940s she remembers the city and her childhood: the triangle motif is employed not only because of Prismanova's interest in creating geometrical landscapes like those in cubist painting, but also because of its connection with the theme of passing time (the cone of sand at the bottom of an hourglass) and with the triple view of the émigré (who lives between past, present and remembered past).

ANNA PRISMANOVA
'Triangles'

'Sand', no. 2, in *Salt* (Paris, 1946)

Oftener than otherwise, headlands are angled,
the curving lines of boats come to a point:
the stoves in cottages each have four corners,
and herrings heads like gussets in a shirt.

The lighthouse's one eye, metalled by sunlight,
cuts like a knight's sword, blinding fishermen;
and splayed between the water and the sand-dunes
is the beach's scattering of amber grain.

I feel precious little warmth for docks and divers,
and less nostalgia for Latvians,
but the side-wall of a wheat warehouse in Libau
is where I'll lay my spirit's cornerstone.

In a white-veed sailor suit, sun-streaked with scarlet,
a small child, pleated like a tricolour flag,
hung out, holding tightly to the slanting
window-cheek, to hear the Sunday band.

The town was musical, and would be dancing
to the tune played by the rain, most of the time.
The seagulls, folding their wings flatter than tricorns,
zigzagged like twigs in a diviner's hands.

But on my pony made of cardboard
I rode through streets coiled tight as wintering snakes;
my feet shone, and my wet galoshes
carved up the cobbles of the Platz.

Raising its three church spires towards the heavens
(o earthly vault with springing in the skies!)
the worldly, busy town was a surveyor's
theodolite, its tripod fixed in ice.

The old man of the sea, salt-bearded,
stabbed with his trident at the harbour wall;
the tide that Peter the carpenter once breasted
now had a houndstooth fringe of sails.

The rains were murderously long and spiky,
the wind industriously drove them deep.
Like tsars or leaders, knocking people sideways,
three-decker waves came rushing up.

 Translated by Catriona Kelly

As Russian refugees gradually absorbed the fact that their exile was likely to be a lasting one, the fate of the children of the emigration began to generate anxiety. This was not only because of the social distress that had come for many families with life abroad: work was hard to find and money short, and decisions about whether to return to Russia, or indeed emigrate in the first place, could split families apart. It was also because the relatively rapid adaptation of children to new cultural conditions, and in particular their absorption of new languages, seemed to threaten the émigré dream of maintaining Russian civilization, and especially Russian literature, in a pure, pre-Revolutionary state outside the borders of the home country. Nadezhda Teffi, whose studies of oppressed children are similar in tone to those of Saki's portraits of small boys persecuted by terrible aunts, shows in 'Huron' how children could be made to suffer on account of these adult illusions.

NADEZHDA TEFFI
'Huron'

Vozrozhdenie, 635 (27 February 1927)

When Sergo got back in the afternoons from his lycée, Lynette would be having her rest. Later, she would go off to the music-hall to do her show.

On Thursdays and Sundays, when there weren't any lessons, she had a matinée performance. So they hardly ever saw one another.

Publicity photographs of Lynette were drawing-pinned to the grubby walls of their tiny salon. All of them showed her wearing funny clothes: feathers, flowers, wigs. She looked anxious and unlike herself.

They hadn't got any friends. Sometimes uncle would come: he was Lynette's brother. Lynette was Sergo's aunt, but of course he never called her that. It would have been stupid, like calling Thumbelina Granny, or something.

Lynette was tiny, only just bigger than Sergo, who was eleven. Her hair was cut short like his, and she had a nice little voice for singing songs in, songs in every language under the sun, and dainty little legs for dancing on.

Once Sergo had come back to find a black man and a shiny gentleman in tails in their cramped little salon. The shiny gentleman was laying into the keys of their dusty upright piano, producing a noise like a drum roll, while the black man rolled the whites of his eyes, which had a yellowish look, like eggs after being baked in a Russian stove. The black man was dancing on the spot, occasionally flaring out his fleshy lips to lay bare a single gold tooth – it looked absurd, almost indecent, in that mouth as dark and dangerous as a puma's – and grinding out a single sentence, incomprehensible yet insistent, always the same sentence, always in the same way . . .

Lynette, with her back to the black man, sang strange words in her sweet little voice, then suddenly stopped and, expressionless as a bird, said, 'Coo-coory-coo.' And put her head on one side.

'Coo-coory-coo' and the gold tooth were Lynette's work.

At school Sergo studied diligently. He soon lost his Russian accent, and immersed himself with all his heart in the glorious history of France, revelling in the Clovises and the Charlemagnes, delighting in the country's proud dawn. Sergo loved school. Once he even mugged up a long monologue from his textbook, and treated uncle to a performance of this. But uncle didn't seem at all pleased.

'See how quickly they forget it all!' he said to Lynette. 'He's turning into a real little Frenchman. We'll have to get him some Russian books, if nothing else. This can't go on.'

Sergo was upset and offended. Why hadn't he been praised for his efforts? After all, they'd spent ages nagging him over his accent at school. Then they'd congratulated him, said he was speaking like a French person now. But then it turned out that wasn't a good thing either. He seemed to be in the wrong whatever he did.

A few days later, uncle brought him three books.

'Here's some Russian literature for you. I loved these books at your age. Read them whenever you have some free time. You mustn't forget life back home.'

The Russian books turned out to be by Mayne Reid.[1] Still, uncle had meant well, done what he thought was right. And it was the start of a new life for Sergo.

Lynette was coughing as she lay on the sofa, stretching out her delicate legs, like a dragonfly's, and staring with horror and astonishment

into a make-up mirror, which showed a reflection of her puffy nose.

'Sergo, put that book down for a minute and tell me how old you are, eh?'

'Eleven.'

'How odd. Didn't auntie tell you that you were eight?'

'I was eight ages ago, in Berlin.'

Lynette raised her plucked eyebrows scornfully.

'Well, so what's the difference?'

Sergo lapsed into embarrassed silence. He'd obviously said something stupid, though he couldn't think what. Everything was so complicated. One thing at school, another thing at home. At school France was the best country in the world. Well, that was obvious: it really was. But at home you had to love Russia, even though everyone had run away from there. The grown-ups remembered a few things about Russia. Lynette had gone skating, and there'd been horses and foals down on the estate, and uncle said that Russia was the only place where you got proper hot *zakuski*.[2] Sergo had never seen the foals or eaten the *zakuski*, and he'd never heard anything else about Russia. It wasn't exactly enough to make you feel patriotic.

The Head-hunters. The Vanished Sister. The Headless Rider.

No problems there. Everything was straightforward, close, familiar. It was family, it was home. Strength, bravery, honesty.

'*Manitou loves brave men.*'

'*A Huron cannot lie, my pale-face brother. A Huron dies rather than break his word.*'

That was real life.

'*The insides of breadfruits were sweet and juicy. They made an excellent breakfast . . .*'

'So do they still exist?' he asked Lynette.

'"They"? Who d'you mean?'

Sergo blushed fiercely. He was almost on the point of tears: it was painful to mention something you were so attached to.

'Red Indians.'

'Of course. In America they sell postcards with them on. And I've seen pictures in *L'Illustration* too.'

'They sell postcards? Does that mean you can buy them, then?'

''Course you can. Listen, let's write to Lili Karnavtseva: she'll send as many as you fancy.'

Sergo let out a great sigh. He got to his feet, then slumped down

again, lost for words. Lynette looked at him, mouth half open. She'd never seen so much excitement on a human face before.

'I'll write straight away. It's no trouble.'

Lynette ran into Sergo by the entrance to the apartment block. He looked so little, standing there on the street with his battered school-bag.

'What is it?'

He came up close and, unable to look her in the eyes for embarrass-ment, asked: 'Haven't you had the answer yet?'

'What answer?'

Lynette was in a hurry to get to the theatre.

'From there? About the Red Indians?' she muttered, going a bit red. 'Oh yes . . . We'll have to wait a little while, you know. The post isn't too good.'

'So when will we get the answer?' asked Sergo, provoked into bravery by his desperation.

'Another week or two at the earliest. Got to fly now!'

'A week or two . . .'

He waited patiently for a week. Only then did he start looking question-ingly at Lynette. A week after that, he came home earlier than usual one afternoon. As the door of the apartment opened, he asked breath-lessly: 'Did you get the answer?'

Lynette didn't know what he meant.

'Did you get the answer from America?'

She still didn't understand.

'About . . . about the Red Indians?'

His lips were trembling. Lynette went red once again. 'Don't pester me! Lili's got better things to do than rush round buying you postcards. You'll have to wait, after all, it's not exactly urgent. She'll send them when she's bought them.'

So he waited for another month, only then plucking up courage to ask: 'So you still haven't had an answer?'

This time Lynette really lost her temper. 'For God's sake, let me alone with your damn Indians! I told you I'd write, and I will. But if you keep pestering me, then I won't write. I won't write on purpose.'

'You mean you . . .'

 ✿ ✿ ✿

Lynette needed a pencil. She had lots herself: eyebrow pencils, lip pencils, eyeliner pencils, pencils she could use to paint blue veins on the back of her hands. But none of them was any good for writing with.

'Let's take a look in little Sergo's treasure-chest.'

The treasure-chest was in the dining room, on top of a trunk covered by a threadbare rug. Books, feathers, exercise books, pebbles from the beach packed carefully into a little box, a stub of sealing wax, silver paper off a chocolate bar, and his most precious treasures: a few shotgun pellets, a crow's tail-feather and, in the centre, part of the firing-chamber of a toy gun. It was empty.

Sergo's whole human life was there in the trunk, exposed like a flame in an open lantern.

Lynette sneered at the bit of firing-chamber. 'I suppose that's on account of his stupid Red Indians. What a load of nonsense!'

Still hunting for her pencil, she riffled through Sergo's things. Eventually she turned up a little engagement book: it was the kind that you get sent free by the Post Office round about New Year. Sergo had scrawled all over it, crossing off the days, marking the passage of time till the great day arrived. Underneath was an old exercise book, with conscientious tables of French verbs. In the margins Sergo had been keeping a diary, a private record meant only for his own eyes, written in broken Russian: *The Hurons are magnanimous*. I affe given to Paul Gros my Italien stampe.'

'The response from America it arrive in ten days.'

'*Manitou loves the brave.* Today on purpose I stop myself on the crossine just as an auto was cuming.'

'Onlie six days now.'

'I ave bot it for 4 francs.'

'Onlie four days now.'

'She as peut-être still not ritten, but she soon will rite. The response will be ere in un quinzaine de jours. Today is the fourth of Mars. *The Hurons are patient and steadfast.*'

Lynette sighed. 'What stupid, stupid nonsense! It's all getting quite pathological. Just as well I never did write that letter to Lili.'

Translated by Catriona Kelly

Sasha Chorny here answers the call made by Khodasevich for a literature 'marked by emigration' with a moving evocation of an old couple whose humble serenity points up the rootlessness of the observer.

SASHA CHORNY
'Coiffeur de chiens'

Poslednie novosti, 18 June 1930

So difficult to find in this enormous city
Any romance. But then, salvation for sore eyes:
The clouded Seine,
A pock-marked wall,
And curving in, a bridge's closing arch,
An awning, bench and table.
An old man with the features of a poet
Is trimming into mounds a poodle's pelt.
The movements of his hands so nobly flowing.
And so benevolent his eyes,
You'd think perhaps he'd found himself
The world's most marvellous vocation.
That saucy little pooch meanwhile is well content;
He volunteers his flank,
Rolls up his eye and wags his pom-pom tail . . .
In summer heat to be a shaggy demon
Is not the easiest of jobs;
He's flattered by the thought of being handsome,
And clever enough to read the barber's mind.
All done!
The client, energized, springs free, jumps down.
O lion of a dog! Don Juan full of tricks,
Grizzled imperial beneath your snout . . .
The ribbed fur lets the pinkish skin peep through,
Over the neck a muff like swelling waves,
The poodle's owner makes his fond inspection,
Puts on the leash, and leads him off,
A fairy prince after the spell's been broken.

A balcony cat observes, eyes slitted with contempt . . .
The barber meanwhile sets upon his table
An ancient lap-dog, canine *demi-vierge*,
Like a squashed caterpillar ringed in kiss-curls . . .
The scissors scintillate, Seine billows slap,
And in his spectacles the sun plays tricks.

Here comes the barber's wife with her enamelled pot,
His close companion, jaded and submissive.
She wipes the clippings off the table,
Spreads out a newspaper . . .
Three hues light up the gloom beneath the arch,
Pale green, crimson, and amber:
Lettuce, tomatoes, loaf.
Sophisticated, solemn,
The ancient couple pass each other
A knife, the salt . . .
No words; they've all been spoken long ago.
Their meek eyes, though,
Are staring fixedly, far far away
Towards the clouds, those grizzled liners
That sail above the grimy houses;
Out of the sky-blue hatches
Through wisps of steam
Their bygone days come floating out in waves.
And I, a passer-by,
Look down from my green slope
Through the lattice-window of the weeds,
And I too reminisce,
Before I left my native land, I once
Read something of this pair in an old story
Where they were called 'The Old-World Landowners' . . .[1]
All right, it wasn't *them*. The symbolism stays,
And it's the same washed-out and kindly eyes,
The same serene attention to each other;
Two ancient hearts welded for evermore.

How was it that this ancient man
With a distinguished, subtle face like his,

Began to barber dogs?
In this enormous life, perhaps,
No other kind of pastime came along?
Or does the roulette wheel of evil omen
Palm off on us one number or another,
And never check what we might choose ourselves?
I've no idea . . .
But anyway, as I looked on covertly,
I saw no grief reflected in his eyes . . .
Perhaps in ancient times he would have been a sage,
Crouched hirsute in a barrel by the forum,
Soothsaying to the foolish passers-by
For a few beans . . .
But modern times are not so nice as that:
Every last barrel occupied,
The citizens just doing what they like,
And beans no longer cheap.
Meanwhile, dog fur keeps growing, I'm afraid,
And *someone* has to trim it.
Look, lunch is over. Table cleared, hands free.
A girl approaches, peep-fanged pug in tow;
He must get down to business, fix a price
For barbering her darling à la mode.

Translated by G. S. Smith

21. Master of ceremonies: The pre-Revolutionary artistic cabaret, more or less a lost art in Soviet Russia, had a far from negligible after-life in the Russian emigration. This drawing by Aleksandr Arnshtam depicts Nikita Baliev (1877–1936), a director of the Bat (Chauve-Souris), which operated in various European and American locations between 1920 and 1936.

The disorienting effects of emigration were never more strikingly evoked than in the hallucinogenic, heroin-fuelled imagery of Boris Poplavsky's poetry (akin to that of French surrealist poetry and painting, and also to the canvases of Marc Chagall).

BORIS POPLAVSKY
'Another Planet'

Dirigible of Unknown Destination (Paris, 1965)

To Jules Laforgue

With our monocles, our frayed pants,
our various diseases of the heart,
we slyly think that planets and the moon
have been left to us by Laforgue.

So we scramble meowing up the drainpipe.
The roofs are asleep, looking like scaly carp.
And a long-tailed devil, wrapped in a thundercloud,
struts around like a draughtsman's compass on a map.

Sleepwalkers promenade.
House-ghosts with sideburns lounge sedately.
Winged dogs bark quietly;
we fly off softly, mounted on dogs.

Below, milky land glistens.
A train belching sparks is clearly visible.
A pattern of rivers ornaments the fields,
And over there is the sea, its waters waist-deep.

Raising their tails like aeroplanes,
our pilots are gaining altitude,
and we fly off to Venus – but not the one
that wrecks the charts of our life.

A motionless blue mountain, like a nose.
Glassy lakes in the shadow of mountains.
Joy, like a tray, shakes us.
We head for a landing, our lights fading out.

Why are these fires burning on the bright sun's surface?
No, already they fly and crawl and whisper –
They are dragonfly people, they are butterflies
as light as tears and no stronger than a flower.

Toads like fat mushrooms come galloping,
carrots buck and rear and quiver,
and along with them toothed plants
that cast no shadows are reaching for us.

And they start to buzz, they start to crackle and squeak,
they kiss, they bite – why, this is hell!
Grasses whistle like pink serpents
and the cats! I won't even try to describe them.

We're trapped. We weep. We fall silent.
And suddenly it gets dark with terrifying speed.
Frozen rain, the snowy smoke of an avalanche,
our dirigible no longer dares to fly.

The insects' angry host has vanished.
And as for us, we have stretched out to die.
Mountains close in, a deep blue morgue shuts over us.
Ice and eternity enchain us.

Translated by Emmett Jarrett and Dick Lourie

The central theme of Khodasevich's later poetry was disillusion, a disillusion exacerbated by, though not originating in, the frustrations of émigré literary culture.

VLADISLAV KHODASEVICH
'In Front of the Mirror'

Sovremennye zapiski, 24 (1925)

Nel mezzo del cammin di nostra vita.

'I, I, I.' What a strange word he's saying!
That man there – can he really be 'I'?
Such a creature my mother watched playing –
Ashen skin, and the hair slightly greying,
As all-wise as a snake, and as sly?

The boy dancing at country-house dances
In Ostankino's[1] summer-night heat –
Was that I, who at each of my answers
Can read loathing and fear in the glances
Of the half-fledged young poets I meet?

Can that boy who poured out all his feeling
In debates that went on half the night
Be myself – the same self that was steeled in
Sadder talk where I learned to conceal,
To say nothing, or keep my words light?

But all this is the traveller's hazard
On the journey by which life is spanned:
You look up, for no cause you could guess at,
And you're lost in a featureless desert,
Your own tracks even vanished in sand.

No black tigress in Paris defied me –[2]
I can't claim a bohemian past –
And I've no ghostly Virgil to guide me. –[3]
Merely loneliness standing beside me
In the frame of the truth-telling glass.

1924

Translated by Michael Frayn

The years between 1910 and 1915 – those when Akhmatova first made her poetic reputation – were the inspiration for much of her post-1940 poetry, most famously her magnificent Poem without a Hero, *in which she saw 1914 as the beginning of the 'real twentieth century'. The same combination of historical and individual thematics as in* Poem without a Hero *is evident in the poem below. 'Burdock plants' and 'nettles' were regularly associated in Akhmatova's autobiographical writings with Tsarskoe Selo, where the poet lived between 1910 and 1917, while the Pushkin citation (taken from the lyric poem 'Tsarskoe Selo' of 1823) hints that this poem is not only a reminiscence about Akhmatova's own earlier self, but also a meditation upon close friends and relations from whom the poet is now separated because, as Pushkin put it in* Evgeny Onegin, *'some have passed away, others are far away' (that is, in political exile).*

ANNA AKHMATOVA
'The Willow'

Zvezda, 3–4 (1940)

A battered copse of trees
 – Pushkin

A patterned silence lapped me as I grew,
The temperate nursery of a dawning era,
The human voice found me a grudging hearer.
The wind's voice, though, I understood and knew.
Though burdock plants and nettles gave me pleasure,
The silver willow was my chiefest treasure.
And, out of gratitude, it lived with me
Through all its life; its branches streaming
Entwined my sleeplessness about with dreaming.
I have survived it, odd as that may be!
A stump remains, while other willows chatter

Both here and elsewhere, under other skies
In alien voices, of some other matter.
And I stay mute . . . as when a brother dies.[1]

18 January 1940

Translated by Alan Myers

Less well known than Akhmatova, Sofiya Parnok is an equally striking example of an 'internal exile'; alienated from Soviet culture both because of her aesthetic preferences (her work is close to that of the Acmeists in its fastidious phrasing and employment of a register close to that of educated everyday speech) and because of her sexual preferences, she gave voice in her work not to bilious discontent at her exclusion, but to the belief in an intellectual community above national borders and transient political affiliations.

SOFIYA PARNOK
'Through a Window-light'

From *Collected Works*, S. Polyakova (ed.) (Ann Arbor, Ardis, 1979)

With both knees pressed down on the sill,
Mouth fixed like a fish's to the pane,
I breathe, and then breathe in again:
So, clinging to life, a body will
Suck from a greyish sack: so the heart bounds
Insistently: it's time, it's time to go!
The firmament is heavy on the ground,
The night has turned a dirty grey like snow,
Grey like this cushion filled with oxygen.

But I'm not dying yet: I'm still
Stubborn. I think. And now again
The bullying, magic syllable
Demands its tribute from my life:
I push my head out through the light
– The moon is ringed with rusty cloud –
And, gazing on the ordered stars,
Address the distance in these words:

'As in a steam-bath dirt evaporates
From sweaty skin, so now above the soil
Dark thoughts and septic secrets, petty hates
Rise in a miasma dense and foul.

And though the window's wide for air
I none the less choke on despair.
Strange, don't you think? Ills of all kinds
Are treatable: sarcoma, age's slow decline,
Sclerosis . . . But find the place
That might slow down the germ of evil's race!
Kneeling, like this, I'd crawl down rutted lanes
Down cratered city streets, if I could go . . .
Go where? Where to? God only knows!
Perhaps to a hermitage somewhere,
Repent my sins in tears and prayer –
Where is Zosima, faith's defender,[1]
Or is the world without end ended?'

It's light. The houses in the dawn
Are bare and thoughtful: high above the roofs
The Burning Bush church[2] dome and cross
Give off a flat and meagre glint;
And somewhere in the West, in Paris.
In Rome or Hamburg – who cares where?
Pressing against the pane for air,
Forcing its sour slops past the larynx,
Breathing with last reserves of strength,
Another stands and weeps and thinks:
Not Red. White, Black: a woman or a man.
A human being and not a citizen,
Like me, perhaps: someone whose life now ebbs
In stagnancy, and not in happiness.

February–March 1928

Translated by Catriona Kelly

Notes

1 New Worlds

[Moscow Symphony], Andrei Bely

1. *He knew nothing of the removal of the final veils*: That is, from Isis, the Egyptian goddess, whose mystical cult was extremely popular as a point of reference with the post-1900 generation of Russian symbolists. See also note 7 to Osip Mandelstam, 'Literary Moscow', below.

2. *A talented artist had painted a 'miracle' on a large canvas*: According to A. V. Lavrov's notes to Andrei Bely, *Symphonies* (Leningrad, 1991), the artist referred to is Mikhail Nesterov, whose painting *The Miracle* (1895–7) represented Saint Barbara kneeling before her own decapitated head. The painting, exhibited at the 1900 Paris International Exhibition, was later (perhaps fortunately) destroyed by Nesterov.

'Proposals', Velimir Khlebnikov

1. *the theory of resonant plates (Kundt's dust figures)*: August Kundt (1839–94) was a German physicist whose subjects of research included the speed of transmission of sound in gases and in solid bodies. His experiments employed fine dust that was dispersed inside glass tubes.

[The Temple of the Machines], Fyodor Gladkov

1. *let me rub you down with juice from the machines*: The analogy between the machine and the human body that is made by Gladkov was a cliché of 1920s Soviet writing; the homoerotic overtones of the instance here are, however, unusually overt.

2. *Brynza the mechanic*: A singularly odd choice of name, since Brynza is the name of a Caucasian sheep's milk cheese. It would be like talking about a heroic Italian worker named 'Mozzarella'.

3. *a sideline in making cigarette lighters*: Just after the Civil War, when Soviet industries were working well below capacity, workers were often forced to use their tools to make saleable goods, such as cigarette lighters, in order to survive.

4. *He had remained faithful to them till the bitter end*: This line appears only in the 1929 edition of *Cement*, but has been interpolated here to bring the extract to a suitably resounding conclusion.

'The Fair at White Kolp', 'Ivan Kremnyov' (Aleksandr Chayanov)

1. *'The Russian Cuisine' compiled by Mr Levshin in 1818*: V. A. Levshin (1746–1826), a prolific translator and author, issued a six-part *Cook's Dictionary* in 1795–7, a *Cook's Calendar* in 1808 and a *Russian Cook-Book* in 1816. If not a slip, Chayanov's reference must be to a reprint of one of these.

2. *Tsar Ivan Vasilievich*: Both Ivan IV ('the Terrible') and Ivan III had the patronymic 'Vasilievich', but the Tsar usually referred to by the name is Ivan III (ruled 1462–1505), whose achievements include important victories against the Tartars, diplomatic contacts with Western Europe, and (perhaps most relevantly here) a huge building programme in Moscow, including the construction of cathedrals and palaces in the Kremlin.

3. *A. G. Venetsianov*: Venetsianov (1780–1847) was an important pioneer of realistic landscape painting in Russia, a forerunner of the so-called Wanderers group in his preference for genre subjects of peasant life. *P. P. Konchalovsky* (1876–1942) was a post-impressionist figurative painter best known for his flower paintings and portraits. *I. S. Ostroukhov* was a late-nineteenth-century collector and patron of the arts; his collection was nationalized after the Revolution.

4. *F. S. Rokotov*: Rokotov (1735/6–1809) was a prominent portrait painter of Catherine II's reign, responsible for a likeness of the Empress in profile that was widely copied.

From *Lenin*, Nikolai Klyuev

1. *the lark and her double the pipit*: Literally, 'her namesake', an image that does not work in English (the two birds look alike, but their names are dissimilar).

2. *Mount Tabor*: The mountain top on which the Transfiguration of Christ, an important theme in Russian icons, took place.

3. *Solovki*: In northern Russia, the site of an important monastery, used as a political prison during the 1920s.

[An Experiment Goes Wrong], Mikhail Bulgakov

1. *House committee*: (Russian *domoupravlenie*) The committee responsible for overseeing living space allocation and observation of house rules in Soviet apartment blocks. The humour of the situation depends on the fact that the house committee in Professor Preobrazhensky's block spends most of the first part of the story trying to get the professor to submit to *uplotnenie* (surrender of part of his flat to other tenants), so that this loss of determination on their part is totally unexpected.

[Hammersmith Station], Evgeny Zamyatin

1. *the little monument*: One of the leitmotifs applied to Craggs is 'little monument' (Russian *monumentik*), suggesting his pomposity and triviality. It is possible there is also a buried reference to the figure of the Commendatore in Mozart's

Don Giovanni, though whether Craggs exacts terrible revenge upon those he discovers in adultery is not revealed.

[The Rhythm of the Future], Vadim Shershenevich
1. *the whole fill, the quick*: Shershenevich uses the neologisms *poln* and *bystr*, which are abbreviations of the usual Russian words for 'fullness' and 'quickness'.

[Living in Utopia], Olga Berggolts
1. *There's many a slip 'twixt cup and lip*: The original Russian, *Falanstera na Rubinshteina sem ne sostoyalas*, means literally 'Falanster plus Rubinstein doesn't equal seven [men].'

2 Visions of Art

From 'On Beautiful Clarity: Remarks on Prose', Mikhail Kuzmin
1. *Prévost . . . Le Sage . . . Henri de Régnier*: Abbé Antoine François Prévost d'Exiles (1697–1763), author of *Manon Lescaut*; Alain René Le Sage (1668–1747), novelist and dramatist most famous for *Gil Blas*; Henri de Régnier (1864–1936) was a minor neoclassical poet and novelist best known for his fiction in a pastiche seventeenth- and eighteenth-century manner, such as *La Double Maîtresse* (1900).
2. *to turn it into kosher meat*: Because this is drained, as far as possible, of blood in order to make it ritually pure, and hence, by implication, 'lacks juice', it is flavourless. (Kuzmin's remark reveals a supercilious attitude to traditional Jewish practices that was quite widespread in Russian culture at the turn of the century.)
3. *Ostrovsky, Pechersky . . . Leskov . . . Dal's dictionary*: That is, Aleksandr Ostrovsky (1823–86), playwright, Pavel Melnikov-Pechersky (1818–83), prose writer, and Nikolai Leskov (1831–95), all realist writers specializing in scenes of provincial Russian life who were known for their command of popular speech; Vladimir Dal's dictionary of the Russian language, first published in the 1860s, was, and is, an invaluable storehouse of information about popular figures of speech, proverbs and customs.
4. *The* Queen of Spades, Scenes from the Age of Chivalry . . . Caesar was on a Journey: *The Queen of Spades* (1833), Pushkin's most famous short story, set at the time when it was written, is a model of polished laconicism; in the unfinished drama *Scenes from the Age of Chivalry* (1835) and the prose fragment *Caesar was on a Journey*, Pushkin's style is equally compressed, but is clearly influenced by a desire to imitate colloquial speech in the first case, and Caesar's own Latin in the second.

From 'The Paths of Classicism in Art', Léon Bakst

1. *anyone who knows the biggest names in contemporary French art will be able to deduce as many different directions emanating from these*: Bakst has in mind such 'directions' as Cézannisme, painting inspired by the work of Paul Cézanne.

2. *Courbet*: That is, Gustave Courbet (1819–77), the pioneer of naturalist painting and a specialist in genre scenes of peasant life, whose *Enterrement à Ornans* shocked the sensibilities of the French Salon in 1850. I have not been able to trace the source of the anecdote that Bakst quotes.

3. *Muther's* Geschichte der Malerei im XIX Jahrhundert: That is, the history of nineteenth-century painting (3 vols., Munich, 1893), by Richard Muther, erudite and prolific professor of visual arts at the University of Breslau, known in its English edition as *The History of Modern Painting* (London, 1895). It was a standard source on its subject in the late nineteenth and early twentieth centuries.

[Against Linear Perspective], Pavel Florensky

1. *in scarlet*: Literally, in mercury sulphide (Russian *kinovar*), a pigment with a bright yellow-red colour.

2. *Anaxagoras and Democritus*: Both Athenian philosophers of the fifth century BC. Anaxagoras of Clazomena, the teacher of Pericles and admired by Aristotle, held that the world was composed of a mixture of organic and inorganic matter. Democritus of Abdera was a contributor to atomist theory who, in the words of *The Oxford Classical Dictionary*, 'defended the finite or perishable universe, efficient or "mechanical" causes'. In other words, both took a materialist view of the world inimical to the neo-Platonic dualism of mind and matter underlying Florensky's own world-view.

3. *the Wanderer movement*: The Wanderers (Russian *Peredvizhniki*) were a group of Russian painters who rebelled against the constraints of the Russian Academy in the 1860s. They favoured socially relevant themes, such as genre subjects from peasant life, and their most famous adherents included Ilya Repin (whose attack on modernist painting is included in the 'Altercations and Provocations' section).

4. *the worldly theatre*: The Russian word that Florensky uses, *obmirshchennyi*, was used by the Old Believers (strict Orthodox sectarians who split off from the main Church in the mid seventeenth century) in order to refer to objects or to behaviour that had been corrupted by contact with the secular world (*mir*).

From *On the Nature of the Word*, Osip Mandelstam

1. *'clarism'*: The term was coined by Mikhail Kuzmin to refer to a new, anti-symbolist, limpidity: see his essay 'On Beautiful Clarity', above.

2. *The author of* Boris Godunov . . . *an ode in the style of Derzhavin*: Pushkin's play *Boris Godunov* (1825) is a historical tragedy in the Shakespearean manner, and the same author's juvenilia (written while he was at the Tsarskoe Selo

Lyceum) are usually referred to as his 'Lyceum Verse'; Gavrila Derzhavin (1743–1816), Pushkin's most talented immediate predecessor, was the author of odes both sumptuously magnificent ('The Waterfall', upon the death of Potemkin), and conversationally playful ('Felitsa', a piece of ambiguous flattery addressed to Catherine II as enlightened monarch).

3. *Lobachevsky's*: N. I. Lobachevsky (1792–1856) was the author of *Geometrical Researchers in the Theory of Parallels* (1840). Mandelstam's comparison of him with Euclid is intended to be ironic.

4. *logophagic*: (Gk) 'word-devouring'; the Russian means literally 'hungry for words'.

From 'On Contemporary Photography', Aleksandr Rodchenko

1. *My dear Kushner*: Boris Kushner, critic, associate of the Lef group.

2. *the pictures of Vereshchagin and Denner*: Vasily Vereshchagin (1842–1904) was best known for his photo-realist paintings, many on Orientalist subjects (e.g., *The Tamburlaine Gates*, 1872). By 'Denner', Rodchenko may mean Balthasar Denner (1685–1749), a north German painter, but the name could be a mistake for the Austrian naturalist Franz von Defregger (1835–1921).

3. *The Association of the Artists of Revolutionary Russia*: This militant neo-realistic organization, whose most prominent members included the painter Isaak Brodsky, made little impact on artistic policy until the late 1920s/early 1930s, but thereafter its ideologies played an important role in the establishment of socialist realism.

4. *The World of Art*: See headnote to the extract from Bakst's 'The Paths of Classicism in Art', above.

5. *Repin's canonical* Zaporozhian Cossacks: A colossal history painting, representing the rebellion of the Cossacks against Turkish domination, to the non-nationalist eye lurid, painted by Repin 1880–91.

6. *Kaufman and Fridlyand*: P. S. Kaufman and Semyon Fridlyand, Soviet photographers who, like Rodchenko, were interested in work expressing a commitment to leftist formal principles.

From *How to Make Verses*, Vladimir Mayakovsky

1. *the social command*: (Russian *sotsial'nyi zakaz*) Term coined by the Lef group for the relation between consumer and producer of art works in socialist culture. Rather than individual patrons commissioning works (as in feudal societies), or publishers and literary societies (as in capitalist societies), in socialist societies works are 'commissioned' by society at large (whose wishes are grasped by the politically literate artist).

2. *a good rhyme*: The content of the quoted passages has been freely adapted to allow the approximate rhymes that attracted Mayakovsky to be conveyed. Some of the rhymes and themes mentioned here did indeed find their way into his poetry: for example themes 2 and 3 occur in 'Foreign Piece' and 'La Parisienne'

respectively, and theme 4 (the October Revolution) *passim* in his post-1917 work.

3. *where rhymes . . . came to me*: The places that are mentioned lie in central Moscow and in the suburbs of the city.

4. *that son of a bitch Danthès*: Danthès is infamous in Russian literary history as the man suspected by Pushkin of adultery with the latter's wife Natalya, and challenged by him to a duel in which the poet was killed. Here, Mayakovsky seems to have been attracted by the sheer abusiveness of the term 'son of a bitch' rather than by any sound chime between it and 'Danthès'.

5. *Shengeli's manual*: Georgy Shengeli's *Kak pisat stati, stikhi i rasskazy* was published in Moscow in 1926.

6. *appeared in the Kharkov newspaper* The Proletarian: According to the editors of Mayakovsky's *Complete Works*, this advertisement really did appear in no. 256 of *The Proletarian* for 1925.

7. Leisure *magazine*: *Razvlechenie* was published as a supplement to the popular newspaper *Moskovskii listok* (*Moscow Newssheet*, 1859–1915).

[Milton, Mayakovsky and Montage], Sergei Eisenstein

Notes 1–5 below are indebted to those in Eisenstein's *The Film Sense*.

1. *Everything martial . . . its colour*: From Hilaire Belloc, *Milton* (Lippincott, 1935), p. 256.

2. *at last . . . furious expedition*: Milton, *Paradise Lost*, Book VI, lines 78–86.

3. *that proud honour . . . to Battel*: *Paradise Lost*, Book I, lines 531–53.

4. *in strength . . . Battel hung*: *Paradise Lost*, Book VI, lines 231–46.

5. Book V, 622–4.

6. *Emptiness . . . your way*: Eisenstein quotes from the opening of Mayakovsky's great elegy 'In Memory of Sergei Esenin' (1926).

[Svistonov Writing], Konstantin Vaginov

1. *Guillaume de Rubrouck's journey into Eastern lands*: Friar Guillaume de Rubrouck's *Itinerarium*, a description of his visit to the court of the Great Khan Möngke in 1253–5.

2. *Panaeva's* Memoirs: Avdotya Panaeva (1819 or 1820–93) was a leading figure in the radical circles associated with the journal *The Contemporary* (*Sovremennik*) in the mid nineteenth century. Her sprightly and incisive – if also partial and at times spiteful – reminiscences were published in an edition edited by Kornei Chukovsky in 1929.

3 Altercations and Provocations

'Choosing a Sack', Zinaida Gippius

1. Russian Herald, *Gringmut and Prince Meshchersky*: *Russian Herald (Russkii vestnik)*, a reactionary monthly; Vladimir Gringmut (1851–1907), critic and publicist best known for his chauvinist assaults on 'Zolaism' as a 'non-Russian' phenomenon; Prince V. P. Meshchersky (1839–1914), extreme conservative, editor of *The Citizen (Grazhdanin)* and other reactionary magazines, and author of trashy novels of high society life.

2. The Wide World: (*Mir bozhii*) The journal of the Legal Marxist group. It published realist fiction, reportage and socialist polemics. Fyodor Batyushkov (1857–1920), critic and littérateur of left-populist inclinations, was its editor from 1902.

3. Education: (*Obrazovanie*) A self-improvement magazine printed on acid paper (yellowish in colour). Gippius also insinuates that its views and readership were in some ways not dissimilar from those of the boulevard press, known as *zholtaya pressa* ('yellow press').

4. *Mr Oldthoughts*: From Starodum, a tedious *raisonneur* in Denis Fonvizin's play *The Minor (Nedorosl*, 1782), who expresses respect for the 'good old ways' in everything.

5. Foma Gordeev: A novel published by Gorky in 1899.

6. *his 'old woman Izergils'*: Gorky's story 'Old Woman Izergil' appeared in a Samara local newspaper in 1895.

7. *Ilyas . . . 'Orlov the husband'*: Ilya is one of the heroes of the novel *Three* (1900); 'The Orlov Couple' was first published in 1897.

[Jam Turnovers and a Slanging Match], Fyodor Sologub

1. *dear*: In the original, Varvara addresses Peredonov by name and patronymic, a sign of respect, while he addresses her by her first name alone. Varvara's ingratiating use of 'dear' in the English is an attempt to capture the discrepancy.

'An Ass in the Latest Style (Aria for Abraded Voices)', Sasha Chorny

1. *give my own toes a bite*: The original has *za lokot sebya ukusu*: 'I shall bite my own elbow', from the proverb *Blizok lokot, da ne ukusish*: 'Your elbow is right by you, but you'll never bite it' (said of something impossible).

'A Slap in the Face of Public Taste', David Burlyuk, Aleksei Kruchonykh, Vladimir Mayakovsky, Velimir Khlebnikov

1. *New First Unexpected*: No noun is specified in the Russian: the effect is that the manifesto is too novel to be easily named.

2. *sunsets of pleasures yet unknown*: The phrase parodies Bryusov's decadent themes and phraseology.

3. *the filthy slime oozed out by the many Leonid Andreevs*: Andreev's works, such as *The Abyss* (*Bezdna*, 1902), were notorious for their pessimism and for their frank treatment of erotic themes.

4. *All those Gorkys . . . Bunins, and so on*: This is a list of the most successful writers of the day, including not only symbolists (Blok, Sologub, whose name is deliberately misspelt in the original in such a way as to suggest the writer's affinity with Count Sollogub, a minor author of the early nineteenth century, and Remizov), but also realists (Kuprin, Gorky, Bunin), a post-symbolist (Kuzmin, whose name is also misspelled in the original) and two satirists (Arkady Averchenko, 1881–1925, who, like Sasha Chorny, was a collaborator on the patrician St Petersburg satirical journal *Satirikon*, which regularly poked fun at the artistic avant-garde).

5. *the Word is innovation*: A polemical encapsulation of the theory of *zaum*, or 'transrational language', which was to be elaborated by Kruchonykh and Khlebnikov in *The Word as Such* (*Slovo kak takovoe*, 1913).

6. *from the bristles of scrubbing-brushes*: Literally 'from banya birch-twigs'. In the Russian *banya* ('steam bath'), birch twigs are used to thrash the skin in order to remove dirt and impurities and to stimulate the circulation.

7. *Aleksandr Kruchonykh . . . Viktor Khlebnikov*: Kruchonykh sometimes used the first name 'Aleksandr' rather than his given name 'Aleksei'; conversely, Khlebnikov occasionally favoured his given name, 'Viktor', over his sonorous Slavonic pseudonym 'Velimir' (literally 'Commander of the World').

From 'Noted Names', Sofiya Parnok

1. *'unhoped for joy'*: (Russian *nechayannaya radost*) The title (sometimes translated 'inadvertent joy') of a collection of lyric verse by Aleksandr Blok, published in 1907.

[No-hopers, Amateurs and Those Who Make So Bold], Nikolai Gumilyov

The notes below are partly indebted to R. D. Timenchik's edition of Nikolai Gumilyov, *Letters on Russian Poetry* (Moscow, Sovremennik, 1990).

1. *Modest Druzhinin*: Little is known about the biography of this author, who published seven books of verse between 1909 and 1916, and was much derided in the literary press of St Petersburg.

2. *This person*: Konstantin Antonov had published his first collection in 1903; his third and apparently last book of poems came out in Harbin in 1920.

3. *Sergei Alyakrinsky*: Born in 1889, he remained in literary life until the early 1920s; he eventually fell victim to the Great Purges in 1938.

4. *he's imitating not Nadson*: Semyon Nadson (1862–87) 'marks the low-water mark of Russian poetical technique; and his great popularity, the low-water mark of Russian poetical taste' (D. S. Mirsky).

5. *A. M. Fyodorov*: Fyodorov (1868–1949) was a versatile writer from Odessa, well known in his time.

6. *Imatra Falls*: A famous beauty-spot in the Grand Duchy of Finland, much visited by Russians on dacha holidays in the late nineteenth and early twentieth centuries.

7. *The lines where he imitates Bunin*: That is, Ivan Bunin (1870–1953); better known as a prose writer (he was awarded the Nobel Prize for Literature in 1933, and many of his stories have been translated into English), he enjoyed esteem in the 1900s and 1910s for his mellifluous, if also slightly empty, verse.

8. *Prince D. Svyatopolk-Mirsky*: Dmitry Petrovich Syvatopolk-Mirsky (who later preferred to be styled D. S. Mirsky) was born in 1890; after fighting in the Civil War, he emigrated to England, where he taught at the University of London for ten years. After becoming a communist, he returned to Russia in 1932, was arrested in 1937, and died in the Gulag. He is best known for his classic *A History of Russian Literature* (1949).

9. *without the letter 'yat' or hard signs*: These 'tricks', as Gumilyov terms them, advertised the futurists' left-wing beliefs.

'The Donkey's Tail', Maksimilian Voloshin

The notes below are partially indebted to those by T. L. Nikolskaya in Maksimilian Voloshin, *Liki tvorchestva* (Nauka, Leningrad, 1988).

1. *Kriksy-Variksy . . . played around with it*: The epigraph is a quotation from Aleksei Remizov's story 'The Fires on Saint John's Eve', part of the collection *Widdershins* (*Posolon*, 1907). The story, a stylized Russian folk-tale, relates the events on Saint John's Eve (23 June, the eve of Midsummer Day), when various folk demons roam about doing mischief. The Kriksy-Variksy are creatures who personify the wails of a small baby.

2. *The Knave of Diamonds . . . fire brigade had to be called out*: The Knave of Diamonds was the avant-garde group founded by Larionov and others in 1910. The Donkey's Tail, a splinter group founded by Larionov, began to exhibit separately in 1912. Voloshin's analogy with the plot of the Remizov story depends on seeing the Knave of Diamonds as the 'rump' organization from which the 'tail' has been chopped off. At the opening of the Donkey's Tail exhibition, a fire actually did break out, but was extinguished before any major damage was done to the pictures.

3. *the one 'artistic platform'*: Voloshin is not quite fair to the two groups: the Knave of Diamonds was of a more conservative orientation than the Donkey's Tail, its influences including such post-impressionist painters as Cézanne, while

the Donkey's Tail favoured more outré and avant-garde styles such as neo-primitivism.

4. *Georgy Chulkov*: Symbolist writer (1879–1939) who was also a prominent critic, so that this painting was personally as well as generically insulting.

5. *a notorious prank . . . dipped in paint*: The incident to which Voloshin refers took place at the Salon des indépendants in 1910.

6. *Russia still does not have a single art school of real authority*: The most prestigious art schools in Russia were the Academy of Arts in St Petersburg, and the School of Painting and Sculpture in Moscow, but the hidebound training given there had become increasingly unappealing to young painters by the early twentieth century. It was customary for ambitious young Russian painters to go to Paris to complete their studies.

7. *almost all Viktor Bart's drawings*: V. S. Bart (1887–1954), artist and theorist.

From 'Literary Moscow', Osip Mandelstam

1. *Dolidze*: Fyodor Dolidze (1883–?), an impresario who organized poetry readings and tours in the years after the Revolution; occasions that he set up included the 'Poetesses' Evening' made infamous by a sarcastic passage in Tsvetaeva's memoir of Bryusov, 'Hero of Labour'.

2. *The Polytechnical Museum*: A Moscow museum of arts, crafts and technology set up in the 1890s with the aim of educating working-class Russians.

3. *I. A. Aksyonov*: Poet and critic (1884–1935) of avant-garde orientations. The article to which Mandelstam refers appeared in the journal *Print and Revolution* (*Pechat i revolyutsiya*) in 1921.

4. *The saddest language . . . Anna Radlova*: Here Mandelstam conveniently forgot his own tributes to Tsvetaeva the Muscovite in a series of poems written during their brief affair in 1916, for example, 'On sacking, covered with straw . . .' His attack on women's writing is fully in the spirit of orthodox Soviet criticism during the early 1920s: compare Trotsky's comments in *Literature and Revolution* (1923). Anna Radlova (1891–1949) was a poet and translator, the wife of the theatre director Sergei Radlov and an associate of Mikhail Kuzmin.

5. *is Russian scientific poetics*: the Russian noun used by Mandelstam in the original (*nauchnaya poetika*) is feminine in gender.

6. *from among inventions and reminiscences*: See below in this essay, where Mandelstam expounds his view that these are the twin impulses of poetry.

7. *Isis*: The Egyptian goddess of fertility, who in legend collected the limbs of her murdered son Osiris so that he could be made whole again.

8. *Adalis*: The pseudonym of Adelina Efron (1900–1969), Moscow poet, prose writer and translator, the second wife of Valery Bryusov.

9. *Aseev's*: Nikolai Aseev (1889–1963), futurist poet, who after the Revolution was a strong supporter of Bolshevism and collaborated with the Left Front of Arts.

10. *gives his work the militaristic air of a political demonstration*: Literally 'makes it come across like something freshly mobilized', a term used for both political and military activity in the early Soviet period.

11. *well-respected Petersburg publishing house*: That is, World Literature (*Vsemirnaya literatura*), founded by Gorky in 1918 and specializing, until closed down in 1924, in literary translations.

'The First of May', Vladimir Mayakovsky

1. *the poetry muzzle clamps over your mouth*: Literally 'the poetry blinkers [American blinders] clamp down over your eyes'. Mayakovsky's tough-minded view of human beings was accompanied by a deep sympathy for animals, most particularly horses (see, for example, the poems 'Kindness to Horses' and 'Two Slightly Curious Incidents').

'In Praise of the Rich', Marina Tsvetaeva

1. *For their root*: The underlying image here is that of the family tree, which in the case of the rich is rotten at its base (the sins of parents are visited upon their children, a reversal of the traditional saying that is used directly by Tsvetaeva in her 1926 poem *The Staircase*).

4 Men and Women

'The Gaze of the Egyptian Girl', Aleksandr Blok

1. *the passionate captivity of Caesar*: That is, Julius Caesar's fabled passion for Cleopatra.

2. *the disgrace of Axium*: Mark Antony fled the battle of Axium (1st century BC) because of his love for Cleopatra.

3. *that made Pushkin 'forget himself in a hot-blooded dream' in a 'nomad wagon'*: The quotations are taken from Pushkin's poem 'To a Kalmyk Girl' (1829), which also describes a woman whose face does not conform to classical canons of female beauty.

4. *no Hyperborean barbarian*: The Hyperboreans were a tribe residing on the shores of the Black Sea, who, like the Scythians, were seen by early-twentieth-century Russian intellectuals as their own ancestors.

From 'The Cold of Morning: A Few Words about Women's Writing', Nadezhda Lvova

1. *where it would be hard to find even half a dozen names of women poets working in the nineteenth century*: There were in fact several dozen nineteenth-century women poets, but only a few of these, such as Karolina Pavlova, Evdokiya Rostopchina and Mirra Lokhvitskaya, were familiar to readers of Lvova's generation.

2. *René Ghil*: French symbolist poet and theorist (1862–1925), author of *Traité du verbe* (1886) and *Méthode évolutive d'une poésie rationelle* (1889).

3. *the harsh words of Valery Bryusov*: In a review in the journal *Russian Thought* (*Russkaya mysl'*), no. 7 (1912). [This note is taken from the original publication of Lvova's article.]

'Wires, no. 3', Marina Tsvetaeva

1. *I'm getting high*: The translator has replaced some of the linguistic play in Tsvetaeva's original (e.g., the pun on *provoda*, 'telegraph wires', and *provody*, 'a farewell party') by an analogous pun on 'wires' and the colloquial sense of 'wired up' (i.e., 'high on drugs').

'Because I had to let go your arms', Osip Mandelstam

1. *And three times in dreams . . . lips*: This translation is some distance from the original, which reads literally: 'And three times they dreamt of that seductive image/icon.'

From 'The Whip', Lidiya Zinovieva-Annibal

1. *My handwriting notebook*: The following passage plays subliminally on the Russian term for handwriting taught as a school discipline, *chistopisanie*, 'pure' or 'clean' writing.

2. *she*: That is, Aleksandra Ivanovna, the narrator's governess (see introductory note to text).

3. *Chinese flowers*: A kind of toy made up of a shell with shreds of crêpe paper as 'flowers' inside. When the shell is placed in water and the paper becomes wet, the 'flowers' extend from the shell, so that they look as though they are blooming under water.

[People Whose Sex is Naturally Different, or Homosexuals (*utriusque naturae [sexus] homo*)], Vasily Rozanov

1. *an* utriusque naturae (sexus) homo – *that is, someone attracted to individuals from his own sex*: In the letter to which Rozanov's note was a response, the critic N. P. Strakhov wrote, 'I knew all about Leontiev [i.e., Konstantin Leontiev, 1831–91, writer, critic and aesthete], but I didn't want to tell you: *de mortuis*, etc. [i.e., *de mortuis nil est nisi bonum*: nothing but good should be spoken of the dead]. You see, he charmed you with his intelligence and his aestheticism; but that particular phenomenon [i.e., homosexuality] is one of the most disgusting there is.' A vitriolic diatribe against homosexuality followed, ending with the words, 'This moral monstrosity outrages me; I simply cannot force myself to come to terms with it.'

2. People of the Lunar Light: *Lyudi lunnogo sveta*, Rozanov's 1911 treatise on homosexuality (see introduction to 'Men and Women').

3. *Weininger's famous book,* Sex and Character: *Geschlecht und Charakter*

(1904) by Otto Weininger, a famous, or infamous treatise, on sexual identity (see introduction to 'Men and Women').

4. volo: Latin for 'the will'.

5. prima philosophia *and* primum movens: Latin for 'the primary philosophy and prime moving spirit of the world'.

From 'Histoire édifiante de mes commencements', Mikhail Kuzmin

1. *Histoire édifiante de mes commencements*: Kuzmin's title for this part of his *Diary* is in the spirit of eighteenth-century French fiction and autobiography, but does not seem to refer to any specific source.

2. *I was born on 6 October 1875*: Kuzmin was in fact born on 6 October 1872. The error is almost certainly deliberate, and attributable to the writer's desire to conceal the relatively late date at which he made his literary début.

3. *southern or western men*: That is, men from the Caucasus or from Poland and the Ukraine.

4. gimnaziya: An elite high school with a curriculum focused on the classical languages.

5. The Cornfield: *Niva*, a weekly illustrated journal for family reading, published 1870–1918; the collected works of several notable writers appeared as supplements in the late nineteenth and early twentieth centuries.

6. *Seryozha*: Sergei Auslender (1886 or 1888–1943), the son by her first marriage of Kuzmin's sister Varvara Moshkova, a schoolteacher. He was the author of prose and drama 'stylizations' and also of theatre criticism. He lived in Moscow after 1922, was arrested in 1938, and died in the Gulag.

7. *'On the Volga a crag . . .' 'My cape I donned . . .'*: Two popular student songs, the first written by A. A. Navrotsky (1839–1914: the correct title is 'Stenka Razin's Crag'), the second by Count V. A. Sollogub (1813–82).

8. *Chicherin*: Georgy Vasilievich Chicherin (1872–1936), the son of a diplomat; originally a Menshevik, he lived abroad from 1903, but in 1918 returned to Russia, joined the Bolshevik Party, and in May 1918 became Commissar for Foreign Affairs. He resigned in 1930 for health reasons. He remained Kuzmin's close friend and mentor until about 1907.

9. *the Belyaev concerts*: The impresario and music publisher Mitrofan Petrovich Belyaev (1836–1903) put on public orchestral concerts in St Petersburg from 1885 and chamber concerts from 1891; the 'Belyaev circle', dominated by Rimsky-Korsakov, met in his home in the 1880s and 1890s.

10. *Stolitsa*: Evidently a schoolboy acquaintance of Kuzmin, rather than the poet Lyubov Stolitsa (real name Ershova, 1884–1934), who was very well known in Russia between 1906 and 1914.

11. *B. N. Chicherin*: (1828–1904), the distinguished legal philosopher and liberal.

12. *a man I fell deeply in love with*: The identity of this man, later referred to by Kuzmin as 'Prince Georges', remains unknown.

13. *Köner's*: A private music school in St Petersburg; Kuzmin attended classes there for two years.

From *Lament for Esenin*, Nikolai Klyuev

1. *ulus*: A Turkic-Mongolian campsite. The image is presumably suggested by the fact that the sides of the open-neck shirt rose up from Klyuev's chest like yurts.

2. *Khozars*: The Hazars or Khazars, an ethnic minority resident in the areas around the Caspian Sea who were the rulers of a vast territory in the early medieval period.

5 Origins

[Entering into Life], Andrei Bely

1. *a bull-headed man with a staff*: That is, the Minotaur, the monstrous offspring of Zeus and Pasiphäe, which inhabited the Labyrinth in Crete.

2. *papirosy*: Russian cigarettes, short with a cardboard filter, designed to be smoked in cold weather with gloves on. Bely's grandmother was rather adventurous in smoking these, since they were (and are) typically a masculine delight.

3. *the Arbat*: A residential district in central Moscow favoured by the creative intelligentsia (not dissimilar to Chelsea in London at the same date).

[The Childhood of Natalya Goncharova], Marina Tsvetaeva

1. *Yasnaya Polyana*: The ancestral estate of Tolstoy. *Bezhin Lug*: setting of a story in Turgenev's cycle *A Huntsman's Sketches* (*Zapiski okhotnika*).

2. *Ivan and Alyosha*: The two younger Brothers Karamazov from Dostoevsky's novel. The place where Ivan and Alyosha meet is in fact a tavern in Skotoprigonevsk (modelled by Dostoevsky on the northern Russian town of Staraya Russa).

3. gimnaziya: A girls' high school of a type modelled on the German Gymnasium. The girls' *gimnaziya* was not as heavily biased towards the classics as its masculine equivalent, but it still provided a demanding academic education and extremely rigid discipline.

4. *the 'chapel'*: In a section omitted from this extract Goncharova described how she and her siblings had turned a massive old water-filter into a sort of pagan shrine, or 'chapel'.

5. *Natalya Goncharova . . . her ancestor of unhappy memory*: Natalya Goncharova, Pushkin's wife, is customarily blamed for his early death in a duel in 1837.

6. *Derzhavin's notes to his own poems*: Tsvetaeva's frustration with the autoglosses of Derzhavin's 'Explanations' (1809), republished in K. Grot's great seven-volume collected works of 1868–78, is understandable, since they are indeed remarkably dry records of biographical details, information on sources

('The idea comes from Psalm 140'), etc., which give no help in understanding the sinuous arguments and complex rhetoric of Derzhavin's odes. (For biographical information about Derzhavin, see note 2 to extract from Mandelstam's *On the Nature of the Word.*)

'Judaic Chaos', Osip Mandelstam

Note 1 is partly indebted to Clarence Brown's notes to his edition of Mandelstam's *Noise of Time*.

1. *Jewish quarter*: The Kolomna district (originally a lower-class area of St Petersburg made famous by Pushkin's narrative poem *The Little House in Kolomna*). It is dismissed in Baedeker's 1914 guide to Russia as 'unattractive'. The 'Litovsky' (Lithuanian) castle was one of the city prisons.
2. *Great Russian*: The nationalistic nineteenth-century name for Russian, as opposed to Ukrainian ('Little Russian').
3. *Courland*: The old name for Lithuania. A 'Courland' accent would be a mixture of Baltic German and Russian, with a touch of Polish and Yiddish thrown in.
4. *Karavannaya*: Karavannaya Street, at the top end of Nevsky Prospekt near the Admiralty and the Winter Palace.

[A Baltic Childhood], Sergei Eisenstein

1. en travesti: In drag.

'No, a Tula peasant woman, not my mother', Vladislav Khodasevich

1. *She knew no fairy-tales and sang no folk-songs*: Unlike Pushkin's nurse, and the line of her literary descendants.
2. *Quite simply everything for which she lived*: Literally 'And simply everything that was dear to her'. An indirect reference to the fact that Kúzina's son had been placed by her in the Imperial Children's Home when she took up her place as wet-nurse; he died there at the age of two.
3. *At Iverskie Gates*: That is, in the chapel holding the icon of the Iverskaya Mother of God, one of the most sacred in Russia, which stood at the foot of the Iverskie Gates to Red Square from 1669 until its demolition in 1929. (A replica was erected in 1997.)
4. *'empire of thunderous might'*: Literally 'resounding empire'. The phrase is used in Pushkin's narrative poem *The Gypsies* to refer to Rome; the transfer of reference was particularly relevant to the case of the Catholic Khodasevich.
5. *The years . . . soul*: A quotation from Khodasevich's own poem 'Let's allow the past is not to be regretted' (1921).
6. *the Khodýnka dead, guests of the last Tsar*: In Volkovo Cemetery, just north-east of the centre of Moscow, lie the graves of more than 1,300 people killed at a stampede that occurred in 1896 at Khodýnka Field, while working-class

Muscovites queued to receive refreshments and souvenirs that were being distributed by the Tsar and Tsaritsa as part of the festivities marking the coronation of Nicholas II.

[Homer's Catalogue of Ships], Innokenty Annensky

1. *dark blue dictionaries*: Annensky may have in mind W. H. Roscher's *Lexikon griechischer und römischer Mythologie* (Leipzig, 1894).

2. *Cornelius or Overbeck*: Peter Cornelius (1783–1865), German artist whose work includes a series of illustrations to Goethe's *Faust*, and Johann Friedrich Overbeck (1789–1869), painter and friend of Cornelius.

3. *Voss*: Johann Heinrich Voss (1751–1826), author of *Luise: ein ländliches Gedicht in drei Idyllen* (*Louise: A Rural Poem in Three Idylls*, 1795), whose translation of Homer's *Iliad* and *Odyssey* was published in 1793.

4. *through the prism of Goethe and Leconte de Lisle*: That is, the vision of Helen of Troy in Goethe's *Faust*, Part II, and 'Hélène', an 'antique poem' (*poème antique*) by the French Parnassian poet Charles Leconte de Lisle (1818–94).

5. *Fra Beato's*: The Florentine painter more commonly known as Fra Angelico (1387–1455).

6. *Ophelia*: It is possible that Annensky also has in mind the painting of Elizabeth Siddal as Ophelia by Rossetti's Pre-Raphaelite colleague John Everett Millais.

'Scythians', Aleksandr Blok

The epigraph is a slight misquotation from Vladimir Solovyov's poem 'Panmongolism' (1895: the original has 'The *word*, though savage').

1. *When Lisbon and Messina crumbled!*: Lisbon was devastated by an earthquake in 1755, and Messina in 1908.

2. *Paestums*: Paestum, a Greek colony in southern Italy, was sacked by the Saracens in 871.

[My Grandfather Kept a Dancing Bear], Nikolai Klyuev

1. *tarts with bramble jam*: Klyuev has in mind the Arctic bramble (*Rubus arcticus*), known in northern dialect as *kumanika*.

2. *porphyry bulls of Shiva*: This is generally interpreted by Klyuev's editors as a boast that the poet visited India, a boast now known to have no foundation.

3. *Andrei Rublyov's singing testament*: That is, the painting of Andrei Rublyov, medieval Russia's most famous icon-painter, subject of a masterly film by Andrei Tarkovsky (1971).

4. *Roman the Sweet Singer*: Roman Sladkopevets, the Russian name of Saint Roman the Melodist, the Syrian author of *kondakia*, texts used in the Orthodox liturgy. While he was living in Byzantium in the sixth century AD, the Mother of God appeared to him in a dream and inspired him to write his first hymn, 'The Virgin Now . . .'.

6 The Last Circle

From 'The People and the Intelligentsia', Aleksandr Blok

Some of the notes below are indebted to those in Blok's *Collected Works*, vol. 5 (Moscow and Leningrad, 1962).

1. *Material was and is collected . . . for the cause of the People*: Here Blok gives a compressed history of nineteenth-century Russian intellectual populism, from folkloric and ethnographical studies (beginning in the 1830s and 1840s), to the radical populism of the 1860s, when political activists 'went to the Russian people', i.e., lived and worked amongst them teaching literacy and political awareness, to the populist terrorism of the 1870s.

2. *Kulikovo Field . . . the Nepryadva*: At the Battle of Kulikovo Field in 1380, the Russian forces under Dmitri Donskoi had a famous, and later much mythologized, victory over the Tartars. The battle had strong personal symbolic resonance for Blok, who, in his lyric cycle *On Kulikovo Field* (1907), evoked its significance as a turning-point in Russian history and a harbinger of the future defeat of the 'Tartar' intelligentsia by the 'true Russian' lower classes. The *Nepryadva* River runs across Kulikovo Field, and in Blok's lyric cycle is seen as the mystical boundary between the two warring sides.

3. *Lomonosov*: Mikhail Vasilievich Lomonosov (1711–65), scientist and poet, author of pioneering treatises on subjects from rhetoric to versification to the atmosphere surrounding Venus and the exploitation of natural resources. Blok's statement about Lomonosov's clashes with the establishment is perfectly accurate, though Lomonosov's own crabbed temperament and notorious fondness for strong liquor were factors here as well.

4. *Samarin was right when he wrote to Aksakov*: Yury Samarin (1819–76) and Konstantin Aksakov (1817–60) were central figures in Slavophile circles during the 1850s; the comment quoted by Blok is taken from N. Barsukov's biography of M. P. Pogodin (published in 1893).

5. *Mendeleev*: Dmitri Ivanovich Mendeleev (1834–1907), Blok's father-in-law and a famous chemist best known for his work on the Periodic Table of the Elements; here Blok refers, however, to Mendeleev's notion that humanity was suspended between 'two abysses', the forces of God and the Devil (cf. his *Notebook* entry for 25 September 1908).

6. *Pushkin's phrase*: The original usage of the term 'infrangible boundary' (*nedostupnaya cherta*) is in the 1826 poem 'Under the blue sky of her native country', which commemorates the death of Pushkin's former mistress Amalia Riznich in Italy.

7. *the opposition between Tolstoy and Dostoevsky that was pointed out by Merezhkovsky*: In his highly influential study of the two writers (1901–2) Merezhkovsky had described Tolstoy as 'a seer of the flesh' and Dostoevsky as 'a seer of the spirit'.

8. *Baronov's paper*: Blok refers to a talk given by G. A. Baronov at the St Petersburg Religious–Philosophical Society on 13 November 1908, under the title 'The Deification of the Russian People (Apropos Maksim Gorky's *Confession*)', in which Baronov had set out what he saw as a 'turn to mysticism' in Gorky's work. A discussion intended to take place after the talk, in which Blok was to have been involved, was forbidden by order of the St Petersburg police.

9. *as Gogol wrote just before his death*: The quotations here and later in this paragraph come from Letter 20 of Gogol's *Selected Passages from Correspondence with Friends* (1847), a conservative and Slavophile disquisition upon Russia's future and on the need to establish Christian brotherhood in the country.

10. *Belinsky, the 'father of the Russian intelligentsia'*: Vissarion Belinsky (1811–48), the most authoritative literary critic of the 1840s, had given voice in his 'Letter to Gogol' (1847) to the distress felt by the Russian radicals with Gogol's 'treachery' to progressive views in *Selected Passages*.

11. *'the most uninteresting question of our times'*: The quotation is taken from the first sentence of Merezhkovsky's essay *Not Peace, but the Sword* (St Petersburg, 1908).

12. *'Life . . . the grave is everywhere'*: From Letter 33 of Gogol's *Selected Passages*.

13. *'Rus', where on earth are you rushing?'*: From Gogol's *Dead Souls*, vol. 1, chapter 11.

'The Death of Dolgushov', Isaak Babel

1. nachdiv: Division commander.

2. tachanka: A light four-wheeled vehicle drawn by two horses; the term is also used for a horse-drawn gun-carriage.

[Eyes Like Glass Buttons], Hava Volovich

1. *'Grain levy'. 'Voluntary norm'*: Among the brutal injustices of collectivization were the 'grain levy', or confiscation from peasants of all grain, including seed corn, under the pretext that they might be 'hoarding', and the 'voluntary norm', or imposition of impossible production targets on newly established collective farms (whose accomplishment was essential if wages were to be paid), supposedly at the request of the collective farmers themselves.

[Two Visions of Mayakovsky], Yury Olesha

1. *Gendrikovsky Lane*: A street in central Moscow (Russian: *Gendrikovsky pereulok*), which was renamed Mayakovsky Lane (*pereulok Mayakovskogo*) after the poet's death. Here Mayakovsky shared a flat with Lili Brik and her husband Osip from 1926. The Mayakovsky Museum was moved in the 1970s from here to Mayakovsky's work address in Lubyanka Passage (*Lubyansky proezd*).

2. pashka: A sweet dish made of curd cheese and cream, drained in a pyramidal mould, and traditionally served (with *kulich*, a rich tall loaf) at the Orthodox Easter celebration meal.

From 'The Unknown Soldier', Osip Mandelstam

1. *in lieu/Of Lermontov*: Probably a reference to Lermontov's famous 'The Dream' (1841), a poem in which a dead man relates his dream of how his beloved has dreamt of him lying in his grave as she sits at a banquet.
2. *Shakespeare's old man*: In the colloquial sense, i.e., 'father'.

7 Exile

[A Small Town on the Seine], Nadezhda Teffi

1. *'their little Nevka'*: Literally 'their Nevka' (a tributary of the Neva in St Petersburg). Russians have never been much impressed with the size of what pass for major rivers in the West.
2. *they've sold us all down the Seine*: The original has *zhivyom kak sobaki na sene* ('we live like dogs in the manger'), with a pun on *na Sene* ('on the Seine') and *na sene* ('on the hay').
3. *Reevegosh*: That is, Rive Gauche, or Left Bank of the Seine (traditionally a quarter of students and artists).

[Russian Paris], Nina Berberova

1. *the Zaitsevs . . . General Miller*: Boris Konstantinovich Zaitsev (1881–1972), novelist, short-story writer, essayist and critic, one of the most prolific and popular prose-writers of the Russian emigration, and his family. Lev Shestov (pseudonym of Lev Shvartsman, 1866–1938) and Nikolai Berdyaev (1874–1938) were prominent religious philosophers noted for their contributions to mystical tradition; the Old Believers were Orthodox sectarians who split off from the main Church in the seventeenth century and formed a tight-knit community with its own idiosyncratic rites and practices (see also note 4 to Florensky's [Against Linear Perspective]); Generals Skoblin and Miller were leaders in the White Guard resistance to Bolshevism.
2. *the behaviour of Mitya Karamazov*: The eldest of the three Brothers Karamazov in Dostoevsky's novel, who is arrested for the murder of his father while taking part in a wild drinking-orgy with entertainments provided by gypsy girls. It is not impossible that visitors to Russian restaurants in Paris would have read Dostoevsky, even then one of the most popular Russian writers with Westerners, but they might have formed their stereotypes of extravagant Russian behaviour when watching popular films (e.g., *The Bear's Wedding*, 1926).
3. *Children burr when they pronounce the Russian r*: More accurately, 'roll their rs in Russian as if they were speaking French'.

4. *Their teacher complains that they do not understand Griboedov's* Woe from Wit: The masterpiece of Aleksandr Griboedov (1795–1829); the play's countless witty aphorisms (like those of Oscar Wilde's *The Importance of Being Earnest* in Britain) have turned into proverbs. However, the language of the play is archaic, and formidably difficult; not only émigré children but Soviet schoolchildren could only read it in annotated editions.

[The Reasons for the Decline of Émigré Literature], Vladislav Khodasevich

1. *M. L. Slonim*: Mark Lvovich Slonim (1894–1976), distinguished literary critic of the Russian emigration, author of books and articles in English as well as Russian, including *The Epic of Russian Literature from Its Origins through Tolstoy* (1950).

[A Literary Soirée in Berlin], Vladimir Nabokov

1. *This conversation went on in the Street of Sin*: The passages from Herman Busch's play that follow are devastatingly accurate parodies of the sort of appalling watered-down symbolist drama that was produced by provincial followers of Blok, Annensky, Bryusov and Sologub in the 1900s and 1910s, at a time when dramatists freely mixed influences from Greek tragedy, Maeterlinck, harlequinades and street theatre.

'Huron', Nadezhda Teffi

1. *Mayne Reid*: Captain Mayne Reid (1818–89), author of popular adventure stories for boys.

2. zakuski: Russian hors-d'œuvres, eaten as an accompaniment to vodka; before the Revolution, well-off families prided themselves on having a lavish spread of *zakuski*, which were often served in a separate ante-room rather than at the main dining table.

'Coiffeur de chiens', Sasha Chorny

1. *'Old-World Landowners'*: Title of a famous story by Gogol, which depicts the cosy life of an elderly Ukrainian couple on their small estate, revolving around meals and creature comforts. Gogol's treatment is in fact more moralistic, and his tone more melancholy, than the comparison here might suggest.

'In Front of the Mirror', Vladislav Khodasevich

Epigraph: *Nel mezzo del cammin di nostra vita*. 'In the middle of the road of our life': the opening line of Dante's *Inferno*.

1. *Ostankino's*: Now a north-eastern suburb of Moscow, but before the Revolution better known as a *dachnaya mestnost* ('resort and place for dachas').

2. *No black tigress in Paris defied me*: The translation Baudelairizes the original,

which reads literally: 'I was not driven by a panther/Into my Paris garret'. The 'panther' (*lonza*) is mentioned in the *Inferno*, Canto I, line 32.

3. *And I've no ghostly Virgil to guide me*: Virgil was Dante's guide to Hell in the *Inferno*.

'The Willow', Anna Akhmatova

Epigraph: From Pushkin's 'Tsarskoe Selo' (1823), in which the poet recalls the glades and lawns that inspired his own early verse. To an informed reader, though, Akhmatova's reference also suggests other poems by Pushkin, for example '19 October 1831', commemorating close friends from the Tsarskoe Selo Lyceum, who had died or suffered political oppression.

1. *as when a brother dies*: The noun 'willow' (*iva*) is grammatically feminine in Russian, so that a more natural usage would be, 'as when a *sister* dies'. The reference to the willow as a 'brother' makes clear that this is a metaphor for a male friend or relation: possibly Akhmatova's brother (who lived in emigration), but more likely Mandelstam, who is commemorated in a poem originally published as a companion piece to 'The Willow': 'When a person dies/His portraits start to look different.'

'Through a Window-light', Sofiya Parnok

Title: *window-light* (Russian *fortochka*). The top portion of a Russian double-window that can be opened for air when the rest of the window is sealed for the winter.

1. *Zosima*: The saintly *starets* (monastic elder) of Dostoevsky's *Brothers Karamazov*.

2. *Burning Bush church*: The church in Neopalimovsky pereulok, just west of Smolensky Boulevard, in central Moscow; Parnok was living by the church at the time this poem was written. The Burning Bush is a symbol of the Mother of God in Orthodox culture.

Further Reading

The list below is limited to material in English; the emphasis is on full-length books, with substantial bibliographies, that should be available in most good libraries.

Reference Sources

Benn, Anna, and Bartlett, Rosamund, *Literary Russia: A Guide* (London, Macmillan, 1997)

Cornwell, Neil (ed.), *Reference Guide to Russian Writers* (London, Fitzroy Dearborn, 1998)

Kasack, Wolfgang, *Dictionary of Russian Literature since 1917*, trs. J. Carlson and J. T. Hedges, bibliographical revision by R. Atack (New York, Columbia University Press, 1988)

Ledkovsky, Marina, Rosenthal, Charlotte, and Zirin, Mary (eds.), *A Dictionary of Russian Women Writers* (Westport, Connecticut, Greenwood Press, 1994)

Milner, John, *A Dictionary of Russian and Soviet Artists 1420–1970* (Woodbridge, Suffolk, Antique Collectors' Club, 1993)

Terras, Victor (ed.), *Handbook of Russian Literature* (New Haven, Connecticut, Yale University Press, 1984)

Historical Background

Clark, Katerina, *Petersburg, Crucible of Cultural Revolution* (Cambridge, Massachusetts, Harvard University Press, 1996)

Figes, Orlando, *A People's Tragedy: The Russian Revolution 1891–1924* (London, Jonathan Cape, 1996)

Hosking, Geoffrey, *A History of the Soviet Union: Final Edition* (London, Fontana, 1992)

—, *Russia: People and Empire* (London, HarperCollins, 1997)

Service, Robert, *A History of Twentieth-century Russia* (London, Penguin, 1998)

General Studies of Russian Modernism and Anthologies

Bird, Alan, *A History of Russian Painting* (Oxford, Phaidon, 1982), chapters 11–13

Borisova, Elena, and Sternin, Grigory, *Russian Art Nouveau* (New York, Rizzoli, 1988)

Bowlt, John, *The Silver Age – Russian Art of the Early Twentieth Century and the World of Art Group* (Newtonville, Oriental Research Partners, 1979)

Bown, Matthew Cullerne, and Taylor, Brandon (eds.), *Art of the Soviets: Painting, Sculpture and Architecture in a One-Party State* (Manchester, Manchester University Press, 1993)

Brumfield, William C., *A History of Russian Architecture* (Cambridge, Cambridge University Press, 1993)

Cooke, Catherine (ed.), *Russian Avant-garde Art and Architecture* (Architectural Design Profile 47; London, Academy Editions, 1983)

Golomstock, Igor, *Totalitarian Art* (London, Harvill, 1989)

Gray, Camilla, *The Russian Experiment in Art 1863–1922*, revised and expanded edition, Marian Burleigh-Motley (ed.) (London, Thames & Hudson, 1986)

Hutchings, Stephen, *Russian Modernism: The Transfiguration of the Everyday* (Cambridge, Cambridge University Press, 1997)

Kean, Beverly Whitney, *French Painters, Russian Collectors: The Merchant Patrons of Modern Art in Pre-Revolutionary Russia* (London, Hodder & Stoughton, 1994)

Kelly, Catriona, and Shepherd, David (eds.), *Constructing Russian Culture in the Age of Revolution 1881–1940* (Oxford, Oxford University Press, 1998)

— (eds.), *An Introduction to Russian Cultural Studies* (Oxford, Oxford University Press, 1998)

Proffer, Carl, and Proffer, Ellendea (eds.), *The Silver Age of Russian Culture. An Anthology* (Ann Arbor, Michigan, Ardis, 1971)

Pyman, Avril, *A History of Russian Symbolism* (Cambridge, Cambridge University Press, 1994)

Rudnitsky, Konstantin, *Russian and Soviet Theatre* (London, Thames & Hudson, 1988)

Sarabianov, David, *Russian Art: From Neoclassicism to the Early Avant-garde* (London, Thames & Hudson, 1990)

Sicher, Ephraim, *Jews in Russian Literature after the October Revolution: Writers and Artists between Hope and Apostasy* (Cambridge, Cambridge University Press, 1995)

Woodruff, David, and Grubišić, Ljiljana, *Russian Modernism: The Collections of the Getty Research Institute for the History of Art and the Humanities* (Oxford, Windsor Books, 1998)

Material Related to Individual Sections

1 New Worlds

Baehr, Stephen L., *The Paradise Myth in Eighteenth-century Russia: Utopian Patterns in Early Secular Russian Literature and Culture* (Stanford, Stanford University Press, 1991)

Bowlt, John, and Matich, O. (eds.), *Laboratory of Dreams: The Russian Avant-garde and Cultural Experiment* (Stanford, California, Stanford University Press, 1996)

Boym, Svetlana, *Common Places: Mythologies of Everyday Life in Russia* (Cambridge, Massachusetts, Harvard University Press, 1994)

Brumfield, William C., *Reshaping Russian Architecture: Western Technology, Utopian Dreams* (Cambridge, Cambridge University Press, 1990)

Stites, Richard, *Revolutionary Dreams: Utopian Vision and Experimental Life in the Russian Revolution* (Oxford, Oxford University Press, 1989)

2 Visions of Art

Bowlt, John, *Russian Art of the Avant-garde: Theory and Criticism 1902–1934* (London, Thames & Hudson, 1988)

Compton, Susan, *The World Backwards: Russian Futurist Books 1912–1916* (London, British Library, 1978)

—, *Russian Avant-garde Books 1917–1934* (London, British Library, 1992)

The Great Utopia: The Russian and Soviet Avant-garde, 1915–1932 (New York, Guggenheim Museum, 1992)

Lodder, Christina, *Russian Constructivism* (New Haven, Connecticut, Yale University Press, 1983)

Matejka, L., and Pomorska, Krystyna, *Readings in Russian Poetics: Formalist and Structuralist Views* (Cambridge, Massachusetts, MIT Press, 1971)

Shukman, Ann (ed.), *Russian Poetics in Translation*, nos. 1–10

Taylor, Richard, and Christie, Ian, *The Film Factory: Russian and Soviet Cinema in Documents, 1896–1939* (London, Routledge, 1988)

3 Altercations and Provocations

Markov, Vladimir, *Russian Futurism* (Berkeley, California, University of California Press, 1968)

4 Men and Women

Chester, Pamela, and Forrester, Sibelan (eds.), *Engendering Slavic Literatures* (Bloomington, Indiana, Indiana University Press, 1996)

Edmondson, Linda, *Feminism in Russia 1900–1917* (London, Hutchinson Educational Books, 1984)

Engelstein, Laura, *The Keys to Happiness: Sex and the Search for Modernity in Fin de Siècle Russia* (Ithaca, New York, Cornell University Press, 1992)

Kelly, Catriona, *A History of Russian Women's Writing 1820–1992* (Oxford, Oxford University Press, 1994), chapters 5–12.

— (ed.), *An Anthology of Russian Women's Writing 1777–1992* (Oxford, Oxford University Press, 1994)

Moss, K. (ed.), *Out of the Blue: Russia's Hidden Gay Literature: An Anthology* (San Francisco, 1997)

Naiman, Eric, *Sex in Public: The Incarnation of Early Soviet Ideology* (Princeton, New Jersey, Princeton University Press, 1997)

Stites, Richard, *The Women's Liberation Movement in Russia* (Princeton, New Jersey, Princeton University Press, 1978)

Yablonskaya, M. N., *Women Artists of Russia's New Age* (London, Thames & Hudson, 1990)

5 Origins

Wachtel, Andrew, *The Battle for Childhood: The Origins of a Russian Myth* (Stanford, California, Stanford University Press, 1990)

Weiss, Peg, *Kandinsky and Old Russia: The Artist as Ethnographer and Shaman* (New Haven, Connecticut, Yale University Press, 1995)

6 The Last Circle

Bethea, David, *The Shape of Apocalypse in Modern Russian Fiction* (Princeton, Princeton University Press, 1989)

Conquest, Robert, *The Harvest of Sorrow: Soviet Collectivization and the Terror-Famine* (London, Hutchinson, 1986)

—, *The Great Terror: A Reassessment* (London, Pimlico, 1990)

Engel, Barbara, and Posadskaya-Vanderbeck, Anastasiya (eds.), *A Revolution of Their Own* (Boulder, Colorado, Westview Press, 1998)

Fitzpatrick, Sheila, *Stalin's Peasants: Resistance and Survival in the Russian Village after Collectivization* (New York, Oxford University Press, 1994)

Groys, Boris, *The Total Art of Stalinism: Avant-garde, Aesthetic Dictatorship and Beyond* (Princeton, New Jersey, Princeton University Press, 1992)

Lincoln, W. Bruce, *Passage through Armageddon: The Russians in War and Revolution* (New York, Simon & Schuster, 1987)

Vilensky, S., and Crowfoot, J. (eds.), *Until This Day* (Bloomington, Indiana, Indiana University Press; London, Virago, 1999)

7 Exile

Raeff, Marc, *Russia Abroad: A Cultural History of the Russian Emigration 1919–1939* (New York, Oxford University Press, 1990)

Index of Writers and Artists

This index gives brief biographical details of authors and painters whose work is included in the anthology, and also of some major figures (e.g., Gorky) referred to in the selected texts. For further information, consult Reference Sources in the Further Reading section.

Akhmatova, Anna Andreevna (real surname Gorenko; b. 1889 Bolshoi Fontan nr Odessa; d. 1966 Domodedovo, nr Moscow) Poet and essayist. Associated through her first husband Nikolai Gumilyov with the Acmeist circle, she was later to become one of the most prominent Petersburg poets of the twentieth century. She is best known for *Requiem*, her commemoration of the Great Terror, and for her modernist verse narrative *Poem without a Hero*.

Annenkov, Yury Pavlovich (b. 1889 Petropavlovsk-Kamchatskii; d. 1974 Paris) Graphic artist, painter, theatre and film designer, memoirist. After studying painting in St Petersburg and Paris, he returned to St Petersburg in 1913, where he worked as an illustrator and theatre designer. After the Revolution, he at first collaborated with the authorities, assisting, for example, in the re-enactment of the storming of the Winter Palace in 1920. However, in 1924 he emigrated to the West, where he lived in France and Germany until his death.

Annensky, Innokenty Fyodorovich (b. 1855 Omsk; d. 1909 St Petersburg) Poet, essayist, dramatist. A schoolmaster by profession, he began publishing poetry and became involved with literary circles in the 1900s. *The Cypress Chest*, published posthumously in 1910, was a favourite book of Anna Akhmatova. He was also widely known for his translations of Euripides, essays on Greek tragedy and other literary topics, and neoclassical dramas, in particular *Thamyris the Citharede* (1906).

Arnshtam, Aleksandr Martynovich (b. 1881 Moscow; d. 1969 Paris) Painter, theatre designer, graphic artist. He trained in Moscow and Paris, and emigrated to Berlin in 1922. He is best known for his illustrative work for Russian journals and books.

Babel, Isaak Emmanuilovich (b. 1894 Odessa; d. 1940 Moscow) Prose writer and journalist. He began publishing in 1916, but made his reputation after the Revolution with *Red Cavalry* (1926), a semi-autobiographical cycle of stories about the Russo-Polish War of 1920–21. A superb stylist who was much influenced by Maupassant, Babel became an increasingly adept practitioner of the 'genre of silence' after 1934. Arrested in 1939, he was later executed; much of his work did not reappear in Russia until the late 1980s.

Bakhtin, Mikhail (b. 1895 Oryol; d. 1975 Moscow) Literary and cultural theorist. He was educated at Odessa and St Petersburg universities, and then lived in Nevel, Vitebsk and Leningrad before being arrested and exiled in 1930; he spent most of his later life in the provincial town of Saransk before finally being given residence rights in Moscow in 1972. An original and highly influential thinker, the coiner of terms such as 'polyphony', 'heteroglossia' and 'dialogism', he is best known for *Problems of Dostoevsky's Poetics* (1929), and for his book on Rabelais.

Bakst, Léon (real name Lev Samoilovich Rosenberg; b. 1866 Grodno; d. 1924 Paris) Painter, graphic artist, theatre designer. He studied art in St Petersburg and became an associate of Alexandre Benois, Konstantin Somov and Sergei Diaghilev, for whose Ballets russes he was later to design such famous productions as *Le Spectre de la rose* and *Thamar*. His illustrations appeared widely in modernist journals such as *World of Art* and *Apollon*. He was exiled from Russia in 1912 and, though he was granted the right to return after election to the Academy of Arts in 1914, spent much of the rest of his life abroad. A superb colourist, he produced exotic and meticulously executed images with a strong flavour of Orientalism.

Balmont, Konstantin Dmitrievich (b. 1867 Gumnishchi, Vladimir Province; d. 1942 Noissy-le-Grand, near Paris) Poet, in emigration from 1920. The author of verse renowned for its musicality, and a prolific translator who composed pioneering versions of poets such as Whitman and Shelley, Balmont was an important figure in the early symbolist movement, but from the late 1910s his poetry was increasingly neglected.

Bely, Andrei (pen-name Boris Nikolaevich Bugaev, b. 1880 Moscow; d. 1934 Moscow) Poet, novelist, essayist. The most talented author of symbolist prose, he was also an important poet whose musical verse, rich in colour imagery, was strongly influenced by Rudolph Steiner's anthroposophy.

Berberova, Nina Nikolaevna (b. 1901 St Petersburg; d. 1993 Philadelphia) Prose writer, poet. Berberova began writing poetry in the early 1920s, shortly before leaving Russia with Vladislav Khodasevich (see below). Settling at first in Berlin

(1922), the couple later moved to Paris (1925), where their association continued until 1932. Berberova left France for America in 1950 and held a number of positions at different universities there, including Princeton. Berberova's output includes short stories and historical studies (among them a biography of Tchaikovsky), as well as poems and memoirs.

Berggolts, Olga Fyodorovna (b. 1910 St Petersburg; d. 1975 Leningrad) Poet, prose writer, journalist. Berggolts was precocious in various senses – she published her first poems at fourteen and married for the first time at seventeen. She studied language and literature at Leningrad University, graduating in 1930, and worked for a few years thereafter as a journalist. She was arrested in 1937 and imprisoned for the best part of two years. She spent the war in Leningrad, becoming famous for her poems about the Blockade; after the war she won her share of literary honours but also became known for some sharp criticism of Soviet literary policy. She endured much tragedy in her personal life – her second husband died of starvation during the Leningrad Blockade, her two daughters perished in epidemics during the 1930s, and Berggolts herself suffered from alcoholism and drug addiction in the last three decades of her life.

Bilibin, Ivan Yakovlevich (b. 1876 St Petersburg; d. 1942 Leningrad) Painter, theatre designer, illustrator. After studies in art and in law in St Petersburg and Munich, he joined the World of Art group in 1899; later he worked with Diaghilev's *Ballets russes*. He emigrated to Egypt in 1920 and then to Paris in 1925, but returned to the Soviet Union in 1936, where he died during the Leningrad Blockade. His finely detailed, highly wrought paintings, mingling influences from Japanese prints to Russian folk art and Old Russian culture, are the epitome of the early modernist *style russe*. Among his most famous works are his designs for *Boris Godunov* (1908) and *The Firebird* (1910), and his illustrations to Pushkin's verse fairy-tales *The Tale of Tsar Saltan* and *The Tale of the Golden Cockerel*.

Blok, Aleksandr Aleksandrovich (b. 1881 St Petersburg; d. 1921 Petrograd) Poet, essayist, dramatist. He was the pre-eminent Russian symbolist, whose themes, imagery and tonic verse forms influenced a whole generation of successor poets. His enthusiasm for the October Revolution (famously expressed in 'The Twelve', 1918) gave way to despair; his early death was received as a catastrophe by contemporaries.

Bogdanov, Aleksandr Aleksandrovich (b. 1873, Grodna Province; d. 1928 Moscow) Political activist, publicist, author of science fiction. Involved from student days in radical groups, he joined the Bolsheviks in 1903. He left Russia in 1907 and founded a 'Party school' on Capri in 1908. In 1909 he formed the concept of a separatist 'proletarian culture' that was to be the basis of the Proletkult

organization after 1918. From 1926 he ran the State Blood Transfusion Institute; his death was the result of a failed experiment on himself.

Brik, Osip Maksimovich (b. 1888; d. 1945 Moscow) Essayist, script-writer. A graduate of Moscow University, Brik began publishing in 1915, but achieved his greatest prominence as a member of the editorial board of the avant-garde journals *Lef* (*Left Front of Arts*, 1923–5) and *Novyi Lef* (*New Left Front of Arts*, 1927–8); he was an able popularizer of Left Formalism rather than an original theorist. Films whose scripts he wrote include Yakov Protazanov's *The Children of Ghengiz Khan* (1928).

Bryusov, Valery Yakovlevich (b. 1873 Moscow; d. 1924 Moscow) Poet, prose writer, dramatist, critic. A pioneer of Russian decadence with *Russian Symbolists* (1894–5), he was the immensely prolific author of highly crafted poems on every possible subject, a gifted translator and an authoritative critic. After the Revolution he actively supported Bolshevism and held a number of important posts in the cultural administration.

Bulgakov, Mikhail Afanasievich (b. 1891 Kiev; d. 1940 Moscow) Prose writer, dramatist. After training and practising as a doctor, he began publishing fiction in the early 1920s. After 1925 he turned to drama because of difficulties with publishing his fiction; though he was subjected to censorship harassment in the theatre as well, some plays (including *The Day of the Turbins*, 1926, and an adaptation of Gogol's *Dead Souls*, 1932) were allowed on to the stage. He is best known for his magnificent novel *The Master and Margarita*, completed shortly before his death, which reached print only in the 1960s (and, in uncensored form, only in 1973).

Burlyuk, David Davidovych (b. 1882 Semirotovshchina near Kharkov; d. 1967 Southampton, New York, USA) Poet and painter. He trained as a painter between 1898 and 1904, later becoming involved with the Blue Rider circle. From 1909 to 1910 he was a member of the Cubo-Futurist Hylaea group. He left Russia in 1920, settling in America in 1922.

Chayanov, Aleksandr Vasilievich (pen-name Ivan Kremnyov; b. 1888 Moscow; d. 1937 Alma-Ata) Prose writer. After studying agriculture in Moscow, he taught agronomy at various institutes there; he was also well known as a local historian. He began to publish fiction in 1918. Arrested in 1929 in the course of the purge on the Timiryazev Institute in Moscow, he was sentenced to five years followed by exile in Alma-Ata, where he was rearrested and shot during the Great Purges.

Chorny, Sasha (real name Aleksandr Mikhailovich Glikberg; b. 1880 Odessa; d. 1932 La Lavandou, France) Poet best known for his satirical writings and

children's verse. A participant in the St Petersburg journal *Satirikon* during the 1910s, he left Russia in 1918, settling in France in 1924.

Dobuzhinsky, Mstislav Valerianovich (b. 1875 Novgorod; d. 1957 New York) Painter, graphic artist, designer. After studying law and painting in St Petersburg and later in Munich, he joined the World of Art in 1901. He was a wide-ranging and prolific artist whose work embraces political satire, book illustration (notably very evocative images of St Petersburg, which he produced for editions of Pushkin and of Dostoevsky in the early 1920s), theatre and ballet design, as well as easel painting. He emigrated from Russia in 1923 and thereafter lived in France, Lithuania and the US.

Eisenstein, Sergei Mikhailovich (b. 1898 Riga; d. 1948 Moscow) Film director, prose writer, theatre director, graphic artist. Involved with Proletkult theatre groups in the early 1920s, he worked briefly with Meyerhold before making his first film, *The Strike*, in 1924. The most important director in the early Soviet cinema, he was immensely influential both as a practising artist and as a theorist of montage. His later work includes *Alexander Nevsky* (1938), *Ivan the Terrible* (1941–6) and an important production of Wagner's *Die Walküre* in 1939.

Ekster, Aleksandra Aleksandrovna (the name is also spelt Alexandra Exter; b. 1882 Belestok, near Kiev; d. 1949 Fontenay-aux-Roses, near Paris) Painter, theatre designer, graphic artist. She studied art in Kiev and in Paris, where she also had a circle of acquaintances among prominent artists; she exhibited widely with French and Russian avant-garde groups from 1914. From 1916 she began working as a theatre designer (among her important commissions were Wilde's *Salomé*, 1917, and Shakespeare's *Romeo and Juliet*, 1921, both for Tairov's Kamernyi Theatre), and after the Revolution she taught textile design at the Moscow Art Studios, and later carried out clothing design. In 1924 she emigrated to France, where she taught at Léger's Academy of Contemporary Art. Her later work included illustration, easel painting and theatre design.

Esenin, Sergei Aleksandrovich (b. 1895 Konstantinovo, Ryazan Province; d. 1925 Leningrad) The most famous of the so-called 'peasant poets', he was associated in the 1920s with the Imaginist movement (see also Shershenevich, below). His suicide in 1925 sent shock waves through Russian culture.

Filinov, Pavel Nikolaevich (b. 1883 Moscow; d. 1941 Leningrad) Painter, graphic artist. He was orphaned as a boy and spent his childhood as a fairground artist and painter–decorator. After informal studies in art from 1898, he began exhibiting in 1910 with the Union of Youth, and travelled to France and Italy 1911–12. After the Revolution he became an exponent of 'analytical art' and an

influential teacher. His extraordinary, obsessively detailed paintings are among the most original productions of the Russian avant-garde.

Florensky, Pavel Aleksandrovich (b. 1882; d. 1937) Religious philosopher, theorist. After training as a theoretical physicist, Florensky became a lecturer in philosophy at Moscow Theological Academy in 1908 and was ordained in 1911. With Sergei Bulgakov, Berdiaev and Lev Shestov, he was a major figure in the reaction against religious philosophy, attaining prominence with *The Pillar* and *The Foundation of Truth* (1914). After the Revolution he, like many other churchmen, was subjected to repression; he was arrested in 1928 and 1933, imprisoned in Solovki in 1934, and shot in 1937.

Gabo, Naum (real name Neemia Borisovich Pevzner; b. 1890 Bryansk; d. 1977 New York) Sculptor. After studying mathematics and engineering in Munich, he moved to Paris and later to Oslo, where he began making sculptures. He returned to Russia in 1917, and was for a time associated with the Constructivists; lacking their commitment to communism, however, he emigrated in 1922, where he lived in Germany, France, England and the US. His designs for *La Chatte* are unusual in terms of his work, which generally inclines to abstract sculptural forms.

Gippius, Zinaida Nikolaevna (married name Merezhkovskaya; b. 1869 Belyov, Tula Province; d. 1945 Paris) Poet, critic, author of short stories and essays. Symbolism's most important and innovative woman writer, and a gifted poet noted for her metrical finesse, she was a representative of the 'mystical symbolist' direction and participant in the St Petersburg Religious–Philosophical Society. She lived in emigration from 1919, becoming a leading figure in Paris émigré circles.

Gladkov, Fyodor Vasilievich (b. 1883 Chernavka, Saratov Province; d. 1958 Moscow) Prose writer. From an Old Believer family, Gladkov worked as a schoolteacher before becoming involved in the 1905 revolution. He achieved prominence with the publication of *Cement*, whose many redactions make it possible to trace the increasingly proscriptive stylistic canons of socialist realism. His other work includes *Energy* (1933), a novel about the building of the Dneproges Power Station.

Goncharova, Natalya Sergeevna (b. 1881 Ladyzhino, Tula Province; d. 1962 Paris) Painter, graphic artist, theatre designer. She studied sculpture in Moscow before turning to painting in 1900. Began exhibiting *c.* 1904 and thereafter took part in many important shows, including the Knave of Diamonds, the World of Art and the Donkey's Tail. She began working for Diaghilev's Ballets russes in the 1910s (productions on which she worked included *Le Coq d'or*, 1914). Largely resident outside Russia after 1915, she and her lifelong companion Mikhail Larionov (see below) settled in Paris for good in 1919.

Gorky, Maksim (real name Aleksei Maksimovich Peshkov; b. 1868 Nizhny Novgorod; d. 1936 Gorki, near Moscow) From a working-class background, Gorky published his first story in 1892, after some years of wandering round Russia. A number of other stories followed, before a collected edition in 1898 brought him widespread recognition in Russia and abroad. Though he had been associated with the revolutionary movement before 1917, his relations with the Bolsheviks were far from smooth; tangles with the censorship were followed by a long period abroad (1921–31), though for some of this time he was working actively for the Soviet security services. After his return to Russia, Gorky became a figurehead for literary Stalinism, with his 1905 novel *The Mother* proclaimed a model of socialist realism; he also spoke out in support of the regime, even going so far as to endorse the notoriously inhumane forced labour camps along the White Sea Canal.

Gorodetsky, Sergei Mitrofanovich (b. 1884 St Petersburg; d. 1967 Obninsk) Poet, librettist. A member of Vyacheslav Ivanov's Tower circle from 1905, he was a co-founder of the Acmeist movement in 1912. After 1917 he was committed to the Bolshevik cause and held numerous posts in the cultural administration; he wrote *bien pensant* occasional verse, translated libretti and adapted pre-Revolutionary libretti to make these acceptable to the new order (e.g., *Ivan Susanin*, based on Glinka's *A Life for the Tsar*).

Grigoriev, Boris Dmitrievich (b. 1886 Rybinsk; d. 1939 Cagnes-sur-Mer, France) Painter, graphic artist, theatre designer. After studies in Moscow and St Petersburg, he began exhibiting with the World of Art group in 1913. He emigrated to Berlin in 1919 and thence to Paris in 1921. Apart from spells in Santiago, Chile, and New York, he spent the rest of his life in France. He was a talented draughtsman whose portrait drawings in particular are of superb quality.

Gumilyov, Nikolai Stepanovich (b. 1886 Kronstadt; d. 1921 Petrograd) Poet, critic, co-founder of the Acmeist movement. He began publishing in 1902; many of his mature poems draw on his extensive travels, which took him to Africa and the Near East as well as to western Europe, and his works include a translation of *Gilgamesh*. He was briefly married to Anna Akhmatova (see above). After the Revolution he was active as an organizer of poetry workshops, which made him an important influence on beginning poets. Arrested for counter-revolutionary activity on 3 August 1921, he was shot, along with sixty others, three weeks later.

Ivanov, Vyacheslav Ivanovich (b. 1866 Moscow; d. 1949 Rome) Poet, essayist, dramatist. After studying ancient history at the University of Berlin, he returned to Russia with his second wife Lidiya Zinovieva-Annibal (see below) in 1905; his 'Tower' apartment overlooking the Tauride Gardens in St Petersburg rapidly

became the centre of important literary gatherings. His exceptionally dense poetry and neoclassical dramas draw heavily on his knowledge of Greek and Roman culture, and particularly of the Dionysiac cult. He lived in Italy from 1924; his late poetry is characterized by simplicity and lucidity, rather than by the mythological allusiveness of his earlier work.

Kharms, Daniil Ivanovich (real surname Yuvavchov; b. 1905 St Petersburg; d. 1942 Novosibirsk) Prose writer, dramatist. Founder member of the OBERIU (Association for Real Art) in the late 1920s. After severe criticism had been meted out by critics on OBERIU works of the late 1920s, Kharms, like several other members of the group, became active as a children's writer. Arrested in 1941, he died in a prison camp and was rehabilitated only in 1956. Kharms's pseudonym, generally supposed to derive from the English 'harms', reflects the sinister and disturbing undertones of his plays and stories.

Khlebnikov, Velimir (real forename and patronymic Viktor Vladimirovich; b. 1885 Malye Derbety, Astrakhan Province; d. 1922 Santalovo, Novgorod Province) Poet. He began publishing in 1908, after a move to St Petersburg University from Kazan (he was never to complete either course); soon afterwards he became involved in avant-garde circles. Like Aleksei Remizov, he was a genuine eccentric; eschewing a permanent place of residence, he wandered, carrying his manuscripts in a sack. Much of his work has been posthumously published; it is densely symbolic (depending partly on Khlebnikov's mathematical theories of the nature of the universe) and rich in references to Russian pre-Christian and folk culture.

Khodasevich, Vladislav Felitsianovich (b. 1886 Moscow; d. 1939 Billancourt, near Paris) Poet, essayist, critic. Khodasevich's pre-Revolutionary collections, *Youth* (1908) and *The Happy House* (1914), were little remarked, but with *The Way of the Grain* (1920) he attained a considerable literary reputation. In 1922 he emigrated with his companion Nina Berberova to Berlin; three years later the pair settled in Paris. Apart from poetry (a further three collections of which appeared in Berlin and Paris), Khodasevich also published reviews, memoirs and a biography of the eighteenth-century Russian poet Derzhavin.

Klyuev, Nikolai Alekseevich (b. 1884 near Vytegra, Olonetsk Province; d. 1937 Tomsk) Poet and prose writer. He was involved in radical populist movements before the Revolution, and was originally sympathetic to the Bolshevik cause, but became increasingly critical as he observed the devastation of peasant culture beginning in the early 1920s. Arrested in 1934, he was exiled to Tomsk; arrested for a second time in June 1937, he was shot in October that year. His ornate and impassioned mature verse is now recognized as among the most extraordinary achievements of any Russian poet this century.

Kruchonykh, Aleksei Eliseevich (b. 1886 Levka, Kherson Province; d. 1968 Moscow) Poet. From a peasant background; studied as a painter in Odessa before moving to Moscow in 1907. One of the most important theorists of the Cubo-Futurist movement, and a committed avant-garde poet who referred to his own poems as 'products'.

Kustodiev, Boris Mikhailovich (b. 1878 Astrakhan; d. 1927 Moscow) Painter, sculptor, graphic artist, theatre designer. He studied in Astrakhan and St Petersburg, and made lengthy trips to France, Spain and Italy in the 1900s. He is best known for his colourful and crowded paintings of traditional Russian life, for example *The Merchant's Wife Drinking Tea* (1918), and his designs for Evgeny Zamyatin's adaptation of Leskov's story 'The Flea' (1924–6).

Kuzmin, Mikhail Alekseevich (b. 1872 Yaroslavl; d. 1936 Leningrad) Poet, prose writer, critic, dramatist, translator, composer. Erudite, diversely talented, and widely travelled, he studied at the St Petersburg Conservatoire before beginning to write poetry in 1896, in the aftermath of a psychological crisis. He published his first verse in 1905; from 1906 he was prominent in literary circles in St Petersburg, particularly Ivanov's 'Tower' (see above), and later the post-symbolist *Apollon* group. He remained in Russia after the Revolution, but was a marginal figure; his final collection, *The Trout Breaks the Ice* (1929), was received coldly, being considered 'inappropriate to the times'.

Larionov, Mikhail Fyodorovich (b. 1881 Tiraspol; d. 1964 Paris) Painter, graphic artist, theatre designer. After studying art in Moscow, and exhibiting with the World of Art group and Union of Russian Artists in the 1900s, he became one of the leaders of the Russian avant-garde movement from 1909, when he espoused primitivist techniques. He was a co-founder of the Knave of Diamonds and the Donkey's Tail groups, and the inventor of 'Rayism' in 1912–13. He was mostly resident in the West after 1915 and settled in Paris with his lifelong companion Natalya Goncharova (see above) in 1919; like her, he designed numerous productions for Diaghilev's Ballets russes. Larionov devoted much of his later life to arguing vehemently that the Russian avant-garde had pioneered many techniques that only evolved later in the West; he was not above predating his own and Goncharova's paintings in order to counteract accusations that they were derivative.

Lvova, Nadezhda Grigorievna (née Poltoratskaya; b. 1891 Podolsk; d. 1913 Moscow) Poet, translator, critic. Lvova began publishing poetry in 1911, after studying on the Moscow Higher Courses for Women (a university-level institute). She had published only one book of verse, *Old Tale* (1913), notable for its employment of 'fixed forms' such as the ghazal, before her suicide, for which her lover Valery Bryusov was widely blamed, put an end to her promising poetic career.

Malevich, Kazimir Severinovich (b. 1878 Kiev; d. 1935 Leningrad) Painter, graphic artist, essayist, theorist. After studying art in Kiev, he moved to Kursk in 1898 and thence to Moscow in about 1904, where he worked in the studio of the painter Fyodor Rerberg until 1910. He exhibited with the Knave of Diamonds, the Donkey's Tail, the Target and the Union of Youth groups before launching the Suprematist movement in 1915. After the Revolution he became active and influential in the new art establishment, and in 1919 moved to Vitebsk, where he founded the Posnovis (later Unovis) collective in 1920. In 1923 he moved back to Petrograd, where he was Director of the Institute of Artistic Culture (INKhUK) from 1923 to 1926. In the final years of his career, he returned from abstract art to a semi-figurative and finally to a neo-impressionist style.

Mandelstam, Nadezhda Yakovlevna (née Khazina; b. 1899 Saratov; d. 1980 Moscow) Memoirist. Brought up in Kiev, Mandelstam trained as a painter and theatre designer under Aleksandra Ekster (see above), but in 1920 abandoned her career in order to make a life with Osip Mandelstam, whom she married in 1922. After Mandelstam's second arrest, she herself was subject to constant harassment on the part of the security services, and spent the next twenty years in exile in the Russian provinces, devoting herself to preserving the poet's memory. She was able to return to Moscow in 1964; from then until her death she worked on her memoirs, which not only provide an unparalleled account of the life of a major poet, but are also an immensely valuable chronicle of the times that Mandelstam herself lived through.

Mandelstam, Osip Emilievich (b. 1891 Warsaw; d. 1938 Vladivostok) Poet, prose writer. The outstanding poet of the Acmeist movement, and also a very gifted and original prose writer, Mandelstam began publishing in 1911, but much of his best work dates from after 1917. Generally favourably inclined towards Bolshevism at first, he changed his mind as he became subject to attacks in the late 1920s; in 1933 a volume of his poetry was blocked by the censorship. Arrested in 1934 for a poem ridiculing Stalin, he was exiled to Voronezh; allowed to return to Moscow in 1937, he was rearrested in 1938 and died in a prison camp some months after his arrest.

Mayakovsky, Vladimir Vladimirovich (b. 1893 Bagdadi, near Kutaisi, Georgia; d. 1930 Moscow) Poet, dramatist, essayist. Involved in the revolutionary movement and the artistic avant-garde from his teens, he originally trained as a painter, but was best known, after the publication of *A Cloud in Trousers* (1915), for his literary works. A vehement supporter of Bolshevism after 1917, he was a central figure in the left arts movement during the 1920s. Subject to increasingly virulent attacks by supporters of proletarian arts in the late 1920s, he committed suicide in 1930.

Merezhkovsky, Dmitri Sergeevich (b. 1865 St Petersburg; d. 1941 Paris) Poet, author of fiction, essayist, critic. Merezhkovsky published poetry from the 1880s, but first achieved real renown with his essay *On the Causes for the Decadence and New Directions in Modern Russian Literature* (1893), a landmark in the development of Russian modernism. He published influential studies of Gogol, Tolstoy and Dostoevsky, as well as historical fiction. Along with his wife Zinaida Gippius (see above), he was one of the main movers in the Religious–Philosophical Society of St Petersburg. He left Russia with Gippius in 1919 and became a major figure in the Paris emigration.

Meyerhold, Vsevolod Emilievich (b. 1874; d. 1940 Moscow) Theatre director, actor. After studying drama in Moscow, he worked as an actor and director for the Moscow Arts Theatre and for the Imperial Theatres, soon becoming one of the most prominent directors of his time. His ground-breaking productions included Aleksandr Blok's verse play *The Fairground Booth* (1906) and radical adaptations of classic plays by Gogol and Griboedov in the 1920s. He also worked in the cinema, notably in adaptations of Wilde's *The Portrait of Dorian Gray* (1915) and Blok's *The Rose and the Cross* (1917). Arrested in 1938, he was executed in prison.

Nabokov, Vladimir Vladimirovich (b. 1899 St Petersburg; d. 1977 Montreux) Poet, novelist, essayist. Nabokov and his family left Russia after the Revolution in 1919. He settled in Berlin in 1922, moved to Paris in 1937, and thence to the US in 1940, before finally relocating to Switzerland in 1959. His early poetry was competent but conventional, but his prose (published under the pseudonym Sirin) soon brought him acclaim as the most original author of fiction in the emigration. After his move to America he began writing in English, becoming world-famous for his novel of obsessive love, *Lolita* (1955), but also publishing numerous other novels, including *Pnin* (1957) and *Pale Fire* (1962), as well as reviews, poetry and essays.

Olesha, Yury Karlovich (b. 1899 Elisavetgrad; d. 1960 Moscow) Novelist, short-story writer, dramatist, author of film scenarios, journalist. Born into a Polish family in the Ukraine, Olesha had his school and university education in Odessa. He volunteered for the Red Army in 1919 and worked as a propagandist for the Soviet cause; later he was to publish satirical verse in the humorous magazine *Gudok* before making his reputation as a prose writer with *Envy* (1927). His other important works include the novella *Three Fat Men* and some remarkable short stories, for example 'The Cherry Stone'. After the rise of socialism realism, he worked mainly on translations, film scenarios and journalism. Olesha's prose was much admired by Nabokov, but is still relatively little known in the West: it is remarkable for its combination of intense observation with self-deprecating humour, and of an interest in the mundane world with flights into a parallel universe of fantasy.

Parnok, Sofiya Yakovlevna (b. 1885 Taganrog; d. 1933 Karinskoe, near Moscow)
Poet, translator, librettist. She studied music and law before becoming involved
in Moscow literary circles in the 1910s; her first collection of poetry appeared
in 1916. She published several more collections after the Revolution before
being forced into translation to support herself in the late 1920s. Fiercely
independent-minded, Parnok never allied herself with any group, but was
perhaps closest to Khodasevich (see above) among other poets of her time.

Pasternak, Boris Leonidovich (b. 1890 Moscow; d. 1960 Peredelkino, near Moscow)
Poet, prose writer, translator. After studies in music and philosophy, he published
his first collection in 1913; he later became involved with the Centrifuga group
of futurists. He established his literary reputation above all with his third
collection, *My Sister Life* (1922), and his fourth, *Themes and Variations* (1923).
Recognized as Soviet Russia's foremost poet, he maintained an ambiguous
relationship with the Soviet authorities, keeping his distance from political
commitment of all kinds while also (in the Stalin years) avoiding persecution.
Following a nervous crisis in the mid 1930s, he turned for some years to
translation; his versions of Shakespearean tragedies have become canonical. His
novel *Dr Zhivago* was a pioneering instance of *samizdat* (publication outside
the Soviet Union) when it appeared in Italy in 1957. The award of the Nobel
Prize for Literature to Pasternak in the following year unleashed a scandal
culminating in his expulsion from the Soviet Writers' Union; the stress hastened
his death two years later.

Petrov-Vodkin, Kuzma Sergeevich (b. 1878 Khvalynsk; d. 1939 Leningrad) Painter,
graphic artist. From a working-class family, he trained in an icon-painting
workshop as a boy before studying art in Samara, St Petersburg, Moscow and
Munich. After extensive travels to Algeria, Greece, France and Italy, he began
exhibiting in 1909 and was a member of the World of Art 1911–24. After the
Revolution he continued painting, but was also active in the reconstruction of
art training. He was a highly original figurative painter whose theories of 'spherical
perspective' mediated between cubism and the traditions of icon-painting.

Platonov, Andrei Platonovich (real surname Klimentov; b. 1899 Voronezh; d. 1951
Moscow) Prose writer, dramatist. Trained as an engineer, he began publishing
proletarian poetry and prose soon after the Revolution. His short stories and
novels, written in a strange and haunting style remarkable for its mixture of
registers, and with a symbolism that draws on Russian religious philosophy and
folklore, include the anti-utopian *Chevengur* (1927–8) as well as *The Foundation
Pit* (written 1930). Banned from publication after 1946, Platonov ended his days
as a caretaker; many of his works were only cleared for publication in his home
country after 1987.

Poplavsky, Boris Yulianovich (b. 1903 Moscow; d. 1935 Paris) Poet. He left Russia with his parents in 1919 via Constantinople and settled in Paris, where he began publishing in 1928. He was widely recognized as one of the most talented young poets of the emigration, and his death from a heroin overdose was mourned as a tragedy by prominent émigré writers, including Khodasevich and Tsvetaeva.

Prismanova, Anna Semyonovna (b. 1892 Libau/Liepaja, Latvia; d. 1960 Paris) Poet, prose writer. Prismanova was involved with artistic circles in Petrograd (or, according to another account, Moscow) from 1918, but began publishing only after her move to Paris in 1924 (she had originally emigrated to Berlin in 1920). One of the most original writers of the Paris emigration, she was the author of short stories and four books of verse.

Protazanov, Yakov Aleksandrovich (b. 1881; d. 1945) Film director. After education at the Moscow Commercial School, he began working in the cinema in 1907; his first film, *The Fountain of Bakhchisarai*, was released in 1909. His most famous films include adaptations of Pushkin's *The Queen of Spades* (1916) and Tolstoy's *Father Sergius* (1918). After the Revolution he emigrated briefly to Paris and Berlin, but returned to Russia in 1923; apart from *Aelita*, his Soviet films include *Don Diego and Pelageya* (1928), *The White Eagle* (1928) and *The Girl with No Dowry* (1937).

Remizov, Aleksei Mikhailovich (b. 1877 Moscow; d. 1957 Paris) Prose writer, playwright, poet, calligrapher. His work was inspired in particular by Russian folk culture (traditional tales and popular dramas) and by medieval texts such as *The Lay of Igor's Campaign*. He lived in emigration from 1921, and was resident in Paris from 1923. A talented calligrapher, he was also a notable eccentric whose beautiful illuminated documents include the charter of the Worshipful Order of Monkeys.

Repin, Ilya Efimovich (b. 1844 Chuguev, Kharkov Province; d. 1930 Kuokkala, Finland) Realist painter, graphic artist. Trained in Chuguev and St Petersburg, he joined the anti-academic Wanderers group in 1878. An immensely authoritative figure, he is best known for his historical paintings (e.g., *The Zaporozhian Cossacks Write a Letter to the Turkish Sultan*, 1877–91) and genre subjects (for example, *They Did Not Expect Him*, 1884, depicting the return to his family of a former political prisoner).

Rodchenko, Aleksandr Mikhailovich (b. 1891 St Petersburg; d. 1956 Moscow) Painter, graphic artist, designer, photographer. After studying art in Kazan and Moscow, he began exhibiting in 1916; after the Revolution he was a major figure in the Constructivist movement, executing a variety of projects from clothing and

furniture design to architecture to photography. He continued working widely as a photographer in the 1930s.

Rozanov, Vasily Vasilievich (b. 1856 Vetluga, Kostroma Province; d. 1919 Sergiev Posad, Moscow Region) Writer and thinker. A prolific commentator on religious and philosophical questions, as well as on sexual and family problems, Rozanov published in both conservative and liberal journals; though his anti-Semitism and hostility to women's liberation allied him with the forces of reaction, his attempt to recast Christian theology so as to allow a greater degree of freedom of expression to sexual desires was as inflammatory to official Orthodoxy as his religiosity was later to prove to Soviet political opinion (his work was unpublished in his home country between 1918 and 1989).

Rozanova, Olga Vladimirovna (b. 1886 Malenki, Vladimir Province; d. 1918 Moscow) Painter, graphic artist, prose writer. After training at art schools in Moscow and St Petersburg, she became a member of the Union of Youth (1911–14) and was later associated with the Suprematist and Knave of Diamonds groups. She was particularly active as a book illustrator, and, after the Revolution, in the field of applied arts.

Serov, Valentin Aleksandrovich (b. 1865 St Petersburg; d. 1911 St Petersburg) Painter, theatre designer. The son of two composers, Serov began his art studies as a child (his teachers included Ilya Repin). He was widely travelled and keenly aware of Western trends in art. Beginning his career as one of the most original and talented Russian impressionists, he was later to gravitate to a starker, more graphic manner of representation, as illustrated in *The Rape of Europa* and in his famous nude study of the dancer Ida Rubinstein. His designs for Diaghilev's Ballets russes included *Schéhérazade* (1910). He taught at the Moscow Institute of Art and Sculpture from 1897 to 1909.

Severyanin, Igor (real name Igor Vasilievich Lotaryov; b. 1887 St Petersburg; d. 1941 Tallin) Poet. He began publishing in 1905 and founded the Ego-Futurist group in 1911, before achieving renown with *The Thunder-foaming Goblet* in 1913; later collections included *Pineapples in Champagne* (1915) and *Crème de violettes* (1919). Leaving Russia in 1918, Severyanin spent the rest of his life in Estonia. Though critics and other, more fastidious, poets were inclined to despise Severyanin's poetry for its flashy neologisms, it enjoyed massive popularity in the 1910s.

Shalamov, Varlam Tikhonovich (b. 1907 Vologda; d. 1982 Moscow) Prose writer, poet. He studied law at Moscow University, but his course was interrupted when he was arrested in 1929 and sentenced to three years in prison. He published some prose and poetry after 1932, but in 1937 was again arrested,

and he spent the next seventeen years in labour camps in Kolyma. In the late 1950s he began publishing poetry through official channels, but is best known for his *Kolyma Stories*, which were published in the West in the 1960s and 1970s, but in the Soviet Union only after 1987.

Shershenevich, Vadim Gabrielevich (b. 1893 Kazan; d. 1942 Barnaul) Poet, essayist. Beginning his career as a member of the Ego-Futurist group, he became in 1918 a founder member of, and the most important theorist among, the Imaginists. During the 1920s his criticisms of proletarian poetry subjected him to increasingly hostile attacks, and he resorted to translation in order to support himself. Arrested during the Purges, he was to die in exile.

Shklovsky, Viktor Borisovich (b. 1893 St Petersburg; d. 1984 Moscow) Critic, theorist, novelist. After studying at St Petersburg University, he became a founder member of Opayaz (see under Brik above), and coined some of the most widely used terminology in the Formalist movement, for example 'defamiliarization'. He emigrated briefly to Berlin in 1922–3, where he published two fictional works, *A Sentimental Journey* and *Zoo*. He survived the attacks on the Formalists of the late 1920s and early 1930s, and spent his later career writing on film, children's literature and biography.

Sologub, Fyodor (real name Fyodor Kuzmich Teternikov; b. 1863 St Petersburg; d. 1927 Leningrad) Prose writer, dramatist, poet. From a working-class family, Sologub worked as a teacher until 1907, but began publishing in the mid 1880s, becoming well known for *A Low-grade Demon* (1907; also known as *The Petty Demon*). Generally considered one of the most important symbolists, Sologub can also be seen as an heir to nineteenth-century realist writers such as Dostoevsky and Ostrovsky.

Stepanova, Varvara Fedorovna (b. 1894 Kovno (Kaunas); d. 1958 Moscow) Painter, designer, graphic artist. She studied art in Kazan, where she met her husband, Aleksandr Rodchenko; the two were later to be central figures in the Constructivist movement. In the 1910s Stepanova produced futurist book designs; in the 1920s she was a notable designer of Constructivist theatre sets and costumes; in the 1930s and 1940s she and Rodchenko were prominent as designers for Soviet magazines, including, in Stepanova's case, *Soviet Woman* (*Sovetskaya zhenshchina*, 1945–6).

Tatlin, Vladimir Evgrafovich (b. 1885 Moscow; d. 1953 Moscow) Painter, sculptor, graphic artist, designer. Raised in the Ukraine, he studied art briefly in Moscow before working as a seaman. He became friendly with the Burlyuk brothers, Goncharova and Larionov, in 1907 and began exhibiting at the Izdebsky Salon 1910–11. He later exhibited with the Union of Youth, World of Art and Knave

of Diamonds groups. After the Revolution he was a prominent member of the new art establishment and taught at the Higher Arts Workshop between 1918 and 1920. His design for a Monument to the Third International, better known as the 'Tatlin Tower', was one of the most important Constructivist projects. In the late 1920s he carried out designs for an experimental flying machine (the 'Letatlin'). From the mid 1930s he went back to easel paintings and carried out a number of theatre designs.

Teffi, Nadezhda (real name Nadezhda Aleksandrovna Buchinskaya, née Lokhvitskaya; b. 1872 St Petersburg; d. 1952 Paris) Poet, dramatist, and author of popular humorous stories and essays. A participant in the St Petersburg journal *Satirikon*, she lived in emigration from 1919, but continued to publish regularly right up to her death.

Tsvetaeva, Marina Ivanovna (b. 1892 Moscow; d. 1941 Elabuga) Poet, prose writer, dramatist. She lived in emigration from 1922, first in Prague, from 1925 in Paris, before returning to Russia in 1939; she committed suicide in the evacuation from Moscow following the German invasion of the Soviet Union. She was recognized in her lifetime as an outstanding and original poet with an extraordinary and unmistakable voice, and since her rediscovery in the early 1960s has been generally considered one of the best twentieth-century Russian poets.

Tynyanov, Yury Nikolaevich (b. 1899 Rezhitsa, Vitebsk Province; d. 1943 Moscow) Formalist theorist, literary historian, prose writer. He studied at Petrograd University and worked as a translator before taking up a post at the Institute for the History of Arts in Petrograd. Perhaps the most deep-thinking and original of the Formalists, Tynyanov was also an outstanding textological scholar; he was the author of historical novels about the Pushkin circle as well as of short stories.

Vaginov, Konstantin Konstantinovich (real surname Wagenheim; b. 1899 St Petersburg; d. 1934 Leningrad) Prose writer, poet. He began as a member of the Acmeist movement before moving towards more avant-garde directions in the second half of the 1920s. *The Song of the Goat* (1928) and *Bambochada* (1931), like *The Days and Labours of Svistonov*, were greeted by critical incomprehension, and *The Harpagoniad* was published only in 1983, and then in the US. However, in recent years his grotesque and compositionally sophisticated novels have attracted increasing interest, and been the subject of several academic studies.

Vertov, Dziga (real name Denis Arkadievich Kaufman; b. 1896 Belostok; d. 1954 Moscow). Film director. After studies at a military musical academy and at the Psycho-Neurological Institute of Moscow University, he began working as a newsreel producer in 1918. In the early 1920s he became dissatisfied with

documentary realism and evolved his strikingly original theory of the 'Cine-Eye'. In the 1930s he made a series of biographies of Revolutionary leaders, and during the Second World War a number of propaganda films.

Voloshin, Maksimilian Aleksandrovich (real surname Kirienko-Voloshin; b. 1877 Kiev; d. 1932 Koktebel, Crimea) Poet, painter, critic. After studying law at Moscow University, he began publishing in 1900; he lived largely in Paris until 1917, returning to Koktebel in the summer, where his house was a famous meeting-place of writers and artists. His early poetry was heavily influenced by French symbolism, but the events of the First World War, and particularly of the Revolution, inspired some work of real strength and resolution. Though himself living in great poverty during the 1920s (his work stopped being published in 1922), Voloshin continued to offer hospitality to all comers, and left his house to the Literary Fund of the Writers' Union for use as a summer home for writers.

Volovich, Hava (b. 1916 Mena, Ukraine) Journalist and memoirist. See headnote to [Eyes Like Glass Buttons].

Vrubel, Mikhail Aleksandrovich (b. 1856 Omsk; d. 1910 St Petersburg) Painter, sculptor, designer, illustrator. A major figure in the symbolist and in the Art and Crafts movements, Vrubel trained in St Petersburg. Among his earliest works were the frescos for the Cathedral of Saint Vladimir in Kiev; his later works include a famous cycle based on Mikhail Lermontov's Romantic poem *The Demon*, sets for Rimsky-Korsakov's opera *The Tale of Tsar Saltan* (1900), and remarkable ceramic sculptures produced for the Abramtsevo studio near Moscow. He suffered all his adult life from bouts of insanity, and from 1906 was confined to an asylum, where he remained until his death.

Yutkevich, Sergei Iosifovich (b. 1904; d. 1985) Film director. He was one of the first students to study at the Higher Arts Workshop, where he was a pupil of Meyerhold (1921–3). After beginning his career as a set designer, he began working in the cinema in 1924. His best-known films include *Counterplan* (1932, co-directed with Fridrikh Ermler), *Yakov Sverdlov* (1941), *Othello* (1956) and a series of films about the life of Lenin (1938–81). He also made innovative documentaries employing animation sequences, etc., in the 1960s and 1970s.

Zamyatin, Evgeny Ivanovich (b. 1884 Lebedyan, Tambov Province; d. 1937 Paris) Prose writer, dramatist. Active from 1908 in his first profession of marine architect (a profession that took him to England 1916–17), Zamyatin became a full-time writer and literary activist after the Revolution, an event that he at first welcomed (he had nurtured revolutionary sympathies since the 1900s). However, a process of disillusion was initiated when he had difficulties in publishing his

dystopian novel *We* (1920: the novel eventually appeared in English translation in 1924, in French in 1929, and in Russian in 1952; it was not to be published in the Soviet Union until 1988). Though Zamyatin's play *The Flea* was performed successfully in 1925, criticism became increasingly hostile, and in 1931 he petitioned Stalin to be allowed to emigrate (which, after Gorky's intercession, was duly allowed). He spent the rest of his life in Paris.

Zazubrin, Vladimir Yakovlevich (real surname Zubtsov; b. 1895 Penza; d. 1938 Moscow) Arrested in 1916 for revolutionary activity, Zazubrin greeted the 1917 Revolution with enthusiasm, fighting in the Civil War on the side of the Reds. He then became an important cultural activist in Siberia, acting as editor of the journal *Siberian Lights* from 1923 to 1928. In 1928 he moved to Moscow at the invitation of Maksim Gorky, a funeral eulogy for whom is among Zazubrin's last publications. Arrested in 1937, he was shot in prison the following year.

Zinovieva-Annibal, Lidiya Dmitrievna (real surname Zinovieva; b. 1866 Kopore; d. 1907 Zagorie, Mogilyov) Prose writer, dramatist, critic. The second wife of Vyacheslav Ivanov (see above), Zinovieva-Annibal presided over their 'Tower' gatherings until her untimely death during an epidemic of scarlet fever. Her short novel *Thirty-three Freaks* (1907) made her notorious with the Russian reading public, but her right to lasting recognition is dependent on her other prose works, notably *The Tragic Menagerie*, and her dramas.

Zoshchenko, Mikhail Mikhailovich (b. 1895 Poltava; d. 1958 Leningrad) Prose writer, dramatist. He established himself as a writer in the early 1920s and rapidly became extremely popular for his humorous short stories; his readership included both working-class and intellectual readers, and émigrés as well as Soviet citizens. Even in the late 1920s Zoshchenko had some difficulties with the censorship (his comedy *Respected Comrade* was cleared for performance, but only in a version not sanctioned by Zoshchenko); in the 1930s he exercised a degree of self-censorship (choosing safer subjects, making excursions outside satire); despite these precautions in 1946 he (along with Anna Akhmatova) was denounced by the Leningrad Communist Party chief Andrei Zhdanov. Between then and 1953 he lived off translations; even when restored to favour in 1953, he produced no more major work.

Copyright Acknowledgements

Grateful thanks are due for permission to reprint copyright material in this book, as follows: ANNA AKHMATOVA: 'To the Defenders of Stalin' from *The Complete Poems of Anna Akhmatova*, translated by Judith Hemschemeyer, edited by Roberta Reeder, © 1990 by Judith Hemschemeyer, reprinted by permission of Zephyr Press; 'The Willow' from *Zvezda*, 3–4 (1940), translation © Alan Myers, 1999; INNOKENTY ANNENSKY: [Homer's Catalogue of Ships] from 'What is Poetry?' in *Apollon*, 6 (1911), translation © Catriona Kelly, 1999; MIKHAIL BAKHTIN: [The Carnival Crowd], in *Rabelais and His World*, translated by Hélène Iswolsky (Indiana University Press, 1984), reprinted by permission of the MIT Press; LÉON BAKST: from 'The Paths of Classicism in Art', in *Apollon*, 2 (1909), translation © Catriona Kelly, 1999; ANDREI BELY: [Moscow Symphony] from *The Dramatic Symphony: The Forms of Art*, translated by Roger and Angela Keys (Polygon Books, 1986), translation © Roger Keys, 1986, reprinted by permission of the publisher; [Entering into Life] in *Kotik Letaev, Skify*, 1–2 (1917–18), translation © G. S. Smith, 1999; NINA BERBEROVA: [Russian Paris] from *The Italics are Mine*, translated by Philippe Radley (Vintage, 1993), © Nina Berberova, 1969, translation © Philippe Radley, 1969, reprinted by permission of Random House UK Ltd; OLGA BERGGOLTS: [Living in Utopia] from *Daylight Stars* (Leningrad, 1971), translation © Catriona Kelly, 1999; ALEKSANDR BLOK: [An Evening in Siena] from 'Lightning-flashes of Art' and 'The Gaze of the Egyptian Girl' in *Sobranie sochinenii* (Berlin, 1923), translation © Catriona Kelly, 1999; 'Scythians', translated by Robin Kemball, from *Russian Review*, 14 (1955), translation copyright *Russian Review*, 1955, reprinted by permission of the publisher; from 'The People and the Intelligentsia' in *Zoloto runo*, 1 (1909), translation © Stephen Lovell, 1999; ALEKSANDR BOGDANOV: [A Martian Factory] from *Red Star: First Bolshevik Utopia*, translated by C. Rougle, edited by L. R. Graham and R. Stites (Indiana University Press, 1984), translation © Indiana University Press, 1984, reprinted by permission of the publisher; OSIP BRIK: 'The So-called Formal Method', translated by Ann Shukman and L. M. O'Toole, from *Russian Poetics in Translation*, 4 (1977), translation © A. Shukman and L. M. O'Toole, 1977, reprinted by permission of Ann Shukman; VALERY BRYUSOV: 'Prologue, no. 6' from *Juvenilia, Russkie simvolisty*, 3 (1895), translation © Catriona Kelly, 1999; MIKHAIL BULGAKOV: [An Experi-

ment Goes Wrong] from *The Heart of a Dog*, translated by Michael Glenny, first published in Great Britain by Harvill, 1968 © in the English translation the Harvill Press and Harcourt Brace & World, Inc., 1968, reprinted by permission of the Harvill Press; DAVID BURLYUK (with V. Mayakovsky, A. Kruchonykh, V. Khlebnikov): 'A Slap in the Face of Public Taste' (1912), translation © Catriona Kelly, 1999; ALEKSANDR CHAYANOV: [The Fair at White Kolp] from *The Russian Peasant 1920 and 1984*, edited by R. E. F. Smith, from *Journal of Peasant Studies*, 4, 1 (1976), reprinted by permission from the *Journal of Development Studies*, published by Frank Cass & Company, 900 Eastern Avenue, Ilford, Essex, England, © Frank Cass & Co Ltd; SASHA CHORNY: 'An Ass in the Latest Style' from *Struzhki* almanac (1909), translation © Catriona Kelly, 1999; 'Coiffeur de chiens' from *Poslednie novosti* (18 June 1930), translation © G. S. Smith, 1999; SERGEI EISENSTEIN: [Milton, Mayakovsky and Montage] from *The Film Sense*, translated by Jay Leyda (Faber & Faber, 1943), copyright 1942 by Harcourt Brace & Company and renewed 1969 by Jay Leyda, reprinted by permission of Harcourt Brace & Company; [A Baltic Childhood] from *Memoirs*, vol. 1 (1997), © Trud/Muzei kino, 1997, translation © Catriona Kelly, 1999; PAVEL FLORENSKY: [Against Linear Perspective] from *On Reverse Perspective* in *Sobranie sochinenii*, vol. 1 (YMCA Press, 1985), © YMCA Press, 1985, translation © Catriona Kelly, 1999; ZINAIDA GIPPIUS: 'The waves of other-worldly nausea foam up' from *The Last Circle* in *Difficult Soul: Zinaida Gippius*, edited and translated by Simon Karlinsky, © 1980 The Regents of the University of California, reprinted by permission of University of California Press; 'Choosing a Sack' from *Literary Diary 1899–1907* (1908), translation © Catriona Kelly, 1999; FYODOR GLADKOV: [The Temple of the Machines] from *Cement*, in *Krasnaya nov*, 6 (1925), translation © Catriona Kelly, 1999; NIKOLAI GUMILYOV: [No-hopers, Amateurs and Those Who Make So Bold] from 'Letters on Russian Poetry', no. 18, in *Apollon*, 4 (1911), translation © G. S. Smith, 1999; VYACHESLAV IVANOV: [Dostoevsky and the Dionysiac] from *Freedom and the Tragic Life*, translated by Norman Cameron (Harvill, 1952), reprinted by permission of the publisher; DANIIL KHARMS: 'Four Illustrations of How a New Idea Gobsmacks a Person who is Unprepared for It', 'Pakin and Rakukin' and 'The Start of a Really Nice Summer's Day' from *Incidents* (1933–9), in *Flight to the Heavens* (*Sovetskii pisatel*, 1988), translations © Catriona Kelly, Alan Myers, 1999; VELIMIR KHLEBNIKOV: 'Proposals' from *The Collected Works of Velimir Khlebnikov*, vol. 1, edited by Charlotte Douglas (Cambridge, Mass.: Harvard University Press), © 1987 by the Dia Art Foundation, reprinted by permission of the publisher; 'Fore-Father' from *Stikhotvoreniya i poemy*, 5 (1933), translation © Catriona Kelly, 1999; VLADISLAV KHODASEV-ICH: 'In Front of the Mirror', translated by Michael Frayn, from *Twentieth-century Russian Poetry* edited by Yevgeny Yevtushenko, © 1993 by Doubleday, a division of Bantam Doubleday Dell Publishing Group Inc., reprinted by

OLESHA: [Two Visions of Mayakovsky] from *Izbrannye sochineniya* (1956), translation © Catriona Kelly, 1999; SOFIYA PARNOK: [The Ice Hole] and 'Night. And it's snowing', translated by Diana Burgin, from *The Life and Work of Russia's Sappho* (New York University Press, 1994), translation © New York University Press, 1994, reprinted by permission of the publisher; 'Through a Window-light', translated by Catriona Kelly, from *An Anthology of Russian Women's Writing 1777–1992*, edited by Catriona Kelly (Oxford University Press, 1994), translation © Catriona Kelly, 1994, reprinted by permission of Catriona Kelly; from 'Noted Names' from *Severnye zapiski*, 4 (1913), translation © Catriona Kelly, 1999; BORIS PASTERNAK: from 'Zhenya Luvers's Childhood' from *The Voice of Prose*, vol. 1, edited by Christopher Barnes (Polygon Books, 1986), translation © Christopher Barnes, 1986, reprinted by permission of the publisher. KUZMA PETROV-VODKIN: [Noises in the Night] from *Khlynovsk* (1930), translation © Catriona Kelly, 1999; ANDREI PLATONOV: [The Building Site of the Future] from *The Foundation Pit*, translated by Robert Chandler, first published in Great Britain by Harvill in 1996, © the Estate of Andrei Platonov, © in the English translation the Harvill Press 1996, reprinted by permission of the publisher; BORIS POPLAVSKY: 'Another Planet', translated by Emmett Jarrett and Dick Lourie, from *The Bitter Air of Exile: Russian Writers in the West 1922–1972*, edited by Simon Karlinsky and A. Appel Jr (University of California Press, 1977), © 1977 The Regents of the University of California, reprinted by permission of the publisher; ANNA PRISMANOVA: 'Triangles' from *Sand*, no. 2, in *Salt* (1946), translation © Catriona Kelly, 1999; ILYA REPIN: [Unbridled Roisterers] from *Ilya Repin* by Elizabeth Valkenier (Columbia University Press, 1990), © 1990 Columbia University Press, reprinted by permission of the publisher; ALEKSANDR RODCHENKO: from 'On Contemporary Photography', translated by Stephen Lovell, from *Novyi Lef*, 9 (1928), © Rodchenko & Stepanova Archive, translation © Stephen Lovell, 1999, reprinted by permission of Alexander Lavrentiev and Varvara Rodchenko; VASILY ROZANOV: [People Whose Sex is Naturally Different . . .] from *Literary Exiles* (1913), translation © Catriona Kelly, 1999; OLGA ROZANOVA: from 'The Principles of the New Art and the Reasons Why It is Misunderstood' from *Soyuz molodyozhi*, 3 (1913), translation © Catriona Kelly, 1999; VADIM SHERSHENEVICH: [The Rhythm of the Future] from *Green Street* (1915), translation © Catriona Kelly, 1999; FYODOR SOLOGUB: [Jam Turnovers and a Slanging Match] from *A Low-grade Demon* (1907), translation © Catriona Kelly, 1999; NADEZHDA TEFFI: 'Huron' from *Vozrozhdenie*, 635 (27 February 1927), translation © Catriona Kelly, 1999; [A Small Town on the Seine] from *The Small Town* (N. P. Karabasnikov, 1927), translation © Catriona Kelly, 1999; MARINA TSVETAEVA: 'In Praise of the Rich', translated by Mimi Khalvati, from *Poetry Review* 83, 3 (1993), © Mimi Khalvati, reprinted by permission of Mimi Khalvati and the Poetry Society; 'Wires, no. 3', translated by Sarah Maguire,

Illustrations

PENGUIN CLASSICS

www.penguinclassics.com

- *Details about every Penguin Classic*

- *Advanced information about forthcoming titles*

- *Hundreds of author biographies*

- *FREE resources including critical essays on the books and their historical background, reader's and teacher's guides.*

- *Links to other web resources for the Classics*

- *Discussion area*

- *Online review copy ordering for academics*

- *Competitions with prizes, and challenging Classics trivia quizzes*

PENGUIN CLASSICS ONLINE

READ MORE IN PENGUIN

In every corner of the world, on every subject under the sun, Penguin represents quality and variety – the very best in publishing today.

For complete information about books available from Penguin – including Puffins, Penguin Classics and Arkana – and how to order them, write to us at the appropriate address below. Please note that for copyright reasons the selection of books varies from country to country.

In the United Kingdom: Please write to *Dept. EP, Penguin Books Ltd, Bath Road, Harmondsworth, West Drayton, Middlesex UB7 ODA*

In the United States: Please write to *Consumer Sales, Penguin Putnam Inc., P.O. Box 12289 Dept. B, Newark, New Jersey 07101-5289.* VISA and MasterCard holders call 1-800-788-6262 to order Penguin titles

In Canada: Please write to *Penguin Books Canada Ltd, 10 Alcorn Avenue, Suite 300, Toronto, Ontario M4V 3B2*

In Australia: Please write to *Penguin Books Australia Ltd, P.O. Box 257, Ringwood, Victoria 3134*

In New Zealand: Please write to *Penguin Books (NZ) Ltd, Private Bag 102902, North Shore Mail Centre, Auckland 10*

In India: Please write to *Penguin Books India Pvt Ltd, 11 Community Centre, Panchsheel Park, New Delhi 110017*

In the Netherlands: Please write to *Penguin Books Netherlands bv, Postbus 3507, NL-1001 AH Amsterdam*

In Germany: Please write to *Penguin Books Deutschland GmbH, Metzlerstrasse 26, 60594 Frankfurt am Main*

In Spain: Please write to *Penguin Books S. A., Bravo Murillo 19, 1° B, 28015 Madrid*

In Italy: Please write to *Penguin Italia s.r.l., Via Benedetto Croce 2, 20094 Corsico, Milano*

In France: Please write to *Penguin France, Le Carré Wilson, 62 rue Benjamin Baillaud, 31500 Toulouse*

In Japan: Please write to *Penguin Books Japan Ltd, Kaneko Building, 2-3-25 Koraku, Bunkyo-Ku, Tokyo 112*

In South Africa: Please write to *Penguin Books South Africa (Pty) Ltd, Private Bag X14, Parkview, 2122 Johannesburg*

READ MORE IN PENGUIN

READ MORE IN PENGUIN

Published or forthcoming:

Wars Edited by Angus Calder

'Soon there'll come – the signs are fair –
A death-storm from the distant north.
Stink of corpses everywhere,
Mass assassins marching forth.'

Wars dominated life in Europe in the first half of the twentieth century
and have haunted the second, as the terrible legacy of guilt and grief is
worked through. In this powerful and original anthology, Angus
Calder brings together writings which emphasize that, despite the
camaraderie and heroism of war, it is really about killing and being
killed.

It concentrates on why men fight wars and how something we can call
'humanity' somehow survives them. Primo Levi, Robert Graves,
Wilfred Owen, W. B. Yeats, Anna Akhmatova , Seamus Heaney,
Kurt Vonnegut, Marguerite Duras, Jacques Brel, Bertolt Brecht,
Sorley Maclean and Miklos Radnoti are among the many writers
represented; all offer a vivid sense of what war at the sharp end is
really like.

READ MORE IN PENGUIN

Published or forthcoming:

Artificial Paradises Edited by Mike Jay

Taking Baudelaire's now famous title as its own, this anthology reveals the diverse roles mind-altering drugs have played throughout history. It brings together a multiplicity of voices to explore the presence – both secret and public – of drugs in the overlapping dialogues of science and religion, pleasure and madness, individualism and social control. From Apuleius's *Golden Ass* to Hunter S. Thompson's frenzied *Fear and Loathing in Las Vegas*, via Sartre's nightmarish experiences with mescaline and Walter Benjamin's ecstatic wanderings on hashish, *Artificial Paradises* is packed full of the weird, the wonderful and the shocking.

'This is a superb anthology – scholarly, penetrative, mind-expanding. It's probably the best of its kind' Ian McEwan

'Excellent . . . shows how drugs permeate the very fabric of our history and culture' Irvine Welsh

READ MORE IN PENGUIN

READ MORE IN PENGUIN

Published or forthcoming:

Titanic Edited by John Wilson Foster

RMS *Titanic* sank to the bottom of the Atlantic during a night of rare calm, but the tragedy caused shock waves on both sides of the ocean and has continued to haunt our imaginations ever since.

The human drama of the disaster still has much of the power to excite and appal that it had in 1912, inspiring novels, films, plays, paintings and music. This anthology draws from more than eight decades of literature about the great ship, combining journalism, essays, fiction, poems, letters, songs and transcripts of hearings. It relives the event through the accounts of survivors, witnesses and commentators, with contributions from major writers of the time such as Joseph Conrad, H. G. Wells, Thomas Hardy, George Bernard Shaw and Sir Arthur Conan Doyle.

But beyond that it also shows how the sinking of *Titanic* was a cultural phenomenon which fulfilled the anxieties of its time – the frictions of class, race and gender, the hunger for progress and machine efficiency, and the arrogant assumptions of the Mechanical Age.